ONE NATION
UNDER GOD?

———————————————

CULTURE WORK

A Book Series from the Center for Literary and Cultural Studies at Harvard University
Marjorie Garber, editor
Rebecca L. Walkowitz, associate editor

ONE NATION UNDER GOD?

RELIGION AND AMERICAN CULTURE

Edited by Marjorie Garber
and Rebecca L. Walkowitz

Foreword by Cornel West

Routledge

NEW YORK AND LONDON

Published in 1999 by
Routledge
29 West 35th Street
New York, NY 10001

Published in Great Britain by
Routledge
11 New Fetter Lane
London EC4P 4EE

The publisher and editors are grateful for permission to reprint chapter 10, by Cheryl Gilkes. An earlier version of this essay appeared in *The Annals of the American Academy of Political and Social Science*, vol. 530 (July 1998).

Printed in the United States of America on acid-free paper.

Library of Congress Cataloging-in-Publication Data

One nation under God? : religion and American culture / edited by Marjorie Garber and Rebecca L. Walkowitz.
 p. cm. — (Culture work)
 Includes bibliographical references.
 ISBN 0–415–92223–2 (alk. paper). — ISBN 0–415–92224–0 (pbk. : alk. paper)
 1. Religion and culture—United States. 2. United States—Religion. 3. n-us.
I. Garber, Marjorie B. II. Walkowitz, Rebecca L., 1970–. III. Series.
BL2525.054 1999
291.1'7'0973—dc21 98–50482
 CIP

CONTENTS

FOREWORD

A DISTURBING PARADOX HAUNTS American cultural studies— why is the United States the most market-driven *and* religious nation of modern times? How do we understand the complex relation between the mobility and anxiety generated by market forces and the moralism and meaning provided by religious practices? Is there a distinctive religious character to U.S. capitalism and a unique capitalist content to religions in the United States? And what do these questions have to do with the quality of public life and democratic politics in the American past and present?

This fascinating volume signifies an American cultural studies coming-of-age in the midst of an uncanny American age of material prosperity and existential insecurity. Never before has the nation (and world) been so seduced by markets and so hungry for spirituality. The fragility of the international economic order looms large, yet markets remain the idols of our epoch. The hypocrisy of our religious (and political) leaders surfaces daily, but the quest for transcendence intensifies. If the two dominant forces on the globe are capitalist markets and religious energies under the aegis of U.S. hegemony, what are the prospects for democratic life here and abroad? What roles do nation, gender, race, sexual orientation, and ecology play in discerning these prospects?

Earlier keen observers of American life—from Alexis de Tocqueville to Louis Hartz—noted that the lack of a feudal past allowed the United States to conceive of itself as an innocent European settler society—born modern, liberal, and capitalist, with no antecedent encumbrances. This Edenic misreading of U.S. origins indeed hid and concealed violent conquest,

imperial expansion, patriarchal subordination, wage labor exploitation, and slave subjugation. Yet it does highlight a fundamental truth: Market ways of life saturate and permeate American culture in an unprecedented manner. Capitalism gained a foothold and moved to center stage much earlier and with more gravity in the United States than elsewhere. In stark contrast to leading theories of modernization—from Karl Marx to Talcott Parsons—religious worldviews and sensibilities have remained highly influential in American life. With the grand exception of the Russians, is there another modern literary tradition so obsessed with God and evil in flight from society and politics as great U.S. writers, whether Melville, Hawthorne, Fitzgerald, O'Connor, O'Neill, or Ellison?

American cultural studies rarely engages this undeniable paradox of American civilization. We have been so preoccupied with our early inferiority complex vis-à-vis Western Europe, our frontier mentalities, our regional diversities, our shifting democratic consensus, and recently our racialized and gendered hybridities, that we have overlooked the underlying American relation of markets to religion. This challenging collection of essays addresses this oversight. The dominant U.S. ideology of individualism and the pervasive American lived-experience of loneliness (or failed intimacy) may be rooted in the often ignored relation of capitalist markets to religious sentiments.

In short, this book could produce a new way of literary and cultural inquiry that sheds light on not only the dynamic "American character and mind," but also on our present historical moment given the Americanization of the globe—a world in which U.S. products engulf us all. In this way academic scholarship more fully engages the world by performing its sacred duty: pursuing truths and exposing lies about the past and present based on the insights and blindnesses we inherit from our past in light of our democratic visions for the future.

—Cornel West

INTRODUCTION

A PILGRIMAGE TO GRACELAND, praying football players, Jewish ritual in the Capitol Rotunda, cremation, and Christian Rock— all of these describe the landscape of American religion and mark the continuing fellowship of national identity and religious practice. The question in our volume's title—*One Nation under God?*—is meant to query both the "oneness" of the nation in religious terms and the relationship to religion of national consciousness, patriotism, and "Americanism." The title phrase, as many will know, comes from the Pledge of Allegiance, that common feature of American public school education.

Though the Pledge of Allegiance is common, its content has not been as constant as its recitation. In fact, in the early 1950s, the words "under God" were not part of the text. The phrase was not originally in the Pledge, and had never been in it, from its first publication in 1892 to its official recognition by the U.S. government in 1942. Religious Christmas carols in music class and the Lord's Prayer before assembly were regular fare in the public schools, but the Pledge of Allegiance was purely and simply "American," an equal opportunity pledge—or so it seemed. In 1954, at the urging of President Eisenhower, Congress voted to add the words "under God," no doubt a slap at "Godless communism" and a sign that "the American way of life" for some was inseparable from a particular way of religion. The new words made explicit a connection between patriotism and "God" that their sponsors argued was already there.

The Pledge of Allegiance is one sign among many that religion, often a private and personal topic, continues to play a central role in American public life. There is today a renewed interest in religion among Americans.

Religious schools are on the rise, as is a return to traditional ceremonies and dress among students, baby boomers, and elders alike. The "Americanness" of this renewal has something to do with ethnic and religious diversity, which has produced, variously, forms of assimilation, rigorous insulation, and eclecticism. It has something to do with the desire for self-invention and self-determination, a desire that has produced not only "religious freedom" but also religious bigotry, from an older anti-Semitism in the universities to the more recent destruction of Muslim mosques.

The contributors to this volume—religion scholars, lawyers, literary critics, historians, and clergy—elaborate the many styles of religion in contemporary American life. "Civility," "Law," "Practice," and "Conversion" organize the work that follows, though many of these essays themselves cross boundaries of topic and discipline and argue for such crossing as a primary characteristic of American religion. The authors collected here turn to local rituals and critical scenes to investigate the content of "religion" and to analyze particular and crucial debates. These readings often challenge the uniform narratives with which many religious practices are associated. In this challenge, contributors describe in Jewish denominationalism, multireligious townships, debates over homosexuality, and televangelist infighting the differences that compose and contest singular communities and singular rhetorics. *One nation under God?* That, among others, is the question this volume addresses.

In the opening essays of the collection, "Civility" refers both to sites of public government and to ways of public negotiation. Diana L. Eck describes the intersection of these sites and ways as she examines how the religious practices of immigrant populations have affected American towns and cities, and how American towns and cities have shaped the religious life of the people who have recently settled there. David L. Jeffrey explores the constitutional separation of "church" and "state," whereas Rabbi Irving Greenberg and Rev. Dorothy A. Austin show how religious communities try to maintain their own civility as they debate important political questions of family and sexuality. From racial politics to religious language, Michael Eric Dyson's provocative essay traces the work of black sacred rhetoric in the movement for civil rights.

The essays on "Law" locate the place of American religion in legal debates and discourses at home and abroad. Often, Janet Jakobsen and Ann Pellegrini attest, religion goes undernoticed as a context for legal deci-

sion-making. In the Supreme Court, they argue, Americans frequently "get" religion when they least expect it. David Kennedy brings this question of the secular into the court of international law, and Azizah Y. al-Hibri considers the contribution of American Muslim women to the work of Islamic jurisprudence throughout the world.

The essays on "Practice" look closely at religious activities that have been shaped by American popular iconography and culture. Deborah E. Lipstadt measures the symbolic importance of a Holocaust commemoration in the rotunda of the Capitol building in Washington, D.C., Cheryl Townsend Gilkes records the changing practices and implications of the black megachurch, and Stephen Prothero offers a history of cremation that rises and falls with celebrity trends and a taste for accessories. Robert Kiely's pilgrimage across America takes him to the houses of Thomas Jefferson and Elvis Presley, where he considers the patriotism and the religiosity of these two, often idolized figures. Lastly, turning to one of the most American of American popular creations, Barbara Claire Freeman goes looking for the rock 'n' roll in Christian Rock.

The essays on "Conversion" also attend to popular culture—to films, theme parks, and football stadiums—to tackle the controversial topics of evangelism and fundamentalism in American public life. William Handley, in a trenchant reading of Mormon baptisms for the dead and other American death rituals, explores today's extreme technologies of religion, and Peter S. Hawkins, sent by Yale Divinity School on a fact-finding mission, reports on his travels among the ministries of televangelism. In the volume's final essay, Marjorie Garber describes the role that God plays in American sports and sports stadiums, and the relation between patriotism, public prayer, and Christian masculinity.

As the diverse essays in this volume indicate, there are many, many instances of American religion, and in them the association of "God" and "nation," faith and politics, conversion and patriotism, is not far to seek. The writers collected here explore the dilemmas and benefits that these alliances, and our allegiances, pose.

The editors would like to thank Diana L. Eck and Robert Kiely, whose expertise and conceptual insight have helped make this book possible. For their participation in early conversations about religion and contemporary American culture, we are grateful to Rita Nakashima Brock, Harvey Cox, Robert Ellsberg, David Hall, Charles Hallisey, Evelyn Brooks Higginbotham,

Wendy Kaminer, Barbara Johnson, Mary Steedly, and Preston Williams. The preparation of the volume was greatly assisted by the tireless efforts of Barbara Akiba, Liz Campbell, David Horn, Karen Paik, Mun-Hou Lo, Lesley Lundeen, Brian L. Martin, Nish Saran, Mindy Smart, and Rachel B. Tiven. Finally, we would like to acknowledge William Germano, our editor and friend, whose intellectual commitment to this project has been invaluable.

CIVILITY

1

THE MULTIRELIGIOUS
PUBLIC SQUARE

Diana L. Eck

I WAS ALREADY IN GRADE SCHOOL and had memorized the Pledge of Allegiance when Congress passed the legislation in 1954 adding the words "under God." My classmates and I in Longfellow School in Bozeman, Montana, tripped over those words that so interrupted the more melodious flow of "one nation indivisible," but neither we nor most Americans tripped over the concept. Even, perhaps especially, with our childhood's theological imagination, we knew pretty much what it meant.

In the past thirty years, in the wake of the 1965 immigration act and the new waves of immigrants that have come to the United States from all over the world, that "we" has become much more complicated, and so has the "under God." While the United States has been home to small groups of Hindus and Sikhs for nearly a century and to Muslims and Buddhists for even longer, the visibility of these religious minorities has risen dramatically in the past thirty years. America has become not only a multicultural, but a multireligious society with a substantial and diverse Muslim minority virtually equal in size to the Jewish population, and growing Hindu, Buddhist, Sikh, and Jain communities. Christianity and Judaism have become more complex as well, with new immigrant Christian communities from Korea, Taiwan, and the Philippines, new denominations such as the Mar Thoma Syrian church, and an infusion of new Jewish immigrants from Russia. The Pluralism Project has tracked the changing religious landscape of the United States, especially investigating the ways in which immigrant religious traditions are changing in the American context and the ways in which America is changing as a result of the new immigration.[1]

We Americans—Hindu, Sikh, Muslim, Jewish, Christian—speak of God or gods in various ways. New Americans who join in the Pledge as they become citizens at Faneuil Hall in Boston may speak of God as Allah or Vishnu, with all the associations of which these powerful words partake. Some who are Buddhist Americans do not have a theistic concept of God, or do not use the symbol "God" at all. That phrase "under God" which seemed in the fifties to gather us together under a common umbrella is now constructed in our religious imaginations in complex and diverse ways. The "we" is also more complex. "We the people of the United States of America," in the first words of our Constitution, are now a multireligious people who guard in our founding covenants the "free exercise" of religion, including the freedom to eschew religion altogether.

The controversies of the American public square are just beginning. "Screw the Buddhists and kill the Muslims," said a South Carolina education official, Henry Jordan, during a public discussion in May of 1997. The question was whether the Ten Commandments should be posted in the schools and public buildings in South Carolina. He was also quoted as having spoken of Islam as a "cult," worshippers of "Lucifer." The Council on American Islamic Relations (CAIR), an Islamic advocacy group, called for his resignation as a member of the state Board of Education, saying, "American Muslims, and particularly Muslim parents in South Carolina, view these remarks with great alarm. The remarks demonstrate a level of bigotry and intolerance that is entirely inappropriate for a person charged with formulating public policy. As you may recall, when a South Carolina mosque was the target of an arson attack in October of 1995, the suspect in the case was quoted as saying he set the fire to 'rid the world of evil.' Mr. Jordan's comments can only serve to incite further acts of violence."[2]

The terms "diversity," "multiculturalism," and "pluralism" have come to common, though uncritical, use in the 1990s as such issues come to visibility in the public square. Some critics see these ideas as largely political, a new ideology of the American left. But the changing religious landscape of America reveals that diversity is not just an idea, let alone an ideology, but the appropriate descriptive term for the increasingly complex reality of American life. The battle lines are drawn over what to make of this diversity. For those who see these terms as dangerous, written in flashing neon, they signal the many ways in which the cultural consensus of "one nation under God" is being called into question. As Arthur Schlesinger, Jr., argues in *The Disuniting of America*, there is simply too much *pluribus* and not

enough *unum*.[3] Others argue, as I have, that the *pluribus*, the diversity, is the very stuff out of which the *unum* is created, a oneness marked not by uniformity but by the engagement of our deepest differences in the common covenants of citizenship. Whether diversity is a source of division or strength is one of the crucial questions in the controversies of the public square as racial, cultural, and religious differences are negotiated.

Our analysis of the issues at stake is often distorted by academic blindspots when it comes to religion, even in the interdisciplinary fields of cultural studies and Asian American studies. Many theoretical perspectives on America's complex racial and cultural issues take no note whatsoever of the profoundly important religious dimensions of culture. Writers in Asian American studies, for example, too often work within constricted intellectual frameworks that elide religion from analysis, as if immigrants from Asia— old and new—had no religious roots and formed no religious communities as they settled in the United States.[4] In mapping the faultlines of America's diversity today, we must look at the construction of race, ethnicity, class, and gender to be sure, but we must also look carefully at religion as a category of analysis. Not only have immigrants brought Buddhist, Sikh, and Muslim traditions of faith to these shores, but the visible markers of their religious faith often become the symbolic flashpoints of conflict in an America presumptively construed by the the likes of Henry Jordan as normatively Christian or "Judeo-Christian." So powerful is religious symbolism that racial and economic conflict is often embedded in religious discourse.

Taking religion seriously as a category of analysis means, at the outset, developing a more nuanced and dynamic understanding of religious traditions as both bearers and creators of culture. Too often even the most sophisticated cultural theorists are content to operate with a highly reified thing-ish notion of religion as if "it" were a bounded set of ideas, institutions, and practices that could be placed here or there, or completely ignored in the discussion of culture. But religious traditions such as Christianity, Buddhism, and Islam are dynamic, more like rivers than structures, constantly negotiating the terms and directions of change. They are also highly multivocal, more like long historical arguments reconfigured around the issues of each generation than like dogmas passed along in a box from one generation to the next. The study of religion in America forces upon us this more dynamic and nuanced understanding of the life of religious traditions, for the tensions of conservation and change come with the terrain of immigration. Immigrants to America—whether nineteenth-century Swedish Lutherans or late twentieth-

century Gujarati Hindus—have had to recreate their religious community life in new forms in a new land, negotiating the past and the present, the old country and the new, both setting themselves apart religiously and culturally and also participating in dynamic reality that is America, with its many religions and its cultural sanctions and expectations of religion.

In the 1990s, America has many visible and increasingly vocal religious minorities, hence the new spate of what I have referred to as the controversies of the pubic square. Here I intend to focus on the sites where religious difference is negotiated, looking especially at these public expressions of America's new multireligious reality. "Going public" takes many forms—building places of worship, submitting a case to the zoning board or city council, or getting a permit for a parade. There are inevitably tensions between wanting to be visible in the public arena and fearing that visibility may be risky.

For new immigrants, "going public" or becoming visible is an important expression of agency that often includes the creation of visible institutions such as temples and mosques. In the 1970s, Hindu religious life in America was predominantly centered in publicly invisible spaces—the home altar in the family room or in the kitchen cupboard, the festival days observed in rented halls. Muslims adapted a garage, a storefront, a gymnasium, or a commercial space for Friday prayers and weekend classes. But gradually these growing religious communities decided to build their own publicly visible places of worship. They broke ground and laid foundations for a spectacular new mosque in Toledo, a huge new Hindu temple in Lemont, Illinois, a new gurdwara in El Sobrante, California, a Jain Temple in Bartlett, Illinois—to name just a few of the hundreds of new places of worship that now dot the American religious landscape.[5] Building these institutions is no small undertaking, for it involves a complex set of negotiations both within the immigrant community and with the wider society.

Becoming visible also includes the creation of organizations, networks, and a national infrastructure to link immigrant co-religionists. The Islamic Society of North America (ISNA), the Federation of Zoroastrian Associations in North America (FEZANA), and the Association of Jaina Associations in North America (JAINA) are just a few of the burgeoning number of organizations that provide an infrastructure for America's minority religious traditions, many of them organized along what American sociologists have called a "federal" model, with national and regional or local chapters.

As religious communities gain confidence, "going public" means bringing their voices to bear on the debates and controversies of the pub-

lic square—from PTAs and school boards to national arenas of civic and political life. The 1990s has been a decade in which new voices have registered their views in America's public institutions. The most impressive infrastructure has been created by Muslim communities, with such organizations as the American Muslim Council, formed to be a catalyst for American Muslims to be more politically powerful in mainstream American life. Its first national conference held in Washington in 1997 began with Friday prayers in the Rayburn Building on Capitol Hill and concluded with a Sunday panel on "Eid—A National Holiday by the year 2000." The Council on American Islamic Relations monitors Muslim civil rights in America, publicizing incidents of discrimination, violence, and bias crimes. The Council on Islamic Education works to provide accurate information on Islam and Muslims to educators and textbook publishers.

Visibility makes a religious community more effective and also more vulnerable in the public square. When a new Hindu temple is constructed, when an Islamic school applies for permission to build, when a Sikh wearing a turban appears for a job interview, or when a Muslim woman wearing *hijab* goes to the grocery store, the striking visibility of a religious culture unfamiliar to many Americans may be the catalyst of suspicious and fearful response. In 1994, for instance, a Muslim woman wearing a full *hijab* was stopped by police in a St. Paul, Minnesota, mall and given a ticket for violating a local statute making it illegal to conceal one's identity "by means of a robe, mask, or other disguise."[6]

ENCOUNTER IN THE PUBLIC SQUARE: VISIBILITY AND VULNERABILITY

Two conflicting images suggest the direction of new encounters in a multireligious society. One is a snapshot from April 2, 1993: Jews and Christians, both clergy and laity, are gathered on hillside in Sharon, Massachusetts, to join the Muslim community of New England in breaking ground for a new Islamic center. The Islamic Center had suffered several set-backs in the previous two years. In 1991, in the wake of the Persian Gulf war, its mosque in Quincy had sustained half a million dollars worth of damages in an arson attack. In 1992, the growing Muslim community had been shut out of purchasing a site in suburban Milton. At the last minute, as the bank loan for the Islamic Center of New England was being worked out, a group of Milton residents joined together to purchase the

disputed property outright. Rather than enter into lengthy litigation, the Muslims decided to look for another property. The owner of a large horse farm in Sharon stepped forward to suggest his property as a site. After months of dialogue with the clergy council in Sharon, a suburb more than half Jewish, the ground-breaking took place. On that rainy spring day in 1993, there was a visible sign of contagious hope. Rabbi Barry Starr remarked, "Sharon is the place where Jews, Christians, and Muslims can live together in harmony—and that's what we in America have to export to other countries." Dr. Mian Ashraf echoed Rabbi Starr's sense of hope, "Our vision is to reach out and make this a place where people of all faiths can come together and learn about each other." Six years later, the fifty-four acre horse farm has been transformed into a vibrant center of Islamic education, community life, and prayer.[7]

A second image displays the other side of the story: a mosque, nearly completed in Yuba City, California, is burned to the ground in an arson attack in September of 1994. The *Muslim Journal*, a weekly publication of the African-American following of Imam W. D. Mohammed, was one of the few newpapers to carry the story. "The dream of a mosque and an Islamic center for Muslims in the Yuba-Sutter area of California was one that all the local Muslim brothers and sisters held very dear for a long, long time. For now, after the struggle and toil to make that dream a reality, it has been taken back to zero. The brand new nearly-to-open mosque on Tierra Buena Road outside of Yuba City is gone. It burned to the ground late Thursday night, Sept. 1, 1994. The distinctive dome and minaret of the mosque was left lying in its ashes. Only a wall with pointed arches remained to show the beauty of what once was."[8]

For Muslims, becoming publicly visible has unquestionably meant becoming more vulnerable as well. The case of Yuba City can be added to a list of dozens of incidents recorded by the Council on American Islamic Relations, a Muslim advocacy group similar to the Jewish Anti-Defamation League, collecting and reporting incidents of violence. In the days following the bombing at the Murrah Federal Building in Oklahoma City in 1994, CAIR received reports of more than two hundred incidents of violence, threats, or vandalism directed at Muslims and Muslim institutions through-out the United States. In 1995 alone, CAIR reported the arson of a mosque in High Point, North Carolina, in April, in Springfield, Illinois, in June, and in Greenville, South Carolina, in October. In September of 1995, obscenities and graffiti were spray-painted on the Islamic Center of Passaic County in

New Jersey, and Masjid Al-Momineen in Clarkston, Georgia, was vandalized and desecrated with satanic symbols. In October, the Islamic Center in Flint, Michigan, was spray-painted with an obscene anti-Islamic message. At the Flint mosque in 1998, Muslims emerging from Eid al-Fitr observances found the parking lot strewn with iron spikes.

As America's new immigrant religious communities "go public," it is critical to begin to track the stories of what is happening in the neighborhoods of America. These stories do not yet have conclusions. They are still being written in towns and cities across the country. Theories of multiculturalism or pluralism will eventually be shaped from the evidence of this new phase of America's multireligious life. But first it will be necessary to do our homework, looking carefully at the sites of interreligious and intercultural encounter, those places where religious differences are negotiated in the public arena. This means investigating the stories of both conflict and cooperation in America's public spaces—neighborhoods, zoning boards, city councils, courts, and schools.

SITES OF ENCOUNTER: FROM ZONING BOARDS TO PUBLIC SCHOOLS

No one can study the new multireligious America without a trip to the zoning board, for this is where a community classifies that most important commodity of American life: property. Zoning controversies are a common site of neighborhood encounter and perhaps the first context in which an immigrant religious community meets its new neighbors. For nearly a decade, the Pluralism Project has followed the case of the Lien Hoa temple in Garden Grove, California, one of dozens of small "home temples" in Orange County. At the outset, a Vietnamese Buddhist monk transformed a suburban home into a temple: The living room became the Buddha hall and the back patio with its picnic tables became the weekend education center. During the week a dozen daily worshippers came for conversation and meditation, but on special occasions such as a funeral ceremony or the Buddha's birthday observance, two or three hundred people would arrive. Understandably, some of the neighbors were upset. There was too much traffic, too little parking, and probably too many strangers. Lien Hoa's five-year controversy with the zoning board raised new questions about the meaning of religious liberty. A "church" in Garden Grove was required to have an acre of land and a certain ratio of parking places

to parishioners. But the worship patterns of the Vietnamese Buddhists were not those of a "church." Indeed, the monk's home was the "church," and membership was not fixed, but fluid. There were no parishioners as such. "Parking" and "traffic" became the terms of a negotiation that had more to do with different forms of religious observance.[9]

Another kind of zoning dispute is the case of the Swaminarayan Hindu temple in nearby Norwalk, California, where city officials were concerned to regulate not only the size, but also the style of the proposed temple. The city council required that the Hindus create a smaller temple than the $1.2 milllion dollar structure planned, and also insisted that it be more in keeping with the "Spanish" architectural norms of the city, thus modifying the distinctive ornate style of Hindu architecture. In this case as well the planning commission cited complaints about potential problems with parking and traffic as determinative in its ruling.

Not all encounters take place in the public space of city councils and zoning boards. Vigilante acts, like the arson in Yuba City, take the form of violence and vandalism targeting the most visible symbol of a religious community: its buildings. It is clear from the history of prejudice in America that religious institutions become the key markers of difference and strangeness. The history of anti-Semitism with persistent attacks on synagogues and graveyards provides ample testimony to the tactics of prejudice and hatred. So does the long history of racist attacks on black churches, the most recent spate of which has attracted the attention of a congressional investigation. Religious insignia, religious markers of identity, and religious institutions come to stand in a public way for the soul of the community and often become the targets for bigotry and violence.

In Monroeville, Pennsylvania, the Hindu-Jain temple was vandalized in February of 1983. Its sacred deities were smashed and the word "leave" was scrawled across the altar. Another style of aggression was the 1997 case of a Hindu temple in Shawnee, Kansas, a suburb of Kansas City, where a side of beef was tied on the door of the temple, a clear insult intended to the vegetarian Hindu community. In Portland, Maine, a Buddhist temple called Watt Samaki, "Unity Temple," the home of a tiny Cambodian Buddhist community, was vandalized in August of 1993. The door of the two-story wood frame house was hacked with an axe, the contents of the Buddha hall strewn about the yard, and everything of value destroyed or stolen. Here, too, there was writing on the wall of the temple room: "Dirty Asian, Chink, Go Home."[10]

Incidents of violence and vandalism make clear that race and religion

are different yet inseparable markers of identity. Many attacks on religious institutions, like those cited above, also have racist overtones. It is clear that the arson of a black church is not directed against Christianity, but against the buildings that visibly represent the life of the African-American community. In New Jersey, the dot or *bindi* on the forehead worn by many Hindu women stood for the strangeness of the whole Indian immigrant community in the eyes of a racist group calling themselves the "Dotbusters." The attacks on Indian immigrants in urban northern New Jersey in the 1980s were not about Hindu theological ideas or religious practices, but about race. Those who shouted, "Hindu, Hindu," as they beat Navroze Mody to death in Jersey City in 1987 conflated race, religion, and culture in one cry of hatred.[11] But not all such incidents are about race. For instance, the arson of a mosque is more likely a statement about Islamophobia than about the racial composition of the Muslim community that gathers at the mosque, though it may also involve anti-Arab prejudice conflating the entire Muslim community with its Middle Eastern constituents.

Harder to research, but probably more numerous, are the countervailing stories not of violence, but of growing understanding and cooperation between and among religious communities in the United States. Documentary evidence of a new deliberate era of interreligious relationship does not usually make it into the newspapers, but its prognostic significance is far greater, I would venture, than the incidents of zoning controversies, violence, and vandalism. The interfaith ground-breaking in Sharon, Massachusetts, is one instance of local interfaith cooperation, wholly outside any institutional network or structure. It is one of hundreds of similar stories that can be documented only by researchers truly interested in investigating interreligious relations "on the ground," or by journalists who classify such stories as "news."

In Fremont, California, there was a ground-breaking even more unusual than that in Sharon. On April 18, 1993, St. Paul's United Methodist Church and the Islamic Society of the East Bay broke ground together for a new church and a new mosque, to be built side by side. The Muslims and Methodists met the day they bought adjacent lots of property at a city auction. They did not set out to create a new vision of neighborliness, but found themselves cooperating through force of circumstance. As they laid plans for building, the two communities discovered they could build larger facilities through cooperation in common parking, landscaping, and lighting. They began working closely together

and came to know each other not in a formal "interreligious dialogue," but in negotiating their complex set of easements and agreements with the city. They named their common access road "Peace Terrace," and they are now next-door neighbors. As one of the Muslim leaders put it, "We want to set an example for the world."[12]

By the fall of 1997, both buildings were open for worship, but what will happen as these two new neighbors develop their religious lives side by side is a story still in process of being written. No theory of multireligious encounter can as yet be adduced from Peace Terrace in Fremont. It may be that they will develop a relationship of mutual tolerance, but relative ignorance of each other's faiths. It may be that they will develop energetic educational programs to learn about each other, to visit in each other's homes, to share as visitors in each other's worship and festivals. It may be that they will form joint committees for public service and work together on issues of common civic concern.

Sites like Peace Terrace are not so uncommon in the 1990s in the United States. There are countless places where people of other faiths are no longer metaphorical neighbors around the world but literally next-door neighbors. A new Vietnamese temple was built directly across the street from a Lutheran church in Garden Grove, California; in San Diego, the Islamic Center has been constructed right next door to a Lutheran Church; on New Hampshire Avenue in Silver Spring, Maryland the Cambodian Buddhist temple and monastery, the Ukrainian Orthodox Church, the Muslim Community Center, the Disciples of Christ Church, and the Mangal Mandir Hindu Temple are all virtual neighbors within a few miles of one another. The question that is still under negotiation is whether proximity will generate the kind of relationship and mutual engagement that could be called "pluralism." Diversity, after all, is a mere fact of our society, but pluralism is a creation.

To take the measure of how multireligious America is faring, we also have to study the courts, important sites for the negotiation of religious difference in the context of constitutional law. Cases of native sacred lands (Lyng v. The Northwest Indian Cemetery Protective Association, 1988), the ceremonial use of peyote (Employment Division of Oregon v. Smith, 1990), and Santeria animal sacrifice (Church of the Lukumi Babalu Aye v. City of Hialeah, 1993) have set important, if controversial, precedents in First Amendment litigation.[13] As we look to the future, the questions are many. It is not surprising that as America's newest religious minorities go public,

those most visible in their appearance are the first to experience discrimination: Muslim women wearing the *hijab* or head-covering and Sikh men wearing turbans. Can a Muslim woman wear her head-covering on the job as a flight attendent for US Air? as a public school teacher? Can Domino's pizza chain be required to hire an unshaved and turbaned Sikh? Can a turbaned Sikh serve in the city police force or the U.S. armed forces? Can a Sikh student wear the *kirpan,* the symbolic knife required of all initiated Sikhs, to school? These are the new questions, some of them civil rights questions, that have been raised in the court system in the 1980s and 1990s.

Along with zoning boards and courts, public schools are unquestionably at the front lines of interreligious encounter in the United States. Much needed guidelines for negotiating the role of religion in the public schools have been proffered by dozens of organizations from the PTA to the Americans United for the Separation of Church and State. Misunderstanding among educators, parents, and students—and the politicization of misunderstanding among groups advocating a stronger role for religious practice in the public schools—led President Clinton and the Department of Education to articulate clearly the principles that govern religious expression and the teaching of religion in the public schools. The 1995 document "Religious Expression in Public Schools" clarifies the law in relation to some of the most contested issues in America. For example, students can certainly pray in school, but teachers or administrators cannot lead students in prayer. Schools can teach religion, but not advocate any particular religion. Schools can teach about religious holidays, but not observe religious holidays.[14]

While many churches weigh in on all sides of the classroom prayer controversy, one of America's oldest Buddhist communities has also made its views public. In 1985, the National Council of the Buddhist Churches of America approved a statement drafted by its Social Issues Committee, insisting that any form of school prayer would implicitly impose a form of religiousness privileging certain theological and religious notions of "God" and "prayer." The statement reads, in part, "Prayer, the key religious component, is not applicable in Jodo Shin Buddhism which does not prescribe to a Supreme Being or God (as defined in the Judeo-Christian tradition) to petition or solicit; and allowing any form of prayer in schools and public institutions would create a state sanction of a type of religion which believes in prayer and 'The Supreme Being,' would have the effect of establishing a national religion and, therefore, would be an assault on the religious freedom of Buddhists."[15]

The range of church-state issues in the public schools today is far more complex than ever before. In Dallas, for example, the Dallas Independent School Board found it needed advice on the restrictions, observances, and holidays of its increasingly diverse student population, including not only Christians, Jews, and Muslims, but Hindus, Sikhs, and Jains, Vietnamese, Laotian, and Chinese Buddhists. It was the school board that called together an interreligious council, the Religious Community Task Force, to provide guidance and information for the schools. Together they worked out a set of guidelines. For example, religious symbols such as the cross, the star of David, or the Buddha can be used for teaching, but not for display or devotion. The scriptures of the world may be studied in an academic context, but not in a devotional context. Religious music can certainly be used as part of a program or concert, but any such program or concert containing the religious music of only one faith would be out of place.

ICONS OF THE PUBLIC SQUARE

During the 1990s, ritual public discourse and public enactments have begun to reflect America's new multireligious reality. Officials sensitive to their range of constituents now commonly speak of our religious institutions as "churches, synagogues, and mosques." Occasionally the term "temples" becomes part of the litany as well. The signals of inclusion are recorded in the routine but highly important symbolic proclamations of mayors and city councils. For example, in Savannah, Georgia the City Council issued a proclamation in April of 1990 stating that Islam has "been a vital part of the development of the United States of America and the city of Savannah."[16] The resolution continues:

> WHEREAS
> The ethical system of the United States of America is in many respects consistent with the ethics upon which the religion of Al-Islam is based, also recognizing the need for this fact to be reflected in our referring to our Nation's Code of Ethics as being "Judeo-Christian-Muslim Code of Ethics"; and
>
> WHEREAS
> Al-Islam is presently the fastest growing religion in the world and in the United States of America, notwithstanding the fact that there

exists historical documentation that many of the African slaves
brought to our country were followers of the religion of Al-Islam;

NOW THEREFORE, I, John P. Rousakis, Mayor of the City of
Savannah, in recognition of this religious community in Savannah,
do hereby proclaim

THE RELIGION OF AL-ISLAM BE GIVEN EQUAL ACKNOWL-
EDGEMENT AND RECOGNITION AS THE OTHER RELIGIOUS
BODIES OF OUR GREAT CITY. I URGE THE CITIZENS OF SAVAN-
NAH TO SUPPORT THE MUSLIM COMMUNITY IN ITS EFFORTS
TO BRING ABOUT PEACE THROUGH GOD CONSCIOUSNESS.

These peculiar formal expressions—cast in the cumbersome language of
resolutions and pronouncements—provide a significant index of the bid
for public space among new immigrant communities. In 1991, for example,
the city of San Francisco recognized the annual Hindu festival of Ganesha
Chaturthi, a festival in which specially created temporary images of the
elephant-headed deity, the remover of obstacles, are worshipped. At the close
of the festival the images are carried in procession to the sea, where they are
de-consecrated and submerged in the water, a ritual called *visarjana*. The
mayor of San Francisco proclaimed "Golden Gate Ganesha Visarjana Day,"
and the *India Abroad* on September 6, 1991 noted, "It is believed to be the
first time that the mayor of a city in the United States has honored the
Hindu deity."

In every city, parades and processions are important evidence of
"going public." New York's Irish Saint Patrick's Day and Chinese New Year
parades have been joined on the annual calendar by a plethora of relative-
ly new processions: the India Day parade featuring a huge float of the god-
dess Kali; the Jagannath Rath Yatra pulling Krishna's giant chariot down
Fifth Avenue; the Baisakhi Day parade with rank after rank of brightly tur-
baned Sikhs. In New York, where official holidays are registered by the sus-
pension of alternate side of the street parking, the two major Islamic feast
days—Eid al-Fitr and Eid al-Adha—have been added to the list.

An incremental public recognition of holidays also takes place at the
highest levels. On February 20, 1996, at the end of the month of Ramadan,
Hillary Clinton welcomed Muslims in a ceremony at the Old Executive
Office Building across from the White House. Her official remarks began,
"Eid Mubarak. I want to welcome you all to the White House as you and

Muslims all over the world celebrate the end of Ramadan. I am honored so many of you could take the time to share part of this holy month with us here. This is a historic occasion—the first Eid celebration ever at the White House. It is only fitting that, just as children and families of other faiths come here to celebrate some of their holy days, so you, too, are all here to mark this important Islamic tradition." The significance of the event itself is amplified by the photographic icons that display a new image of what America looks like: the American flag and and the Great Seal of the Presidency frame the First Lady receiving American Muslims. In a culture saturated with print media and television, these iconic representations convey, above all, the public record an extraordinary historic occasion.[17]

The 1990s have seen a "first" in the armed forces: Buddhist and Muslim military chaplains. During World War II, Muslim soldiers could not even have "Islam" inscribed on their dogtags to identify their religion; they had to settle for the identification "other." This was one of the concerns that led an Iowa Muslim, Abdullah Igram, to establish the International Muslim Society in 1952, the first forum for the expression of a Muslim voice in the public arena. Not until the 1990s, however, did the armed forces move to seek out Muslim chaplains. In 1996, ensign M. Malik Abd al-Muta' Ali Noel, Jr., became the first Muslim Naval chaplain in U.S. history.

Finally, legislative prayers have been an index of the presence of new voices in the public square, and here too the 1990s have seen change. On June 25, 1991, Imam Siraj Wahhaj of Masjid al-Taqwa in Brooklyn was the first Muslim to open a session of the U.S. House of Representatives with the customary invocation. On February 6, 1992, Imam W. Deen Mohammed, leader of the large majority of African American Muslims, became the first Muslim to offer the daily invocation in the U.S. Senate. Like official resolutions and proclamations, legislative prayers are routine public enactments to which few citizens or legislators pay much attention. Their historic significance as indices of change, however, is that they represent the will to lay claim to a visible and vocal presence in the public square.

TOWARD PLURALISM

So how is America doing as a multireligious society? In the early 1980s, Richard John Neuhaus warned of the "naked public square" in which American public life was hostile to religion, excluding religion from public discussion and stripping the public square of any religious presence.[18]

To some extent he was right: A secularism of absence interpreted the public arena as space devoid of religious voices and values according to a rigid reading of what has come to be called the "separation of church and state." Equal access litigation, however, has gradually established that the public sphere cannot discriminate against religious groups. If a book club or the Red Cross can use a public school for an event, a Christian group should be able to use the same space for showing a film, and a Hindu community should be able to hold Diwali or Holi celebrations there.

In the 1990s, the American public square is scarcely "naked," but filled with religious voices on all sides of the issues—from abortion to capital punishment. And it is not Christian, nor Judeo-Christian, nor Judeo-Christian-Islamic, but increasingly multireligious.[19] Diverse religious communities are visible, if one takes the time to look, and diverse voices contribute to the public discussion, if one takes the trouble to hear. Those who use the language of secularism would have to speak of a secularism of presence, not absence: the participation and engagement of religious communities in the public debate, weighing in with a host of other voluntary organizations and lobbies, negotiating for voice and influence in public discussion. This secularism of presence involves not only the voices of the growing religious infrastructure of Muslims, Sikhs, and Jains, but also a growing interreligious infrastructure bringing new instruments of interrelation to the public square.

The 1990s have seen the rapid expansion of interfaith councils in cities, towns, and suburbs from Columbia, South Carolina, to DuPage County, Illinois. Again, the photographic icons of this movement have become familiar: the clergy of different faiths arrayed in liturgical regalia, at least for those who are distinctively visible by virtue of their regalia. Among the pioneers in urban interfaith activity is the Interreligious Council of Southern California, one of America's oldest active interfaith councils. It began in 1969 as a Catholic, Jewish, and Protestant organization and now includes Baha'i, Buddhist, Greek Orthodox, Muslim, Sikh, and Hindu representatives as well. It has supported the appointment of a Buddhist chaplain in the California State Senate and backed the Sikhs in their petition to the L.A. Police Department to serve as policemen while wearing the required beard and turban. When the Hsi Lai Buddhist temple in Hacienda Heights was stalled in five years of zoning battles, it was the Interreligious Council of Southern California that came to the support of the Chinese Buddhist community. It helped Los Angeles Muslims and Thai Buddhists in zoning battles as well. Members of the Council insist

that its strength is in the trust and friendship built up by a network of personal relationships. As in many interfaith councils, channels of communication forged by friendships are brought powerfully to bear on issues from zoning disputes to urban homelessness.

After more than thirty years of this new period of soaring immigration, the question of who "we" are is again a topic of national argument, related, as in the past, to the discussion of immigration policy. As Harvey Cox puts it, "Whether we are going to make it as a people, with this immense, rich, heterogeneous population, or whether we're going to burst apart into some kind of fragmentation is still a question in my mind." [20] There are modern-day exclusionists not unlike those who argued in support of the 1882 Chinese Exclusion Act, insisting that Chinese and American cultures, like oil and water, could never mix.[21] For instance, Peter Brimelow, in *Alien Nation*, calls for closing the door, arguing that the 1965 immigration act was a mistake and that the Anglo-Saxon core is being squeezed between the "pincers" of rising Asian and Hispanic populations. There are also new assimilationists, arguing for one or another version of the "melting pot," not excluding but melting and transmuting difference. Here one might think of Arthur Schlesinger, Jr., who calls for a renewed emphasis on the common, the *unum*, in the face of the growing *pluribus* he refers to as "the disuniting of America."

And there are pluralist voices too, recalling the views of Horace Kallen who argued in 1915 that the melting pot is contrary to the spirit of democracy, that one does not have to shed cultural difference to become American, for the right to one's differences within the context of common citizenship is foundational. His image was not the melting pot, but the symphony.[22] Religion does not readily melt. Religious differences resist the assimilative forces of the melting pot, even as they create new and sometimes syncretistic forms of religiousness. It is not surprising that the voices of many of America's immigrants are pluralist, emphasizing the right to differences, and the engagement of difference in public space. But the discussion is far from over.[23]

An Orthodox Jewish rabbi, for example, puts it this way: "What America means to an Orthodox Jew? After centuries of being persecuted precisely because of the way he looks and eats, he is for the first time in a place where it is perfectly alright for him to wear a black coat, and to talk Yiddish, and to teach his children the aleph-beth before he teaches him the alphabet. He appreciates it, because America gives him a chance to be himself without losing his humanity."

A Muskogee Creek Indian, looking at the reconfiguration of the terrain with the new immigration, offers an important corrective to the assumption that everyone has the "freedom to be oneself." She says, "We talk about religious freedom in this country, and yet the first people who were here are still suffering. Many people are very touched by the sensitivity that has to be shown to Jewish people and to the Hindus and to the Muslims, but yet you have a whole group of people who are already here, who already had spirituality, and no one realizes that this group is still fighting to be able to practice what they did freely before colonization." She concludes with the strong dissenting voice of many Native peoples: "I cannot say that I am an American. I'm a Muskogee Creek Indian. That's who I am."

A Muslim feminist law professor recognizes both the ideal and the problems. The ideal, of course, is that "everybody has a seat at the table and can speak out." And yet she sees clearly that racial and religious minorities like the Muskcogee and even the Muslims often don't have a seat at the table. "But the thing is," she says, "you can stand up and say, 'I don't like your racism. I don't like your parochialism.' I can talk to feminists and say, 'You're silencing me as a Muslim woman.' I can talk about these things, and struggle with them, and fight about them, so that the ideal of American one day will come to be true."

NOTES

1. This paper was based on and presented with the CD-ROM produced by our research. Diana L. Eck and the Pluralism Project, *On Common Ground: World Religions in America* (New York: Columbia University Press, 1997).
2. CAIR Press Release, "CAIR Calls for Removal of South Carolina Office who said 'Kill the Muslims,'" Washington, D.C., May 19, 1997.
3. Arthur Schlesinger, Jr., *The Disuniting of America* (New York: W.W. Norton & Co., 1992).
4. The work of the distinguished historian of Asian America, Ronald Takaki (*Strangers from a Different Shore: A History of Asian Americans*, 1989 and *A Different Mirror: A History of Multicultural America*, 1993) is an example of this form of scholarly disinterest in religion, as is the more theoretical work of Lisa Lowe (*Immigrant Acts*, 1996).
5. *On Common Ground: World Religions in America*, A New Religious Landscape, "New Neighbors."
6. *Christian Century*, October 26, 1994, p. 979.
7. *On Common Ground: World Religions in America*, Encountering Religious Diversity, Today's Challenges, "Grassroots Cooperation."
8. Saleem Shah Khan, "Faith Survives Devastating Fire," *Muslim Journal*, September 30, 1994. See *On Common Ground: World Religions in America*, Encountering Religious Diversity, Today's Challenges, "Violence and Vandalism."

9. See the case study of "The Lotus Flower Temple" in *On Common Ground: World Religions in America*, Encountering Religious Diversity; Today's Challenges, "Not in This Neighborhood!"

10. For reports on the Hindu-Jain Temple and Watt Samaki, see *On Common Ground: World Religions in America*, Encountering Religious Diversity; Today's Challenges, "Violence and Vandalism."

11. For an account of the incident see *On Common Ground: World Religions in America*, Encountering Religious Diversity; Today's Challenges, "Stereotypes."

12. *On Common Ground: World Religions in America*, Encountering Religious Diversity, Today's Challenges, "Grassroots Cooperation."

13. *On Common Ground: World Religions in America*, Encountering Religious Diversity; Today's Challenges, "Encounter in the Courts" includes selections from the Supreme Court decisions on the Smith case and the Santeria case.

14. All these documents are included in *On Common Ground: World Religions in America*, Encountering Religious Diversity; Today's Challenges, "Encounter in the Public Schools."

15. "Buddhist Resolution Opposing the School Prayer Amendment," San Francisco: Buddhist Churches of North America, 1985. See *On Common Ground: World Religions in America*, Encountering Religious Diversity; Today's Challenges, "School Prayers? Holidays?"

16. *On Common Ground: World Religions in America*, Encountering Religious Diversity; Today's Challenges, "Encounter in the Public Square."

17. See *On Common Ground: World Religions in America*, Encountering Religious Diversity; Today's Challenges, "Encounter in the Public Square" for the text of Hillary Rodham Clinton's remarks on this occasion.

18. Richard John Neuhaus, *The Naked Public Square* (Grand Rapids, MI: Eerdman's Publishing, 1984).

19. Even Stephen Carter in *The Culture of Disbelief* (New York: Basic Books, 1993), who echoes some of Neuhaus's lamentations a decade later and advocates a stronger and less apologetic voice for religious faith in the public sphere, still writes of a Judeo-Christian America, without a single reference to the religious communities that have reconfigured the public square.

20. *On Common Ground: World Religions in America*, "Voices of America."

21. *On Common Ground: World Religions in America*, Encountering Religious Diversity, Historical Perspectives, "Asians and Asian Exclusion."

22. Horace Kallen, "Democracy versus the Melting Pot," *The Nation,* vol. 100, no. 2590, February 18 and February 25, 1915. Excerpts in *On Common Ground: World Religions in America*, Encountering Religious Diversity, Historical Perspectives, "The Right to be Different."

23. The three closing quotations are from *On Common Ground: World Religions in America*, "Voices of America."

2

CIVIC RELIGION AND THE
FIRST AMENDMENT

David Lyle Jeffrey

I have sometimes asked Americans whom I chanced to meet in their own country or in Europe whether in their opinion religion contributes to the stability of the State and the maintenance of law and order. They always answered, without a moment's hesitation, that a civilized community, especially one that enjoys the benefit of freedom, cannot exist without religion. In fact, an American sees in religion the surest guarantee of the stability of the State and the safety of the individuals. This much is evident even to those least versed in political science. Yet there is no country in the world in which the boldest political theories of the eighteenth-century philosophers are put so effectively into practice as in America. Only their anti-religious doctrines have never made any headway in that country, and this despite the unlimited freedom of the press.

—*Alexis de Tocqueville,* The Old Regime and the French Revolution

FOR FRIENDS OF AMERICA, looking in from outside, the long-standing American preoccupation with the anti-establishment clause of the First Amendment can seem confusing, even while the primary purpose of that amendment—protection of the right to free speech—seems admirably clear. On the one hand the Constitution famously excludes the legal possibility of a civic religion; this in notable contradistinction to the practice of religious establishments in a majority of European and South American nation states. On the other hand, few nations project a public image in both domestic and world affairs so self-consciously religious in its symbolism, iconography, and rhetoric of public discourse. Thus, while a school child or laborer from the Pacific rim (for example) might well be uncertain whether to identify Scandinavia and

Germany with Lutheranism, Holland with Calvinism, Bulgaria with Orthodoxy or even Brazil with the Roman Catholic church, it is entirely likely such persons will readily identify the United States with the religion of the televangelists—even though they may be understandably uncertain of what to call it. That the association is probably unfair is not my point. How to connect the usual identification with the anti-establishment clause, however, remains for many an intractable mystery.

History, where it becomes available, helps the uninitiated only a little. While it is clear that for the first century and a half of American constitutional history the anti-establishment clause was interpreted only in the narrow sense of prohibiting the establishment of a national church, it is equally apparent that by the mid-twentieth century there had grown up a strong political and cultural interest in limiting more generally the role of religion in public life. To serve this interest, a phrase from the correspondence of Thomas Jefferson seems to have been elevated from a personal remark "to virtual constitutional status."[1] One suspects that up to the presidency of John F. Kennedy the animus for this will to constraint of religion was largely anti-Catholic sentiment in the matter of funding parochial schools, though the efforts of Madeline O'Hare and others to remove "In God we trust" from coinage and Bible reading and prayer from public schools have kept the narrowest sense of the clause dominant well beyond that fateful day in Dallas. But not much of the constraint has seemed very plausibly connected to the First Amendment *as such*. What the anti-establishment clause actually says, of course, is that "Congress shall make no law respecting an establishment of religion, *or prohibiting the free exercise thereof*." However distressing to some critics on both the right and the left, President Clinton's August 14, 1997, "new guidelines" requiring government supervisors to respect individual expressions of faith by federal employees seem unremarkably consistent with the First Amendment as it reads. The ostensible effect of the Clinton guidelines (*Washington Post*, August 17 1997) is to affirm the constitutional intent to protect religious pluralism—neither more nor less.[2]

But fear remains. Apprehension that a conspiracy for the political establishment of religion—notably the kind of religion represented by the televangelists (and perhaps the Rutherford Institute) persists on the left side of these guidelines, while fear that the powers of the Supreme Court will be employed undemocratically to repress religious freedom gathers on the right, Clinton's gesture notwithstanding. That is, for part of American society the *bête noir du jour* remains the threat of an electorally imposed

civic religion, for another part the scenario that threatens is a denial of religious freedoms imposed by the judiciary. This undoubtedly oversimplifies the reality, but it roughly represents the way the conflict is imagined by concerned onlookers beyond your borders.

One of the most articulate of such onlookers in recent years has been the novelist and poet Margaret Atwood. A Canadian, she was a student at Harvard in the sixties notably of Perry Miller, the literary historian of New England Puritan culture. If one understands her controversial novel, *The Handmaid's Tale,* in the light of her New England experience, so to speak, the complexity of her concerns and imaginative criticism of American culture becomes more accessible.

When one comes from a reflexively tentative culture, the self-confident utopianism of American political writing in every generation naturally strikes one forcibly. Titles such as Cotton Mather's *Magnalia Christi Americana* (1702) and Timothy Dwight's *Conquest of Canaan* (1775) seem almost messianically charged with the aura of civic religion, and one notes that in New England academic environments the rhetoric does not easily die away, even in the nineteenth century. Dwight, president of Yale and signer of the Declaration of Independence, thought of America as chosen by providence to usher in "the praise and piety of the millennium" (1812), and in his famous Harvard oration of 1865 James Russell Lowell could likewise praise America as "the Promised Land / That flows with Freedom's honey and milk."[3] When even an anti-establishment novelist like Herman Melville (1850) can proclaim Americans to be "the peculiar, chosen people—the Israel of our time," bearing "the ark of the liberties of the world," one begins unavoidably to acquire a sense that religious utopianism is a cultural institution, Thomas Jefferson notwithstanding.[4]

I do not mean to be parochial in this observation. Many an American as well, one assumes, has been disconcerted by the proclamation of Melville's speaker (in *White Jacket*) that "the political Messiah" has come, and "he has come in us" (149–150). While some of this kind of rhetoric is merely the calculated hyperbole of political oratory (which tends in any culture to be "preachy" in the best of times) the persistent appropriation of biblical language, typology, and authority, even into the twentieth century, would strike any thoughtful student of American culture as both extraordinary and yet fairly representative. Sacvan Bercovitch has deftly analyzed the 1980s campaign speeches of Ronald Reagan, showing how, in effect, his speech writers could count on reflex affirmation of biblical buzzwords and phrases applied

to affirmations of nationalism and manifest destiny of "the land that will be for all mankind a shining city on a hill."[5] This recurrent phrase, remembered from John Winthrop's sermon on "Charity," actually comes originally from a passage in Jesus's Sermon on the Mount (Matt. 5–7) which, as Winthrop himself clearly knew, resolutely condemns the kind of triumphalism evinced in Reagan's speech. The speech writers, however, had little fear of the voters recognizing a fraudulent misappropriation of either text.

Actual biblical literacy, even among the ostensible "Bible-belt constituency," is exceedingly slight. This fact raises a question about how much of the putative civic religion of the "religious right" is really religious. Is it possible that political evocations of (KJV) biblical diction are merely inserted by political speech writers in an effort to valorize the actual civic religion of America—a religion which happens to be in striking contradiction to the Sermon on the Mount? Is it not more plausibly the case that the more recognizable testament of American religion is the gospel of success, an assurance of the heavenly kingdom in the here and now? Certainly a number of distinguished American poets have thought so: One thinks of Robert Lowell's "Children of Light," Edward Arlington Robinson's "Cassandra," and Howard Nemerov's splendidly vicious 1957 satire, "Boom," with its imagined prayer of a pharisaical minister of the National Presbyterian Church in Washington (no televangelist). The prayer reaches its self-congratulatory crescendo in assertions of national merit to the deity, who is obliged, presumably, to make concrete his gratitude, for

> Thy name, O Lord,
> is kept before the public, while the fruits
> ripen and religion booms and the level rises
> and every modern convenience runneth over,
> that it may never be with us as it hath been
> with Athens and Karnak and Nagasaki,
> nor Thy sun for one instant refrain from shining
> on the rainbow Buick by the breezeway
> or the Chris Craft with the uplift life raft;
> that we may continue to be the just folks we are,
> plain people with ordinary superliners and
> disposable diaperliners, people of the stop'n'shop
> 'n'pray as you go, of hotel, motel, boatel,
> the humble pilgrims of no deposit no return
> and please adjust thy clothing, who will give to Thee,

if Thee will keep us going, our annual
Miss Universe, for Thy Name's Sake, Amen.[6]

What is most delicious in such literary satire is that those who are most its objects typically fail to see that it is out of the religious source they claim to uphold that their de facto civic religion is condemned. The sign of redemption is not the liberating ark of the faithful but, in a brilliant typological pun, "the Chris Craft with the uplift life raft," the sign of Covenant assurance not the arc in the sky, but the "rainbow Buick by the breezeway." A Buick (at least then), was something to believe in.

Less humorously, it is this very focus upon false biblicism that undergirds Margaret Atwood's *The Handmaid's Tale*.[7] Her alarming narrative is set in a New England sick unto death, claiming ironically and disingenuously to be governed, as Harold Pinter's screenplay of the novel compresses it, by the "Old Testament, our sole and only Constitution." In Pinter's screenplay the minister who pronounces this credo to a group of captive childbearers himself bears striking resemblance to another source of contemporary disaffection from the myth—a host of electronic media descendants of Hawthorne's Arthur Dimmesdale, confidence men of the generally discreditable Elmer Gantry kind. In them, Pinter suggests, the success gospel intrinsic to the old American myth is almost perfectly self-parodied.

Almost everyone in North America has seen portions of one or more televangelistic shows; a significant percentage see a great many such broadcasts in whole or in part during the course of a year. The number and variety of such programs are great, and the notoriety of their personalities legendary. Clearly, many who watch, including, it would seem, academics and presidential speech writers, do so largely out of a yen for diversionary entertainment. Yet for others, perhaps, such telecasts may be the chief means by which an impression of contemporary American Christianity—especially self-advertisedly "biblical" Christianity—is formed.

Within America all this has become so commonplace that it may seem scarcely to deserve comment. Yet it bears repeating, I think, that the presentation of ostensibly biblical religion in this transparently self-contradictory fashion is *prima facie* evidence of a foundational confusion at the heart of American biblicism. As with the corruption of Puritan millennial typology and "New Canaan" warrant in the colonial period, so too with the typical televangelist: His *evangelion* is above all a key to health and wealth. On one such Sunday morning show biz hour a decade ago I observed a preacher who seemed at first a comedian doing a take-off: The star appeared, surrounded by the usual edenic

tropical plants and stage scenery; he was dressed in a white dinner jacket with not one but three red roses in his lapel. With rolling eyes and a wobbly wave of both chubby hands he began: "Mah topic for toda-ay is, *Gawd, ah want it all!*" He then went on to declare that verification of God's blessing upon the faithful (according to his definition) could be had by visiting the parking lot of his church, where there was almost nothing of a lower status than Cadillac, Lincoln, Mercedes, or Jag-u-ar. Eventually he got down to the practical business of exchanging for donations certain talismanic trinkets: a "prayer-timer" (a conventional three-minute egg-timer embossed with a Bible verse) and scraps of "healing cloth" over which he had prayed ("just lay it on the a-ffected member," he said). It was as if Chaucer's Pardoner had returned from the grave.

There is also a woman televangelist with a variant sales ploy for the nineties: "Reverence Woman, for she is the Mother of the Universe," she intones, claiming that "ascendant masters" have revealed to her that, "The I am that I am is standing right where you are now," and that the "coming revolution in higher consciousness is the revelation of the God within us." Hence, for her as for the decadent Puritans of yesteryear, "The promised kingdom is America now." Indeed, as if to answer Atwood's dystopic feminist critique of the Puritan myth with a feminist utopianism to outdo the Puritans, in a recent broadcast Elizabeth Clare Prophet said, "I proclaim to you in the state of California, the state of Amy Semple MacPherson, the emancipation of women." Meanwhile, her followers are rumored to be bunkering down with machine guns somewhere north of Yellowstone National Park.

Where does all of this lead? For Atwood, as for many Americans, it could seem to lead to something at last tyrannical. In her *fin de siècle* America, it is the "religious right" that has seized power in a coup, and while using much of the old Puritan biblical typology to effect a tyranny the most stringent of Puritans could not have imagined, they move quickly to stifle religious liberty. That these people are not at all Christian in any biblical sense is part of Atwood's point. In fact, traditional Catholics, Southern Baptists and Quakers alike are "smoked out" and slaughtered by them; the "Children of Ham" and the "Children of Shem" are likewise forcibly resettled abroad or exterminated (79, 188). The "earliest church" in Cambridge becomes a museum; Harvard's library becomes a center for torture and Harvard Yard the scene of ritual public executions.[8] Empty icons of a desiccated biblical Christianity abound: like the old pillow embroidered "Faith" in the imprisoned narrator's room or the name of the new republic itself—Gilead—they are omnipresent witnesses to the utter absence of what once they signified. Despite angry claims to biblical

authority for their despotism, the commanders of the new regime and their "Angels of Light" military police keep actual Bibles under lock and key. Unsurprisingly, literacy in general is also in process of being stripped away: Only in the inner lairs of the evil despots are there books that have not been transferred to computer disks and then shredded. In this wordless world an illicit game of Scrabble is to the nameless narrator a luxurious indulgence in the vanishing possibility for language and meaning.[9]

Unlike the Pinter screenplay, Atwood's novel has no catharsis, or even moment of nemesis, let alone a possibility of hopeful conclusion. Her prophetic stance is Jeremiah-like—a denunciation and a cataloguing of culture-destroying consequences. Her text is also far more subtle than the film script. As a feminist, she explores even the dark possibility that a misdirected feminism might unwittingly unleash upon itself undreamed-of realizations of "woman-centered culture" (112–16, 120, 204–9); as a secular writer with no claims upon institutional Christianity, she suggests that actual faithfulness to biblical values is what a pseudo-biblicist republic will most wish to eradicate, and that the most important weapon against such a regime's perversions might be the very Bible that the despots alone now control, heavily edited to suit their oppressive purposes. Watching the commander lift the Bible from its locked box to read the handmaid narrative from Genesis 30, the narrator, about to be subjected to a grotesque mating ritual, looks from a "hungry darkness" toward the open text and thinks, "He has something we don't have, he has the word. How we squandered it, once" (84).

Apocalyptic Gilead is an America where civic religion requires of its free citizens certain pious gestures. One of these is a certain number of digitally recorded billings for dial-a-prayer, of which there are five prayers available in set repetitions, one each "for health, wealth, a death, a birth, a sin" (157). Yet out of the depths of her own misery Atwood's pitiable narrator offers the only real biblical prayer the reader actually meets with in the novel: an amplification of the Lord's Prayer (from Matt. 6:9–13), it reveals her utter dissociation of the god of the Bible and the biblicist rhetoric of the republic. "I don't believe for an instant that what's going on out there is what you meant," she prays, then poignantly asks for help to forgive her tormentors (182). Atwood's broken-hearted victim suffers at the hands of her pharisaical patriarchs in the New World Order much as did the Jesus of the New Testament under his own religious and civic tormentors. But the character of that suffering is lost on the smug academics Atwood shows studying the archaeological remains of a self-destructed America a century later. The last chapter of the novel depicts an

academic conference in the year 2095—but it is transparently intended as a stinging rebuke of academic analysis in our own time. Her imagined survey-ors of the ashes of Gilead can be moved no further than to say of the hand-maid's anguished tale (to a round of self-congratulatory applause), "Our job is not to censure but to understand" (284). Yet what is apparent to Atwood's reader is that the academics of the New Age understand little or nothing of the way in which their own kind of thinking might prepare a rationale for human horrors such as those perpetrated on the women of Gilead.

In the light of Atwood's cultural criticism it is perhaps not fortuitous that this should be a time of unprecedented biblical illiteracy in America. Ignorance of the contents of the Bible is pandemic not only among the sec-ular and unchurched but, more dangerously, among many of those who may well fancy themselves to be spiritual descendants of the old Puritans. To be sure, the modern Dimmesdale (who often has a similarly parodic Dickensian name—Falwell, Angely, Prophet, Swaggart, Van Impe) may carry a large Bible iconically aloft as he preaches, his thumb holding open the authorita-tive page. But one wonders if, week in and week out, it is not the same page. The thumb never seems to move, and the sermon is often impervious to its supposed source, which is seldom enough directly addressed. Partly as a con-sequence, the audience grows ever more deaf to the text.

Americans themselves are only gradually becoming aware of the shift of the center of world Christianity from North America to South America, Africa, and Asia. Yet it is increasingly apparent that by far the majority of what one might have called "biblical" Christians now live elsewhere. Considered in relation to the political viability of a biblically intoned American myth, this fact seems to be as disturbing for some as earlier recognitions that the most authentic cultural evocations of biblical narrative in America itself might have come out of African-American culture. Who could doubt that in the hymns and preaching of their struggle for liberty the biblical idiom of African Americans has often rung more true than in the status quo speeches of their mainstream white counterparts?[10] Yet even this legacy is tarnished. This gen-eration's African-American Moses, the Rev. Al Sharpton, or "Rev. Soundbite," as he is often called, is no Martin Luther King. A boy preacher at the age of four, ordained at age ten and by forty-two author of a spiritual autobiogra-phy, *Go and Tell Pharaoh*, he is far better known for taboid melodrama, including his dubious involvement in the notorious Tawana Brawley case and with the underworld-connected boxing promoter Don King.[11] Evidently, it is Sharpton's notoriety rather than his piety, which has led him to be twice a

candidate for the senate and once for the mayor's office in New York City, yet he trades heavily on biblical rhetoric and the spiritual capital of Martin Luther King with his growing constituency.

It has been widely recognized that in Eastern Europe a leading role in the disintegration of totalitarianism was played by a widespread, flourishing though persecuted underground Christian church. This last point has not been lost on the leaders of China, which currently has the fastest growing Christian church in the world. Nor has it been lost on China that their vigorous repression of religious freedom is unlikely, despite a few ritual gestures, to deflect appetite for its huge market among the commercial beneficiaries of President Clinton's "New Covenant."[12] All of these developments and their attendant ironies are, I think, mutually reinforcing, and make biblical idiom, formulation, and myth, seem less and less distinctively "American." They also suggest that a final divorce of American public myth from ersatz biblical rhetoric in this generation might even be a good thing both for politics and for genuine religious life.

For one thing, it could reduce the incidence of certain kinds of posturing, such as occurred at the height of the recent White House sex scandal,when President Clinton arranged to be photographed, oversized Bible conspicuously in hand, at the Foundry United Methodist Church. There he heard a sermon by the Rev. J. P. Wogaman on 1 Cor. 13, "Love keeps no account of wrongs, does not gloat," etc.; other clergymen, it was duly reported, deluged the First Parishioner with letters and phone calls suggesting helpful Bible verses, e.g. Romans 3:23: "For all have sinned and come short of the glory of God."[13] Talismanic biblical quotations—proof texts to ward off opprobrium or moral judgment among a supposedly Bible-honoring electorate—are not, apparently, an exclusive political weapon of the religious right.

Such gestures remind us, I think, that civic religion (whether *de facto* or *de jure*) is simply a contradiction in terms. The offense in this contradiction would not be lessened if it was to take the form of a civic religion of the left. This is perhaps a pertinent point on which to conclude our reflection, if only because arguments are now being made for a universalizing religion of the left, subsuming the secular and religious spheres in one ethos and dictum. The advertised purpose of this new, "post-Marxist" version of civic religion is to counter the social and political castration of current religions that has been brought about through their privatization (forgive the pun). In the view of Patrick Grant, for example:

today's largely secular Western culture has
effectively depersonalised (or falsely personalised)
many of its hegemonic practices by insistently equating
the personal with the private, or individual. One
pressing issue is, then, how such a privatised view
of the person can be relocated in the public, and
indeed in the cosmic sphere.[14]

In his book *The Divine Supermarket: Travels in Search of the Soul of America,* Malise Ruthven similarly concludes that while the separation of church and state serves to hold in check the "totalitarian" tendencies or organized religions, one unsatisfactory result is that *laissez-faire* religious competition grows to be so diverse that its potential for an effective social criticism is compromised.[15] Even the British philosopher John Millbank is apparently willing to reconsider the sacrosanct, eliding the separation of sacred and secular in modern society, largely so as to effect a more "progressive" controllable and secularized civic ethos.[16] Although beyond our scope here, it is worth noting that such gestures toward a new kind of "establishment," along with the religious sociology of figures such as Edward Schillebeeckx and Leonardo Boff, have begun to prompt a new range of speculative literary apocalypses, in which the imagined threat is on the left. Among the most provocative of these are two recent novels by Michael O'Brien.[17] The point of these novels is that the perennial temptation to civic religion always sacrifices too much, including inevitably the multicultural pluralism, toleration, and basic human rights that are such a hard-won legacy of the world's great religions.

Perhaps, as Millbank finally reflects, the best of all solutions is to keep the boundaries between church and state fuzzy and indistinct, so that "many complex and interlocking powers may emerge." On this reading, if so to be fuzzy, then good—at least for the First Amendment. The characteristically American paradox that so amused de Tocqueville could yet prove to be America's best legacy to its children of the next millennium, making fears of the right *and* the left seem a vigilance both necessary and notwithstanding, a durable, non-dialectical, and fruitful instance of "check and balance."

NOTES

1. The remark is George Marsden's, in *The Outrageous Idea of Christian Scholarship* (New York: Oxford University Press, 1997).
2. *The Washington Post* (Aug. 17, 1997, E. J. Dionne, Jr.), reported Barry Lynn, executive director of Americans United for Separation of Church and State, as saying that the guidelines

"go far beyond what the Constitution requires for religious expression," and "really urge… all government employees to set up a kind of religious shrine at their own workplace." For Cathy Cleaver, legal policy director of the conservative Family Research Council, the guidelines leave "much room for discrimination based on the employer's judgment."

3. Dwight is cited in Sacvan Bercovitch, *The American Jeremiad* (Madison: University of Wisconsin Press, 1978), 130. For Lowell see William Michael Rosetti, edit., *The Poetical Works of James Russell Lowell* (London and New York, 1889), 298.

4. *White-Jacket; or, The World in a Man of War* (Oxford and New York: Oxford University Press, 1967), 152–53.

5. *New York Times*, Sept. 22, 1980; quoted in Bercovitch, "The Biblical Basis of the American Myth," in Giles Gunn, edit., *The Bible and American Arts and Letters* (Philadelphia: Fortress, 1983), 224. Winthrop's sermon is on the subject of charity and mutual self-transcendence. There is here no reference yet either to the celestial New Jerusalem or to a terrestrial facsimile in America; the call is rather to an imminent "duty of love" by which "we must love brotherly without dissimulation, we must love one another with a pure heart fervently, we must bear one another's burdens, we must not look only on our own things but also on the things of our brethren" (ed. Miller, 82). These words did not find their way into the presidential candidate's address.

6. *The Collected Poems of Howard Nemerov* (Chicago: University of Chicago Press, 1977), 222–23.

7. *The Handmaid's Tale* (Toronto: McLelland and Stewart, 1985). Citations are from the corrected "Seal" edition (1986).

8. For commentary on Atwood's institutional criticism, see David Staines, *Beyond the Provinces: Literary Canada at Century's End* (Toronto: University of Toronto Press, 1995), 62-3.

9. *Handmaid's Tale*, 121, 129, 145, 156, 172, 189.

10. E.g., Elizabeth Fox-Genovese, *Within the Plantation Household: Black and White Women of the Old South* (Chapel Hill: University of North Carolina Press, 1988); Linell E. Cady, *Religion, Theology and American Public Life* (Albany: SUNY Press, 1993), and Eric C. Lincoln and Lawrence H. Mamiya, *The Black Church in the African-American Experience* (Durham, N.C.: Duke University Press, 1990).

11. See "Tempers Flare as Sharpton Testifies," *Washington Post*, Feb. 12, 1998; "Postcard from Poughkeepsie," *Village Voice*, Dec. 16, 1997; "Al Sharpton's Second Act," *Salon Magazine*, interview by Dwight Garner, www.salonmagazine.com/weekly/sharpton 1.html.

12. I refer to President Clinton's 1995 State of the Union address, as reported in *Time Magazine*, Feb. 6, 1995, 42–53. Clinton called for a renewal of (Emersonian) self-reliance, saying "I call it the New Covenant, but it is grounded in a very, very old idea that all Americans have not just a right but a solemn responsibility to rise as far as their God-given talents and determination can take them. And to give something back to their communities and their country in return" (45).

13. "Fact Can Obscure Truth," *Ottawa Citizen*, Jan. 26, 1998.

14. *Spiritual Discourse and the Meaning of Persons* (New York: St. Martin's Press, 1994), 21. See also his *Personalism and the Politics of Culture* (New York: St. Martin's Press, 1996).

15. Malise Ruthven cites (281) as a provocation the reported remark by Jerry Falwell that "we just have to stay away from helping the poor" (London: Chatto and Windus, 1989), and offers it as instancing an American religious bias that "explicitly favors personal salvation above the public good" (309). See also Gary Wills, *Under God: Religion in American Politics* (New York: Simon and Schuster, 1991).

16. *Theology and Social Theory: Beyond Secular Reason* (Oxford: Blackwell, 1990), 193.

17. See O'Brien's *Father Elijah* (San Francisco: Ignatius, 1996) and *Eclipse of the Sun* (San Francisco: Ignatius, 1998).

3

JEWISH DENOMINATIONALISM
MEETS THE OPEN SOCIETY

Rabbi Irving Greenberg

N THE 1970S JOHN MURRAY CUDDIHY published two important studies of the impact of Americanization/modernization (particularly of the socially open society) on Judaism and Christianity. In the case of the minority (Jews) who were latecomers to modernity, Cuddihy concluded that "the specific problem of social integration with the West" demanded that Jews give up both the claims of chosenness and the "anti-Goyism" that characterized their internal culture.[1] Civility in language, behavior, and value claims was the minimum expectation in order to obtain social acceptance. But, argued Cuddihy, the prospect of being "gentled" posed a danger to Judaism.[2]

For one, the sense of chosenness and the consequent social/ethnic solidarity was at the heart of Judaism's theological and sociological world. Furthermore, the anti-Gentile feelings were a powerful motivator of Jewish solidarity and self-definition. While the anti-Goy feelings were blamed on anti-Semitism and justified by the continuing sense of Jewish victimhood, they were offensive to the majority that was being called upon to accept Jews.[3] They also were an embarrassment to the growing number of assimilated Jews who found themselves living with Christian neighbors and identifying with their values. The Jews, argued Cuddihy, were driven to a "brutal bargain."[4] The public demeanor of Judaism and Jewry was being gentled and self-limited as to play down or renounce the denial of the other. However, the private area of belief and culture was relatively untouched. Instead, attempts were made to redirect the superiority claims into forms that masked them or into areas that were acceptable to the majority culture. Thus in American suburbia, Judaism's "ethnic solidarity

[seen as exclusionist and offensive] was rearticulated and would have to be perpetuated under religious auspices" (where separate social worlds were deemed appropriate.)[5]

The bargain was "brutal" because it led to a bifurcation of private effect from public demeanor. This reduction of Jewish identity also necessitated continuing self-censorship on the part of unassimilated Jews so as not to embarrass other Jews and not to arouse the wrath of Gentiles.[6] This also led to another guiding maxim in the culture of civil Judaism, "Thou shalt not reveal in group secrets to the Goyim."[7] (In the rest of *The Ordeal of Civility*, Cuddihy suggested that resistance to accommodation and acting out the claims of specialness were important factors in the work of Freud, Marx, and Levi Strauss, motivating their shaking up the paradigms of modernity—but that is a different topic.)

In his follow-up book *No Offense: Civil Religion and Protestant Taste*, Cuddihy argued that the yoke of civil religion was imposed on all immigrant religions whose adherents sought admission into the establishment. The entry price was that they must promise to abide by the self-limiting tradition and bear "the civil demeanor of being merely one among many."[8] For Protestants, who were the mainstream's leaders, the brutal bargain led to surrender of absolute Christian claims. The most dramatic expression of that trend was Reinhold Niebuhr's renunciation of any Christian missionary approach to Jews and Judaism.[9] Cuddihy masked his personal feelings and instead cited Jewish theologian, Arthur Hertzberg's claim. Hertzberg's critique of Niebuhr characterized Niebuhr's view as a "surrender." Nevertheless, it seemed clear that for Cuddihy also, the denial of Christianity's universalism was too high a price to pay for civic religious virtue. Cuddihy treated Rabbi Hertzberg's critique of the parallel Jewish "surrender" at great length.

Hertzberg found that public expressions of Jewish chosenness were being censored. Instead, the state of being special was rearticulated as being expressed in the State of Israel's miraculous existence and its exemplary role as "a light unto the nations." This special state of Israel became the bedrock of the Jewish consensus in America. (N.B.: Bear in mind that Israel was at the peak of its acceptance in American intellectual and theological circles in the afterglow of the Six Day War.) The good rabbi also found that in a host of public and other private areas, Judaism paid up its obligations to self-censor (one is tempted to say self-neuter) in order to be accepted into the American religious consensus as one of the approved

triple melting pots. Indeed, because they paid up quicker, Jews were admitted to this establishment role faster than groups, such as the Eastern Orthodox, which were larger and had stronger statistical claims to be one of the civic trinity. Still Hertzberg questioned, "Must Jews abandon all these ancient traditions and adopt the cult of civic virtue?" The new civic faith's other bitter fruit were (in Hertzberg's characterization) agreeing to be "decently inconspicuous in public by removing all marks of Jewish ritual distinctiveness outside the home."[10] During this period, Jews also fought in the courts (alongside blacks) to require America to live up to its civic consensus in the area of civil rights and (alongside civil libertarians) in the matter of reducing public display and recognition of religion. On the basis of one golden rule, "Do unto others what you would have others do unto you," the marks of Christian ritual distinctiveness such as Nativity scenes and for that matter, prayer in the classroom were to be removed from the public square as well.

Cuddihy and Hertzberg believed that freedom led to domestication of conflict but were concerned that the civil religious establishment would take the juice out of accommodating religions in the course of Americanizing them, thus giving rise to a homogenized national civic religion. They feared that this uniformity would be enforced by the continuing dominant culturally hegemonic class. They saw this as a case of the bland leading the bland, from here to puerility.

In retrospect, we can say that Cuddihy and Hertzberg overestimated the self-confidence, legitimacy, and continuity of this national elite (which many would today characterize as L-Dwam's-Living-Dead White American Males) and grossly underestimated the thrusting forces from below, which were challenging and soon dismantling the regnant national consensus. Especially from the sixties on, the United States was going through a much wider transformation, which within decades was to define itself as the new norm (or non-norm) of multiculturalism. The "black is beautiful" movement followed by black nationalism—whether out of the perceived hopelessness of ever qualifying for homogenization or out of self-pride and hope for something better—repudiated the "brutal bargain" of uniformity in exchange for uniform treatment. This challenge to universalist notions (which covertly excluded many groups or which bleached them as the price of admission) was taken up and amplified by a wide variety of liberation movements from feminism to New Left, from gay rights to Native American self-affirmation. An equally wide variety of cultural and reli-

gious movements challenged the liberal Enlightenment consensus itself. Of this wave, deconstructionism on the one hand and the surge of fundamentalist and minority religions on the other hand are (unacknowledged) twin expressions.

While these last sentences have stressed the impact of hitherto excluded groups on the breakdown of uniformity, one should not lose sight of the central role of two other forces. One was the media with their powerful presentation of the Other and their recasting of the culture so that increasingly everyone lived in the presence of the Other—and this was no longer the demonized other. The second force was the enormous expansion of individualism and individual opportunity in these decades. As people felt freer to move geographically, socially, and economically, they felt free to choose and to relocate themselves in terms of identity, religion and even gender. Thus loyalties and ways of living, hitherto perceived as given or dictated by descent, were increasingly viewed as legitimated and chosen by consent only. Therefore, they were subject to change in the search for fulfillment and happiness. Far from accepting that deprivation or lifetime secondary status was dictated by birth into a certain group, the individual revolted by challenging the accepted norm or by changing group membership. Ground between all these forces, the notion of one national cultural template faded or disintegrated. Nor should one omit a third force for dehomogenization—the acceptance of pluralism and recognition of the needed plurality of paradigms by a significant fraction of the leadership groups. In the later conservative backlash, this was often described as surrender or moral collapse even as in some radical critiques it was described as a pro forma empty gesture designed to give concessions without transferring power. But it can also be described as a moral breakthrough and a step toward a principled civility.

For Jews in America, one striking result of the decline of a standard national model was a decline in the anti-Semitism that historically was nurtured by resentment at the Jews for being other than the national norm. Three broad national surveys commissioned by Jewish inter-group relations agencies gives us a snapshot of the change in motion. In 1964, the ADL/Survey Research Center/National Opinion Resource Center found that substantial numbers accepted "some of the traditional tenets of anti-Semitic ideology" as well as other negative beliefs about Jews. Large numbers believed that "Jews are more willing to use shady practices to get what they want" (42%) "Jews stick together too much" (52%) "Jews have a lot of

irritating faults" (40%). On an "Index of Anti-Semitic Belief" (based on eleven survey items), the study found 37% to be prejudiced (i.e., they accepted five or more beliefs), 32% to be in a neutral to middling anti-Semitic group (accepted two to four beliefs), and 31% to be least anti-Semitic. Although support for actual discrimination against Jews was low, only 58% said that they would vote against an anti-Semitic candidate. In 1981, the American Jewish Committee commissioned a study carried out by Yankelovitch, Skelly & Wright. The study found that "Anti-Semitism has declined significantly in the United States since the mid-1960s."[12] "Jews... more willing to use shady practices" dropped from 42% in 1964 to 23% in 1981; "Jews have irritating faults" dropped from 40% in 1964 to 19% in 1981. Using a similar eleven-item Index of Anti-Semitism, they found 23% prejudiced (down from 37%) 32% neutral (unchanged) and 45% unprejudiced (up from 31%). Except among African Americans, the younger and better educated people were less likely to express negativity toward Jews. In 1992, the Anti-Defamation League and Martilla & Kielly surveyed again. The report noted that respondents were *less* likely to *accept* and, strikingly, more likely to *reject* negative stereotypes of Jews. Thus while the belief that Jews used shady practices dropped from 42 % in 1964, to 23% in 1981 and to 21% in 1992, the figures on those *rejecting* this belief went from 46% in 1964 and unchanged at 46% in 1981 up to 73 % in 1992. The belief that "Jews had irritating faults" declined from 40 percent in 1964 to 19% in 1981, and went to 22% in 1992 but the figures for *rejecting* this belief went from 43% in 1964, to 48% in 1981 to 71% in 1992. There were corresponding shifts in willingness to marry Jews and in willingness to vote for Jews for the highest offices in the land.

For Jews, the net result of these trends was the arrival of an open society, perceived as one in which the national collectivity was accepting Jews personally and individually as never before, while being prepared to allow Jews—and other groups—acting as a group to be themselves. This set in motion two powerful trends with contradictory implications. Neither development followed the self-censorship civility model. On the one hand Jews experienced unconditional acceptance that led to considerably greater identification with American society and the majority culture than had ever been achieved under the duress of the brutal bargain. The rise was so sharp that American Jewish historian Jonathan Sarna of Brandeis University wrote of "four [new] great discontinuities in American Jewish

life." The first was the loss of the millennia old sense of being a separate people; the fourth—outcome of the acceptance and the growing sense of shared values and commonality—was the loss of the belief "that ethnicity is destiny," the end of the conviction that there is "something innate, immutable and passed on from one generation to the next as if through genes (i.e., Jewish descent). . . ."[13]

The most dramatic expression of the remarkable openness of American society came in a soaring intermarriage rate. In marriages before 1960, Jewish intermarriage rates ranged from 9–14 percent. The 1970 National Jewish Population Study found that for marriages made in the sixties the rate had surged to 30% while the 1990 NJPS found that over those past two decades, the percentage had soared to 52%. What is more, the intermarried found themselves less bound by the norm of defining themselves out of the Jewish community (or for that matter into the Jewish community) but began to explore a series of individual arrangements. There was a rise in the numbers of Gentile partners who converted to Judaism; however, a considerably larger number did not convert to Judaism but raised the children as Jewish anyway (despite the fact that historically if the Gentile mother did not convert, the child had been deemed to be Gentile). Many others raised the children (at least nominally) in both parents' religion.

The contradictory trend was expressed in the reassertion of distinctive Jewish values, such as in the movement within Reform Judaism and its spiritual leadership to reaffirm tradition. There was an influential theologians' drive to reappropriate Covenant, chosenness, and Jewish particularity as legitimate central categories of Jewish liberal religion. A parallel movement among lay people is captured in two snapshots. Marshall Sklare's late 1950s study of Lakeville, a pseudonymous Jewish community in the Midwest found that Reform lay people were overwhelmingly identified with American liberal values. Over 90 percent held that being a good, ethical human being and/or showing primary concern for social justice in the general society was *the* essential definition of *Jewishness* whereas support for Israel and Zionism was not regarded highly, viewed as essential by only 21 percent and 7 percent respectively. The concern for the practice of specific rituals was not even in the top twenty norms.[14] By the 1970s, Lenn & Associates' study of the movement (published in Leonard Fein's *Reform is a Verb*) found that combination of the Six Day War and America's new

openness had catapulted concern for Israel and distinctive Jewish interests into the top ten Jewish values for over 90 percent of these same lay people.[15] Concomitantly, there was a strong push for Jewish studies at universities. This movement was not unlike the struggle for other types of ethnic and gender studies that racked academia—although the Jewish community and Jewish academics did everything to deny the similarity and to distance the field from these other new interdisciplines.[16] In parallel fashion, Orthodoxy reasserted its agenda in America, starting with a rebirth of fundamentalism and an affirmation of its separatist agenda at the expense of the hitherto dominant modernizing Orthodoxy.

The seeds of this Orthodox development had been nurtured in the postwar migration of surviving Hasidic and Lithuanian *yeshivot* groups to America and to Israel. Since these groups can be described as pre-modern, they set about adjusting to America with some of the advantages of latecomers—including coming as groups rather than as individuals who were maximally pressured by the host culture. They were also armored by consciousness of the Holocaust (its memories were burned in their minds and bodies) which motivated a strong hermeneutic of suspicion and distancing to the claims of modernity. An early harbinger of their rollback of civility came in 1956. By the rules of civil religion, the exclusive claims of one's own group were self-limited out of deference to the outside religions whose practitioners' approvals were needed. However, far from moderating Jewish rejection of Christianity, a group of eleven leading Yeshiva heads and Hasidic Rebbes were determined to assert traditional Judaism's unreconstructed claims of exclusive validity, both externally and internally. They would not insult Christianity too openly for they were restrained by a potential Gentile backlash.[17] Still, they would publicly repudiate the inter-denominational organizations, such as the Synagogue Council of America and the Boards of Rabbi, which represented Jews to Gentiles. This was done in the course of fighting the deviant modernizing—shall we say gentling—heresies that had grown inside American Judaism in the form of its liberal denominational movements.

In 1956, the eleven proclaimed a prohibition against Orthodox Jewish spiritual leaders participating in the Synagogue Council of America, the official organization representing Jewish denominations, Orthodox, Conservative, and Reform, *jointly* in their dealings with the U.S. government and with Christian organized church bodies. The prohibition was clearly based on the premise that sitting together with representatives of

alternative organized religious groups *legitimated* them; this was forbidden by inherited, exclusivist halakhic norms. This ban was applied to membership in The New York Board of Rabbis and similar groups in other communities, which included Reform and Conservative "Rabbis."[18] (I should note that the title Reform and Conservative "Rabbis" was stated in the Yiddish equivalent of quotation marks, e.g., they were deemed to be alleged, but not really Rabbis.)

This repudiation of civility, however, fell flat because it was ahead of its time. Orthodoxy overall was still dominated by the "brutal bargain" and the fear of offending in the American context and thereby arousing anti-Semitism. Thus in defending continuation of Orthodox participation in such bodies as the Synagogue Council of America, Rabbi Joseph B. Soloveitchik, the foremost spiritual leader of modern Orthodoxy drew the distinction between *Klapei Chutz* (vis-à-vis the non-Jewish world) and *Klapei pnim*—(the internal Jewish interdenominational world.)

In a Yiddish newspaper interview, Soloveitchik said: "When representation of Jews and Jewish interest *klapei chutz* (vis-à-vis the non-Jewish world) are involved, all groups and movements must be united. There can be no divisiveness in this area for any division in the Jewish camp can endanger its entirety.... In the crematoria, the ashes of Hasidim and Anshei Maseh (pious Jews) were mixed with the ashes of radicals and freethinkers and we must fight against the enemy who does not recognize the difference between one who worships and one who does not." Still, Soloveitchik foreshadowed what would happen when restraint was thrown off, e.g., when fear of Gentiles ended. However, in internal relationships such as education, synagogue, and rabbinical organizations, "when the unity must be manifested in a spiritual-ideological meaning as a Torah community, it seems to me that Orthodoxy cannot and should not join with such groups that deny the foundations of our Weltanschauung."[19] The interview indicated that Soloveitchik's (and, by implication, modern Orthodox's) civility was skin deep.

With the exchange between Soloveitchik and the eleven yeshiva heads, one comes full square to the paradox of the impact of the open society. The breakdown of the central dominant paradigm and the release of the pressure to conform and to be civil can be expressed in two ways. One is discovery and dialogue with the other that can lead to a true pluralism in which one's own paradigm is revised and self-limited to do justice to the dignity and to incorporate the uniqueness of the other. These changes may

go far beyond civility into self-criticism and reconstruction in the light of the other. The second polar possibility is the pluralization of voices in which each group feels free for the first time to fully speak up and be heard. This development may allow for the assertion of exclusivist claims and aggressive delegitimation of the other. In an atmosphere of "do your own thing" reinforced by the self-righteous feeling that the group's voice has been suppressed by the needs or pressure of the other, the result may be an unself-conscious assertion of the group's own agenda regardless of how it impacts or even denigrates other faith groups.

A small but telling indicator of the underlying attitude toward Christianity of the newly assertive right-wing Orthodoxy shows up in the Art Scroll series of religious publications that were created with enormous success, starting in the 1980s. The series is edited, translated, and annotated by scholars of the traditional Yeshiva world; each volume bears letter(s) of approval/imprimatur from leading Roshei Yeshiva (heads of Yeshiva). The Siddur, the traditional daily prayer book, was the central volume of this series in its first decade.

In the Art Scroll Siddur, in the Aleinu prayer which is the most important closing prayer in all three daily services, a sentence was reinserted. The prayer reads: "It is our duty to praise the Master of all . . . for He has not made us like the nations of the lands . . . *for they bow to vanity and pray to a god which helps not. . . .*"[20] The sentence, a quote from Isaiah 45:20 was perceived and probably intended as a repudiation of Christianity that historically delegitimated and claimed to supersede Judaism. The passage had been dropped from the prayer in the late Middle Ages under pressure from the Church and government censors. Modern prayer books—even Orthodox ones such as Philip Birnbaum, editor, *Daily Prayer Book* (Hebrew Publishing Company, 1949 on) omitted the sentence even though there were no governmental censors anymore. Birnbaum footnoted that the passage had been excluded "through fear of official censors" but made no move to restore it. The passage flouted the brutal bargain and would embarrass, if not offend, modern Orthodox Jews.

However, the Art Scroll principals, playing to an aggressively traditional audience now feeling considerably more at home in America, reintroduced the sentence. In a footnote, the editor referred to "the slander that this passage was meant to slur Christianity." The footnote text claimed that this charge was refuted although the editor knew that the Roshei Yeshiva overwhelmingly believed that Christianity was idolatry and that the shoe

of this sentence fit that faith. Conceding that "most congregations had not returned it [the passage] to the Aleinu prayer," the note justifies the reinsertion, stating that "some prominent authorities insist that Aleinu be recited in its original form." (*Ibid.*, p. 159.) Since the authorities cited are hardly world class, it is fair to say that the real key to the restoration is the loss of inhibitory fear. In fact, the reintroduction is a carefully covered repudiation of the very different brutal bargains of the medieval and modern period; it reflects the newly won freedom to be uncivil.

When reinforced by the growing sense of individualism and loss of respect for the general paradigm of the civil society, to release from pressure to homogenize can lead to rejection of outside faiths and to "othering" even of groups inside one's historic inner circle. This is especially likely when there is less feeling for the need to self-limit for the sake of a collective good—because there is reduced fear that outsiders may intervene. This is indeed what has happened in American Jewry. The arrival of the open society and consequent freedom from fear has led to a polarized response. Theories of pluralism have been developed far beyond any previous paradigms in the traditional community.[21] There is identification with other faiths and even a blurring of lines between Judaism and Christianity or Buddhism in the liberal community. At the same time, there is erosion of civility and unleashing of aggressive delegitimation and social withdrawal vis-à-vis other denominations inside the Jewish community.[22] This last behavior is exhibited by segments of the Orthodox and liberal denominations alike. Freedom and the absorption of general values has translated into a series of acting-out behaviors, which elsewhere I have called "the demographics of separation."[23]

Let me give three examples. In an open society with a weakening of the old dominant paradigm, there is a greater interest in and willingness to join Judaism and the Jewish community. This led to larger numbers of non-Jews seeking to marry Jews and/or to become Jewish. The outcome was a larger number of conversions to Judaism. In the 1970s, conversions reached an estimated level of 7,000 to 8,000 annually (estimated because there are no reliable central registries).[24] This was the highest rate of conversion to Judaism since the first centuries B.C.E. and C.E. when Judaism was a missionary, competitive world religion. However, the bulk of these converts were being converted by the liberal denominations (especially Reform) which conversions were more and more denied recognition by Orthodoxy in increasingly outspoken ways. This created a large cohort of

Jews deemed Jewish by one group of Jews and denied that status by another denomination.

There was a substantial rise in divorce rates—mirroring the changing status of women and of family norms in the general society. Jewish remarriage rates are among the highest in American society (which only proves that Jewish hope and faith are unquenchable!). However, the vast bulk of divorcees did not obtain a *get*/Jewish halakhic-legal divorce. Under Orthodox Jewish law, the gentile court divorce is not given full faith and credit. On the contrary, in a second marriage in which the wife has not ended her first one with a *get*, she is considered legally to be still married to the first husband; the children of the second marriage are therefore deemed *mamzerim*, illegitimate and ineligible to marry a fellow Jew. Since Reform gives full faith and credit to the American divorce, a second group of people emerged who were considered marriageable by liberal standards and unmarriageable by Orthodox standards.

Thirdly, the surge in intermarriage brought with it a large group of children and adults whom Reform sought to include in the Jewish community and Orthodoxy sought to exclude. Reform created programs aimed at the intermarried and worked hard to create a welcoming attitude toward them in Reform synagogues. The logic of this inclusion led to demands for Reform recognition of children of Jewish fathers and non-Jewish mothers as legitimate Jews, requiring no conversion to be regarded as full Jews. Thus, ideological differences sharpened by the atmosphere of full freedom were increasingly strengthened by social departures and barriers. The desire to enable mutual adaptation legally and theologically (read this as an expression of civility) was being weakened even as the social basis of accommodation was eroding.

Still, other factors fostered the anti-civility effect. All three leading denominations responded to the opportunity for new ethnic self-expression and cultural pluralism by successfully expanding their youth movements and using extended camp experiences to forge a vital cadre of leaders. With the release of pressure from American society, each movement became more successful in holding its own youth cohort. Formerly, people leaving Orthodox families and culture in search of greater Americanization had become the backbone of the liberal (Conservative and Reform) Rabbinate. Now, with the weakening of the pressure and rewards for modernizing, the Orthodox stayed Orthodox. Now, Reform and Conservative Jews raised their own Rabbis primarily through their

particular youth and camping activities. These tendencies were reinforced by the spread of the Day Schools (i.e., parochial schools) which in the atmosphere of pluralism and a pluralized American public culture crossed over to the liberal movements; this development also allowed each group to successfully raise more of its own leadership. The demographic side effect was that Rabbis had less and less siblings or close family in the other movements. This freed them to be less civil and to take steps that sharpened the growing social and cultural separation.

The opportunity to act on these developments was not long in coming. As America opened up and the pressure to conform was released, each group began to act out their principles in a more radical, unfettered way. The Chabad Lubavitcher movement, swept up in the Messianism which would climax two decades later by the open declaration that their Rebbe (spiritual leader) was the long awaited Jewish Messiah, began a massive outreach program to the rest of Jewry. They deemed it essential that Judaism and Jewish symbols be visible in the public square. Thus they pushed to set up Menorahs in public and official places during the Chanukah holidays; they saw their public displays as the Jewish "answer" to the dominance of Christmas in American life. Lubavitch defied the fierce liberal Jewish opposition to putting Jewish religious symbols in public space. (Liberals feared that such displays would legitimate and strengthen the use of Christian religious symbols in that same space.) Lubavitcher fought politically in government circles and in the courts to win the right to exhibit the Menorahs.

To their liberal opponents, Chabad gave a simple answer. This is America; it is a free country; ergo, Jews should not be embarrassed to assert their own presence and symbols. The Rebbe suggested that the liberal opposition only showed that assimilationist clouding of their mind prevented them from reading America correctly. Besides, he argued that in the situation of new cultural openness and multiculturalism (he did not use the term), the greatest danger lay in a possible sweeping away of all religion and traditional values. Therefore, it was incumbent on Jews to publicly affirm Jewish values and symbols—to influence the entire society as well as the Jews. To this end, he encouraged the Lubavitcher to start teaching selected aspects of Torah to Gentiles—a radical departure from the practice of traditional Orthodox Jews.[25]

During the sixties, seventies, and eighties, the Orthodox network of day schools was significantly expanded by a network of Kolelim (advanced

Talmud study institutes), built on the presumption that Jewish men would not go into secular higher education and would not go into the job market. (Earlier these values had been renounced even by modern Orthodox Jews out of the perception that American civil religion did not permit such unrestrained assertion of premodern traditional Jewish values.) Yeshiva University, the bastion of modern Orthodoxy, had as its motto: *Torah U'Madda* (Torah and Science). The implied concept was the integration of Torah and secular culture. The use of a term "science" reflected the work/job orientation of its thinking. For many years, its science and career-oriented departments were stronger than its humanities and social science departments, in faculty and in numbers of students. By the late 1970s, Yeshiva also set up Kolelim at the school and, later, in selected communities.[26]

The radicalization of freedom and the surge in assimilation frightened many Jews (even liberal Jews) and further raised the prestige and credibility of the ultra orthodox, i.e., the practitioners of uncivil Judaism. As this group's influence rose, one of its great scholars, Rabbi Moshe Feinstein, became ever more prominent as religious decisor for Orthodox Jews, modern and premodern alike. Feinstein was unaffected by any notions of civil religion. Increasingly uninhibited by American cultural expectations, Feinstein sought to exclude liberal movements from the Jewish community and from religious legitimacy. In Feinstein's rulings, one is permitted to maintain relations with non-observant Jews on the assumption that their non-observance is non-ideological in nature. This, however, does not apply to one who deviates from halakhah on an ideological basis. "[By being the members of] a conservative synagogue [they thereby] announce that they are a group of people who deny some of the Laws of the Torah and have removed their way far from it . . . for those who deny even one thing from the Torah are considered 'deniers' [*Kofrim*] of the Torah . . . and they are considered heretics [*Minim*] . . . even if they merely err like infants who were captured by the heathen because their fathers and their surroundings led them astray and the laws [concerning heretics are not acted out] on them. . . . In any event they are heretics and one must remove himself from them."[27] Rabbi Feinstein also ruled that Conservative Rabbis ought not to officiate at weddings. Furthermore, even if such Rabbis performed halakhic behaviors, their ideological unfitness made their religious actions null and void. Therefore, Rabbi Feinstein wrote that ". . . it appears that it is forbidden to honor the heretical 'Rabbis' to recite the blessings

over the bread since their blessing is not considered a blessing. One is also not obliged to answer 'Amen' after his blessing."[28]

For their part, liberal Rabbis were increasingly sensitive to the new values in American society and impatient with Orthodox traditionalism, which appeared to be a drag on the community's capacity to respond. Thus under the impact of feminism, Conservative women and some male allies launched a movement called *Ezrat Nashim* (literally, the help of women. The name is actually a pun because *Ezrat Nashim* is also the name of the traditional gallery in which women were segregated from the liturgical action in traditional synagogues). Over the next decade and a half, under the cumulative impact of the movement and especially growing lay pressure, the Conservative movement moved to ordain women.[29] The Reform movement had ordained women earlier but the Conservative movement was committed to tradition as well as change. Opposition to egalitarianism was led by its Orthodox-based spiritual leaders such as Professor Saul Lieberman, the dominant faculty leader at Jewish Theological Seminary, as well as by other people in significant positive relationship with the world of Orthodox leadership. With the decline of Rabbis with Orthodox social backgrounds and with the radicalization of freedom in its lay people and Rabbis, the movement decided to ordain women. The result was the secession of a group of traditionalist Seminary faculty and a group of right-wing Conservative congregations. Within a few years, the Joint Chaplaincy Commission of the Jewish Welfare Board, the official commission that certified Rabbis for chaplaincy in the armed services at the request of the United States government, broke up when the Orthodox refused to certify a woman Rabbi as a chaplain.[30] In the past, fear of condemnation by American society if there were any Jewish failure to provide chaplains (or any needed services for the Armed Forces) had dragooned all the groups into cooperation. Now there was less fear of what the Gentiles might say and more anger and rejection between the denominations. While arrangements were made to supply the needed chaplains by having each movement certify its own Rabbis, the episode was another signal of the breakdown of intra-Jewish civility precisely because the pluralism in American life allowed for a wider range of uncivil behavior.

All these tendencies were sharply reinforced by what can only be described as the panic of freedom. As the indicators of the leap in intermarriage rates sank in and as evidence grew that among the intermarried families—certainly where the non-Jewish partner did not convert—less

than 30 percent were raising their children as Jews,[31] a storm arose in the Jewish community. The 1990 National Jewish Population Study with its 52 percent intermarriage rate in particular generated a crisis of confidence in the organized Jewish community as to whether Jews had the capacity for continuity in an open society. However, within the Reform movement, which had the highest concentration of such intermarried people, lay pressures to do something positive for the intermarrying grew enormously.

In the early 1980s, a group of leading Reform Rabbis banded together to declare that they would *not* perform intermarriages.[32] The need to make the declaration grew out of the lay pressure to perform such marriages. By the rules of the Central Conference of American Rabbis (the Reform Rabbis' professional organization), the congregation is not allowed to ask the Rabbi applying for a job whether he would perform an intermarriage. (The purpose of the restriction was to protect the Rabbis' freedom of conscience and of pulpit.) However, lay people were now checking up on Rabbinic candidates' behavior in the matter by touching base with his/her previous congregation. The majority of the CCAR had passed a resolution calling on its members not to perform intermarriages only a decade earlier.[33] Now the Rabbis had to band together to defend their right not to perform intermarriages—for the parents and grandparents perceived such a ceremony as the only way to save some shred of their children and grandchildren's Jewishness.

Two-thirds of intermarriages involved Jewish men marrying non-Jewish women. In this context, the CCAR now moved to change two thousand years of social/halakhic practice. Traditional rabbinic law ruled that when the mother is Jewish, then the child is legally Jewish even if the father is a Gentile who does not convert. But, if the mother was not Jewish, then the child of a Jewish father was deemed to be non-Jewish. However, the increasing influence of the values of feminism and egalitarianism implied that descent from neither parent should be so privileged. More and more Rabbis proposed that children of mixed marriages should be judged equally—a child of (either) one Jewish parent should be deemed Jewish. It was understood that a decision to recognize children of patrilineal descent as Jewish would be rejected by Orthodoxy and would be considered a particularly drastic breach because it changed social boundaries. Incorporating significant numbers of halakhically non-Jewish people into Reform would also tend to create socially separated groupings. The step threatened to tear up the remaining bonds between Reform and Orthodox. Elders of the tra-

ditional wing of Reform opposed such an official decision for this very reason.[34] However, as speakers at the CCAR convention noted, what was the point of self-restraint since the Orthodox would never accept any other policy but their own and would behave uncivilly toward Reform even if the patrilineal descent decision was delayed. Community civility and expression of liberal values were in conflict and the overwhelming majority of the CCAR determined that civility would have to defer. Besides, the Orthodox had long since turned aggressively delegitimating in their anti-Reform rhetoric. There was no point in being civil to the uncivil.[35]

Interestingly, this resolution that appeared to "loosen" the criteria for being considered Jewish, tightened the rules in one way. It required that parents of all patrilineal Jewish children publicly declare that they would raise their child in the Jewish faith. This requirement reflected the desire to strengthen the sense of group adherence in intermarried Jewish families. It also reflected the growing influence of the atmosphere of freedom to choose one's own faith, life style, gender, etc. The requirement served to underscore the growing sense—highly expressive of an open society—that identity and values are chosen and not acquired by descent. Indeed, there was some support at the CCAR for decoupling Jewish status from lineality all together. However, the movement drew back from such a step that appeared to be too similar to a decision made by the nascent Jewish Christian movement in the first century to declare faith in its belief (in Christ), rather than descent from Jewish parents as the criterion for inclusion in the community.

The patrilineal decision was a landmark on the road to uncivil Judaism. The Reform movement took a drastic step, clearly creating a group of Jews who would socially not be marriageable with Orthodox Jews. Lawrence Schiffman, an important historian of the Second Temple and Intertestamental Judaism pointed out in his book *Who Was a Jew*[36] that on this rock of parental descent, the Rabbis and Rabbinic Judaism broke with Jewish Christians; this in turn led to the formation of two separate communities that lived two different faiths. To the objection that Orthodox Jews could never accept this decision, Rabbi Roland Gittelsohn, a leading Reform Rabbi, declared that the Orthodox had no normative status in Reform Judaism.

In short, the patrilineal decision reflected a systematic writing off by the two sides of each other. The patrilineal resolution could only work if one assumed that the Orthodox Jews would so dwindle or disappear that they would not pose a serious obstacle to the future marriageability of patrilineal Jews. For this reason, the Reform movements of Canada,

England, Australia, and Israel opposed the resolution. These were all countries where Orthodoxy remained the largest grouping or the dominant religious establishment; there one could not imagine that the Orthodox would disappear and thus resolve the coming social conflict. In America, the combination of Orthodox decline outside of major metropolitan centers (e.g., in communities where Reform had larger numbers) and the lack of social contact between Reform and Orthodox created a de facto atmosphere of Orthodox "disappearance" in the eyes of American Reform.[37]

In any event, the Orthodox were now the Other with a vengeance. The only concession made to the other national Reform groups was that the resolution was articulated to apply to North America only.[38] But the passage of the resolution showed that each American denomination was predicating its policies on the illegitimacy and/or disappearance of its opponents. (The Reform Rabbinate recognized that the Conservative Rabbinate also would not accept the patrilineal decision. However, they counted on the growing rate of intermarriage among Conservative Jews to generate a lay pressure for rabbinic acceptance of the same criterion or at the least, lay acquiescence to their own children marrying patrilineal Jews.)[39]

Indeed, for a decade already—and with increasing frequency—Rabbi Moshe Feinstein and the Orthodox Rabbis who followed him had fashioned a halakhically bold solution to the illegitimacy of the children born of second marriages whose mother had failed to obtain a *get* to end her first union. Moved by the plight of *baalei teshuvah*—children of Reform and unaffiliated Jews—who returned to full scale Orthodoxy only to discover that they were halakhically illegitimate and unmarriageable, Rabbi Moshe ruled that Reform marriages were legally never valid. Since they were performed by heretics and were not witnessed by valid witnesses who observed Jewish law, no *get* was required to dissolve them. Since children of unmarried parents were legitimate and marriageable in traditional Jewish law, this was a brilliant and bold solution to end the children's suffering and marginal status. However, it achieved its goals by delegitimating Reform as a religion having no halakhic validity in its practice.[40]

Amazingly enough (and showing the high degree of mutual dismissal now governing relationships between the movements), Eugene B. Borowitz, a leading Reform theologian wrote that he welcomed Rabbi Feinstein's ruling.[41] Borowitz argued that this approach would reduce the problems of unmarriageablility between Jews without restricting Reform Rabbis' actions. Otherwise, Reform would have to take on the obligation of *get* and

possibly other Orthodox practices in order to prevent a social rupture in the Jewish people. Borowitz took lightly—in fact, came close to dismissing the concern that the very solution he was affirming treated Reform religious rituals as null and void, bearing no religious weight. In effect, Borowitz was welcoming Orthodox incivility because it would allow Reform to behave uncivilly, e.g., act as if the Orthodox do not exist. Thus, there would be no need to accommodate Orthodox religious standards for the sake of preserving one community with universal legitimacy. This was a telling indicator that the thrill of untrammeled freedom was overriding emotionally the expectations and restraints which make up the code of civility. Rabbi Moshe Feinstein's ruling spread and his various views won increasing dominance in modern Orthodoxy, leading to further uncivil rhetoric.

Within the decade, the remaining venues of Orthodox/Conservative/ Reform joint religious actions were steadily breaking up. The Synagogue Council of America ran into financial difficulties and was allowed to die in 1992.[42] Circumcision boards, *Kashrut* Commissions and other areas (such as *mikvehs* [ritual baths])where communities had been served jointly with non-Orthodox or singly by communally minded Orthodox were declining. Ironically, as more Conservative and Reform parents began to send children to day school to assure continuity, the haredization of Orthodoxy (e.g., the shift along the spectrum toward unrestrained, anti-pluralist pre-modern positions) made it uncomfortable or impossible for liberal Jews to send their children to communal Orthodox schools. The result was the growth in Conservative and Reform denominational day schools—and further separation of the social worlds of the children of the different denominations.[43]

Adding fuel to the fire, were the unmistakable signs of triumphalism exhibited by the polar wings of Judaism. Side by side with the panic and the new freedom and consequent assimilation, both sides began to wave the magic talisman of their own successes to bolster their rejection of compromise. Reform affiliation had grown throughout the seventies and eighties; by 1990, 38 percent of American Jews categorized themselves as Reform.[44] This made Reform the largest denomination among third generation American Jews. Reform also had the largest number and percentage of people who were currently connected to it who were born into a parental home aligned with a different denomination.[45] The Reform denominational central institutions were wealthier and perceived as more vital. In the view of many Reform leaders, this validated their strategy and their refusal to adjust their winning formula out of deference to the needs and assumptions of the other.

For their part, the Orthodox were undergoing a numerical decline in the 1970s and 1980s as the 1990 Population Study would show. But this was not the Orthodox (or the non-Orthodox) perception. During this period, a highly visible *baal teshuvah* (religious returnees to Orthodoxy) movement spread widely. Everyone seemed to have personal anecdotes of their accomplishments.[46] Orthodox birth rates (especially *haredi*) were considerably higher than the other groups' and their intermarriage rates were lower. The Orthodox benefitted from the shift in the community tone from Americanism *uber alles* toward a search for renewed Jewishness. Their formula, including day school education for the rank and file, won wide acceptance and made many liberals feel that they must play catch-up ball. Modern Orthodox professionals rose to unprecedented higher level ranks of service in communal agencies. The net result was the widespread conviction among Orthodox and non-Orthodox alike that Orthodoxy was vital, growing and possibly insulated from the crisis of continuity. This created a psychology which reinforced the trend toward aggressive statements of the Orthodox agenda and a policy of "no quarter" for Reform positions and claims. Orthodox Rabbis who spoke for pluralism, or even for compromise, with Reform were marginalized, if not delegitimated.[47] In fact, any recognition of liberals was punishable. Thus, in 1993, Rabbi Walter S. Wurzburger, a distinguished modern Orthodox Rabbi, a Professor of Philosophy at Yeshiva University, a past President of the Rabbinical Council of America and of the Synogogue Council of America was criticized, defamed, and even berated in his own synagogue for the "sin" of addressing the annual convention of the Central Conference of American Rabbis (Reform). In actual fact, much of Rabbi Wurzburger's speech was a (friendly, but) strong critique of Reform behavior and policies but that could not wipe out the stain of the "original sin" of "addressing the enemy."

By 1986, the author of this essay, an alarmed Orthodox Rabbi, although himself a pluralist and in strong opposition to the dominant trends, warned that the Jewish people was heading for a fundamental schism and a social split into two peoples. The essay "Will There Be One Jewish People in the Year 2000"[48] was dismissed by many Reform Rabbis who saw unity as a stalking horse for an Orthodox "Do It My Way." It was equally opposed by many Orthodox Rabbis who felt that no concessions should be made and no softening of rhetoric was needed. Their basic rationale was that Orthodoxy was absolutely right whereas Reform had no legitimacy or standing. Moreover, Reform's current strength could be overridden because Reform would disappear anyway because of their high intermarriage rate and low birthrate.[49]

Greenberg's views appeared to be far out in 1986. Yet, by 1996–97, a fight over recognition of the Reform and Conservative denominations in Israel brought out how estranged the two communities had become.

Throughout the 1990s, the nascent Progressive (= Reform) and Masorti (= Conservative) movements in Israel were creating a modest but significant infrastructure of synagogues, schools, and indigenous Rabbis. Although the numbers involved were dwarfed by those of the established Orthodox structures, the groups were showing the capacity to reach out to Israelis, that is beyond the immigrant circles that had hitherto contained the appeal of liberal Judaism in the Holy Land. The Orthodox religious and political leadership was particularly threatened by the growing success of liberals in resorting to court actions that time and again, won them the right to participate in various public bodies and governmental programs. The courts that were ruling in the spirit of democratic pluralist values, appeared to be their way to erode or even end the Orthodox monopoly in the vast range of financial aids and communal structures with which government sustained Judaism (as other religions) in the state of Israel. The 1996 election strengthened the hand of the revivalist Sephardic haredi/Shas movement and of other fundamentalist religious elements. They determined to head off a suit winding its way through the courts to establish the legal legitimacy of liberal religious acts, including conversion. The Orthodox decided to use their key votes in the ruling coalition to put through a law that (by legislative fiat, which the courts could not overrule), would declare that only Orthodox conversions would be recognized by the government and established institutions of Israel.

Given the government's razor thin majority and the central role of Orthodox parties in the ruling coalition, the Prime Minister quickly promised to support the law that became known as the Chok Hamarah (conversion law). The liberal groups turned to their American parent movements for help. The American Liberal lay and rabbinic leadership (who were feeling buoyed by their successes in the 1980s and 1990s and even more alienated from Orthodoxy), were infuriated by the proposed legislation. They saw the bill as an attempt to wrap the Israeli flag around the Orthodox delegitimation of liberal religious movements. They swiftly organized a wide range of protests and approaches to the Israeli government. For its part, American Orthodoxy (which had played a moderating role in the Who is a Jew/Knesset legislative controversy in the 1980s) had undergone ten more years of rightward shift, erosion of civility, and loss of contact with liberal Jews. This time, its leadership came out four square for

the new legislation even though it was apparent that such a law would be bitterly resented by Diaspora Liberal Jews.

Leading liberal Rabbis spoke to the press about their alienation from Israel where their religious views received no respect. Some openly stated that Israel failed the test of democracy in its denial of Reform and Conservative Judaism. In 1996 and in 1997, hundreds of Conservative and Reform Rabbis preached High Holiday sermons—generally the most important talks of the year because synagogue attendance is at its peak—on the topic of the denial of pluralism and the assault on liberal Judaism in the state of Israel.

Hitherto, Israel and the federation world that raised money in its support had been oases of unity and civility in the midst of the growing divisiveness in American Jewish life. But by now the restraints of mutual regard were worn thin; anger and partisanship erupted with a vengeance. The federations were pulled into the battle almost immediately. In the 1980s, their top leadership had finally intervened to ask Israel not to legislatively change the definition of who is a Jew in favor of the Orthodox; this time the wave of outrage embroiled them earlier and in a more polarized fashion on the issue. Various federations announced that they would divert money from the Jewish Agency and official government programs to specific projects to advance liberal Judaism in Israel. Lay leaders and professionals worried that the alienation from Israel would make it difficult to raise money for the Jewish state or to continue the same level of allocation for Israeli programs.

In the United States, one incident stands out among many as highly symptomatic of the polarization. Ernie Michel, executive vice president emeritus of the New York UJA Federation, spoke at the annual Wall Street UJA dinner. Wall Street was UJA's largest division. Throughout his career, Michel, himself a survivor, was an icon of transdenominational status and a strong proponent of unity. Although the New York Jewish community has a large Orthodox element, UJA's top leadership felt that he had to respond to the blazing anger of the major givers: many were secularist personally, but were inflamed by the controversy; many others were Conservative and Reform Jews who felt personally assaulted. Speaking emotionally, Michel stated that not one penny of UJA's money would go to "them," i.e., the Orthodox who were not even serving in the Israeli Army, who were living parasitically in Israel even as they manipulated its political system to demean American Jews and their Judaism. UJA's funds had always been perceived as social welfare oriented and as color, race, or religion blind, at least when it came to Israeli Jews. Michel's words were angry enough and generalized enough to

offend modern Orthodox Jews in the audience and elsewhere (even some people who were opposed to the conversion legislation). They perceived the talk as an attack on all Orthodox Jews. They feared that it foreshadowed a partisan, morally illegitimate cut-off of welfare funds from socially needy *haredim*, even as, simultaneously, UJA promised to funnel extra funds to advance Conservative and Reform institutions in Israel. This added up to UJA potentially no longer being a *United* Jewish Appeal.[50] Stung by the backlash, UJA leadership sent out a letter to all attendees, apologizing for the impression that the speech had made and reaffirming that eligibility for the charity's help was based on need with no distinctions being made between the various segments of the community.[51]

As the message of liberal alienation got through, the Israeli government scrambled to backtrack. The government created a commission, headed by an Orthodox Finance Minister, Yaacov Ne'eman, which proposed creation of a unitary conversion. Orthodox, Conservative, and Reform Rabbis would be allowed to educate their own converts. In the final step, the courts of the Chief Rabbinate would perform the conversion, but they would convert the liberal educated candidates as well.[52] The proposed law, in fact, was delayed and finally buried in committee. But the genie of anger could not be put back in the bottle.

In this superheated atmosphere, a marginal Orthodox group, the Agudas HaRabbonim (Union of Orthodox Rabbis), the shell of the previous immigrant generation's leading Orthodox rabbinic organization, released a statement declaring that liberal conversions could not be recognized by Israel because, in fact, Conservative and Reform were a different religion—not Judaism.[53] The statement caught PR lightning in a bottle and was widely covered, not just in the Jewish community, but in the general press and media. The U.O.R. was articulating the consequence of the steady deterioration of connections. There were no serious public relationships between the denominations. De facto, the breakdown of civility was the equivalent of becoming two religions in conflict with each other. In fact, in the haredi Jewish press, especially its immigration language section, this kind of U.O.R. language was freely used. However the general Jewish population was not prepared for such open dismissal. In the ensuing backlash, the broader Orthodox leadership had to distance itself from the statement. Nevertheless, and notably, their repudiations (if such they can be called) focused on denying that Orthodoxy denied the Jewish status of Reform and Conservative Jews. This was true, but the U.O.R. had not denied the Jewish status of liberal Jewish individuals

either. The offending statement had denied the corporate legitimate status of liberal denominations. The mainstream Orthodox leadership's statement never unqualifiedly repudiated the U.O.R. claim. Rather, it focused on the need to lower tones, to speak softy and argue respectfully.[54] Left unanswered was the question: Why be polite to movements that were illegitimate? In the free, open environment of America, the honest answer was that there were no checks to uncivil language—other than the network of relationships and dependencies, which was fast unraveling.

For their part, liberals' anger was rampant. On a visit to America, Prime Minister Netanyahu was repeatedly challenged publicly. When the Knesset passed a first reading of the conversion bill (later it was buried in committee), the Reform and Conservative leaders urged their congregations to punish all those members of Knesset who voted for it. They were to refrain from welcoming them as "honored guests," to "refrain from extending invitations [to them] to appear as speakers or lecturers" and to boycott communal activities to which such Knesset members were invited.[55] The liberal delegations that met with Israeli government officials were verbally assaulted by Orthodox figures and they responded with fury. A spokesman for the Chief Rabbinate, Rabbi Yisrael Rosen proposed that Reform and Conservative converts be recognized in Israel—as converts to a different religion,—"for Reform religion is not our religion." Rabbi Eliyahu Bakshi Doron, the Sephardic Chief Rabbi called Reform rabbis "clowns" who were responsible for the rampant assimilation in America. When Rabbi Eric Yoffie, President of the Union of American Hebrew Congregations (Reform) returned to America to report to his national convention, he described the Orthodox religious leadership as "extremist and radical and fanatic . . . a medieval chief rabbinate that is a disgrace to the Jewish people and to its religion."[56] Dr. Ismar Schorsch, Chancellor of the Jewish Theological Seminary and spiritual head of the Conservative movement, trashed the Chief Rabbinate as not only "medieval" and "reactionary"; it possessed "not one scintilla of moral worth."[57]

In his presidential address at the Central Conference of American Rabbis in 1996, Rabbi Simeon J. Maislin (who had engaged in intra-denominational work a decade earlier) called out: "The time has finally arrived to stop deferring to an Orthodoxy that insults us at every opportunity." Maislin enumerated a long list of Orthodox sins including "[The movement] has declared a now deceased rebbe to be the Moshiach, has encouraged scams that victimize non-Orthodox Jews and non-Jews, and has directed its rabbis to maintain blood purity records to make sure that its children do not inter-

marry with ours."[58] Then he underscored the implication of his words. "It is all very well to sloganize about how 'We Are One' [N.B.: a classic UJA motto] and to invoke the ideal of K'lal Yisrael, but, in fact, we have ceased to be one. . . . " Furthermore, it was the Orthodox who were out. "I don't think that I am stretching when I compare the Modern Orthodox to those ancient Orthodox called the Sadducees."[59] The analogy was articulated three times and it was significant. The Sadducees were a sect that had fallen out of Jewish history. They had been delegitimized by the Pharisees who won the historical battle for internal spiritual leadership of the Jewish people. Unlike the minority and opposition views that had been recorded and respectfully reported in the Talmud, the Sadducees' position had been "expelled" from the consensus of Jewish culture and this population had disappeared.

As this article is written, the cycle of hostility continues unchecked. In August 1998, *Moment Magazine* reprinted a statement by Rabbi Moshe David Tendler, a leading Rosh Yeshiva at Yeshiva University and son-in-law of the late Rabbi Moses Feinstein, the dean of Orthodox decisors. "(2) Both [Conservative and Reform] are deviant offshoots, as was Christianity, except that unlike Christianity, they do not profess belief in a Bible (Torah) divinely given by G–d . . . they have irrevocably removed themselves from the congregation of Israel and no longer share in its destiny . . . (5) any convert to Reform/Conservative is not a Jew or Jewess, having converted to a religion other than Judaism." To the Reform Rabbis, Tendler said ". . . most of you have left our faith no less than one who converts to Christianity. You converted to the religion of humanism/atheism. If you want to return to the faith of your fathers, our tradition requires that you undergo a conversion protocol at an Orthodox Jewish *beit din*."[60] It should be added that Tendler is not of equivalent rank in Orthodoxy to Schorsch's standing in Conservatism or Maislin in Reform. However, he is a highly influential figure who is a respected opinion leader at Yeshiva University's Rabbinical Seminary. His views on other Jews have never been repudiated publicly by any ranking Orthodox communal or rabbinic leader.

CONCLUSION

The plain truth was that the Ordeal of Civility II was hurtling toward its likely end—not the suppression of a visible Jewish presence in America, but the creation of two, highly visible, conflicted, socially separated, peoples. The prediction: "Within decades, the Jewish people will split apart, into two mutual-

ly divided, hostile groups who are unable or unwilling to marry each other"[61] still appears to be the path of least resistance for uncivil Judaism. The most powerful theological force in Jewry was not the homogenizing demand for invisibility and the pressure for deference to civility to the point of suppression of the distinctive claims of Judaism. Indeed, Jewry had met the enemy of Jewish unity—it was out-of-control autonomy and freedom without fear of Gentiles; under those circumstances, the enemy was us.

The obvious lesson is that freedom sometimes erodes the capacity to sustain the social ties that bind and undercut the self-restraints that enable marriage, family—and civic society—to persist despite the frustrations and inevitable conflicts of human existence.

In short, freedom requires respect for autonomy, choice, and the inherent dignity of the variety of human belief and practice. It also requires a high degree of patient self-restraint and discipline if the contradictory free decisions are not to lead to social explosions and all-out conflict. In a truly open society, the outcome is not easy to predict. Will it all lead to genuine pluralism or delegitimating withdrawal into different (and separated) private worlds? The outcome is not guaranteed. It all depends on how we use our freedom.

NOTES

1. John Murray Cuddihy, *The Ordeal of Civility* (New York: Basic Books, Inc., 1974), p. 13

2. *Ibid.*, p. 14.

3. *Ibid.*, p. 177.

4. *Ibid.*, p. 182. See the entire treatment on, pp. 180–205.

5. *Ibid.*, pp. 205–6.

6. *Ibid.*, pp. 227–28.

7. *Ibid.*, pp. 225.

8. John Murray Cuddihy, *No Offense: Civil Religion and Protestant Taste*, (New York: Seabury Press, 1978), p. 103.

9. *Ibid.*, p. 107–8. See the entire chapter in Niebuher's views, pp. 31–47.

10. *Ibid.*, p. 105.

11. Renae Cohen, "What We Know, What We Don't Know About Anti-Semitism: A Research Perspective," in Jerome Chanes, ed., *Anti-Semitism in America Today: Outspoken Experts Explode the Myths*, (Secaucus, NJ: Carol Publishing Group, 1995), p. 72.

12. Gregory Martire and Ruth Clark, *Anti-Semitism in the United States: A Study of Prejudice in the 1980s*, (New York: Praeger, 1982), p. 29 cited in Chanes, op. cit., p. 74.

13. No longer was ethnicity/birth the stamp of destiny—or as Sarna put it—all Americans were shifting "from ties of descent to ties of consent." The result was that identities were far more fluid. Sarna cited statistics that one in four American adults changed faith or denominations at least once from the cultural heritage in which they were raised. Jonathan D. Sarna, "Perched Between Continuity and Discontinuity: American Judaism At a Crossroads," in *Proceedings of the Rabbinical Assembly* (1994), pp. 75, 77. The other two discontinuities were 1) that new religions were growing in America, displacing

Judaism from its status as the American "third-faith" to one of many "minority faiths" and 2) that intermarriage was now accepted. Hitherto intermarriage was opposed by the general culture which upheld endogamy, but now intermarriage "is the American way."

14. Marshall Sklare and Joseph Greenblum, *Jewish Identity on the Suburban Frontier*, (Chicago: University of Chicago Press, 1967), pp. 321–28.

15. Leonard Fein, *Reform Is a Verb*, (New York: Union of American Hebrew Congregations, 1972), pp. 65–66.

16. See my "Scholarship and Continuity: Dilemma and Dialectic," pp. 113–131, and Gerson D. Cohen, "An Embarrassment of Riches: On the Condition of American Jewish Scholarship," in Leon Jick, ed., *The Teaching of Judaica in American Universities* (New York: KTAV-Association for Jewish Studies, 1970), pp. 130–50.

17. But, *see* page 15 and note 20 below.

18. The proclamation was published in the Yiddish Press, *The Day*, March 6, 1956, its language was Hebrew (and Yiddish), a reflection of the overwhelmingly immigrant and pre-modern population to which they spoke. It is summarized in Louis Bernstein, *Challenge and Mission*, (New York: Shengold Publishers, 1982), p. 146 and reprinted in an appendix.

19. Soloveitchik's views and the modern Orthodox response are described in Bernstein, *op. cit.*, especially pp. 59–63, 127–57.

20. Italics supplied to the reinserted sentence. *The Complete Art Scroll Siddur*, translation with commentary by Rabbi Nosson Scherman (New York: Mesorah Publications, Ltd., 1984), p. 159.

21. The author of this paper has been actively involved in the process. See Irving Greenberg, "Toward a Principled Pluralism" in Ronald Kronish, ed., *Towards the Twenty-First Century: Judaism an the Jewish People in America* (Hoboken, NJ: KTAV Publishing, 1985), pp. 183–204. See also David Novak, *Jewish Christian Dialogue: A Jewish Justification* (New York: Oxford University Press, 1989) which reviews the development of Jewish thinking on Christianity and which itself articulates a historic new level of respect and appreciation for Christian faith.

22. See on all this, such articles as Jack Wertheimer, "Judaism without Limits," in *Commentary*, vol. 104, no. 1 (July 1997), pp. 24–27; and Rodger Kamenetz, *The Jew in the Lotus* (San Francisco: Harper San Francisco, 1994), especially 147–57.

23. See Irving Greenberg, "Will There Be One Jewish People in the Year 2000?" (New York: CLAL, 1985), p.3.

24. Brenda Forster and Joseph Tabachnik, *Jews By Choice*, (Hoboken, NJ: KTAV Publishing House, 1991), p. 8. See also Irving Greenberg, *Ibid.*, p. 1, which cites a *Wall Street Journal* survey which estimates up to 10,000 annually.

25. On the Rebbe's views, see *Likutei Sichot*, vol. 27, pp. 132–44.

26. Gruss Kollel, a joint venture between Yeshiva University, philanthropist Joseph Gruss and the Israeli government, was announced formally in January 1969; however, its opening was delayed due to the Yom Kippur War. It opened in 1977 in Jerusalem. For more, see "A Legacy of Learning as Preparation for a Promising Future," a publication of Yeshiva University.

27. Rabbi Moshe Feinstein, *Igrot Moshe*, Orach Haim (henceforth OH), vol. 4, no. 91/6, cf. also Yoreh Deah (Henceforth YD) vol. 2, no. 100, YDI, no. 149.

28. Feinstein, op. cit., OH2, No. 50, cf., OH2, No. 49, OH3, Nos. 12, 21–22, Even Haezer (henceforth EH) Vol. 1, No. 76. On all this, see Ira Robinson, "Because of Our Many Sins: Contemporary Jewish World as Reflected in the Responsa of Moses Feinstein." in *Judaism*, vol. 35, (Winter 1986), pp. 35–36.

29. On October 24, 1983, the faculty of the Jewish Theological Seminary voted to begin

ordaining women as Rabbis. Charles Austin, "Conservative Group Votes to Admit Women as Rabbis," in *New York Times*. October 25, 1983, p. A-20. See also Milton Himmelfarb and David Singer, edit., *American Jewish Year Book 1985*, vol. 85 (New York: American Jewish Committee), p. 109.

30. David Singer, edit., *American Jewish Year Book 1992*, vol. 92 (New York: American Jewish Committee), p. 191.

31. David Singer, edit., *American Jewish Year Book 1992*, vol. 93 (New York: American Jewish Committee), p. 179.

32. W. Gunther Plaut, "CCAR President Addresses the Rabbinical Assembly," *Journal of Reform Judaism* (Fall 1985), p. 66.

33. Joseph B. Glaser and Elliot L. Stevens, ed., *Central Conference of American Rabbis Yearbook 1973*, p. 59–64.

34. Jacob J. Petuchowski, "Towards Sectarianism," in *Moment Magazine*, vol. 8, no. 8 (September 1983), pp. 34–36 and David Polish, "A Dissent on Patrilineal Descent," in Ronald Kronish, ed., *Towards the Twenty-First Century: Judaism and the Jewish People in Israel and American*, (Hoboken, NJ: KTAV Publishing House, Inc., 1985), pp. 223–35.

35. Elliot L. Stevens, ed., *Central Conference of American Rabbis Yearbook 1983*, p. 155.

36. Lawrence Schiffman, *Who Was a Jew* (Hoboken, NJ: KTAV Publishing House, 1985), pp. 77–78

37. See Irving Greenberg, "What If Those Jews Don't Disappear?," in *CLAL Perspectives* (New York: 1983), p. 2.

38. Elliot L. Stevens, ed., *Central Conference of American Rabbis Yearbook 1983*, p. 157.

39. Ari L. Goldman, "Rabbinical Dialogue: Three Branches of U.S. Judaism Talk of Differences," in the *New York Times*, July 2, 1985, p. A-11.

40. Rabbi Moshe Feinstein, *Igrot Moshe*, EH #25.

41. Eugene B. Borowitz, "Co-Existing with Orthodox Jews," *Journal of Reform Judaism* (Summer 1987), p. 58–62.

42. Stewart Ain, "Synagogue Council Disbands," *Jewish Week*, November 25–December 1, 1994, p. 10.

43. Steven M. Cohen, "Day School Parents in Conservative Synagogues," in Jack Wertheimer, ed., *Jewish Identity and Religious Commitment: The North American Study of Conservative Synagogues and Their Members*, (New York: Jewish Theological Seminary, 1996), pp. 18–23.

44. David Singer, ed., *American Jewish Year Book 1992*, vol. 92 (New York: American Jewish Committee), p. 129.

45. *Ibid.*, p. 131–32.

46. See for example, David Goldstein, "My Bag: The Yeshiva," in *The Jewish Observer* (March 1978), pp. 9–10 and Daniel Gordon, "One Year in Jerusalem," *Jewish Spectator* (Winter 1984), pp. 12–18. For an extensive treatment on the subject of returnees, see M. Herbert Danzger, *Returning to Tradition*, (New Haven: Yale University Press, 1989).

47. Walter S. Wirzburger, "Kelal Yisrael: Challenge & Opportunity," *CCAR Yearbook 1986* (New York: CCAR, 1987), pps. 33–39.

48. Irving Greenberg, "Will There Be One Jewish People by the Year 2000?" (New York, CLAL, 1985).

49. A classic of this genre was the essay by Anthony Gordon and Richard Horowitz "The Future of American Jewry: Will Your Grandchildren be Jewish?," self-published by the authors but widely reprinted in both secular/communal as well as Orthodox publications. Starting with a hypothetical first generation of Jewry in which 1,000 Jews were equally divided into five groups (secular, Reform, Conservative, Modern Orthodox,

Mainstream Orthodox) of two hundred each, the article projected four generations in which current intermarriage and birth rates would continue unchecked. The conclusion was that the fourth generation would contain 10 secular Jews, 20 Reform, 48 Conservative, 692 Modern Orthodox, and 5,175 Mainstream Orthodox. This amounted to de facto disappearance of the liberal Jewish community. Gordon and Horowitz presented themselves as non-Orthodox Jews who had commissioned the paper's research at their own expense in order to arrive at a true picture of the future. This background increased the impact of the study that was used by the uncompromising wing of Orthodoxy to justify its policies of no recognition, no negotiations, no concessions. At the height of the conversion controversy in Israel (see below), the Chief Rabbi was challenged: Why should the Israeli government support the Orthodox demand for exclusive recognition in the face of the fact that liberal Jews constituted the overwhelming bulk of American Jewry? The Chief Rabbi literally waved the Gordon/Horowitz results at reporters to prove his point that the liberal Jews were, in fact, finished; their present majority was evanescent, nay terminal. The Gordon-Horowitz study actually bristles with loaded assumptions and misleading projections. In fact, present day American Jewry is not equally divided. The modern and mainstream Orthodox together constitute only 7.7 percent of the population. How did Gordon and Horowitz account for the low number? What inability to cope with the American scene was reflected in this low ratio? What disintegration factor was the Gordon/Horowitz study omitting from its projections? The term Mainstream Orthodox was a euphemism for the Haredi/ultra-Orthodox who were not the majority of Orthodoxy, let alone its mainstream. Gordon/Horowitz projected straight line growth for the haredim, assuming that their birthrate would be unaffected by Americanization or any of the processes that affected other American Jews over the previous generations. The study ignored the growing haredi economic crisis due to ultra-Orthodox norms of not working and not going to college, yet the crisis was already affecting the current population and challenging both its culture and its birthrate. There are other sins of omission and commission especially vis-à-vis the liberal projections too numerous to go into here.

50. Video tape, talk by Ernest A. Michel at Wall Street division dinner, December 3, 1997; letter, Joseph C. Shenker to L. B. Greilsheimer, December 4, 1997; letter, J. M. Katz and I. A. Press, to L. B. Greilsheimer, December 4, 1997; letter, M. G. Jesselsom to Stephen Solender, December 12, 1997; letter, Scott Shay to L. B. Greilsheimer, December 23, 1997; all in files of New York UJA-Federation.
51. Louise B. Greilsheimer [President, New York UJA-Federation] to all Wall Street Division dinner attendees, December 15, 1997.
52. On February 10, 1998, the Chief Rabbinate rejected cooperation with non-Orthodox Rabbis in matters of Conversion. However, the government pledged to proceed with the unified process.
53. *New York Times,* April 1, 1997, p. B2.
54. The Union of Orthodox Jewish Congregations and the Rabbinical Council of America released a statements on March 24, 1997, and an ad in the *New York Times* on April 6, 1997.
55. *The Forward,* April 11, 1997, p. 1ff.
56. *The Forward,* April 18, 1997, p. 1ff.
57. *Ibid.,* p. 1ff.
58. Proceedings of the Central Conference of American Rabbis, 1996, p. 224.
59. *Ibid.,* p. 224.
60. Reprinted from the *Algemeiner Journal,* February 20, 1998.
61. Greenberg, "Will There be One Jewish People in the Year 2000?," p.1.

4

THE CLOISTERED CLOSET

The Reverend Dorothy A. Austin

WOULD LIKE TO BEGIN by identifying myself, quite openly, as a "self-avowed, practicing... Christian." Culturally and religiously, Christianity is my tradition of origin. I was born into it. Raised a Christian, born of a Christian mother, christened by the Congregationalists, early on I was schooled on Sundays by the Missionary Alliance and the Assembly of God. In my early teens, I suffered, despaired, and was buried by the burdens of a precocious Christian conscience. In time, I rose to some semblance of order and symbolic stability. When I was sixteen, I was confirmed in the Episcopal Church where, with my mother by my side, together, we received the Holy Spirit. I believe in the teachings of Jesus. I believe my grandmothers are among the communion of saints. I believe that forgiveness is the daily practice of mending and repair. And I believe in the resurrection from the dead, a miraculous event once you've experienced it yourself.

I grew up a Christian kid in a small New England town. Stories from the Bible were among my primary sources. Biblical characters seemed as real as my next door neighbors. The keeping of the calendar and of ordinary time were linked to the rites and rituals and liturgical seasons of the Christian year. But it was the stories I thrived on. I loved the stories I heard in church, the unfolding plots of people's lives, the sad and wondrous stories of people I knew—poor people, people who were sick and in trouble, people who miraculously survived against unbeatable odds, people who went to faraway places and did remarkable things.

How well I remember sitting in South Swansea Union Church on a Sunday evening, twelve years old, rapt with attention, listening to the tales of Miss Lynip, a missionary woman home from the field on furlough,

spellbinding us youngsters with her colored slides and her accounts of children our age in the Philippines who were coming to Miss Lynip's mission school where she taught the children to read and write in English while telling them the stories of Jesus.

I think it was Miss Lynip's vivid account of the details of her students' lives, laced and woven as they were with the biblical stories of Nicodemus and Lazarus, the blind man, the lame man, and the woman at the well that so captured my imagination and set fire to a desire in me, early on, to make something of my life, something of biblical significance, something greater than simply getting my driver's license so that I could drive to the Grand Diner on Route 6 or to the Case High School football game, or ride in a car on a double date to the Saturday night dance at the VFW Hall.

In the 1950s, in working-class America, the Christian Church was the one place in my life where I felt there was a certain majesty of speech that was utterly lacking in the rest of my life. It mattered to me greatly, back then, to hear the readings from the Old Testament on a Sunday morning in Church, to hear the beautiful words and images that were spoken there. To hear that "God is the One who gives snow like wool, who scatters hoarfrost like ashes and casts forth ice like morsels," that "we need not fear though the earth should change, though the mountains shake in the heart of the sea; though its waters roar and foam, though the mountains tremble with its tumult. God is our refuge. God is our strength." Sometimes, on Sunday nights after evening service, after listening to Miss Lynip's adventurous stories, I would go home and lay awake in my bed thinking about God and about foreign places. On those nights I felt sure that someday—I wasn't sure exactly when or where—but I was sure that one day, I would find myself in a whole new world, and that when I did, I knew that I, too, would be different.

As an adolescent, I came to believe through the church and through the power of the gospel preached, that eloquent speech was God's gift to us human creatures; that such speech could move even one's enemies, even the stiff-necked ones and the most hardened of heart. It was my first experience of what Christians call "the social gospel." In my early teens, I thought the writings of the ancient prophets were so moving that they could inspire even the worst of scoundrels to do the right thing.

Essentially, I was learning in church, that if our lives could be turned around through the power of speech, through hearing a liberating and powerful word, then that same power, that same act of speaking up and

speaking out—on our part—could change the social conditions of our lives and the lives of others.

I began to think of literacy and social protest as spirited acts of religious imagination. I came to see how the ability and skill to use words with authority could give us the power of determination over our lives. I began to understand how religious imagination, kindled by the eloquence of the biblical oral tradition, embodied in a prophetic figure like Martin Luther King, Jr., could become a powerful force for social change. It's for reasons like these that the Christian Church must not be permitted to squander its narrative inheritance, the power of its stories and its prophetic witness, by bearing false witness against its own and its neighbors. Name-calling, race-baiting, sending one's own into the desert in exile, discriminating against others of different religious traditions—it poisons the well of our religious resources and our religious imagination.

Recently, I was at a conference on "History and Memory: Gay and Lesbian Literature Since World War II," where John de Cecco gave the keynote address. Dr. de Cecco is a research psychologist of considerable note, now in his seventies. In his speech, he said that he had spent a lifetime trying to study and understand homosexuality within a scientific paradigm. In the course of his lifetime, he said he had witnessed a remarkable paradigmatic shift, which he characterized as "the twilight of the sciences and the dawn of the liberal arts for understanding homosexuality. We live," he said, "in a sea of stories. What we need to understand is how we construct those stories that tell the tale of our lives, because we use stories to find out how things work."

For those of us who are gay and lesbian, and for those of us who would like to understand gays and lesbians, this seems an important and basic place to start—with the essential power of stories and story-telling. James Hillman, the Jungian analyst, has emphasized, throughout his work, that to be a self is to have a story to tell.[1] What Hillman is getting at, of course, is not only the realization that our stories make sense of our lives but that our stories actually spin us into existence. Our stories give us our lives. Like some musical instruments, we humans have to be "voiced" in order to play out our lives. And if we can't tell our stories, if we can't utter them aloud, write them down, let them be read and heard, then there's likely to be no viable, livable self.

Anyone who has worked in a psychiatric clinic or suffered a great loss, calamity, or hardship knows how essential it is to be able to tell the story

of what happened. By the same token, there are those occasions, and we have all known them, when it is too difficult, even impossible, to speak. There are moments when words fail, when no word trips to the tongue. We open our mouths and they're empty; our lives, wordless.

Paul Monette, author of *Becoming A Man: Half a Life Story,* wrote about his life growing up gay in the 1950s in a small New England town. His book is a searingly honest memoir and manifesto. In the opening pages of his now classic text, Monette writes:

> Until I was twenty-five, I was the only man I knew who had no story at all. I'd long since accepted the fact that nothing had ever happened to me and nothing ever would. That's how the closet feels, once you've made your nest in it and learned to call it home. I speak for no one else here, because I don't want to saddle the women and men of my tribe with the lead weight of my self-hatred, the particular doorless room of my internal exile. Yet I've come to learn that all our stories add up to the same imprisonment... I still shiver with a kind of astonished delight when a gay brother or sister tells of that narrow escape from the coffin world of the closet. Yes, yes, yes, goes a voice in my head, it was just like that for me. Every memoir now is a kind of manifesto, as we piece together the tale of the tribe. Our stories have died with us long enough. We mean to leave behind some map, some key, for the gay and lesbian people who follow—that they may not drown in the lies, in the hate that pools and foams like pus on the carcass of America... I can't conceive the hidden life anymore, don't think of it as life. When you finally come out, there's a pain that stops, and you know it will never hurt like that again, no matter how much you lose or how bad you die.[2]

I would like to examine some of the struggles as I see them (they're my own struggles, actually) with the issues of self-revelatory disclosure in the cloistered Christian closet, where one's annunciated life as a gay or lesbian Christian becomes, inescapably, of necessity, a performative, transgressive text subject to textual criticism and ecclesiastical censure, not to mention the inevitable perilous risk of self-abnegation and self-rejection. Coming out of the closet, every gay and lesbian Christian needs a serious spiritual practice, some form of critical theory and textual criticism.

What do I mean by "spiritual practice"? I mean simply (although it's not simple) a disciplined practice of mindful awareness that is psychologically astute: a practice of self-investigation and self-acceptance that one

can learn in psychoanalysis, for instance, or in the practice of insight meditation: a practice that enables one to see and to work through those accretions, habits, and conditionings of the mind that constitute one's habitual way of being in the world; and, which are the very same conditions that cause us to suffer.

As a practicing Christian, an ordained priest, a professor of psychology and religion on the faculty of the Theological School at Drew University, I am faced often with the challenge and responsibility of speaking in the theological classroom on the issue, or as it's more regularly posed, the "problem" of gays and lesbians in the Christian Church.

Drew University has an excellent Theological School and faculty. Its budget is supported—bread and buttered rather generously—by monies from the mainstream United Methodist Church, a denomination not unlike other Christian denominations, whose official policy regarding the ordination of gay and lesbian theological candidates is essentially a military one: a "don't ask, don't tell" agreement.

A don't ask, don't tell ecclesiastical policy enables a gay or lesbian theological candidate seeking ordination to have the opportunity to "serve" as a good and faithful soldier, provided that he or she maintains a vigilant silence in the cloistered closet. If one stays, as it were, "shut up" in the ecclesiastical closet, one can conceivably "pass" for straight, and be ordained.

I know many gay and lesbian Christian students whose souls have been slain. So broken and embittered are they by the rejection of who they are at the hands of the very religious community that has purportedly known them, loved them, and nurtured them since they were children, teenagers, and young adults. Theirs is a psychological and religious identity over-shadowed by prevailing misunderstandings of homosexuality, and the cruelties that come of ignorance: the sodomy laws, the previous psychiatric diagnosis of homosexuality as a mental disorder, and the tenacious moral condemnation of homosexuality on the part of the Church, on the grounds that "homosexuality is incompatible with Scripture."

Growing up religious, as have many gays and lesbians in the Christian community, means that their self-understanding, their work and purpose in the world has been shaped by the Christian tradition, its history, life, and symbols; its rites, rituals, and stories; its prophets, priests, and martyrs; its heretics and reformers. Many gay Christians suffering from ecclesiastical and civil discrimination, will tell you, nevertheless, that they have a vision, a calling to a prophetic journey in the religious life that they believe will free

them and their tribe from the stigma and fear of those in positions of ecclesiastical authority, who, in their profound ignorance, find it necessary to fear, censure, and exclude gays and lesbians from full participation in the Christian Church. Whatever suffering is to be sustained is in the service of the cause and nothing less than a transformation in worldview will do.

As Erik Erikson taught us, many years ago, in his study of the Protestant reformer, Martin Luther: In tumultuous times, religious reformers must be willing and capable of sustaining an imposed suffering in order to solve for the world, what one cannot solve for oneself alone.[3] When one's entire society must inevitably be transformed in the course of a religious struggle, identity and ideology are inseparable. Heretics and infidels become prophets, priests, and martyrs, even great reformers. Our lives become the sites where the cultural wars of our day are fought, suffered, observed, and adjudicated: And that's as true for gay activists and closeted gays as it is for those who love them and hate them. We suffer the conditions of the times in which we live.

Having come to the point where many closeted candidates stand ready to take up their religious vocation in the world, the choice their denominational polity and authority may put before them may amount to what one such candidate summed up as follows: Are you willing to swap silence, self-erasure, and complicity in your own discrimination, in exchange for the receiving of Holy Orders, a professional appointment as an ordained minister; and the promise to live a lie while trying to lead others to a life of liberating truth?

It seems difficult to imagine how such a bargain with the devil could possibly work. Having smuggled one's way into the institution, into the officially closeted workings of the Church to lead a life undercover, these gay and lesbian Christians are expected to button their lip and bite their tongue while they sustain the abject misery of divided consciousness at best, and self-annihilation at worst, until the closeted Christian Church, or at least their particular denomination or diocese, can come out and take a just and favorable stand on the status of gays and lesbians in the Church.

As a teacher and priest, I find the dilemma perplexing. Without question there are closeted students in classrooms everywhere, and at every level of the educational system, theological and otherwise. But for me, it's the closeted *theological* students who pose the most difficult conundrum. They're the ones who hope and pray that somehow, in some miraculous way, I will manage to speak persuasively in support of ordaining gays,

without calling attention to the problem of gays and lesbians in the Christian Church. Ideally, I should be able to speak persuasively without uttering so much as a word. Obviously, this is no simple task, especially when closeted students are so fearful that any mention of the gay issue is likely to draw attention to them, maybe inadvertently expose them and crack their code of concealment.

To complicate matters, one needs to bear in mind, also, that there are theological students, in the same classroom, who are strongly, decidedly anti-gay on the grounds that homosexuality is "immoral," "sinful," and "incompatible with Christian teachings." If I choose to speak affirmatively of gays and of gay rights—is this "advocating a homosexual life-style?"—these students will accuse me of using the theological school lectern as a bully pulpit. Never mind the unspeakable transgression, were I to choose simply to speak descriptively by way of locating myself in my own text, knowing of course that mere identification, by definition, can be thunderously transgressive when it breaks the sound barrier.

In the denominational circle I teach in, there is the expectation that the Theological School will not "advocate a homosexual lifestyle," given that it is "incompatible" (at least officially) with the teaching of United Methodist discipline. An outspoken Theological School could risk losing its church-based funding. One needs to remember that it's not only individual gays and lesbians who must wrestle with the politics, ethics, and consequences of being "closeted" or "out." Institutions may be closeted or out as well. If an institution requires of its constituency that gays and lesbians shall be admitted to membership, only in such instances as they are capable of "passing" through the gate with their sexual orientation concealed, that institution qualifies as being closeted, segregating, and contributing to the systemic discrimination against gays.

Discriminatory politics, at the institutional level, can be painfully subtle. When an issue as fundamental as an institution's economic survival is at stake, as in the case, let's say, of a theological school with faculty who are out-spokenly lesbian and gay: the subtle pressure to conform institutionally to the (anti-gay) status-quo, can succeed in closeting an entire institution.

Loyal faculty members who, in otherwise gay-tolerating circumstances may be known to be gay, if not self-identified and out, may suddenly feel the obligation to sacrifice themselves—give up what now feels like a point of personal privilege (that of being gay and tolerated)—for the

sake of the common good (the economic survival of a theological school caught in an ethical bind and a crisis of identity and ideology).

In times like these, those who are known to be gay, and not sure where (or whether) their institution will stand, have been known to pass ever so quietly out of view, slipping into the closet, while their anxious and threatened heterosexual colleagues wait quietly for the imminent danger to pass. The politics are complex, even in the best of places, where perfectly good people are not at all sure what the right thing is to do.

Let me be clear: It would be a mistake to think that the United Methodists are especially onerous on gay and lesbian issues. A good many gay and lesbian Christian activists and their families and supporters were raised Methodist and remain Methodist and are active in the gay and lesbian movement in the Church. Even many who are ineligible for ordination because they're not heterosexual have stayed in the struggle. Many of those Methodists were brought up believing that while the Bible has been used abusively to legitimate slavery, segregation, the subordination of women, the condemnation of gays and lesbians, and the bearing of false witness against those of other religious traditions, the Bible has also been used, more desirably to be sure, as a powerful and liberating source for courage and social change.

Christianity, not unlike the other major religious traditions, is a house divided against itself on whether gays and lesbians will be granted their God-given religious rights (and rites). Will Christian gays and lesbians be received into full and equal communion by their heterosexual brothers and sisters, mothers and fathers, who stand at the gate to the Church?

Will lesbians and gays be accorded the same civil rights as heterosexual citizens? In the electoral politics of this country, the religious and civil rights of gays and lesbians remain inextricably linked. Discriminating, gay-baiting Christian coalitions have been known to conspire with gay-baiting politicians, much of it as mainstream as the conservative wing of the Republican party. For as long as Christian citizens are willing to raise political money by whipping up fear and demonizing gays as a major threat to family values, gay-bashing is likely to remain a political and ecclesiastical strategy for so-called "Christian" coalitions.

How, then, does one—how do I—work skillfully in the struggle for gay and lesbian rights—as a priest, a theological educator, a mentor to theological students preparing for ordination and leadership in the Christian Church? Where do I stand as I speak? How do I speak the unspeakable? How

do I perform gracefully what is arguably an unperformable act of revelatory self-disclosure in a theological school classroom that doubles as a cloistered Christian closet? When I speak on gay and lesbian issues, in an ecclesiastical or church-related context, in the theological school classroom, I often find myself—in spite of myself—lurking somewhere in the cloistered closet. Like some creature in Narnia, having made my way through the ecclesiastical vestments, to the back of the wardrobe, I find it's quite possible, seductive even, to disappear, cloaked and passing—out of sight from my own gaze.

For some time, now, I have been studying these nearly imperceptible moments and movements in consciousness that render me MIA, missing in action from my own life; missing from my own text. What I am referring to is a kind of self-silencing; a self-erasure in the mind that moves like an invisible hand across my mouth; a kind of self-imposed silence that insidiously absents me from myself, from speaking and writing, from making of my life a text.

I am reminded of some remarks that first-time author Frank McCourt made in an interview, following the publication of his Pulitzer Prize winning memoir, *Angela's Ashes*, the story of Mr. McCourt's desperately poor, Irish childhood. Frank McCourt is a retired high school teacher who struggled, unsuccessfully, for thirty years, to write an account of his life. The years passed, every attempt he made to wrestle his story onto the page had failed miserably. Time was marching on. Mr. McCourt was now in his sixties. He knew, he said, that "the point of permanent regret was approaching," that he had to write his book, or else he would have "died howling." Sharpening his resolve, he sat down at his desk and finished the book in a year. At the time of his interview, he was off to speak at a high school assembly on the subject of writing from experience, a message that McCourt thought was so important, that he had decided to keep this long-standing high school invitation instead of attending a party being given in his honor to celebrate his Pulitzer Prize.

What was it that Frank McCourt so wanted to tell those high school students? More than anything, he said, he wanted them to know the story-telling power of their own lives. When the author was asked what he thought he had learned from writing his book, McCourt answered: "I learned the significance of my own insignificant life."[4]

For closeted gays and lesbians, McCourt's advice poses the question: How do we take up the storytelling power of our own lives? How do I take up my life and speak through it, write it down, turn it into a text, a tale of

significance, a map for those who will come after me? Who knows how many gays and lesbians are buried alive, trying to live unwritten, unspoken lives, sealed in a Christian tomb, a stone at the mouth of the grave? If we're deeply religious, gay, lesbian, and significantly devoted to the transformation of our spiritual lives and that of our religious tradition; if we're devoted to the transformation of those who hate gays, then we have serious, mind-opening work to do.

It is impossible to do this work if one is afraid; if one is schooled in the habits of self-rejection; if it is one's habit to return hate with hate. Mind-changing work requires skillful spiritual practice. It takes practice to cultivate genuine equanimity in the face of hostility. If I am a member of a persecuted minority, trying to develop self-acceptance in the shadow, say, of homophobia, racism, or religious persecution, it requires considerable patience, forbearance, and self-knowledge to remain open and judiciously wise. Even the ability to refrain from taking insults personally requires a steady practice. As one spiritual teacher wryly advised: As long as you're capable of being annoyed, I guarantee you there's something out there that will annoy you.[5]

Just look at the scope of the dilemma: If my whole life is a secret and its secrecy a source of unremitting shame; if what lies at the heart of who I am, is a story I cannot utter aloud because I might lose my job, lose the respect of my colleagues, lose my orders as a Christian priest, lose my family, lose my mental stability, maybe even lose my life for telling the truth, then let me lose this life. Let it die and be buried without "me," that "I" might rise to a more livable life, and live.

In moments like these, when we're fully awake to them, there can be a brilliant clarity. One can know with utter conviction what one needs to do. One can know without doubt that one must speak or die; write or be buried; suffocate or come out. One can know as I heard one woman say recently, having escaped from the closet and having survived to tell of it: "Now I know I would willingly give away all that I have, to be who I am."

When freedom comes, it's priceless at whatever age. I myself am past the half-century mark. I've been a practicing psychotherapist for decades, a college teacher, and a priest. Even so, having said all of this by way of locating and identifying myself in your presence, and in my own, I inevitably hear my mind pause. It's simply a matter of conditioning, a matter of mind moments, thousands of them. I know this pause so well. I see it in my spiritual practice, in the up-close investigation and analysis of my

own mind. If I'm paying attention to the momentary movements of the mind, I can watch it pause. I can hear it and feel it: It's lighter than a twitch; it's softer, even, than a clock's tick. It's the silent, silencing sound of my own mind, doubling back on itself, imperceptibly slipping into the smallest cloistered closet. It's a nearly instinctual gesture that I now can watch without judging myself, without condemning myself, without getting lost in this one single moment of the mind that inevitably arises when I am in the midst of others: The habituated move to hide myself, protect myself, bury myself, cover myself, snuff myself out, like an acolyte putting the cup over my own mouth and nose.

It seems instinctual, this gesture to conceal what is at the heart of me, even as I would willingly disclose it to you: That I love a woman I have lived with for more than twenty years; that we have lived together, she and I, through her father's suicide, the suspected murder of her brother, her treatment for cancer, and the deaths of our relatives and close friends from cancer and from AIDS.

I love this woman, knowing as I do that my sensibilities and hers, sharpened as they undoubtedly are by loss, are rendered all the more grateful by the gift of ordinary days. Like many a middle-class, middle-aged couple, we've paid our taxes and our mortgage, our insurance and our car payments; we've shopped and cooked, burned the toast and run out of milk; we've travelled the world over, from Bozeman to Banaras, two pilgrims. We've staked our tomatoes and shovelled the snow; we've walked in the rain, happy and in love. We've listened to music and cried at the movies; we've visited our relatives, cared for our in-laws, and buried our loved ones; we've given our money to the church and to causes we've believed in. We've voted, marched, stood up and been counted. We've read each other's work, we've mentored students, we've served on committees. We know we're lucky, we're fortunate and privileged.

I live with the terror of good fortune and the inevitable terror I hear in the machinations of my own mind, like the sound of a tank rumbling through the streets, a silencer holding down the noise of the engine. I find it difficult to admit such fear. I tell myself it's irrational, that it's my Christian mind sensationalizing itself, having grown up, as I did, in the midst of the Second World War, having seen the black and white pictures of the camps, having heard as a child the stories of the martyrs, the heretics who were burned at the stake because they couldn't keep their lives between the lines, inside the margins of Holy Writ.

It's demoralizing to find oneself demonized in print and from the pulpits of Christian churches; it's spiritually fatiguing to read accounts of oneself as a gay person in the pages of Christian texts that claim to love us while hating who we are. It can be mortally wounding if we take it personally or identify with it. It takes practice to let it go by without falling into retaliation or becoming psychically numb. Anti-gay policies and rhetoric threaten our spiritual and civil health. We're tempted to hate, to draw up sides, to pit ourselves one against the other; we're tempted to give up, to insulate ourselves and to withdraw. We're tempted to discouragement and self-doubt.

For more than a decade, I've been practicing insight meditation. I practice daily, receive spiritual instruction and study and practice in intensive periods, on retreat, with teachers whose teaching and practice is skillful and accomplished. Several years ago, while I was on sabbatical, I spent three months on a silent retreat practicing at a Buddhist Center. I'm serious about this practice. Without it, I doubt that I could remain a priest or an activist; and without it, I might be still in the recesses of the cloistered Christian closet, or in the recessive shadows of self-rejection.

Like many of my colleagues, I'm drawn to insight meditation for its teachings and practice on how to cultivate the mind by paying attention; how to become more skillful in daily life and ethical conduct by following certain precepts; how to acquire insight and wisdom into the nature of things: the cause of suffering and the way out of suffering; impermanence; and the paradoxical nature of the self.

As one begins to practice one quickly comes to see why the mind is likened often to a pack of monkeys. It chatters, it's easily distracted, it grabs for this and that, it clings, it pulls, it pushes, it runs away. As one practices and develops some concentration and steady attention, the mind gets more quiet, focused, and stable. One cultivates the ability to be with one's experience: to sit with whatever comes up; with whatever difficult thoughts, emotions, feelings, and mind states arise—fear, anxiety, anger, envy, bitterness, hate, grief, and the like—and simply be with it, in one's own good company, without getting lost, swept away, and becoming reactive. One learns to open more fully, with compassion, to whatever is—including the inevitable suffering that comes of living—and finds the path to compassion, love, kindness, restraint, a skillful mind and a peaceful heart.

With practice, we discover that we're less likely to be at the mercy of our circumstances, caught up in the conditions of the moment. We're less likely

to harm ourselves or harm others; more likely to do what we intend; less likely to do the things we'll regret. I'm reminded of a practice story about a woman who was serving a life-sentence for having shot and killed her husband. Over the years, she had taken up a meditative practice, a course of instruction offered to her in the prison. Her story was telling: She and her husband had gotten into a terrible argument; there had been a gun in the drawer; she remembers a moment of blinding rage; the shot rang out; the gun was smoking in her hand; her husband was dead. Years later, as a practiced meditator, she is reported to have said: "If I had known back then about this practice, I could have saved two lives: my husband's and my own."

If one is seeking a non-violent path of spiritual practice—and most of us are, even those of us whose violent actions are a result of a misguided, unskillful attempt at self-preservation in the face of overwhelming fear; or in the face of a perceived threat to our physical or emotional survival—we have to learn to take our fear and our terror in hand and slowly befriend it, make it the subject of our investigation and interest and open to it— open to ourselves—with compassion—let the suffering work of freedom be our moment to moment practice. I think it's clear: The only way out of suffering is to open to it, to take up this one precious and priceless life, and suffer it through to freedom. I can think of no other way to live.

Coming to know ourselves with all the accompanying lessons of self-regard, self-respect, self-esteem, self-acceptance takes a lifetime to cultivate. I see no reason to think that we should be entirely self-taught, that this extraordinary instrument of mindfulness should be accomplished without lessons. Even if we're sufficiently gifted with a native talent to play by ear—practiced instruction renders us far more skillful and gives us the technique and virtuosity sufficient to accomplish difficult material that otherwise would be out of reach. Such mindfulness gives us enormous pleasure, and it gives pleasure to others. But it requires practice.

It's common knowledge in spiritual practice that our most difficult circumstances are our greatest teachers. Being gay has been my great teacher, one of the greatest gifts of my life. It's been a tremendous struggle, this shining affliction of coming out and becoming self-affirmingly gay. There were times when I thought the struggle would kill me and bury me. Life in the closet was deadly. Coming out was life-threatening. Impaled on the horns of a dilemma from which I couldn't extricate myself, there were times when I know I thought that I would simply "die" of an unlived and unwritten life.

On a long and intensive retreat, coming out became the polishing stone of my practice. And just as I feared: Coming out proved to be a struggle to the "death." Miraculously, it was a death that saved my life. But I had no way of knowing at the time, that "dying" would actually save my life. I had no way of knowing (apart from the lessons on dying which I was learning in spiritual practice) that I *had* to die in order to live. Instead, I was clinging to my life in the closet, all the while not realizing that while I was holding on for dear life I was dying from an unlivable life that was killing me. I didn't know that dying was the only cure for an unsustainable life.

Every time we come out (and it's not a once-and-for-all event) especially the work of coming out to ourselves—we die to the life we're holding onto. Our life increases in equal measure with our self-acceptance, as we recoup and assimilate those parts of ourselves previously lost. Homophobia is like a dense fog: it keeps us from finding our way home in the dark. We need a map that shows the terrain; a compass; and a powerful source of light to make our way.

We learn from practice that the lessons on dying are essential to our human survival. I wish I had learned that lesson in Sunday School. I would have begun practicing at a much younger age. I know it's essential to accomplish the lessons of dying all our life-long. It's far too important to leave until the end of our days, without putting our lives at risk. Dying takes practice. It takes a lifetime to accomplish. I certainly don't want to get to the end of my days, and discover that I haven't lived my life. We know it's impossible to get out of this alive, without dying. Is there a way to die that takes us out alive? This is a question for practice.

Eventually, we know we will lose everything, whether we're ready or not. It's the lesson of impermanence. We'll lose our spouses, our family and friends and loved ones, our work, our health—the whole world—even our lives. Having to let go when we don't want to; aren't ready to; are afraid to; wish we didn't have to is to feel that our lives are being stolen from us before our time. How can we keep from losing everything? By learning to let go. Our lives can't be stolen from us, or taken from us, if we've already given them away. When losing has been transformed into letting go at the behest of our own initiative and practice, loss is relinquished, given up.

Can I learn to live, love, and die, without clinging and grasping, and trying to hold on forever? Can I practice generosity at the same time I'm

letting go? I'm trying to learn the practices of relinquishment. I'm trying to teach myself the little daily lessons of foregoing of letting go of going without. I would like to taste for myself what the sages of every religious tradition have known: Whoever wants nothing has everything. I would like my life to be simple. I've not yet learned to travel light.

One deeply-realized moment of impermanence can be life-changing. One can come to realize for example, that happiness is not dependent upon the accumulation of pleasant experiences. What's remarkable is that these realizations should come to us in such little telling moments. Meditation teachers and practitioners are full of narrative accounts of small, discrete moments. They constitute a recognizable genre of narrative telling that sends the listener back to his or her practice with a pointer toward paying attention to the close observation of the significant, seemingly insignificant, moment-to-moment experiences of our lives.

Let me offer one such queer little moment by way of a telling illustration. I was on a three-month retreat. It was a sunny day in December, I had just walked through the snowy woods, my mind was clear, I was very happy. The thought arose, suddenly, very clearly, like a line being spoken in the cool, crisp air, a clear and simple utterance: I have spent my whole life feeling basically flawed because I'm gay.

Interestingly enough—and it *was* interesting—such a remarkable thought appearing as it did, unbidden, not in relationship to anything I was thinking or feeling in this bright, light, sunny, very happy moment, I noticed in the next moment, an absence of a whole host of accompanying feelings, that, given my conditioning, I was expecting to feel: shame, defeat, self-pity, self-condemnation, embarrassment, failure, and the like. I put my hand up to my chest, and up to my neck, there was no sensation of pain where this thought may have struck and wounded a "me" that could have reacted to the thought, causing it to materialize. The bright, light, sunny, very happy moment continued. Happiness was unabated. It was a remarkable moment, this realization about the nature of happiness.

How to think about it? The thought had arisen; I had seen it; the truth of it was instructive and interesting. I opened to it, embraced it, acknowledged it—with interest and compassion—and without reactivity. It was a moment of clear seeing, without a struggle: "I" (that illusory character who portrays "me") was not attached to a life-long conditioning of feeling basically flawed for being gay. Seeing it clearly, without any sting, I was released from my conditioning. It simply dropped. And as it did, I realized in that

moment that death had no hold on me. I had risen from the closet. I was free to go on my way.

In the final analysis, it is precisely this quality of self-acceptance that brings a wholesome measure of peace and patience, happiness, and joy, even in the face of adversity. It's a simple fact of human economy: Given a healthy sum of self-respect and self-acceptance, we have a substantial reserve to spend on others, even those who hate us. Without compassion for ourselves, we're not likely to be generous toward those who despise us.

As practice makes it possible, truly, to love ourselves, we discover that we need to love our enemies, and we want to love them, out of regard for ourselves and for them. It may seem ironic, to some utterly foolish, but we do need to love those who hate us. The very quality of our life and theirs depends upon it. So does the world. As long as we have enemies we're afraid, and fear is deadly. If we've not befriended ourselves, fear erodes our confidence: It diminishes our capacity to trust ourselves to do the right, wise, and skillful thing. Fear leads to suspicion, aggression, war, cruelty, and the loss of human life. I've often heard it read from the book of ancient teachings: "Perfect love casts out fear." Now I tell myself: Go and practice it.

NOTES

1. See for example, James Hillman's essay, "The Ficton of Case History: A Round," in *Religion as Story*, edited by James B. Wiggins, (New York: Harper & Row, 1975).
2. Paul Monette, *Becoming A Man: Half a Life Story* (New York: Harcourt Brace Jovanovich, 1992).
3. Erik H. Erikson, *Young Man Luther, A Study in Psychoanalysis and History* (New York: W.W. Norton, Inc., 1958).
4. Interview of Frank McCourt by Dan Barry, *New Times*, Late Edition, April 10, 1997.
5. Pema Chodron, *When Things Fall Apart, Heart Advice for Difficult Times* (Boston: Shambhala Press, 1997).

5

WHAT'S DERRIDA GOT TO DO WITH JESUS?: RHETORIC, BLACK RELIGION, AND THEORY

Michael Eric Dyson

R HETORIC IS AN INDISPENSABLE FORCE in shaping narratives of black cultural identity. Indeed, the narrativity of black experience—the ways that stories constitute self-understanding and enable self-revelation—is powerfully glimpsed in a variety of rhetorical forms, from autobiographies to sermons, from novels to hip-hop culture. These forms embody in complex and conflicting ways the collective racial effort to articulate the goals of survival, resistance, and excellence through the literacy of representative figures.[1] If we acknowledge the unavoidable storyness of human existence, then narrative can be viewed as a dominant shape of black intelligence; speaking and writing can be viewed as the crucial rhetorical surfaces on which black identity is inscribed.

This is particularly true with black religious identities. Among its many functions, religious rhetoric is deployed to reinforce racial aspirations, situate intellectual and cultural expressions, articulate moral expectations and norms, and combat social evils, especially white supremacy. Although religious rhetoric is among the most vital spheres of cultural expression, it is virtually ignored by cultural studies, critical social and race theory, and poststructuralist theory.[2] This essay has a modest ambition: to examine black sacred rhetoric—its ecclesiastical expression and its public moral function—through the lens of theory. I will begin by briefly addressing the racial and social function of black rhetoric, especially oral traditions, since they are key to understanding black sacred rhetoric. I will then discuss the importance of theory for black discursive practices, particularly religious discourse. I will conclude by briefly reading through the lens of theory the public moral performance of black sacred rhetoric in the speech of Malcolm X and Martin Luther King, Jr.

I

Oral traditions are a significant aspect of black rhetoric. They serve a crucial genealogical function: They index how blacks have passed history, memory, and culture over to contemporaries and down to the next generation. Of course, these processes of oral transmission are not static. People who engage rhetorical forms transform what they inherit. In that sense, these oral traditions exemplify Nietzschean and Foucaultian elements of genealogy as well: They mark how and when ideas, beliefs, values, and practices emerge and flourish.[3]

The genealogical effect of these oral traditions accentuates the essential constructedness of rhetorical practices, since such practices rely to a large degree on invented traditions of racial memory.[4] Such invented traditions suggest that racial memory is shaped by the intellectual parameters, social circumstances, historical limitations, and existential needs of a particular group or society.

Then, too, given the racist cultural context in which black rhetorical practices have evolved, black oral traditions have been deployed to mobilize racial agency against the ideology of white supremacy. White supremacy is shorthand for the institutional and cultural practices of white racial dominance that are intellectually justified by its exponents as normal and natural. In such a cultural milieu, black rhetorical acts are read as unavoidable gestures of political contestation.

The social circumstances in which black rhetoric has survived have also given black oral traditions a surplus utility: supplying empirical verification of black humanity while enabling the struggle for black identity and liberation. Black rhetoric is thus implicated in bitter cultural debates about the value and status of black intelligence. In many ways, orality and literacy, in Walter J. Ong's memorable phrase, are flip sides of rhetorical articulation.[5] In the contentious social climate in which black rhetoric has usually functioned, it is central to claims about black intelligence as evidenced in black facility with reading, writing, and speaking.

Very often, however, beliefs about how black intelligence and identity are marked by literacy and speech are not engaged in an explicit manner that reveals the ideological stakes and political predicates of such beliefs.[6] In this light, it makes sense to think of the paradoxical functions of black rhetoric in two ways. First, black rhetoric is used to assault the dominant culture's ideological *inarticulateness*—that is, the suppressed features and unspoken dimensions of its hegemony over black culture. Second, black rhetoric is fash-

ioned to resist the *overarticulation* of negative readings and distorted images of black life in the dominant culture's political economy of representation.[7]

Finally, black rhetorical practices are shaped in an international and multiethnic context. As cultural theorists have recently argued, black cultural meanings are generated in the intersection of diasporic cultures in the Black Atlantic—comprised of the United Kingdom, Caribbean, and the United States.[8] Hence, black rhetorical practices are likewise polyvocal and multiarticulative: They register the accents of a variety of simultaneous, mutually reinforcing cultural voicings in a transnational zone of exchange, appropriation, and emulation. All in all, this emphasizes the radical mobility of black narratives. The meanings and mediators of black rhetoric move back and forth along—and certainly across—an ever enlarging circumference of ethnic experience and racial identity.

II

In theorizing the relation of race to rhetoric, intellectuals have largely drawn upon cultural studies, literary criticism, feminist theory, and critical race and social theory.[9] While the contribution of cultural studies scholars, literary critics, and critical race and social theorists to debates about race and language is well established—although not without controversy—it is neither obvious nor acceptable to some black critics that they should employ European theories in explicating black culture.[10] I think that French poststructuralist theory, for example, has a great deal to offer critics who interrogate the complex meanings of African-American discursive and rhetorical practices.[11]

Of course, those French critics must not be fetishized or given undue deference. Nor should their thought be uncritically adapted to black life without acknowledging the complicated process by which European theory has historically been deployed to colonize the psychic, intellectual, and ideological spaces of black culture.[12] Colonization as a corollary to European theoretical transgression against indigenous, native and subaltern populations—or more precisely, theoretical transgression as an adjunct to European colonial expansion—is reason enough for a healthy skepticism about such matters.[13] Still, the critical appropriation of poststructuralist theory by black intellectuals can prove beneficial.

For example, parts of Jacques Derrida's theory of deconstruction might help illumine the relation of black identity to rhetorical expression.[14] Derrida's

critique of the conception of speech as expression independent of a transcendental object of inquiry rather than as a mode of articulation constitutive of its object of inquiry might strengthen the liberation of African-American critical discourse from the quest for transcendental epistemic security within a framework of universal reason. This is helpful in at least two ways.

First, it relieves the "burden of representation," so that African-American criticism is not viewed as the effort to suture the gaping theoretical wound produced by splitting truth from its discursive mode of expression.[15] Representational theories of truth are only relevant when one believes that accurate pictures of the world are possible.[16] Once one dismisses the quest for such a transcendental basis of epistemic authority and representational accuracy, one clears discursive space for a new conception of truth as a function of justifying beliefs by referring to the contingent practices of human reason. Truth cannot be known apart from the linguistic resources and intellectual grounds at our disposal. Hence, black critics need not fear that by contending that truth is produced and known by fallible human beings that they are fatefully departing from epistemic strategies and philosophical procedures that allow others to know with certainty the objective world. On the view I have discussed, *all* human efforts to discover truth are similarly circumscribed, despite the apparently authoritative character of many epistemological claims.

The second consequence flows from the first: The political fallout of such a theory of truth is that all linguistic assertions, and the grounds of reason and morality that support them, are provisional rhetorical practices subject to revision as the telos of the social order is transformed through conflict and struggle. Thus, differential assertions about race are often predicated on conflicting social or group values within a hierarchy of racial perspectives that reflects a structural validation of certain views as more legitimate, hence more *reasonable,* than others.

This conception of reasonableness is widely viewed as the adjudicative force that resolves disputes, or that restores an illusory balance between rival claims to racial common sense. As a result, a contingent set of racial norms is made to appear natural and universal. In the process, supplying the necessary condition of the relative social and intellectual merits of racial claims is deceptively portrayed as the sufficient condition of such arguments. There is in turn a neat, even elegant, justification of the inherent superiority—i.e., the self-evident and logically irresistible character— of certain racial claims. By highlighting the logical means, rhetorical

strategies and political ends that structure hegemonic racial practices—
showing how the contingent is rendered permanent—black critics help
demystify the complex procedures by which racial hierarchy is maintained.

Another relevant feature of Derrida's theory of deconstruction is the
accent on multiple meanings of sentential rationality and linguistic practice.
This means that the horizon of meaning—and here, Gadamer's and Ricoeur's
work is of paramount importance as well—is not closed by definitive
hermeneutic acts or absolute notations of truth.[17] In determining a text's
meanings—already that's a polemical plural, suggesting a break of the power-
ful link between authorial intentionality and textual interpretation, while also
suggesting that a text might be a book, a social convention, a rhetorical prac-
tice, a film and so on—the emphasis is not on the singular meaning, the deci-
sive reading, or the right interpretation, ideas premised on the belief that it is
possible to exhaust the ways one might understand *(verstehen)* a text.[18]
Rather, the question one asks of a text is not "What does it mean?" but "How
does it signify?"[19] This is linked to black critical reflections on signifying prac-
tices within black diasporic cultures.[20] The simultaneous convergence of pos-
sible meanings underscores the multiple valences a text may generate. These
valences index a political economy of expressive culture that produces a thick
network of flexible readings which are an exercise in hermeneutical warfare.

Indeed, competing schemas of explaining and knowing the world are
implicated in the readings, *re*readings, *mis*readings, and *anti*readings that flow
from poststructuralism's jouissance. It might be useful as well to remember
Michel Foucault's notion of the "insurrection of subjugated knowledges."[21]
Such a notion sheds light on how marginalized discourses, suppressed
rhetorics, decentered voicings, and subaltern speech have erupted along a tra-
jectory of political struggles and discursive quests for self-justification, since
the search for other-validation is arrested by the recognition that truth is con-
tingent. In short, all quests for truth are interested and biased. The rise of such
knowledges—signifying in part what Althusser termed an "epistemic break"
with previous epistemological conditions, positions, and authorities—enable
the articulative possibilities and rhetorical resources of minority cultures.[22]

But borrowing from my own theological tradition, I think we must bap-
tize European cultural and social theories. It is not that Derrida, Foucault,
Guattari, Deleuze, Lyotard, Kristeva, Irigaray, Baudrillard, and Barthes must be
subject to a xenophobic rearticulation of American nationalist values. Neither
is it the case that we should force them to show, as it were, their theoretical
passports in order to traverse the semiotic or ideological borders of (African)

American theory. Rather, we should shape poststructuralist theory to the pecu-liar demands of (African) American intellectual and social life. The translation of poststructuralist theorists with our rhetorical resonances, linguistic tics, and discursive habits challenges national biases and intellectual insularities on all sides of the Atlantic. We must make gritty the smooth surface of poststruc-turalist theories—which often enjoy untroubled travel to our intellectual shores—with the specificities of our racial and political struggles. This is espe-cially the case as we theorize the links between rhetoric and black identities.

I I I

In light of the intellectual richness of contemporary debates about black rhetoric, and drawing on recent theory, I want to posit four crucial features of black religious rhetoric: its *ontological mediation*, its *performative episte-mology*, its *hermeneutical ubiquity*, and its *dense materiality*.[23] Ontological mediation stresses how black religious narratives help structure relations between beings: horizontal relations between human beings, and vertical relations between human beings and God. Black religious discourse helps define, and mediate, the moral status of human existence. It also helps clar-ify the ethical ends human beings should adopt in forming human com-munity, and the moral means they should employ in its defense. Black religious narratives define a relationship of human subordination to divine authority as the linchpin of personal redemption, while asserting moral transformation as the consequence of spiritual rebirth. Black religious nar-ratives support the claim that human emancipation is rooted in observa-tion of, and obedience to, divine imperatives of justice and equality.

The performative epistemology of black religious narratives underscores the intimate relation between religious knowledge and social practice, and sec-ondarily, the link between belief and behavior. In black sacred rhetoric, a cru-cial distinction is made between *knowing about* God and *knowing* God. The former represents a strictly intellectual exercise devoid of fideistic commit-ments; the latter is rooted in the faithful assertion of a cognitive and personal relationship with the supreme supernatural being. The consequence of such cognition is the *performance of faith*, the *dramatization of devotion*, and the *behaving of belief.* In black religious discourse, there is little substance or ben-efit to knowing God without *doing*, or performing, one's knowledge of God.[24]

Moreover, performative epistemology emphasizes that knowledge is not produced by having an accurate account of the relationship between

truth and its representation, but by the relation of knowing to a grounding ideal of truth whose justification depends in part upon an appeal to human praxis. Performative epistemology also accents the engaged, humane, and political character of religious curiosity, linking the experience of knowing and loving God to knowing and loving human beings. Black religious discourse suggests that it is difficult, and indeed morally noxious, to know God and not do right in the world.

The hermeneutical ubiquity of black religious discourse highlights the fecund interpretive properties to be found in all forms of black sacred rhetoric, from homiletics to Sunday school pedagogy. I mean this in three ways. First, black sacred rhetoric gives religious believers vast opportunity and great variety in interpreting their religious experience. Black religious narratives secrete interpretation as a function of their justification of a sacred cosmology. Black sacred rhetoric encourages the interpretation of faith in the light of reasoned articulation of the grounds of belief. Second, hermeneutical ubiquity suggests how black religious narratives shape the interpretive activities of believers in secular intellectual and cultural environments. This encompasses two elements: the religious interpretation of ideas and events, including, for example, abortion, civil rights, the Million Man March, and feminism; and the interpretive strategies that believers adapt in the public square, including, for instance, the translation of religious passion into political language and the voicing of religious dissent to political policies and cultural practices in protest rallies.

Third, hermeneutical ubiquity casts light on how black religious rhetoric seizes any event, crisis, idea, or movement as grist for its interpretive mill. Black sacred rhetoricians, especially black preachers, constantly view, and interpret, the world through the prism of moral narratives generated in black churches. Black religious narratives are relentlessly deployed by black sacred rhetoricians to carve an interpretive niche in political behaviors, social movements, cultural organizations, and institutional operations. Black sacred rhetoricians are interpretive cartographers as well: They map prophetic criticism onto social practice with an eye to reconstructing the geography of national identity.

Finally, black sacred rhetoric, especially black preaching, exhibits dense materiality, which refers to the rhythms, tones, lyricisms, and textures of black religious language. Because the narrative generativity, semiotic strategies, and linguistic adaptability of black religious discourse have influenced black scholars, preachers, lawyers, doctors, scientists, and entertainers, black sacred rhetoric should be much more rigorously examined and theorized.[25]

Two brief examples, C. L. Franklin and Charles Gilchrist Adams, will illustrate black sacred rhetoric's dense materiality (and the other features I have described) as it is institutionalized in ecclesiastical functions. Franklin and Adams are towering pulpiteers who, while they possess sharply contrasting styles, are formidable practitioners of black homiletical art.[26]

Franklin, the late father of soul music idol Aretha Franklin, was a legendary preacher and pastor who was uniquely gifted in the style of black preaching known technically as the "chanted sermon," and more colloquially as "whooping."[27] As a species of black sacred rhetoric, whooping is characterized by the repetition of rhythmic patterns of speech whose effect is achieved by variation of pitch, speed, and rhythm. The "whooped" sermon climaxes in an artful enjambment or artificial elongation of syllables, a dramatic shift in meter and often a coarsening of timbre, producing tuneful speech. In the sacred spaces of black worship, the performative dimension of black rhetoric is acutely accented in whooping.

Moreover, the antiphonal character of black ecclesiastical settings means that congregational participation is ritually sanctioned in the call-and-response between preacher and pew-dweller. The interactive character of black worship exerts a profound rhetorical and material pressure on the preacher to integrate into her sermon hermeneutical gestures, semantic cues, and linguistic opportunities that evoke verbal response and vocal validation from the congregation. Franklin was a past master at deploying his vast rhetorical skills to orchestrate the religious rites and ecclesiastical practices of black Christendom with flair and drama.

Charles Adams, who pastors a landmark Detroit religious institution, Hartford Avenue Memorial Baptist Church, is equally gifted. Adams was dubbed "The Harvard Whooper" because of his uncanny fusion of an intellectual acuity honed as a student at the Harvard Divinity School and a charismatic quality of folk preaching gleaned from his immersion as a youth in the colorful cadences of black religious rhetoric. Adams's riveting sermonic style is characterized by a rapid-fire delivery; keen exegetical analyses of Biblical texts; the merger of spiritual and political themes; a far-ranging exploration of the varied sources of African-American identity; and a rhythmic, melodic tone that, at its height, is a piercing rhetorical ensemble composed of deliberately striated diction, staccato sentences, stressed syllabic construction, alliterative cultural allusion, and percussive phrasing.

Further, Adams sacralizes the inherent drama of black religious rhetoric by embodying its edifying theatrical dimensions. As preacher, he

is both *shaman* and *showman.* In his brilliant pulpit oratory, Adams nurtures the sacrament of performance: the ritualized reinvestment of ordinary time and event with the theological utility of spectacle. Adams, for instance, has not only preached the Biblical story of a woman searching for a lost coin; he took a broom into the pulpit and dramatized the search for lost meaning in life and the need to reorder existential priorities.

Franklin and Adams provide a brilliant peek into black preaching's dense materiality (and of its ontological mediation, its performative epistemology, and its hermeneutical ubiquity). Their art illumines as well black sacred rhetoric's polysemous power, and the sanctification of language and imagination for salvific ends. They embody the ecclesiastical functions of eloquence, and the racial utility of religious articulation. They also show how black sacred rhetoric's dense materiality does not negate its other linguistic features. For instance, these figures' rhetorical practices underscore the phenomenological merit of linguisticality—that sacred rhetoric possesses a self-reflexive quality that allows its users to reflect on and refine its constitutive elements. Such figures also highlight how words can lend ontological credence to racial identity, and how religious language can house an existential weight, a self-regenerating energy, that can be levied against the denials of black being expressed in racist sentiment and practice. If Franklin and Adams embody the multiple utilities of black sacred rhetoric in an ecclesiastical context, two other figures, Malcolm X and Martin Luther King, Jr., articulate its public moral posture. Both Malcolm and King sought to shape public moral discourse with the rhetorical resources of their respective religious traditions. After a brief discussion of theories of the public sphere and discourse, I will examine the public uses of Malcolm's and King's sacred rhetoric and moral discourse.

I V

Theories of the public sphere have received a great deal of attention in a variety of disciplines, primarily because of the influential work of Jurgen Habermas.[28] On the one hand, the public sphere has been conceptualized as a crucial component in explications of democratic theory. On the other hand, the exclusions of the bodies of women and (other) blacks, for instance, from the theoretical articulations of the constitutive elements of the *res publica* (the common good), highlights the unjust, antidemocratic dimensions of conceptions of the public sphere.[29] Theorists like Nancy

Fraser and Craig Calhoun have imaginatively extended and criticized Habermas's concept of the public sphere.

Fraser explores the philosophical and social consequences of Habermas's conception of the public sphere as a space where discourse constitutes public opinion; where issues of common concern are debated by members of the public as they deploy reason-giving as a means of rational persuasion; and where political decision making is energized by public opinion.[30] Fraser also presses Habermas as to how critical theory functions to enlighten or reinforce gender hierarchy in modern societies; how it either resists or replicates the ideological justification and rationalization for such hierarchy; and how it can clarify or muddy the terrain of struggle for contemporary women's movements.[31] A similar project—one that theorizes the multiple locations and uses of the public sphere—has been taken up with regard to the black diaspora.[32]

Calhoun engages Habermas's notion of the public sphere by exploring how the public good is distinguished from private interest; by noting the institutions and means by which people are permitted to participate in the public sphere independent of patronage or political power; and by accentuating the conditions and forms of private existence that make it possible for individuals to act autonomously as critical agents in the public sphere.[33] Calhoun argues convincingly, and against Habermas, that there is not a single, authoritative public sphere, but a "sphere of publics"—matched by Fraser's conception of "subaltern counter-publics," and "multiple publics," (including "strong" and "weak" publics) distinguished by ideology, gender, class, profession, central mobilizing issue, and relative power.[34] They both argue that the multiple lines of interaction between publics must be tracked. Fraser and Calhoun both criticize Habermas for his failure to acknowledge alternate publics and alternate routes of public life (such as were constructed by various groups of women in the nineteenth century).[35] And both Calhoun and Fraser recognize that the question of "identity-formation," or the "politics of recognition" must be viewed as a public, not a private, matter, and that they must be theorized within the public spheres in which they are constructed and reproduced.[36]

Discourse is also a crucial concept in social and cultural theory. Poststructuralist thought, especially the work of Foucault, has generated tremendous interest in the conceptual and social functions of discourse. Despite the influence of structuralism on his early work, Foucault's conception of discourse marked a break with the marginalization in structuralism of acute analysis of social phenomena and thick historical detail. Instead, struc-

turalists highlighted governing laws, forms, and structures. Foucault attempt-
ed to transcend—or better yet, discard—binaristic thinking, taking a leap of
discursive imagination beyond a Kierkegaardian either/or, accentuating
instead the variable, subjective character of linguistic and social phenomena.[37]
Foucault eventually embraced a genealogical project—derived in name and
nature from Nietzsche—an intellectual enterprise that discarded meta-
physics, grand theories, foundational myths, timeless epistemic warrants,
teleological philosophies, deep structures, unyielding essences, unifying cen-
ters of reason, and *Heilsgeschichte* (sacred history).[38]

Counterposed to Enlightenment reason's obsession with uncovering
the basis of unmediated truth—a project undermined by Derrida's decon-
struction of metaphysical dualism, rationalist epistemology, and hierarchi-
cal ontology in his attack on logocentrism—Foucault's genealogical
project attempts to bring to light how dominant discourses render certain
ideas normative, certain practices natural, certain interests invisible, and
certain powers discrete. Discourse underscores the construction of mean-
ings that shape and organize both individual and social actions and self-
conceptions.[39] Discourse aids us in comprehending how what is thought
and spoken is situated within a matrix with its own particular history and
its peculiar grounds and conditions of existence.[40]

Foucault viewed discourse as a successor concept to Marx's concept of
ideology.[41] Foucault claimed that ideology was a problematic concept
because it presupposes the existence of truth in opposition to the untruth,
or lies, that the concept of ideology is used to uncover;[42] that the concept
refers to the subject (whose intellectual death Foucault's work pro-
claimed); and finally, that ideology is a secondary effect of a primary,
determinative economic and material infrastructure.[43] Instead, for
Foucault, normalization, regulation, and surveillance are the conceptual
hat-trick that registers how power is dispersed over a field of discursive
practices. The institutionalization of rival discursive regimes of truth pro-
duces effects of domination marked in power operations that fix norma-
tive gazes (a historicization of Sartrean ontology, especially "le regard");
regulate the dispersal of knowledges (a pluralization and politicization of
Cartesian epistemology); and that rationalize surveillance as an ineluctable
and necessary condition of social reality (a technologization of Benthamite
penology). But as Stuart Hall points out, Foucaultian genealogy, with dis-
course at its analytical heart, is not significantly different from notions of
domination that can be explored through the concept of ideology.[44]

Theories of the public, and of discourse—and other postcolonial, political and critical social and race theories—should be kept in mind as we explore the public functions of the religious rhetoric of Malcolm X and Martin Luther King, Jr.[45] Malcolm X was supremely skilled in several aspects of black oral artistry. Indeed, his "broad familiarity with the devices of African-American oral culture—the saucy put-down, the feigned agreement turned to oppositional advantage, the hyperbolic expression generously employed to make a point, the fetish for powerful metaphor—marks his public rhetoric."[46] Furthermore, Malcolm articulated a powerful "black public theodicy" that was "rooted in a theological vision that lent religious significance to the unequal relationship between whites and blacks," and that rejected the belief that "black people should redeem white people through bloodshed, sacrifice and suffering."[47] Malcolm's black public theodicy led him to the conclusion that "white violence must be met with intelligent opposition and committed resistance, even if potentially violent means must be adopted in self-defense against white racism."[48]

Central to Malcolm's religious beliefs was a vehement verbal assault on white supremacy. Through his rhetoric of opposition, Malcolm helped constitute and articulate a black counter-public that revealed itself through the discursive practices of an alternative black religious *Weltanschaaung*.[49] For Malcolm—and for the Nation of Islam to which he belonged—the black public sphere was not only obsessed with resisting white attacks on black being, but with bitterly opposing the discourse of black Christian piety, and its public counterpart, civil rights ideology. By emphasizing the "tricknology" and the brainwashing of black people, achieved by the discursive deceit and rhetorical duplicity of white society, Malcolm meant to underscore the destructive consequences of blacks adopting white religious rhetoric and belief.

Malcolm also wanted to ridicule the discourse of black bourgeois public morality, which he thought was predicated on black capitulation to white intellectual hegemony. Further, the rhetoric of civil rights implied an accommodationist posture to the very political structures that had made blacks "victims of democracy." In that specific sense, Malcolm's public rhetoric of opposition to the ideological articulation of white supremacy—and his rhetorical resistance to black moral surrender to cultural hegemony—evinced an appreciation for what some orthodox Marxists would term "false consciousness."[50] Malcolm's black counter-public—constituted by black Islamic religious belief, racial rhetoric, and the discursive practices of black nationalism—was not only articulated against the discursive practices of white romantic nationalism (the

uncritical celebration of all things deemed purely American); but it also countered black Christian practices articulated in public as the ethical expression of religious narratives of charity and redemptive suffering.

Within the discursive practices and narrative strategies that comprised the black Islamic counter-public, Malcolm X articulated three rhetorics: the rhetoric of reinvention, the rhetoric of rage, and the rhetoric of violence. For Malcolm, the rhetoric of reinvention had to do with the discursive distance between white religious rhetoric and moral indoctrination, and the racial reconstruction, religious rebirth, and moral transformation forged in the crucible of Islam. The rhetoric of reinvention had to do with conversion, the remaking of the ego, and the ideal spiritual self in light of the religious narratives that are crucial to sustaining black dignity, identity, and survival. For Malcolm, this meant a direct repudiation of the ideological distortions, rhetorical fallacies, and racial corruptions associated with white Christianity.

For Malcolm, the rhetoric of rage was enabled by the rhetoric of reinvention: It was not until Malcolm was able to secede from the discursive union of false consciousness and distorted self-identity that he could embrace the righteous anger that is the consequence of black spiritual rebirth.[51] Prior to being reborn within the womb of black Islamic belief, Malcolm lacked the rhetorical resources and intellectual discipline to surgically analyze the discursive operations of white domination and to pinpoint the massive public articulation of the discourse of white superiority. His rhetoric of rage against the machinery of white distortions and dogmatisms was matched by his relentless verbal denunciations of black apathy and racial surrender. In one sense, Malcolm's anger at white foes and black foils was made possible because he shed the secular seductions attached to the hustling life he previously prized and clung to the moral puritanism of the Nation of Islam. The cultic dimensions of the religious group generated for him a discursive framework, rhetorical weaponry, and an existential raison d'être that countered the erosion of black self-confidence, and the promotion of black self-loathing, in the religious cul-de-sacs of the white public sphere.

Finally, Malcolm's use of the rhetoric of violence has been much maligned and misunderstood. Malcolm's fundamental point was that black people should be prepared to defend themselves in the face of white hostility. In Malcolm's view, America was created because a group of citizens refused any longer to be oppressed and exploited, and violently defended their self-interests, and their burgeoning collective national awareness, in war. In short, violence was a profoundly American tradition. It was a cen-

tral force in national self-definition and social practice. Malcolm insisted that the same logic of social practice, group identification, and ideological consolidation be applied to the black liberation struggle.

In this light, Malcolm held that the white demand for blacks to forgo their birthright as American citizens to violently defend their interests in the face of unprincipled, systematic attack was logically flawed and morally indefensible. The rhetoric of violence became a way for Malcolm to use American self-definition and identity as tropes. He posited his reading of American history as the intellectual corrective to the distorting pedagogy of oppression being perpetuated in the white public sphere. For Malcolm, black violence was a morally justifiable reaction to an already existing condition of spiritual and physical violence that threatened the selfhood and, literally, the safety of black people.

In sharp contrast, King's rhetorical opposition to the discursive and material provinces of violent white public spheres—with their discourses of moral purity, intellectual superiority, and racial supremacy—was predicated on the effort to fuse black public spheres with the morally enlightened white public.[52] King sought to transform the white American public sphere by appealing to a broadly shared set of beliefs that held national citizenship and identity together.[53]

King's public moral discourse was inherited from a black discursive and rhetorical tradition in which religious narratives of unearned suffering, patient protest, and political accommodation were juxtaposed to narratives of radical social resistance, violent self-defense, and justifiable subversion of the civil order. In so doing, King deployed a number of rhetorical strategies gleaned from his black Baptist heritage.

First, a crucial rhetorical strategy that King adapted involved the ingenious public performance of the intradiscursive character of black Christian religious discourse: that human speech can lead to more speech, or different speech, that can help alter human behavior. The gist of this strategy is to convince the participants and opponents of a moral crusade—*through rhetoric*—that spiritual and moral rhetoric has the capacity to catalyze human action toward the transformation of the public sphere.[54] Rhetoric can be used to morally energize participants to revive their flagging efforts; and it can be employed to motivate opponents to change their hateful, destructive behavior, and to alter customs, habits, and traditions that prevent black liberation.

The belief in rhetoric's power to transform human behavior and social relations was linked to religious narratives that advocated transformation through moral trial, reinvention through self-examination, conversion

through confrontation with the ultimate good, and redemption through suffering. For King and other black religious figures, their rhetoric rung with moral authority because its ethical claims and public performances were inspired by imminent contact with a transcendent God. King often spoke of civil rights devotees enjoying "cosmic companionship." Thus their rhetoric and social practices were motivated by belief in a God who gave believers the power to speak and act in ways that transform personal sentiments, group thinking, and social structures. Religious rhetoric—and its translations in civil society and its articulations in other public spheres—was an important vehicle for such transformation.

This latter feature highlights another rhetorical strategy employed by King: He fused the language, rhythms, and modes of black sacred rhetoric with civic rhetoric and civil religious symbols in American society. In short, King bombarded the white public sphere with discursive remnants from hegemonic civil culture to argue for the inclusion of black counter-publics, suppressed rhetorics, and subjugated knowledges. His ingenuity consisted in arguing that such publics, knowledges, and rhetorics were not only crucial resources to sustain and refashion American democracy; but that they were indeed a more faithful, authentic articulation of the original meanings and high moral intent of the American republic. When King appealed to the Declaration of Independence and the Constitution, he did so with an eye to making religiously inspired uses of the secular documents that undergird civil society and that codify its basic beliefs about the character of American citizenship. He deployed those documents—along with the beliefs about democracy they encouraged and the rhetoric of equality they mobilized—as a rhetorical vehicle to express his religious interpretations of justice, freedom, and equality. King's religious beliefs were the impetus for his rhetorical efforts to translate an ethic of *love as justice* in public discourse and practice. King linked his understanding of social transformation to the quest for the public good through the language of civic virtue and civil rights.

The public moral discourse deployed by Malcolm and King reveals the multiple utilities of black religious rhetoric. By viewing their speech—and the rhetoric of black religion in general—through the prism of theory, several aims can be achieved. First, we can further locate and illumine how their rhetoric functions within black discursive practices. Second, we can isolate examples of their ideological abridgments of black sacred rhetoric in the translation from ecclesiastical to public contexts. Third, we can examine the aesthetic and stylistic repertoire of religious figures who make

imaginative use of black sacred rhetoric. Fourth, we can cast a brighter intellectual light on the complex forms of intertextuality, intradiscursivity, and intersubjectivity constituted through black religious narratives.

And finally, we can better grasp the ritualized mediation of polyvalent racial significations through black religious practices, such as heteroglossia or "speaking in diverse tongues." In fact, heteroglossia can serve as a metaphor for the psychic, social, and discursive distance between competing vocabularies of rationality within American, indeed, Western, culture.[55] But perhaps most important, theory will be baptized in the fires of black culture, transformed by the lived, material force of black religious practices.

NOTES

1. I have in mind here how the literacy of exemplary black figures is implicated in debates about black intelligence, black humanity, and black culture. For instance, Phillis Wheatley's eighteenth-century verse was the putative proof of black intelligence to white critics (including Thomas Jefferson) who disbelieved blacks' ability to achieve abstract reasoning and sophisticated literary expression. For a brilliant reading of Wheatley's case, see Henry Louis Gates, Jr. *Figures in Black: Words, Signs, and the Racial Self* (New York: Oxford University Press, 1987), pp. 61–79. However, there is another historical debate about representative figures that draws from Ralph Waldo Emerson's *Representative Men: Seven Lectures* (1850), in *Ralph Waldo Emerson: Essays and Lectures,* edited by Joel Porte (New York: Library of America, 1983), where Emerson articulates his conception of the personal qualities and cultural functions of leaders and great men, or representative men. For a provocative and insightful examination of the intellectual pitfalls, ideological distortions, historical inaccuracies and gendered *misrepresentations* that attend the application (by nineteenth century black figures like Delaney and Douglass themselves, as well as by contemporary intellectuals) of the category representative man to nineteenth-century black leadership, see Robert S. Levine's *Martin Delany, Frederick Douglass, and the Politics of Representative Identity* (Chapel Hill: University of North Carolina Press, 1997).
2. Of course, there have been countless scholars in religious studies who have critically appropriated cultural studies, critical social theory and poststructuralism into their work. A random list might include excellent works like *Changing Conversations: Religious Reflection and Cultural Analysis,* edited by Dwight N. Hopkins and Sheila Greeve Davaney (New York: Routledge, 1996) [cultural studies]; Evelyn Brooks Higginbotham, *Righteous Discontent: The Black Women's Movement in the Black Baptist Church* (Cambridge, Mass.: Harvard University Press, 1993), [critical social theory]; and *Erring: A Postmodern A/Theology* (Chicago: University of Chicago Press, 1984), [deconstruction/poststructuralism].
3. See Friedrich Nietzsche, *The Genealogy of Morals* (1887), in *Basic Writings of Nietzsche,* edited and translated by Walter Kaufmann (New York: Modern Library, 1968) and Michel Foucault, "The Discourse on Language" in *The Archaeology of Knowledge,* translated from the French by A. M. Sheridan Smith (New York: Pantheon Books, 1972), pp. 215–37; and "Nietzsche, Genealogy, History" in *Aesthetics, Method, and Epistemology: Essential Works of Foucault, 1954-1984,* edited by James D. Faubion, translated by Robert Hurley and Others, (New York: The New Press, 1998), pp. 369–91.

I am not suggesting that either Nietzschean or Foucaultian genealogy is about tracking and tracing origins. As Foucault wrote, genealogy is rather about a "patience and a knowledge of details," and that it required a "relentless erudition" since genealogy "does not oppose itself to history" but rather, "opposes itself to the search for origins." ("Nietzsche, Genealogy, History," p. 570). Rather, it is the rich sense of history that the genealogist needs to discern the "basis of all beginnings, atavisms, and heredities" (p. 373). I simply mean to stress the historicity of rhetorical practices and oral traditions, and that a genealogical approach helps to situate the history of how such traditions and practices have been read, and how they have functioned within the context of (African) American culture. As such, their beginnings far exceed the dry details of when they started; rather, their histories of emergence register the political conflict and racial experience that led to their use to begin with. The emphasis in such a genealogical approach is on the historical and cultural circumstances under which such traditions and practices emerged, how they survived, what uses they serve, and what needs they fulfill.

4. I mean the "invention of tradition" in a positive fashion, with the intent of establishing a specific, productive relationship with the past, as Eric Hobsbawm states in *The Invention of Tradition,* edited by Eric Hobsbawm and Terence Ranger (Cambridge, England: Cambridge University Press, 1984). Thus, when I argue for invented traditions of racial memory, I am pointing to deliberate acts of racial self-preservation through mobilizing memories of achievement, resistance, opposition, sacrifice and survival. Of course, it is perhaps just such gestures that rile figures like Arthur Schlesinger, Jr., who rail against multiculturalism, especially Afrocentrism, as an "invention of tradition." For a balanced critical reading of Afrocentrism against Schlesinger's assault, see Leith Mullings, *On Our Own Terms: Race, Class, and Gender in the Lives of African American Women* (New York: Routledge, 1997), pp. 189-193, esp. p. 191 where she calls Schlesinger's claim "at best disingenuous and at worst blatantly dishonest." Mullings, of course, is responding to Schlesinger's negative commandeering of the phrase "invention of tradition" to distinguish multiculturalism from ostensibly more established, ancient, authentic traditions. But it would behoove Schlesinger to regard Hobsbawm's point that traditions "which appear or claim to be old are often quite recent in origin and sometimes invented" (p. 1). (Although Hobsbawm has apparently forgotten this as he has recently joined the attack on multiculturalism as well.) For Schlesinger's attack on multiculturalism, and his claim against Afrocentrism, see his *The Disuniting of America: Reflections on a Multicultural Society* (New York: Whittle Communications, 1991).

5. Walter J. Ong, *Orality and Literacy: The Technologizing of the Word,* (New York: Routledge, reprint, 1988).

6. I briefly map the complex expressions of race and racism, and the various ways in which they are manifest—including the subtextual predicates of racial discourse and practice, which I term "racial mystification,"—in my *Race Rules: Navigating the Color Line* (New York: Vintage, reprint, 1997), pp. 33-46.

7. I deal with the issue of how black cultural practices are related to a hegemonic white culture in my chapter on critical white studies, entitled "Giving Whiteness a Black Eye," from my forthcoming book, *Speaking of Race* (Volume I): *Critical Theories,* (Columbia University Press, 2000).

8. Robert Farris Thompson, *Flash of the Spirit: African and Afro-American Art and Philosophy* (New York: Random House, 1983); Peter Linebaugh, "All the Atlantic Mountains Shook," in *Labour/Le Travailleur,* vol. 10, 1982; Peter Linebaugh and Marcus Rediker, "The many headed hydra: Sailors, Slaves and the Atlantic Working Class in the Eighteenth Century," *Journal of Historical Sociology,* 3(3), 1990, pp. 225-352; and Paul Gilroy, *The Black Atlantic: Modernity and Double Consciousness*

(Cambridge, Mass.: Harvard University Press, 1993) and *Small Acts: Thoughts on the Politics of Black Cultures* (London: Serpent's Tail Press, 1993).

9. See, for example, the following anthologies: *Black British Cultural Studies,* edited by Houston Baker, et al. (Chicago: University of Chicago Press, 1997); *Cultural Studies,* edited by Lawrence Grossberg et al. (New York: Routledge, 1992); *Black Literature and Literary Theory,* edited by Henry Louis Gates, Jr., (New York: Methuen, 1984); *Home Girls: A Black Feminist Anthology,* edited by Barbara Smith, et al. (New York: Kitchen Table: Women of Color Press, 1983); *Reading Black, Reading Feminist: A Critical Anthology,* edited by Henry Louis Gates, Jr., (New York: Meridian Books, 1990); *Changing Our Own Words,* edited by Cheryl A. Wall (New Brunswick, NJ: Rutgers University Press, 1991); *The Essential Frankfurt School Reader,* edited by Andrew Arato and Ike Gebhardt (New York: Continuum, 1982); and *Critical Race Theory* (New York: The New Press, 1995), edited by Kimberle Crenshaw, et al.

10. I have in mind here the fierce exchange between critic Joyce A. Joyce (now the head of African-American Studies at Temple University) and Henry Louis Gates, Jr., and Houston Baker, whom Joyce accused of hoisting extraneous, European theories onto indigenous black literary and cultural practices. I also have in mind the skepticism expressed by Barbara Christian about the value and utility of theory in African-American discourse, and her insistence that theory does not function (and is not viewed) in the same way in the West and the non-West, in her well-known essay, "The Race for Theory," in *The Nature and Context of Minority Discourse* (New York: Oxford University Press, 1990).

11. I have in mind here the work of Julia Kristeva, the late Jean-Francois Lyotard, Roland Barthes, Jacques Lacan, Jacques Derrida, Michel Foucault, and so on. I will cite the relevant texts by selected authors below.

12. For example, see the essays by figures like David Hume, Immanuel Kant, Thomas Jefferson and G. W. F. Hegel, in *Race and the Enlightenment: A Reader* (Oxford: Blackwell Publishers, 1997).

13. See the postcolonial theory of figures like Edward Said, *Orientalism* (New York: Random House, 1978), and *Culture and Imperialism* (New York: Alfred A. Knopf, Inc., 1993); Gayatri C. Spivak, *In Other Worlds: Essays in Cultural Politics* (New York: Methuen, 1987), and *The Post-Colonial Critic: Interviews, Strategies, Dialogues,* edited by S. Harasym, (New York: Routledge, 1990); and Homi K. Bhabha, *The Location of Culture* (New York: Routledge, 1994).

14. Jacques Derrida, *Speech and Phenomenon,* translated by David Allison (Evanston: Northwestern University Press, 1973); *Of Grammatology,* translated by Gayatri Spivak (Baltimore: Johns Hopkins University Press, 1976); and *Dissemination,* translated by Barbara Johnson (Chicago: University of Chicago Press, 1982).

15. The phrase is James Baldwin's.

16. Richard Rorty, *Philosophy and the Mirror of Nature* (Princeton: Princeton University Press, 1979).

17. Hans-Georg Gadamer, *Philosophical Hermeneutics,* translated and edited by David Linge (Berkeley: University of California Press, 1976); and Paul Ricoeur, *Hermeneutics and the Human Sciences* (Cambridge, England: Cambridge University Press, 1981).

18. The phrase *verstehen* (understanding) is adapted from Wilhelm Dilthey. For an insightful reading of Dilthey's distinction between "understanding," which is suited for the human sciences *(Geisteswissenschaften),* and "explanation," which is suited for the sciences *(naturwissenschaften),* see Richard E. Palmer, *Hermeneutics: Interpretation Theory in Schleiermacher, Dilthey, Heidegger, and Gadamer* (Evanston, Illinois: Northwestern University Press, 1969), pp. 98–123, esp. pp. 105–6. Of course, the Diltheyan distinction between understanding and explanation—as well as Kantian idealism's distinction between

cognitive and aesthetic judgments—is one to which I am opposed on pragmatist grounds, for reasons best expressed by Richard Rorty in his "Texts and Lumps," from *Objectivity, Relativism, and Truth: Philosophical Papers Volume 1* (Cambridge, England: Cambridge University Press, 1991), pp. 78-92. For an excellent examination of the complex intellectual issues involved in the assertion of meaning(s) in the interpretation of texts, see Jeffrey L. Stout, "What Is the Meaning of a Text?," *New Literary History,* 14, 1982, pp. 1–12.

19. Barbara Johnson has brilliantly illumined this deconstructive approach over a series of engaging books: *The Critical Difference: Essays in the Contemporary Rhetoric of Reading* (Baltimore: Johns Hopkins University Press, 1980); *A World of Difference* (Baltimore: Johns Hopkins University Press, 1987); *The Wake of Deconstruction* (Cambridge, Mass.: Blackwell Publishers, 1994); and *The Feminist Difference: Literature, Psychoanalysis, Race and Gender* (Cambridge, Mass.: Harvard University Press, 1998). In fact, it was from her that I first heard this formulation (or something very much near it) in a lecture at Brown University, circa 1992.

20. Henry Louis Gates, *The Signifyin' Monkey: A Theory of Afro-American Literary Criticism* (New York: Oxford University Press, 1988).

21. Michel Foucault, *Power/Knowledge: Selected Interviews and Other Writings: 1972–1977,* edited by Colin Gordon (New York: Pantheon Books, 1980), p. 81.

22. Louis Althusser, *For Marx,* translated by Ben Brewster (London: Verso, 1979 [reprint]).

23. I first used the term performative epistemology in 1994, in a lecture at the University of North Carolina, before reading Derrida's notion of performative interpretation later the same year in *Specters of Marx: The State of Debt, the Work of Mourning, and the New International,* translated by Peggy Kamuf, (New York: Routledge, 1994). Derrida says "performative interpretation" is "an interpretation that transforms the very thing it interprets" (p. 51), which jibes with my notion of performative epistemology in black sacred rhetoric. Also see Henry Giroux's notion of "performative pedagogy", in "Where Have All the Public Intellectuals Gone?: Racial Politics, Pedagogy, and Disposable Youth," in *JAC: A Journal of Composition Theory (Special Issue: Race, Class, Writing)* volume 17, number 2, 1997, pp. 191–205, where he writes that performative pedagogy "opens a space for disputing conventional academic borders" and which "reclaims the pedagogical as a power relationship that participates in authorizing or constraining what is understood as legitimate knowledge, and links the critical interrogation of the production of the symbolic and social practices to alternative forms of democratic education that foreground considerations of racial politics, power, and social agency" (p. 199). Also see Giroux's powerful *Channel Surfing: Race Talk and the Destruction of Today's Youth* (New York: St. Martin's Press, 1997).

24. It is also interesting to note that in hip-hop culture, a phrase that is currently popular is "doing the knowledge," accenting, as in its religious rhetorical counterpart, the active, agential process of engaging, encountering and enacting—indeed performing—knowledge. On the religious score, with an account that accentuates the performative moral dimension of religious knowledge, see Enda McDononagh's *Doing the Truth: The Quest for Moral Theology* (Notre Dame: University of Notre Dame Press, 1979).

25. Of course, there have been a few excellent studies, but the richness and complexity of black sacred rhetoric cries out for more serious study. For a few interesting examples, see Alice Jones's 1942 Fisk University Master's thesis, "The Negro Folk Sermon: A Study in the Sociology of Folk Culture"; William Pipes, *Say Amen Brother! Old-Time Negro Preaching: A Study in American Frustration* (Detroit: Wayne State University Press, 1992 [1951]); Henry H. Mitchell, *Black Preaching* (Philadelphia: J. B. Lippincott, 1970); Bruce Rosenberg, *Art of the American Folk Preacher* (New York: Oxford University Press, 1970); Gerald L. Davis, *I Got the Word in Me and I Can Sing It, You Know: A Study of the Performed African-American Sermon* (Philadelphia: University of Pennsylvania Press, 1985); Carolyn

Calloway-Thomas and John Louis Lucaites, editors, *Martin Luther King, Jr., and the Sermonic Power of Public Discourse* (Tuscaloosa, AL: University of Alabama Press, 1993); and Walter Pitts, *Old Ship of Zion: The Afro-Baptist Ritual in the African Diaspora* (New York: Oxford University Press, 1996 [1993]), esp. pp. 59–90, and pp. 132–75.

26. C. L. Franklin's rich sermonic history, fortunately, has been preserved on over seventy recordings, initially produced by Chess and Jewel record labels, and now available on audio-cassette recordings sold both in gospel music stores, and also in large retail chain music stores. Franklin's magisterial art has also been transcribed, edited, and analyzed in Jeff Todd Titon, ed., *Give Me This Mountain: Reverend C. L. Franklin, Life History and Selected Sermons* (Urbana: University of Illinois Press, 1989). The sermons of Charles Adams are also on audio-cassette, both from his church, Hartford Avenue Memorial Church in Detroit, as well from sermons preached around the country in various ecclesiastical and social venues, including the Progressive National Baptist Convention. In both cases, of course, as with all great black preaching, Franklin and Adams must be heard to get the full impact of their verbal and religious artistry.

27. Sometimes spelled "hoop": see Robert Franklin, *Another Day's Journey: Black Churches Confronting the American Crisis* (Minneapolis: Fortress Press, 1997), pp. 68–69, 75. For more on the "hooped," or folk, sermon, see Albert Raboteau's splendid essay, "The Chanted Sermon," in *A Fire in the Bones: Reflections on African-American Religious History* (Boston: Beacon Press, 1995), p. 151.

28. Jürgen Habermas, *The Structural Transformation of the Public Sphere: An Inquiry Into a Category of Bourgeois Society.* Trans. Thomas Burger with the assistance of Frederick Lawrence (Cambridge, Mass.: MIT Press, 1993). For insightful treatments and criticisms of Habermas's concept of the public sphere, see the essays in, Craig Calhoun, ed., *Habermas and the Public Sphere* (Cambridge, Mass: MIT Press, 1992); and the essays in Bruce Robbins, editor, *The Phantom Public Sphere* (Minneapolis: University of Minnesota Press, 1993).

29. Nancy Fraser, *Justice Interruptus: Critical Reflections on the "Postsocialst" Condition* (New York: Routledge, 1997), p. 77.

30. Ibid.,p. 101; also, pp. 99–120, and esp. pp. 80–98.

31. Nancy Fraser, *Unruly Practices: Power, Discourse and Gender in Contemporary Theory* (Minneapolis: University of Minnesota Press, 1989), pp. 113–43. For another examination of the social and theoretical effects of the differential exclusion of women from the public sphere in the bourgeois era, see Joan Landes, *Women and the Public Sphere in the Age of the French Revolution,* (Ithaca, NY: Cornell University Press, 1988).

32. See the essays in "The Black Public Sphere Collective," editor, *The Black Public Sphere* (Chicago: University of Chicago Press, 1995), esp. those by Houston Baker, Steven Gregory, Michael Hanchard, and Michael Dawson, which criticize various aspects of Habermas's concept of the public sphere in regard to race. See also the essays in Toni Morrison, ed., *Race-ing Justice, En-gendering Power: Essays on Anita Hill, Clarence Thomas and the Construction of Social Reality* (New York: Pantheon Books, 1992); Evelyn Brooks Higginbotham, *Righteous Discontent;* and Nancy Fraser, *Justice Interruptus,* (on Anita Hill, Clarence Thomas, and the black public sphere), pp. 99-120.

33. Craig Calhoun, *Critical Social Theory: Culture, History and the Challenge of Difference,* (Oxford: Basil Blackwell Press, 1995), p. 244.

34. Ibid., pp. 240–48, esp. 245; Fraser, *Justice Interruptus,* pp. 69–98, esp. pp. 80–81, and 89–93; *Unruly Practices,* p. 167.

35. For alternate publics, see Calhoun, p. 242; for nineteenth century women's groups, see *Fraser, Justice Interruptus,* p. 74. See also Mary P. Ryan, *Women in Public: Between Banners and Ballots, 1825-1880,* (Baltimore: Johns Hopkins University Press, 1990),

and her "Gender and Public Access: Women's Politics in Nineteenth Century America," in *Habermas and the Public Sphere;* Evelyn Brooks Higginbotham, *Righteous Discontent;* and Geoff Eley, "Nations, Publics, and Political Cultures: Placing Habermas in the Nineteenth Century," in *Habermas and the Public Sphere.*

36. Habermas's Enlightenment project fails to account for the complexities of identity formation that he relegates to the private sphere (Calhoun, *Critical Social Theory,* pp. 244–45). A postmodern, or even a sociological conception of identity, versus an Enlightenment concept where identities are stable and uniformly evolve to structure the development of the person over space and time, would help underscore the inter-penetration of public/private spheres in constructing the conditions of identity for-mation. See Stuart Hall on these three types of identity (Enlightenment, sociological, and postmodern), in *Modernity and Its Futures,* edited by Stuart Hall, David Held and Tony McGrew (Oxford: Polity Press), pp. 275–80.

37. I am not arguing against what Martin J. Beck Matustik calls Kierkegaard's "performa-tive holism" in his *Specters of Liberation: Great Refusals in the New World Order* (Albany, NY: SUNY Press, 1998) p. 30. By referring to a leap of discursive imagination by Foucault to overcome the Kierkegaardian either/or, I mark the ironical, even para-doxical, reinscription of Kierkegaard in the text (leap of faith); one must go through Kierkegaard to overcome elements of his thought.

38. However, for Rorty's argument that Foucault exhibited the traits of *Geistgeschichte,* "the sort of intellectual history that has a moral," in Foucault's *The Order of Things,* see the third volume of Rorty's philosophical papers, *Truth and Progress: Philosophical Papers, Volume 3* (Cambridge, England: Cambridge University Press, 1998), pp.271–72.

39. Hall et al., *Modernity and Its Futures,* pp. 292–93.

40. Michele Barrett, *The Politics of Truth: From Marx to Foucault* (Stanford: Stanford University Press, 1991), p. 126.

41. Not a substitute, however. For more on this distinction, see Barrett, *The Politics of Truth,* pp. 123-24.

42. It is important, however, to acknowledge that Marx never used the term "false con-sciousness" (Engels did in a letter to Franz Mehring in 1893, long after Marx's death). See Barrett, *The Politics of Truth,* pp. 5–17.

43. Michel Foucault, "Truth and Power," in *The Foucault Reader* (New York: Pantheon, 1984), p. 60. See Barrett's exploration of Foucault's take on the distinctions between ideology and discourse, *The Politics of Truth,* p. 123–56.

44. Stuart Hall in *Stuart Hall: Critical Dialogues in Cultural Studies* edited by David Morley and Kuan-Hsing Chen (New York: Routledge, 1996), pp. 135–36. Also, in the same volume, John Fiske sees Hall's suspicion of Foucault as "uncharacteristic" (p. 217). Hall concedes, in the interview (with Larry Grossberg) cited above that Foucault's objection to ideology, and his advocacy of discourse, may be more "polemical" than "analytical" (p. 135).

45. For an interesting application of Foucaultian theory—especially notions of "author-function" and "empirico-transcendental doublet"—to King's rhetoric and the civil rights movement, see Richard King, *Civil Rights and the Idea of Freedom* (New York: Oxford University Press, 1992), pp. 111 and 121. However, Richard King also suggests the limited use of domination theories [advanced by Frankfurt School theorists (Theodor Adorno, Max Horkheimer, and Herbert Marcuse) and Foucault], and the concept of hegemony articulated by Antonio Gramsci, in helping to explain the com-plex functions and achievements of the civil rights movement (p. 203).

46. Michael Eric Dyson, *Making Malcolm: The Myth and Meaning of Malcolm X* (New York: Oxford University Press, 1995), p. 85.

47. Dyson, *Making Malcom,* pp. 89–90.

48. Ibid., p. 90.

49. Ibid., p. 89-90.

50. For a rigorous, broadly stimulating and provocative psychoanalytic-Marxist reading of Malcolm X that draws on the insights of Marx and Freud, see Victor Wolfenstein's *Victims of Democracy: Malcolm X and the Black Revolution* (London: Free Association Books, 1989).

51. Despite the lack of Marx's "authorship," the notion of false consciousness may work in the effort to explain Malcolm (or at least his self-conception) because, unlike Foucault, he believed that there was a truth from which one could depart, thus marking error as the distance between false practice and truth. However, Foucaultian discussions of discursive regimes of truth remain salient in discussing Malcolm and the Nation of Islam, since the dispersion of powers over the field of discursive practices constituted within the Nation's social and moral order can be explained by understanding how white supremacist forces and political powers prohibited the articulation of black self-determination within the logic of the state apparatus. In short, certain ideas were made reasonable (white domination) by being rendered normative. Moreover, the power of white supremacist thought to veil itself—to make its operations discrete, and hence, unquestioned—in the logic of the political status quo and underwritten by the rhetoric of democracy, was formidable indeed. In such a light, the very idea of black self-determination—or for that matter, black intelligence, rationality, and humanity—were ruled out of play, or in Foucaultian terms, were suppressed from emergence within the discursive parameters of American nationalism. Still, as Stuart Hall argues, the discursive, at crucial points, bears remarkable analytical resemblance to the ideological. As I stated above, Hall acknowledges that Foucault's strike against ideology might have been more polemical than analytical. In any case, dimensions of both Foucaultian and Marxist theories, offer insight into Malcolm's rhetorical and social practices. For the Marxist take on Malcolm's ideological battles with white supremacy as a false consciousness, see Wolfenstein, *Victims of Democracy.*

52. Initially, King was much less ambitious about the sort of radical social transformation he envisioned near the end of his life, when he began to argue for a revolution of values and a more aggressive approach to social change. For a fascinating study of how major news magazines (*Time, Newsweek,* and *U.S. News and World Report*) changed their coverage of King as he grew more radical, and their coverage grew more critical, see Richard Lentz's *Symbols, the News Magazines, and Martin Luther King* (Louisiana State University Press, 1990).

53. I discuss this in greater detail in *Reflecting Black: African-American Cultural Criticism* (Minneapolis: University of Minnesota Press, 1993), pp. 221–46; 304–8.

54. I am not suggesting that rhetoric alone, without concrete social practice, achieved the ends King and his cohorts sought. I am merely suggesting the materiality of discourse, that is, that it carries weight, and that it can lead to profound social transformation.

55. See Mae Henderson's remarkable essay, "Speaking in Tongues: Dialogics, Dialectics, and the Black Woman Writer's Literary Tradition," in *Feminists Theorize the Political,* edited by Judith Butler and Joan W. Scott (New York: Routledge, 1992), pp. 144-166, which argues the difference between glossolalia—the capacity to "utter the mysteries of the spirit," and is, thereby, speech that is "private, non-mediated, nondifferentiated univocality"—and heteroglossia, which signifies "public, differentiated, social, mediated, dialogic discourse." Heteroglossia is the "ability to speak in diverse known tongues" (p. 149). Such a notion, I believe, marks the polyvocal, multiarticulative character of black rhetorical practices, and suggests the seminal, constructed publicity within which black sacred speech can signify.

L A W

6

GETTING RELIGION

Janet R. Jakobsen and Ann Pellegrini

WE WONDER ABOUT "RELIGION" *and what it might mean to "get religion" in any number of ways. We certainly (at one time in our lives, at least) got religion, and we sometimes wonder if the resistance on the part of some left intellectuals to getting religion isn't based on a desire to distance oneself from those early experiences of "getting it." We also wonder about religion in the ever popular "public sphere." Why, for example, do homosexuals "get it" so often—from religion, that is—but also the topic of this essay is to ask why do homosexuals "get it"—religion, that is—from that most secular of institutions, the Supreme Court? Why are the terms in which the Court establishes the regulation of sexuality so often religious, so that when it comes to homosexuals, at least, what the court seems to be handing out is not justice but religion? Finally, we also wonder about the implications of "getting it" for scholars of cultural studies or the intellectual left (a group within which we would include ourselves).[1] What would it mean if they/we did "get it"? This question is a complicated one (rather than simply referring to a lacunae in the scholarship that can be easily filled in). What the attempt to simply take up the study of religion fails to ask is, what does it mean to take on religion as an "object" of cultural study? This is not the same question as, "What is religion?"*

In a footnote to the article in which Fredric Jameson refers to cultural studies as a "desire," he expresses a desire of his own, a desire for religion, for its analysis and apparently for its representation. He does so through the invocation of none other than Cornel West. Jameson writes, "But it is important to stress, as Cornel West does, that religion (and in particular fundamentalism) is a very large and basic component of American mass culture and in

addition that it is here decidedly underanalyzed and underrepresented".
(1995, 295, fn 12). Fundamentalism here appears as the exemplary instance
of American religion and in its parenthetical reference as that which is set off
from the American public (and hence most in need of explanation by the
scholar).[2] Because we're concerned that the contemporary focus on something
called the "religious right" is not politically sufficient, we've wanted to ques-
tion both the wish and the containment captured by the parenthetical brack-
eting of "fundamentalism": What does it leave in place? Unexamined?
Unmarked? Thus, we turned not to religion per se and especially not to fun-
damentalism so called, but rather to the secular (and in particular the liberal
middle), and we "got religion."

We are arguing for the diacritical relation between the "religious" and the
"secular." This suggestion—that the religious and the secular are mutually
constituting, acquiring their definition and meaning in relation to each
other—will not be very controversial.[3] However, we also contend that "reli-
gious/secular" is a distinction without a difference, or, to put it another
way, a distinction that covers over the difference "Christian/non-
Christian." But not because, or not simply because, in the American con-
text (official claims to religious pluralism or Judaeo-Christian values
notwithstanding) the religious and the Christian may be flashed as signs of
one another.[4] But also because the secular as such is always already mod-
eled in the particular image of the Christian, or at least of a particular
strain of the Christian, reformed post-Enlightenment Protestantism. The
difference "religious/secular" cannot simply be mapped onto the difference
"Christian/non-Christian." As we will see, the secular sometimes changes
places with reformed Protestantism.

INTERVENTION 1

The reason the secularization story is crucial for our concerns here is that it is
often told specifically in terms of "freedom," freedom from the church and
freedom also in relation to the market, where, for example, John Guillory
(1993) argues (and he's careful in his choice of language here) the market pro-
vided a site of interaction between producers and consumers that "felt like"
freedom from ecclesiastical authority. The invention of the secular in relation
to the religious is specifically about instituting the market (as freedom).
Weber, however, in The Protestant Ethic and the Spirit of Capitalism *tells a*

story that could line up with Guillory's, but which is different than the common progressive secularization story, by reminding us that Reformation preceded enlightenment, instituting a form of rationalization that was to Weber decidedly irrational and yet extremely effective as a means of disciplining the body to work with and in the particular (ir)rationality of the market. This form of regulation, "this-worldly asceticism," takes place in order to demonstrate freedom in the other world of salvation, and it takes place as a discourse of "freedom" from the church. Thus, Weber is concerned that we recognize the specific and extensive disciplines that were instituted under the name of "freedom" from the church.

> *[I]t is necessary to note, what has often been forgotten, that the Reformation meant not the elimination of the Church's control over everyday life, but rather the substitution of a new form of control for the previous one. It meant the repudiation of a control which was very lax, at that time scarcely perceptible in practice and hardly more than formal, in favour of a regulation of the whole conduct which, penetrating to all departments of private and public life, was infinitely burdensome and earnestly enforced. (1930, 36)*

These disciplines are those that Foucault has identified as peculiar to modernity and, thus, in these post-Foucaultian times we might call market freedom a technology of body regulation. It may "feel" like freedom, and it becomes so naturalized as part of the market that it becomes unnoticed, both as restraint and as specifically "reformed" Protestant.

Out of this "irrational" rationalization comes the rationality of the enlightenment as secular, and the intertwining of the secular and the religious is forgotten, but not lost, meaning that it can still be operative. The secular is even at its moment of institution not necessarily "free" from the religious. If the modern disciplines, or in Weber's terms, "regulations," of the body are the site of religious authority, or even more strongly in Weber's terms, of "church control," then the new(ly secular) state in enforcing body regulation is also maintaining religious authority. Body regulation is, thus, the site of connection between reformation in religion and the formation of the secular state. It is not a coincidence, then, that Chief Justice Warren Burger makes the following connections, "During the English Reformation when powers of the ecclesiastical courts were transferred to the King's Courts, the first English statute criminalizing sodomy was passed" (Hardwick 196–7). We'll come back to Burger's snapshot of the history of sodomy later.

As a way to expose how particular Christian claims undergird applications of the secular, we want to turn to two Supreme Court cases that involve the regulation of the body, *Bowers v. Hardwick* (1986) and *Romer v. Evans* (1996). It is important to recognize the Supreme Court as the idealized representation of secularism, the site of the separation of church and state, the site, indeed, whereby that separation is performatively produced.

Both *Hardwick* and *Romer* bear on the subject of homosexuality and, to the extent that heterosexuality is constituted in relation to homosexuality, bear also on the subject of heterosexuality. Of course, one important difference is that the privileged term, "heterosexuality," not unlike this other privileged term, "Christianity," works best when it does not proclaim itself too openly.[5]

INTERVENTION 2

Thus, we hope to investigate two important points in looking at the Supreme Court as the site of secularism—1) the moments at which religion makes an appearance at this most secular of sites; and 2) the ways in which even where it doesn't explicitly appear, but takes the form of (reformed) Protestant body regulation, it remains (shall we say) active.

Issued ten years apart, the dispensations in *Hardwick* and *Romer* could not be more different—or so it seems. *Hardwick* upheld the constitutionality of Georgia's sodomy statute as applied to "consensual homosexual sodomy" only, remanding the matter of heterosexual sodomy to a footnote. Writing for the majority, Justice White pronounced the disavowal: "We express no opinion on the constitutionality of the Georgia statutes as applied to other acts of sodomy" (*Hardwick* 188n2). Coming immediately after he has just written, still in the same footnote, the words "consensual homosexual sodomy," we are left to fill in the blank for those other acts of sodomy Justice White will not or cannot utter in the open: heterosexual.

This silence was not an innocent one. A 1968 amendment to Georgia's sodomy statute made the prohibition on sodomy facially neutral for the first time: "A person commits the offense of sodomy when he performs or submits to any act involving the sex organs of one person and the mouth or anus of the other...." (qtd. 188n1[a]). The statute is an equal opportunity prohibition.

By contrast, *Romer* struck down Colorado's Amendment 2, deeming that law, which was passed by Colorado voters in 1992, an unconstitution-

al abridgment of equal protection. Though never enforced, Amendment 2 would have repealed local and statewide ordinances that prohibited discrimination on the basis of—and here we quote the all-bases-covered terms of Amendment 2—"homosexual, lesbian or bisexual orientation, conduct, practices or relationships." Further, it would have prohibited the passage of any future such ordinances. Writing for the majority, and joined by Justices Ginsburg, Souter, O'Connor, Stevens, and Breyer, Justice Kennedy deftly rejected the ruse by which antidiscrimination ordinances and equal rights protections were recast as "special rights":

> We cannot accept the view that Amendment 2's prohibition on specific legal protections does no more than deprive homosexuals of special rights. To the contrary, the amendment imposes a special disability upon those persons alone. Homosexuals are forbidden the safeguards that others enjoy or may seek without constraint. . . . We find nothing special in the protections Amendment 2 withholds. These are protections taken for granted by most people either because they already have them or do not need them. (*Romer*, 1626-27)

Kennedy concluded his opinion by holding that "Amendment 2 classifies homosexuals not to further a proper legislative end but to make them unequal to *everyone else*" (emphasis added; 1629)—and everyone else he does not name, but we can infer, again, as heterosexual.

The majority opinion is thunderously silent on the case of *Hardwick*, which is nowhere mentioned in the ruling, thus sustaining the state's ability to regulate bodies in their sexual acts.[6] This is a silence Scalia will exploit in his scathing dissent, to which Chief Justice Rehnquist and Justice Thomas signed their names. In that dissent, he points out the striking non-appearance of *Hardwick* and implicitly reconfirms the constitutionality of proscribing homosexual sodomy. He imputes homosexuality as a matter of conduct, and so reduces bodies to their sexual acts and discriminates which citizen bodies constitute the "public at large" (as he writes) and which do not.

INTERVENTION 3

We want to look at the work that the "public at large" does for Scalia here, because it is precisely the construction of a supposedly secular and middle (not right-wing), in fact, "tolerant" place. To quote Scalia, the problem with

homosexuals is that "Quite understandably, they devote [their disproportion-
ate] political power to achieving not merely a grudging social toleration, but
full social acceptance, of homosexuality." Importantly, Scalia establishes the
disproportionate nature of this power through a series of anti-semitic images
right out of the "Protocols of the Elders of Zion," effecting a substitution (in
no way an innocent one and not a recent twinning) of homosexual for Jew. He
writes, "Because those who engage in homosexual conduct tend to reside in
disproportionate numbers in certain communities [spatial concentration],
have high disposable income [concentration and accumulation of capital]
and of course care about homosexual-rights issues more than the public at
large [exclusive or self-interested], *they possess political power greater than*
their numbers [political will out of majority control]" (1634). *Most obvi-*
ously, this "public at large" is built through the assumption, or perhaps we
should say supersession, of a Christianity both invoked and unnamed in
Scalia's images. Just as importantly, what homosexuals should be allowed is
the "toleration" so frequently offered by the liberal middle. This is not a right-
wing point.

In fact, Scalia is concerned only for this middle and their "sexual mores,"
calling Amendment 2 "a modest attempt by seemingly tolerant Coloradans to
preserve traditional sexual mores against the efforts of a politically powerful
minority to revise those mores through law." This concern for "values" is part
of the process of the invention of religion in relation to the secular at the turn
to modernity.[7] Over the course of the development of modernity, reason is
(re)invented in relation to religion to replace the God-term, and religion now
operates within the "limits of reason alone." This ordering of the terms is not
merely a reversal but a (re)invention of each term in relation to the other, a
relation that is both oppositional and homologous. Even as reason is defined
in contradistinction to religion, religion establishes the parameters to which
reason must aspire. Reason was, and had to be, universal, in both its opposi-
tion and its homology with religion, while religion in its homology with rea-
son was invented as the universal category underlying Christianity and itself
based on an assent to a set of reasonable principles. Morality thus becomes the
primary articulation of the religious in modernity, of religion as reason.

It is hard to resist the notion that the anti-Semitic recoding of homosexu-
ality is where Scalia was heading all along. He asserts in the first line of his
dissent "The Court has mistaken a Kulturkampf for a fit of spite" (1629).
Among other things, this suggests that the twinning of "the Jew" and "the

homosexual" in Scalia's dissent is not an incidental feature of his logic, but one of its structuring conditions.

Scalia makes a case for the eminent reasonableness of anti-gay discrimination.[8] Against the majority's implicit appeals to an American tradition of tolerance, Scalia conserves the American-ness of opposition to homosexuality: "The Court's opinion contains grim, disapproving hints that Coloradans have been guilty of 'animus' or 'animosity' toward homosexuality, as though that has been established as Unamerican" (1633). Unlike the majority opinion, which skirts the sodomitical territory of *Bowers v. Hardwick*, Scalia draws on *Hardwick* to reassert while overriding a status/conduct distinction. He takes for granted "our moral heritage that one should not hate any human being or class of human beings" (1633).

INTERVENTION 4

Thus, it is important to note that this entire discourse takes place under the terms of tolerance, not hate. The claiming of tolerances contributes to the construction of a "center" where people can experience themselves as "not hating anyone" and still vote for legislation that belies the proclamation.

"Our moral heritage" notwithstanding, Scalia goes on to list "certain conduct" one can reasonably consider "reprehensible": "murder, for example, or polygamy, or cruelty to animals," concluding that "one [that impersonal disembodied one] could exhibit even 'animus' toward such conduct" (1633). And it is this and only this—"animus"—that he claims Amendment 2 does.[9]

This is a familiar story: Love the sinner but hate the sin.[10] If "love the sinner, hate the sin" smacks of Catholic theological dispositions, better to say it is catholic with a lowercase "c," in that it admits the universalizing move by which non-Christians might be invited to leave minority status behind and disappear into the majority's ranks. The bribe is that they acquiesce to the only barely suppressed Christian assumptions and norms that sustain by constituting the distinction (that isn't one) religious/secular.

Although *Romer* is certainly a victory for gay rights, it is a limited one. The majority's silence on the matter of *Hardwick* leaves the status/conduct distinction operational. Thus, the specific mode of the assertion of values through body regulation stands in that heavy silence.

Let's turn back to the moral arguments supplied by Justices White and Burger in *Hardwick* against any constitutional protection for consen-

sual homosexual sodomy. We are interested in tracing their appeal to the "obviousness" of tradition, which, for White and Burger at least, requires no further argument. This is what Althusser might call the "obviousnesses [of] the obvious" ("Ideology," 171–72). In their race through Western history, both justices draw on the "ancient roots" (White's term) of proscriptions against homosexual sodomy, arguing on that basis for the continuing moral claims against such conduct. Thus, White moves from "ancient roots" to laws of the original thirteen states to there being "no cognizable roots in the language or design of the Constitution for homosexual sodomy as a fundamental liberty" (194). Against the backdrop of White's continuous history, to assert that "a right to engage in such conduct is deeply rooted in this Nation's history and tradition is, at best, facetious" (194).

Though White never names the particular moral values assumed by his interpretation of this "Nation's history and tradition," the continuous record he poses is one shaped by and through Christian theological responses to sodomy (though, unlike White, Christian theological treatments of sodomy are not unfazed by the spectre of heterosexual sodomy). However, if White will not fully name or cite the "notions of morality" that inform and shape the law (and which the dissenting justices actually call him to do), he yet thinks the moral claims of law a reason sufficient unto itself: "The law, however, is constantly based on notions of morality" [Read: religion], and if all laws representing essentially moral choices are to be invalidated under the Due Process Clause, the courts will be very busy indeed" (196).

If Justice White is so fully under the thrall of the obvious that he does not stop to mention by name just whose "moral notions" and whose "essentially moral" choices the law represents and which he, in the name of the law, sustains, Justice Burger, in a concurring opinion, cuts to the chase. In his thumbnail sketch of sodomy and Western civilization, he writes:

> As the Court notes . . . the proscriptions against sodomy have very "ancient roots." Decisions of individuals relating to homosexual conduct have been subject to state intervention throughout the history of Western Civilization. Condemnation of those practices is firmly rooted in Judaeo-Christian moral and ethical standards. Homosexual sodomy was a capital crime under Roman law. (196–97)

Was it for this that ancient Greek and Latin texts have been canonized, have been deemed classics, so that we moderns may all the more thoroughly forget their very different moral compass and misrecognize the ancients for ourselves?

And on and on through the English Reformation and the first "secular" statute condemning sodomy until he approaches the Georgia Legislature's first enactment of a law against sodomy in 1816, a statute which, he writes, "has been continuously in force in one form or another since that time" (197). From here, for Burger, it is but a day to 1986 and the up-holding of that statute. However, Burger's condensed history—"in one form or another"—writes over Georgia's 1968 revision of the sodomy law, which made the prohibition facially neutral and applied it equally to homosexual and heterosexual sodomy. This is a facial neutrality against which the majority turns the other cheek.

Despite Burger's invocation of "Judeao-Christian moral and ethical standards," we should not mistake the hyphen for inclusion or some sign of religious pluralism. Rather, the hyphen condenses the story of Judaism's supersession by Christianity and passes off a wished-for assimilation of difference into the one as an instance of religious pluralism.

INTERVENTION 5

Of course, Judaism is not silent on this question, and complex relations are invoked in the term "Judaeo-Christian," but Burger is in fact stunningly silent on the issue of Jewish Law, citing a book entitled Homosexuality and the Western Christian Tradition *as the source of the "ancient roots" of this "tradition." Thus, he implies (all too familiarly) that Judaism is simply the "ancient roots" of a dominant Christian "tradition."*

If to be "traditionally" American is to be Christian in a certain way, then non-Christians, or even those who are Christian in another way, will always be "minorities" that can only be "tolerated" within the "larger" American public. Moreover, members of "religious minorities" are American only insofar as they agree with dominant American, i.e., Christian, "values." So the points of similarity or overlap in values, not the differences, among traditions become the publicly acceptable articulation of all "religions." These claims also pose the secular as the site of the intersection between "religion" and "values" such that any alternative configurations of these relationships—values, for example, that are not necessarily "Christian"—are erased, thus allowing

references to values that are effectively marked as religious and Christian without the need to name them directly as such. This move is at once univer-salizing and specifying, or more accurately it enacts the universalization of a specific set of values, such that all values that travel under other names can be conflated with Christian values or those that cannot be so condensed are sim-ply placed outside the realm of recognizable values. They simply are not val-ues. So, for example, Katie Cannon (1988) argues that Black womanist ethics, despite being in Cannon's case expressly theological, are often not recognized as moral, are labeled immoral or amoral, precisely because they are in resis-tance to capitalism, rather than enacting the dominant U.S. Protestant ethic that supports capitalist endeavor. In other words, even Protestant Christian values if not in line with the secular-market version of Christianity are unrec-ognizable as values.

To be sure, the dissenting justices in *Hardwick*—Blackmun, Brennan, Marshall, and Stevens—explicitly criticize the sectarian claims of Burger. Offering a spirited defense of secular values, the values of the secular, Blackmun argues: "The legitimacy of secular legislation depends instead on whether the State can advance some justification for its law beyond its conformity to religious doctrine" (211). Along the way, however, Blackmun seems to draw the secular in religion's image and to redraw, this time with positive feeling, sexual values into religious values by imputing sexuality as one site for the expression of "man's spiritual nature, of his feelings and of his intellect" (207).

INTERVENTION 6

Even as the religious once again reappears in the assertion of the secular, the particular means by which Blackmun makes this assertion, declaring the need of "secular law" for "some justification beyond its conformity to religious doc-trine" (note: the conformity remains) is precisely the progress narrative of the enlightenment in which reason both depends upon and supposedly moves beyond religion. This site of the true beyond, we have argued, is the site of the market-reformed-Protestantism. Secularization configured in this way is "progress"—the more secular, the more rational, the more enlightened/eman-cipatory/progressive.[11] We (left, progressive, cultural studies scholars) have all, over the last few decades, been well schooled in questions about the progress narrative of the enlightenment and yet it has also been extremely difficult to

give up, particularly given that both the contemporary university and left (progressive?) social movements are in some sense products of this narrative. Moreover, there has been, at least from left/progressive sites, much less questioning of the secularization narrative, in part, because the secular is seen as a bulwark against the irrational regressive aspects of religion. When you're facing something depicted as "the Christian right" as the primary danger, secularism can look pretty good. So, part of our concern here is to question whether this depiction of the contemporary situation, a depiction that focuses on the right rather than, say, the middle, is the most politically useful. When "we" place ourselves on the side of reason, we must remember that so does the middle, Scalia's "public at large," which has at best "grudging social toleration" to offer, a toleration that is all the more insidious because it claims not to be the "hate" of the right wing. But in fact "tolerance" more effectively undergirds body regulation than does "hate."

"The Court has mistaken a Kulturkampf for a fit of spite."

INTERVENTION 7

So, if the secular is not a safe space, free from religion, free from "getting it," what are, as a friend of ours once said, "nice post-Christian homosexual girls" like us supposed to do? To answer this question we must also ask: Why would cultural studies both desire a theory of religion and yet have trouble getting it? We read this refusal as not simply a knee-jerk reaction, but instead as something better termed symptomatic (and what else could desires relegated to footnotes be?). The persistence of this refusal despite admonitions like Jameson's indicates that there is something more going on, that the refusal is somehow motivated, not just by prejudice (prejudging, knowing always already what one is going to find when one "studies" religion) but by something deeper. We would suggest that this something deeper is about the status of knowledge and "study," including cultural study, itself. The only means of getting a more complicated picture of what is happening in the contemporary practice and invocation of religion is to challenge the interwoven terms of the modernization and secularization story, but to do so is to challenge the very basis of knowledge production. Thus, the study of "religion," if undertaken in this complex manner, can tell us something about the current political situation and the role of body regulation, as we have suggested through our readings of the Supreme Court. But it also has broader implica-

tions that point toward the possibility of refiguring the relations of knowledge production, refiguring them not because religion is somehow different than reason, but because religion and reason participate in the same regime of knowledge and power. Thus, "getting religion" opens up a set of problems, not easily solved but important to name because of their wide ranging implications for study, for the possibility of articulating values that are not (always already) circumscribed by the market, and for progressive social movement. Getting (or giving) the more complex story of "religion" offers an opening through the impasse sensed in a number of disciplines that without enlightenment narratives values are simply unavailable, and the choices are to (re)turn to modern values out of necessity, turn to a politics of realism or resentment, or turn to a religion that supposedly counters modernity. Getting religion creates an opening not because somehow turning from reason to religion solves the problem, but because religion is the unnamed part of the story that sets up the impasse.

Our admonition that cultural studies scholars need to stop refusing to get religion (and note, we can only recommend this as a double negation: stop refusing) goes hand in hand with this other wish: That, where cultural studies and its practitioners are concerned, getting religion might itself take the form of a refusal, a refusal of the ways in which knowledge continues to be conducted and the ways in which particular constellations of knowledge/power continue to conduct us.

NOTES

1. By "left intellectuals" we mean that loose concatenation of those who might identify their scholarship with Marxian analysis and social movement, but also with those so-called "new" social movements—feminist, antiracist, queer, etc.—that have played a large role in post-war politics. These sites are also sometimes gathered under the rubric of "progressive" social movements, a name that we sometimes invoke because it can connect Marxist and new social movements more accurately than does the term "left"; and yet just what it might mean to name something "progressive"—given the tie between the progress and secularization narratives of the enlightenment—is one of our central questions. Insofar as cultural studies can be said to have a politics and given its genealogy when traced to the Birmingham school, it can be seen as tied to this same loose concatenation. While our own political and intellectual commitments may be overlapping here and while "cultural studies" as a field may have emerged from the "culture and society" moment in which post-war Marxists tried to recognize the import of working-class cultural activity as well as social structure, we also recognize that not all those who currently take up studies of the cultural have such political ends in mind.

2. In one sense "fundamentalism" is a perfect container for this ambivalent desire because it allows for a focus on religion, but a religion that remains "other" to the scholar. We're concerned that invoking this container for the ambivalence feeds a focus on the "right" that is not politically effective.

3. This is an argument Janet E. Halley makes for the classifications "homosexual" and "heterosexual" ("Construction," 83). Her analysis of the classificatory scheme at work in *Hardwick* has been influential for the argument we are unfolding here.

4. Janey E. Halley has suggested that the "homosexuality is like race" arguments made by some gay rights advocates have enabled, as if on the other side, the opponents of affirmative action to "flash homosexual and black as signs of one another," and so discredit both equal rights for homosexuals and civil rights for blacks and other racial minorities as "special rights" (English Institute Talk).

5. See Halley, "Construction"; Sedgwick, *Epistemology*; Halperin, *Saint Foucault.*

6. Janet E. Halley suggests that the majority in *Romer* "could not have uttered this silence [around *Hardwick*] if they thought that the constitutionality of criminal statutes proscribing homosexual sodomy *a fortiori* produces the constitutionality of every species of anti-gay discrimination" ("Status/Conduct Distinction," 221).

7. For more on the "invention of religion" see Baird (forthcoming).

8. He then uses this distinction to differentiate between giving favored status to people who are homosexual (which he says Amendment 2 would still permit) and giving them this favored status because of homosexual "conduct." The people who are homosexual might be favored insofar as they also happen to be people who are "senior citizens or members of racial minorities" (1633). Out of the list of attributes Amendment 2 named—"orientation, conduct, practices, and relationship"—Scalia has singled out conduct. He even seems to construe the political activity of "those who engage in homosexual conduct" as itself a form of "homosexual, lesbian [and] bisexual . . . conduct."

9. Is "animus" the "fit of spite" he says the majority has mistaken for a Kulturkampf? Consider the odd inversion and, then, substitutions of Scalia's rhetoric. We might have expected him to write that the Court has mistaken a fit of spite for a Kulturkampf, not the other way around. But not only does he deny that Amendment 2 represents "animus," but he also wants to shift the agents of *Kulturkampf* from the presumptively heterosexual electoral majority who approved Amendment 2 to homosexuals—and their allies on the Court. By Scalia's own reasoning, the Kulturkampf is one performed by homosexuals whose single-minded pursuit of homosexual rights, a pursuit that does not stop at achieving "grudging social toleration," but aims at nothing short of "full social acceptance (1634)." The majority writing in *Romer* gets aligned with this homosexual "minority," which seeks to impose its will on the "public-at-large." Thus Scalia: "This court has not business imposing upon all Americans the resolution favored by the elite class from which the members of this institution are selected" (1634).

10. However, given all the work categorizing conduct can do to distinguish nonhomosexuals from homosexuals, is homosexual conduct ever only a matter of acts? Isn't it also a way to constitute through silent exclusion a class of nonhomosexuals AKA "heterosexuals"?

11. Religion here becomes configured as both irrational and regressive; thus, if religion "reappears," as theories of the contemporary "resurgence of religion" claim it has over the past few decades, this is a sign of regression.

WORKS CITED

Althusser, Louis. "Ideology and Ideological State Apparatuses." *Lenin and Philosophy and Other Essays by Louis Althusser*. Trans. Ben Brewster, 127–86. New York: Monthly Review Press, 1971.

Baird, Robert. *The Invention of Religion*. Princeton: Princeton University Press, forthcoming.

Cannon, Katie Geneva. *Black Womanist Ethics*. Atlanta: Scholars Press, 1988.

Guillory, John. *Cultural Capital: The Problem of Literary Canon Formation*. Chicago: University of Chicago Press, 1993.

Halley, Janet E. Paper presented at the English Institute, Harvard University, Cambridge, MA. September 27, 1997.

_____. "The Construction of Heterosexuality." *Fear of a Queer Planet: Queer Politics and Social Theory*, ed. Michael Warner, 82–102. Minneapolis: University of Minnesota Press, 1993.

_____. "The Status/Conduct Distinction in the 1993 Revisions to Military Anti-Gay Policy." *GLQ* 3:2–3: 159–252.

Halperin, David M. *Saint Foucault: Towards a Gay Hagiography*. Oxford: Oxford University Press, 1995.

Hardwick, Bowers v. 478 U.S. 186 (1986).

Jameson, Fredric. "On Cultural Studies." *The Identity in Question*, ed. John Rajchman, 251–95. New York: Routledge.

Romer, Evans v. 116 S. Ct. 1620 (1996).

Sedgwick, Eve Kosofsky. *Epistemology of the Closet*. Berkeley: University of California Press, 1990.

Weber, Max. *The Protestant Ethic and the Spirit of Capitalism*, trans. Talcott Parsons. New York: Scribners, 1930.

7

LOSING FAITH IN THE SECULAR AND THE CULTURE OF INTERNATIONAL GOVERNANCE

David Kennedy

T HINKING ABOUT WHAT'S HAPPENING on a really global scale, law is certainly back. After the Cold War gridlock and the Gulf War hype, the whole regime thing is hitting a crescendo. Now we see law in the slow knitting of interdependent markets, where we once saw only economics, and in the stable patterns of governmental consultation or the machinery of sanctions, enforcement, and compliance, where we once saw only politics. Business at the International Court of Justice is up, if modestly, while the World Trade Organization has taken international economic relations from the mercantile world of bargaining to a smorgasbord of legal dispute settlement schemes. The neoliberalism of institutional convergence, the rational discipline of mobile capital, the peace of ideological consensus, and the civilization of market are upon us. Law is their handmaiden and their witness.

But so is religion. The Pope-mobile is everywhere, French youngsters lining up for a blessing, Russia as religious as Arkansas, a missionary energy in the Third World rivaling the late nineteenth century, while here at home, Jesus is on the Internet, alongside cults and chatroom confessionals. Children kneeling outside their schoolrooms, huddled like smokers on coffee break, begging just one quick nondenominational prayer. And then, of course, there is Islam, increasingly the modern figure for religion. Or, we should say, all the Islams, from the Million Man March to the Taliban, from sleek Gulf financiers to the butchery of an Algerian village, from the conventional liberal humanism of the mainstream Arab-American community to the anguished modernism of once secular politicians in Egypt, Iraq, or Syria, learning new fealties and vocabularies. It is hard to get firm

numbers from the religious sociologists—-by last count it appeared there were 1,927,953,000 Christians—almost double the 1,099,634,000 Muslims and way ahead of the 225,137,000 "Chinese Folk Religionists."[1] In the United States, although Christianity is losing market share in a growing population to conversions—an annualized loss in the 1990s of 317,900 per Year—there is some evidence that the religious intensity of conviction has increased in many quarters. *Time* magazine tells us that 69% of Americans believe angels exist, for example.[2]

It is difficult to know how real either of these trends are on the ground—Is Russia more or less governed by a rule of law today than in 1980? How many Americans believed in angels in 1950? And it is equally difficult to get much of a sense for what we mean by "law" or "religion" when we say they have returned. Which parts of the disaggregated regime of social regularity blossoming across cultures should we think of as "legal"? Or for that matter, "religious." At the O'Hare airport bookshop, under "religion" we find the Bible, *Living Buddha, Living Christ, A Life of Jesus,* or *Jesus in Blue Jeans,* alongside *Foucault for Beginners,* Aristotle and Machiavelli and Norman Vincent Peale. Right next to *Storming Heaven's Gate* we find *Snowboarding to Nirvana.*

What interests me here is the return of law and religion to the consciousness of the secular establishment. For an intelligentsia always deferential to law and faith, but preferring the savvy of power politics and secular rationality, law and faith are all the rage. And it's not just the late Princess Diana or Mother Theresa. Here is Hollywood mogul (and Harvard grad) Marty Kaplan:

> I'm the last guy you'd figure would go spiritual on you. . . . If Harvard had made me a more spiritual person, it would have failed in its promise to socialize me to the values of the educated elite. Those values are secular. . . . The educated person knows that love is really about libido, that power is really about class, that judgment is really about politics, that religion is really about fantasy. . . . The spirituality of [meditation] ambushed me. . . . To be awakened to the miracle of existence—to experience. . . . The God I have found is common to Moses and Muhammad, to Buddha and Jesus. . . . I used to think of psychic phenomena as New Age flimflam. . . . I used to think the soul was a metaphor. Now I know there is a God.[3]

If this was one giant leap for a man, how large a step for the secular establishment? And what links these uncanny returns of law and religion? If reli-

gion is no longer fantasy, is judgment also no longer politics? Love no longer libido? My responsive slogan, and also my title, is this: "Losing Faith in the Secular, and the Culture of International Governance."

II

In the 1970s, when I studied international relations and political science, law was out; international law was a marginal and utopian wish to hard-headed realists with their strategic models and multilevel games. Law was just a hypothesis—while we thought we knew what a prisoner would do in a dilemma. But now it's all different—the study of "regimes" and "institutions," and now "governance" has taken political scientists interested in the international on a great looping trek toward law. Their journey coincides with a post-Cold War outbreak of enthusiasm for international law in the foreign policy establishment—the law of a "New World Order," the law of liberal democracies, the law of a global market. Numbers are hard to find, but it appears spending on "rule of law" injection projects around the world now rivals food aid, refugee assistance, humanitarian aid of all sorts—dwarfed only by military assistance. And even the military is pitching in. I spent some time in Senegal a year ago with a training team of military lawyers instructing the local officer corps on rules of warfare—the need for good discipline and clear rules of engagement merging, in a post-CNN world, into compliance with international humanitarian norms. And it's a big program, operating in more than sixty countries. Indeed, the U.S. military may now provide more training in international law and human rights than all the world's nongovernmental organizations put together.

At the same time, when I studied international law, the point was to demonstrate our savvy about power. Nothing abstract or utopian about it. We were interested only in how nations behaved, in the regularities of coexistence, and the modalities of cooperation. International law was technical and hardboiled. Although as lawyers we held back from the apostasy of conflating law with politics, for a century international lawyers had castigated the idolatry of naturalists and formalists in the name of reason and rationality and pragmatism, the law of international governance articulating its anticlerical cosmopolitanism with the convert's zeal, reducing concern about ethics and community and value to the periodic lamentations of crackpots and Catholics. Not so today. The study of human rights and democracy and the commonplaces of "liberal" societies has taken

international law on a goose chase after the ethical. In the euphoria of post-1989 triumphalism, the discipline's focus on the ever receding horizon of pragmatism's contact with idealism has been radically foreshortened. Suddenly we are almost there—disaggregate the state, embrace the ragtag institutions of civil society, and reach for the good life.

III

So the secular intelligentsia has a new sensibility about both political science and law. Political science takes a shine to law just as law embraces the worlds *both* of ethics, values, faith *and* of politics. And this new sensibility has an emotional tone, a tone of bravura and risk. Suddenly it's no longer suspect to stand for something, even if it is still feels scary—go ahead say it, I know it feels risky, but let's do something bold, now, here, all together—let's admit it, we're liberals.

I'm thinking of middle-class men thronging the capital to affirm their faith in masculinity *and* family values, of loud-mouthed law professors bravely standing up for free speech, of internationalists loosed from the Cold War's coexistence constraints, standing together now for democracy and the peaceful tendencies of liberal states. As I read in all seriousness some time ago, and you may not know this, two nations with McDonald's arches have never gone to war with one another. Think about that.

There is a thrill here—not unlike Marty Kaplan's thrill in his new found faith. The thrill of return, of confession, of taking a little risk, a risk suddenly fashionable among all the multitudes gathered together to keep promises and affirm commitments. The little high of saying something together in a big crowd that still feels so unpopular—like that you support good government, think all men are created equal, believe in the spiritual, in humanism, in love, and why not, in the sacred, even in God. This is the thrill of coming out, and after all, why shouldn't straight people get to come out? Religion and law provide the titillation of identity for great mobs of identity wannabes whom deracination has left so haunted and empty and jealous. And it's also the cheap thrill of fashion—it's so cool now to have a close friend who's a practicing Catholic!

This thrill, this tiny rush of transgression, plays against the background of an ebbing faith, an ebbing faith in the secular. As religion has become a secular blasphemy, ethics has become a tempting little legal Lolita, at once fresh and formidable, while law plays Mrs. Robinson to the

political scientist, all wet behind the ears with newfangled college talk about regimes and compliance loops. Like those first teenage rebellions— clunky boots or sagging bellbottoms—praying the common prayer pays homage to the secular parental authorities, who not only tolerate, but yearn, pray, for just *this* rebellion.

In all the clamor for God and law we can feel, faintly, the slight weightlessness of a pendulum reversing its course. And in the disequilibrium and equipoise of that moment, we can look briefly back at the secular, at the relations between religion and law, or law and politics, against which the blasphemous pendulum turns. It's elementary, after all, that you can't come out once everyone already knows—coming out must place you just ahead of the curve, be written on a denial, or at least on plausible deniability.

I V

The lawyer's denial that law is political *or* ethical, apology *or* utopia, the political scientist's denial that politics is legal, and the secularist's denial that humanism is religious have all been equivocal denials at best. Sure, we know law is a secular project, just as we are all, all secular men and women. However prone legal scholars have been to deny the politics of law, to charge only communists and other no-good-niks with having claimed that law is political, they have also developed a range of admissions to go with their denial, places for politics, exceptions. constitutional moments, moments of private cynicism. However sure political science has been that only utopians (and lawyers) dreamed of the normative, there were also regimes and stable expectations and feedback loops of legitimation and compliance. Law and politics have been disciplinarily divided by a smoky mirror, the lawyer claiming to see in politics only subjective arbitrariness and ideology, the political scientist in international law only hapless dreaming. In such a situation of willful blindness, when one comes out, transgresses to the other discipline from either direction, one will find only what one has already had—a liberal realism, hardboiled and hopeful.

But what about religion? What religion might read as "sacred" and "profane," the secular intelligentsia has read as "secular" and "religious," alternate domains, social configurations, spheres of influence, separate but (once) equal. The intelligentsia has said religion is private where the law is public. Religion is what we had before we had law. Religion is the

domain of irrationality and charismatic authority, law the realm of rea-
son and the bureaucratic. International law understands its birth as a
flooding forth from the darkness of religious strife, antidote to the pas-
sions of faith, on guard against their re-emergence as ideology. Evil were
not empires—we have much to learn from Rome—but imperial ambi-
tions emboldened by religion, or ideology, straining against the leash of
an agnostic territorial limit—that's evil. Religion, like cliterodectomy,
was the sign of the inalienably different—which must be puzzled over
and suppressed and tolerated and denied and accepted and outgrown.
And religion marked not simply the crazy and the sane, passion and dis-
passion. As one international lawyer told me, "Religion is about what
happens after you die, and international law doesn't have anything to do
with it"—read, "we are worried about life, not death, too busy lighting a
single candle to contemplate the dark."

Still, even in the dark of the secular night, legal culture managed a
relationship with religion. Religion was to be respected, even honored, in
its own sphere—the domain of private commitment and spiritual mean-
ing. Law could also honor its roots in religion, from which it inherited the
"principles" and "values" of something as broad as the "Judeo-Christian"
tradition. Religion begins as a social force, is then transcended and cabined
by a new international plane of ecumenical insistence on the prince's pre-
rogatives, is transformed into a "philosophy," the naturalist antidote to an
emerging positivism, and survives in our pragmatic century as a set of
"principles" guiding the practice of institutions.

Religion, reconfigured as a "tradition," would often rise to its new role in
the secular establishment. I attended a conference in which the world's great
ethical traditions Christianity, Judaism, Islam, Confucianism, and (puzzling-
ly I thought) International Law were invited, alongside various strands of
"liberalism," to contribute to thinking about an appropriate regime to govern
territorial boundaries, personal mobility, and citizenship. As we went around
the room, it became clear that all the great traditions ended in consensus on
a clear utopian vision, remarkably consonant with enlightened Upper-West-
Side thinking—that utopia would roughly correspond to our current world,
shifted perhaps two or three inches to the left. Suitably domesticated, church-
es might well take over civic responsibilities, act as arm of the law, provide
social services. Religious organizations are prominent among the new NGOs
whose "civil society" has been scripted to counteract both illiberal, if often
elected, post-colonial governments and corrupt international bureaucracies.

And legal culture, in the old secular days, also knew a deeper truth about itself—that it had displaced religion, and would need to function as a religion—a civic religion, a secular faith. This could be high-minded—the constitutional pole star of a new covenant—or populist, even cynical—give the people courtroom spectacle, the savvy judge a strategic thinker, manager of a legitimation account always in danger of being overdrawn. If religion must be tamed to be deployed, law must also be careful to manage a faith that remains secular. And we find within law not only the narratives of religious redemption and delayed gratification—a substantive justice projected just in front of an interminable procedural present—but also a formidable machinery for purging the secular faith of the apostasy of sacrality. Chief Justice Bedjaoui of the World Court castigates us for "legal paganism."[4] "Formalism" has become an epithet. Our most dispassionate secular modernists denounce enduring faith in something called "sovereignty": Brierly notes "the confusion which the doctrine of sovereignty has introduced into international legal theory"[5]; Henkin insists that "[s]overeignty is a bad word...a substitute for thinking and precision[6]; Lillich proclaims, "the concept of sovereignty...is an idea whose time has come and gone."[7] Indeed, washed clean of its idolatrous stain, the law of international governance sees the sacred only at the margins, in the three horsemen of terrorism, fundamentalism, and nationalism.

V

Against so equivocal a denial, what does it mean to come out, come out for the politics of law, the law of politics, the ethics of both—for the religious in secular society? The thrill in political science as the pendulum turns back to law is less the revenge of a liberal spirit against the perversions of an insistent, if largely imaginary, realism than the titillation of evading even for a moment the censor of pragmatism, finally enunciating the pluralist commitments that have hitherto dared not speak their name. For the secularly faithful, to speak of norms, still less of ethics, was to wash out the rocks of universalism, agnosticism, and reason, upon which were built the latter-day edifice of political science and the priesthood of policy pragmatism. For a generation, it seemed that coming out as legal might disarm the liberal hegemony, just as coming out for the ethical would throw the game of cosmopolitan scientific neutrality, would make one just one more Cold

Warrior. Only a studied ethical neutrality could steel the will of democratic hegemonies to do what was necessary, could sustain the science of strategic studies, for fifty years the bulwark political science offered the West against the East. And now, if all the subtle communications of one hegemony to another across an ideological divide were normative all along, each assured about what the other's prisoner would do in just this dilemma, all that past could be redeemed as the work of a liberal spirit, which, we now know, makes commerce, not war. We were not playing with destroying the world, fiddling while Rome armed, we were hammering a new covenant, modeling a new language, enunciating a new law.

Meanwhile, an obverse story for law. For a generation international lawyers began their training by learning a thousand and one explanations why their discipline was "legal," why international law was "law," rather than politics or ethics, now that it had renounced both positivist form and naturalist value for an engaged pragmatic sensibility. Paradoxically, to have come out as politics would both throw the game to the totalitarians and sully one's neutral posture, the cosmopolitanism of coexistence. At the same time, to have come out as ethical would throw the race to the political scientists, foregoing a hard-fought realist savvy.

The thrill in contemporary returns to the ethical, in collective confessions of faith in the old liberal pieties, lies not in their surface rebellion against the devils of "political correctness," but in their escape from the censors of this secularism, from the high priests of antiformalist pragmatism and the anti-clerical routines of a committed cosmopolitan establishment. The thrill lies in their inversion of liberalism's own disciplines. Would it be too simple to observe that we can say law is politics now that politics has come out everywhere for the ethical, the normative, the liberal? Else who will be my role model, now that all the role models are gone? After 1989, flush with victory over an ideological foe onto whom all challenges to law's legality had been projected, we find international lawyers saying, chapter one, page one, that "law is politics."[8] Nothing else has changed: the thousand and one reasons for law's legality are still there, but now it can be said. And so also for political science—all the models and systems are still there, but now it can be said: the regime, my dear, is a legal one.

Ah, the new liberals: so brave, so risky, so risqué. But how dramatic is it to come out for the politics of law, or the law of regimes, when one dreams only of ideal speech situations, infinite time behind veils of igno-

rance, the endless dialogic consensus of a liberal procedural regime? It seems such cant to come out as Kant.

The puzzling thing is that all these things would seem risky were we still living with faith in the secular, in pragmatism and political realism. In the church of policy pragmatism, there is a Satan, waiting to be loosed by a slip of the tongue, and that devil is ideology, first cousin of religion. Law is not political—because politics is the primitive stuff of ideology, passion, unreason. Political science is not law for the same reason—because law is the temple of norms, beliefs, ideological commitments. And little would have so triggered the pragmatist inquisition than the pious incantation of a universal liberalism. How satisfying, then, now to be able to come out for a global politics, which eschews the ideological, for a cosmopolitan, global liberalism. Or for a global law purged of ideological commitment but committed to liberal virtue. After ideology, all the censors can relax. Including, it seems, the secular separation from religion. How bad can it be, after all, to come out as religious if one means simply that "family values" or "patriotism" or "ethics" are important? I mean, don't we all think that? Once the secular censors have relaxed, a little turn to religion provides a helpful divertissement.

VI

Today's turn to law and religion is thus more of a rotation, more an All-Saints'-Day role reversal than a transvaluation of values. Clausewitz said, "Is not War merely another kind of writing and language for political thoughts? It has certainly a grammar of its own, but its logic is not peculiar to itself."[9] Whether political scientists or lawyers, we are all Clausewitzians now, power a process of persuasion, the missile a missive. At the same time, our law has a religious sense and sensibility, a secret sentiment that powers are more than competencies, property more than a "bundle of rights," rights more than technically enforceable claims. Where there is law there is also mystery: judgment, doctrine, faith.

What work we ask of functionalism to say of this merely that law "functions" like a religion—why not say it, experience the thrill, law is a religion—and not just any religion. An Islamo-Judeo-Christian faith in the secular, sustained by a complex movement, isolating religion, purifying itself in a catechism of antiformalism, while returning over and over to the idols it has shattered. Of course, to come out strongly, publicly, proudly, when everyone

has long known you're out as not out, is less risk than regression. When lawyers admit their faith in rights, politicians their faith in law, law its roots and reverence for religion, it may be a goldie, but it is certainly an oldie.

VII

Why do they do it? Because realism has been the Cerberus of the political savvy. Forswear law all who would enter here, law's door opens only for the realist. Once within, the routines and rationalities of lowest cost avoiders, profit maximizers and self-interested sovereigns can be codified. Across the hall, liberal ecumenicalism stands guard at the door of law's empire, insisting on a penitent and persistent pluralism. All who pass murmur Yes, we have no religion. Once inside, secular cosmopolitans recognize one another in declarations of faith, in progress, in the international, in the pragmatic, and worship together in the routines of bureaucratic power. Everywhere there is culture but here, in the cosmopolis. Everywhere there is ideology, politics, passion, but not here, among the reasonable men and women of the enlightenment, graced with infinite time, reason, and the modesty of the truly powerful. But some days it's just not enough. Terror and nation and fundament, held firmly at bay, shame us, mock us—how long can we inhabit the high road of cultural denial when we know that we too stand for something, dammit. It's not just the Sudanese and Chinese and Sinhalese who have roots and religion. My grandmother read the Bible whenever she was sad—she particularly liked Ecclesiastes and Psalms.

What is this wish for stronger stuff? Gay literary figure Mark Doty wraps his meditation on religion around this italicized sentence: *"My lover of twelve years died just last month."*[10] "It astonishes me to write that sentence," he continues. "It astonishes me that I am writing at all." Doty begins his meditation, "I grew up in two religions," a religion of "images," absorbed from his grandmother's songs and scents, and a "second religion, the codes of explanation and prohibition" learned after her death.[11] "The prohibitions," he remembers, "were worse than the explanations. They suggested that the divinity had constructed the earth as a kind of spiritual minefield, a Chutes and Ladders game of snares, traps, and seductions, all of them fueled by the engines of our longing: the flames of hell were stoked by human heats."[12]

To be queer and literary and a figure, Doty rejected one religion and forgot another. And yet, the dead lover's introduction is preceded by this reflection:

I cannot be queer in church, though I've tried, and though I live now in a place where this seems to be perfectly possible for a great many people. Here in Provincetown we have a wonderful Unitarian church, with a congregation largely gay and lesbian, and it pains me to admit that when I have gone to services there I have been utterly, hopelessly bored. There's something about the absence of imagery, an oddly flaccid quality of neutrality in the language of worship. I long for a kind of spiritual intensity, a passion, though I can certainly see all the errors and horrors spiritual passions have wrought. I don't know what I want in a church, finally; I think the truth is that I don't want a church.

Perhaps my discomfort has to do, still, with issues of desire. Wind, glimmering watery horizon and sun, the watchful seals and shimmered flurries of snow seem to me to have far more to do with the life of my spirit. . . . There is something so *polite* about these Sunday gatherings of tolerant Unitarians that I feel like longing and need must be set aside. Isn't the part of us that desires, that loves, that longs for encounter and connection—physical and psychic and every other way—also the part of us that knows something about God? The divine, in this world, is all dressed up in mortal clothes, and longing and mortality are so profoundly intertwined as to be, finally, entirely inseparable.

My lover of twelve years died just last month.[13]

VIII

Maybe only gay people can come out. Maybe no one can come out anymore, maybe it's already too late. Perhaps everyone already knows. Or maybe there is more than one coming out, sometimes reassuring, sometimes transgressive. In the end, less significant than the coming out of religion or politics or law are the sectarian questions—what religion, what law, what politics? The emergence of religion in the secular intelligentsia today affirms pieties of everyday life more than it risks secular martyrdom or blasphemy, is less Anabaptist than Episcopalian, less liberation theology than Unitarian. Now that Marty Kaplan knows there is a God—now what? Is judgment politics? Is love libido? Or has this new religion displaced his other knowledge, his confession replaced, come in the place of other action? You believe in God, very well, but also in Doty's desire? Law is politics, fine, but is it also ideology? A regime may well have ethics, but what are those ethics, what of choice

and conflict? It is all well and good to know that the regime is a legal one, but what are its distributional consequences? Losing faith in the secular—yet how would we know, the secular at once so pious and pragmatic? The temptation, so familiar in millenarian times, is to wish, even pray, for law and religion to make a violent return. Liberalism at last triumphant, riding the white horse across the plain of collapsed states, fallen idols, and empty ideologies. For I say you must first lose your faith to regain it.

But even these are easy pieties. These days, when lawyers tell me it's all really politics, when political scientists admit their interest in law, when secular humanists confess to the spiritual, I usually smile. But sometimes there is more. Sometimes this great turn, pendulums of commitment poised to crash back on the secular imagination, offers more than a routine ritual of reversal, a euphoric recollection of the everyday religion we left behind. I'm thinking of the white Houston mayor who came out for affirmative action by saying, "don't let people like me get all the contracts." Coming out—here as white and male—can be a shock, an opening, a resistance—just as it can be a ritual, a repetition, nostalgia for the peace and quiet of the closet. As the secular prepares its fall back to the ethical, its shuttle weaving and unweaving the fabric of rulership, that was a gesture, a gesture of remembrance that we've been this way before, that ours is also an ambivalence without exit. Religion, law, politics—each can be reclaimed, invaded, embraced in registers of both routinization and resistance. But when we say they are "back," that law is back to politics, politics back to law, religion back to secular humanism, I'm afraid we usually mean only that the same pieties are being woven from the other side.

The gesture I'm after hints of new territory—new explorations across the boundaries of law and politics, and into a secular establishment's history of religious entanglements. And here we might find in international governance less a moment of tolerant generality, a culture above culture, than a practice of social exclusion, routinizing the exuberance of spiritual fervor as bureaucracy, cultural difference as tolerance. When we hear of religion's return, after all, we ordinarily do not think to upend the suppression of witchcraft, blasphemy, sorcery, or ecstasy of so much millenarianism, unraveling centuries of inter-sovereign/religious collaboration. We normally return to religion less to question than to confirm our eclecticism, less as a displacement of secularism than as a continuation of its will to power. Like most interdisciplinary gestures, the move of law to politics, of politics to law, of both to religion, seeks across the border for reasons to celebrate the most

central commitments of our own disciplinary domain. The interdiscipline comes not to confront, but to confirm, less to confound, than to comfort.

But while the pendulum pauses, we may have a moment to glimpse the transgressive, the innovative, before slipping into quiescent rotation among the pieties of a liberal politics, law or religion. For just a moment, we might think the realist adage that eggs must break to make an omelet in the language of sacrificial violence, we might read human rights violations in the register of pornographic desire, we might understand war "crimes" outside the usual list of quieting metaphors—"crime" joining "sin," "disease," "passion," the "unconscious" or the "primitive"—waiting to be routinized into the practices of global governance. If law and religion are indeed back, I pray we embrace this moment in all its delirium. Perhaps just for an instant we can glimpse together the pieties of power and the power of piety, the two sides of the liberal coin raised up against one another, a critical second of vertiginous equipoise, before one or the other is routinized as rebellion.

NOTES

1. "Religion," *Encyclopedia Britannica 1995 Book of the Year* (Chicago: Encyclopedia Britannica, 1995), 289, 298. Figures are as of mid-1995.
2. Nancy Gibbs and Howard G. Chua-Eoan, "Angels Among Us," *Time,* 27 December 1993, at cover.
3. "Ambushed by Spirituality," *Time,* 24 June 1996, 62.
4. Mohammed Bedjaou, *Towards an International Economic Order* (New York: Holmes and Meter, 1979), 98.
5. J. L. Brierly, *The Law of Nations,* 6th ed. (1963), quoted Louis Henkin et al., *International Law: Cases and Materials,* 3rd ed. (St Paul: West Publishing Co., 1993), 13.
6. *International Law: Politics, Values, and Functions,* Rec. des Cours 24 (1989-IV), 216, quoted Louis Henkin et al, *International Law: Cases and Materials,* 3rd ed., 15.
7. "Sovereignty and Humanity: Can They Converge?" *The Spirit of Uppsala,* ed. Grahl-Madsen & Toman(1984), 406, quoted Henkin et al., *International Law: Cases and Materials,* 3rd ed., 19.
8. Henken, et al., at 1.
9. Carl von Clausewitz, *On War,* ed. Anatol Rapoport (New York: Penguin, 1985), 402.
10. *Heaven's Coast: A Memoir* (New York: HarperCollins, 1996), 18.
11. Id. at 13–14.
12. Id. at 17.
13. Id. at 18.

ISLAMIC LAW AND MUSLIM WOMEN IN AMERICA

Azizah Y. al-Hibri

THIS YEAR PROMISES TO BE an historical year for Muslim women in America. A collection of articles on Muslim women's issues, written from both theoretical and practical points of view, will appear.[1] The collection is unique, because the women who contributed to it represent a microcosm of the Muslim community in America. No such book has ever been written before. It is the culmination of decades of effort at producing significant Muslim women's writings rooted in the Qur'an and uniquely informed by the American experience.

MUSLIM WOMEN AND THE WEST

For decades now, the absence of the Muslim woman's voice in America has been taken for granted. American secular feminist organizations, concerned about the status of women in Muslim countries, have been planning their strategies in full oblivion of the valuable role Muslim women in America could play. At times, they even consciously excluded them.[2] As a result, the strategies these secular women adopted were often not only culturally insensitive but, more significantly, hostile to religion. In Muslim countries that were historically either the cradle of all three Abrahamic religions or other globally recognized religions, one could quickly conclude that secular strategies would not be very promising. In fact, secular efforts of Western feminists in Muslim countries have already created a backlash, even against indigenous Muslim efforts at liberation. The door has thus been slammed shut in the face of any possible constructive dialogue on women's issues.

Muslim women in America must now repair the damage and painstakingly distinguish themselves from Western secular feminists in order to estab-

lish their credibility abroad as legitimate parties in the Islamic dialogue for change and progress. This is one reason why the forthcoming book is so important. It declares once and for all that Muslim women in America have come of age and henceforth they will speak in their own voice. With their sisters at home and abroad, they will create genuine alliances, based on equality and mutual respect, to preserve women's rights in the United States, the Muslim world, and the rest of the world.

MUSLIM WOMEN AND THE MUSLIM WORLD

In developing their views, Muslim women (and men) in America must also face another challenge, this time emanating from other Muslims. For the longest time, non-American Muslims themselves overlooked the American Muslim voice. The famous article written several decades ago by Seyyed Qutb, a major Egyptian scholar, and entitled "American Islam," does not refer to American Muslim jurisprudence as one might think.[3] Rather, it ridicules Muslim leaders who bend Islamic doctrine to suit the demands of American foreign policies.[4] These leaders, Qutb argues, are willing to use Islam as a tool to control the masses and fight communism.[5] They are willing to permit the public to discuss its Islamic views on contraception or the right of women to run for political office, but they are not willing to permit the public to freely discuss broader social, political, and economic issues.[6]

In a way, Qutb's article explains the roots of Muslim discontent with American official and NGO (non-governmental) strategies over the years. Both have disdained religion, either by using it as a tool or by disregarding it altogether. Both ignored the will of the Muslim people in the process and sought their own predefined goals. But Muslims in America are now ready to present to the world a new "American Islam," an indigenous, authentic, and genuinely caring one, not a tool for some political end.

Today, Islamic thought in America is not the product of superpower politics but of constitutionally guaranteed freedoms within the United States and the demands of a technologically advanced society. Muslims who immigrated to the United States joined indigenous American Muslims in exercising their human rights, especially the right to free thought and free speech. Many discovered that they could now discuss previously prohibited topics and entertain previously prohibited thoughts. Furthermore, with the proliferation of modern technological innovations, new Islamic experiments in areas such as banking, corporate governance, and financing, have emerged.[7]

So have modern Islamic educational institutions and women's groups. The result is an authentic Islam in America worthy of its name.

DECONSTRUCTING PATRIARCHAL JURISPRUDENCE

The Muslim experience in the United States, which included more than two decades of spirited American dialogue about women's rights, is reflected in communal concerns. Among these concerns today, the issue of women's rights ranks high. Generally, the present situation of Muslim women in the United States and abroad is fraught with tension and contradiction. On the one hand, as people of faith, Muslim women believe in the inherent justice of Islamic principles. On the other hand, their experiences are often those of injustice and oppression. Furthermore, very few Muslim women have the necessary tools for critically reexamining Islamic jurisprudence in order to expunge from Islamic laws the patriarchal influences of past cultures. I feel to this day the frustration of a Muslim woman abroad who asked me after my lecture, "Why don't *they* [religious scholars] tell us that Islam gives us all these rights?" There was no way that she could have found out the desired answer on her own. She did not have the necessary tools.

A narrow window of opportunity for acquiring some of these tools emerged in some countries when Muslim institutions of higher learning opened their doors to women. But in the absence of women's critical voices in these institutions, and of a free democratic exchange of ideas in some of these societies, the educational opportunities alone were not sufficient to bring about the necessary changes. Incidentally, the thirst for free speech and indigenously defined democratic forms of government in Muslim countries should not be underestimated. As an American on an occasional USIA (United States Information Agency) speaking tour, I was able to express my views in public fora and on television in many countries where freedom of speech often barely existed. The public reaction was usually very enthusiastic. One could feel a sense of relief settling over the audience as ideas of Islamic democracy and human rights were developed on its behalf. In one country, the audience refused to go home after one of my lectures, congregating on the street to continue the discussion. Clearly, they had a thirst for further discussions on Islamic democracy. They craved and needed democracy! Significantly, their positive response to issues of democracy, generally made them more receptive to the idea of gender-justice.

In the United States, not only do citizens have constitutional guarantees for their freedom of speech, but also there are Muslim women who have already acquired either domestically or abroad many of the necessary tools for studying Islam. Some of these women have also been exposed to or were even involved in the American women's movement. Not only did they witness or participate in its rise and struggles, but they also heard the diverse voices within it. They experienced the vigorous exchange of ideas within the movement and about it. In the end, they developed their own views, which contained potent critiques both of Western secular feminism and of the patriarchal interpretations of Islamic law that form the foundations of family law in many Muslim countries.

In an attempt to reach Muslim women (and men) outside the United States, I have personally made serious efforts to distinguish my views from Western secular ones. The result has been heartwarming. In one case, educated Muslim women, frustrated by gender discrimination in their own country, were pleasantly surprised by my gender-just interpretation of a particular Qur'anic passage traditionally interpreted in a highly patriarchal fashion.[8] In another instance, a Muslim woman leader asked me specifically to develop gender-just jurisprudence in the area of child custody. In a third instance, a group of women encouraged American Muslim women to take a leadership role in improving Muslim women's rights around the world. In all of these discussions, the unstated premise was that Muslim women in the United States have the possibility of engaging in these endeavors freely.

At the NGO Forum held in China in conjunction with the UN Fourth Conference on Women, the situation was, however, more complicated.[9] Some Muslim women groups were led by male "advisors" who had a predetermined agenda. In their zeal to realize it, they tried to push through the Muslim Women's Caucus a prepared statement, sight unseen. In response, American Muslim women took a very active role in the Caucus and insisted on proper democratic procedures. While our stance earned us the anger of some, most women appreciated our approach and supported us consistently. After the conference, we received letters of support from Muslim women in South Africa, Malaysia, England and various other places. Subsequently, we established an informal network of Muslim women jurists around the world, some of whom have been more than willing to help us develop a gender-just jurisprudence from the privacy of their own homes.

Despite these initial positive results, Muslim women in the United States still have a long way to go in terms of improving their religious edu-

cation and jurisprudential analysis. We also recognize that we have to fight some of our battles for women's rights closer to home. Fortunately, however, we have enlightened and highly qualified allies: Muslim male leaders and jurists who are both steeped in tradition and willing to take a fresh look at issues of democracy and women's rights.

Because of our recent efforts, Muslims around the world are increasingly welcoming the participation of American Muslim voices in their struggle for democracy and human rights. These Muslims, however, will only listen to authentic voices that are true to the message of Islam. They have become sophisticated at detecting quasi-religious voices that use religion as a tool to achieve secular ends. They have also endured a long history of Western intervention in their religious affairs. Muslims around the world will, therefore, accept no less than sincere as well as well-informed contributions to their struggles. Furthermore, even some leaders in government caught between the forces of political "fundamentalism" and Western secularism have come to appreciate a more balanced point of view in their search for an orderly way to liberate their truly religious societies. These leaders have also at times appreciated our views.

WOMEN IN EARLY ISLAMIC TRADITION

These new and encouraging developments are not a radical departure from early Islamic tradition. In fact, they are a throwback to ancient better times. Muslim women in the distant past took an active role in the development of Islamic jurisprudence. For example, 'Aisha, the wife of Prophet Muhammad, reported a substantial number of *hadiths* (sayings of the Prophet). Additionally, she provided a wealth of jurisprudence based on her extensive knowledge of both the Qur'an and the *sunnah* (the sayings and example of the Prophet).[10]

Not only did 'Aisha recount numerous important *hadiths* together with their surrounding circumstances, but she also refuted some misogynist ones. For example, Abu Hurairah (a male companion of the Prophet) reported that the Prophet had said, "Evil omens are [to be found] in women, mares and homes." 'Aisha became furious when she heard this report. She immediately corrected it, saying, "What he [the Prophet] said was that the people of Jahiliyyah [pre-Islamic era] used to find evil omens in these [three]."[11]

It was also 'Aisha who argued that women should be permitted to travel alone, so long as they felt secure from *fitnah* (trouble, temptation). 'Aisha relied on the Qur'anic verse that pilgrimage is the duty of every Muslim

(3:97). Since not every Muslim woman has a husband or a *mahram* (legal companion, such as a son, brother, or other member of her family), she reasoned, Muslim women must be permitted to travel alone whether or not such travel was for pilgrimage. Not all jurists agreed with her on this point, including those who evaluated her Qur'anically based argument in the limited context of travel for pilgrimage. In fact, even today, most personal status codes in Muslim countries restrict, directly or indirectly, the right of Muslim women to travel or even leave their home.[12]

LATER MUSLIM WOMEN WRITERS

'Aisha does not stand alone in her jurisprudential contributions. Many outstanding male jurists of prior eras have acknowledged their debt to their female teachers.[13] If these women teachers wrote down their views, very little of that writing is known to us today. Surviving jurisprudential contributions by Muslim women generally tend to fall in two categories, the traditional and the critical.

In the first category, I place the work of such jurists as al-Sharifah al-Dahmaa' bint Yahia al-Murtadha, a Yemeni princess who lived toward the end of the fourteenth century. She studied under her famous brothers, al-Hadi and al-Mahdi, as well as Imam Mutahhar bin Muhammad, and wrote several books. Al-Dahmaa' was well-known as a scholar and an educator of both men and women. Despite her familial and individual stature, some men tried to embarrass her and detract from her achievements. In one case, a man said to al-Dahmaa' that women were for the bed, men for knowledge. She replied calmly, "Knowledge is for all the people."[14] This exchange, and others similar to it, reflect the hegemony of patriarchal thought at that time and the decline of the role of women in the area of Islamic jurisprudence.

In her *Kitab al-Nasa'ih al Muwqithat*, al-Dahmaa' focused on those jurisprudential rules that pertained specifically to women and were different from the rules governing men in similar situations. Her book, however, does not question the patriarchal assumptions underlying the jurisprudence of the time. For example, in the passages on the rights of husbands and on *hajj* (pilgrimage), al-Dahmaa' argues with the traditionalists that a woman may not leave her house without her husband's permission, nor may she perform *hajj* unless accompanied by a *mahram*.[15] Nevertheless, given the times in which she lived, al-Dahmaa' was no doubt a shining light for the women of her period.

In the second category, I place the work of Nazirah Zein al-Din, who lived in Lebanon around the turn of this century. The daughter of a well-known jurist, she had an excellent education in religion.[16] Her Islamic education was combined with a Western one when she was enrolled in a missionary school. Perhaps this diversity in her upbringing as well as the more recent era in which she lived made it easier for Nazirah to raise serious questions about the patriarchal interpretations of religious text.

In her book *Al-Sufur wa al-Hijab,* Nazirah questioned the practice of covering a woman's face.[17] In the process of arguing that the practice was not religiously required, she touched upon a wealth of other subjects such as the education of women, Islamic dress, and equality. In the end, the book caused an uproar and was followed by a sequel that documented both the verbal attacks and words of support she received.[18]

COLONIALISM, CIVIL LIBERTIES, AND THE LIBERATION OF WOMEN

History thus teaches us that it is not easy to be a Muslim woman jurist, especially one who questions patriarchy. That is only half the problem. The task of engaging in Islamic jurisprudence, even under the most favorable conditions, is not an easy task. It has its minimal requirements. Among them is knowledge of the original sources. Primary among these is the Qur'an, which was revealed in classical Arabic. It also requires knowledge of *usul al-fiqh* (the jurisprudential rules of interpretation or logic) as well as historical knowledge of the circumstances surrounding the revelations, *hadiths* or laws under study.[19]

Today, very few women or *men* are able to produce competent writing in Islamic jurisprudence. Several historical events have intervened to make their task very demanding. Major among these historical events was the colonialist policy of weakening the Arabic language and indigenous educational institutions in Muslim countries. Algeria is a prime example of the ravages of this policy. There, the French colonialist government confiscated Muslim *awqaf* lands (lands belonging to charitable Islamic trusts that finance local schools and mosques).[20] This calculated move dealt a severe blow to traditional Qur'anic schools.[21] Furthermore, the oppressive educational policies of the French resulted in keeping the predominant majority of Algerians outside the colonialist educational system.[22] Consequently, whole generations of Algerians were forced to pursue their Arabic education in a handful of poorly funded Qur'anic schools.[23] The select few who

entered the colonialist educational system were deprived and often success-fully severed from their linguistic, religious, and cultural heritage.[24]

In the Indian subcontinent, the problems with the colonialists were some-what different. There, British courts took the liberty of interpreting Islamic law. By that time, most of the population lacked linguistic and other tools for exam-ining these interpretations. Furthermore, the legal colonialist regime gave the interpretations its full support. As a result, British interpretations of Islamic law acquired precedential value for Islamic jurisprudence in that region and con-tinue till this day to influence the region's understanding of Islam.[25]

Another major challenge that faced all potential jurists, whether male or female, was the erosion of civil liberties in many Muslim countries. This ero-sion was by no means recent. It began soon after the death of the Prophet when authoritarian governments were formed in contravention of the basic Qur'anic constitutional principles of *shura* (consultation) and *bay'ah* (elec-tion).[26] For several centuries thereafter, so long as jurists avoided discussing Islamic democracy and human rights, they tended to be safe from the wrath of their regimes. Jurists who ventured into these two areas often paid a high price.[27] As a result, Islamic jurisprudence, with few exceptions, languished in the area of *taqlid* (emulation of earlier jurists). For obvious political reasons, the jurists selected for *taqlid* were not necessarily the most democratic or liberal.

THE ROLE OF "IJTIHAD"

A third and important reason for the decline in jurisprudential activity came from well-meaning leading jurists themselves. Witnessing the spread of Islam in non-Arab speaking countries, these jurists were concerned that some of those who entered the field were not well versed in the subject matter. To avoid confusion, leading Muslim jurists restricted *ijtihad* (the interpretation of religious law or text) to those individuals who acquired an advanced level of knowledge of the religious text, relevant history, the Arabic language, and major secondary jurisprudential sources. These restrictions became at one point so daunting that some historians consid-ered them tantamount to a "closing of the gate of *ijtihad*."[28]

Since in Islam there is no central religious authority, no Muslim has the right to close the "gate of *ijtihad*." Every Muslim who has sufficient knowledge and piety to engage in *ijtihad* may do so with no one else's prior permission. One of the earliest examples of this fact occurred in the days of the *Khalifa* (Caliph) 'Omar. While delivering a speech in a mosque, the

Khalifa told the people that he was passing a certain law in the public interest. An old woman in the back of the mosque objected, noting that the proposed law contravened a Qur'anic verse. *Khalifa* 'Omar asked for proof, and when she stated her argument, he said, "A woman is right and a man is wrong."[29] He then rescinded the law.

This incident shows that a person expressing a considered opinion or an *ijtihad* on a matter need not be well known or well versed in the field of jurisprudence as a whole. What is required is simply that the argument provided in support of this *ijtihad* or opinion be sound. If the argument is sound, then it must be taken seriously and properly addressed, regardless of its origin. On the other hand, the restrictive requirements for jurisprudence, which were mentioned earlier, continue to be valuable indicia of one's preparedness for a jurisprudential career.[30]

With these distinctions in mind, the contributions of Muslim women in the United States to Islamic jurisprudence may prove to be at least as significant as that of the old woman who corrected 'Omar in the mosque. They are also urgently needed. The complacency of *taqlidi* jurists, either for political reasons or due to lack of sufficient knowledge, has made them run afoul of a major Islamic jurisprudential principle, namely that laws change with change in time and place.[31] This law is so deeply entrenched in the tradition that the revered Imam al-Shafi'i changed his own school of thought when he moved from Iraq to Egypt.[32] His earlier jurisprudence evolved in light of the new conditions.

The Muslim world continues to this day to emulate the great Imams of Islam who lived in different cultures and different times. Particularly problematic is the transplantation of several traditional schools of thought to the United States, in total oblivion of the need to reexamine them in light of our modern era and American culture. This is especially important since Islam celebrated cultural diversity.[33] As a result, many cultures were encouraged to incorporate in their laws customs that did not conflict with Islamic principles.

Today in America, however, we still find individuals clinging to their ancestral oriental customs and rejecting, wholesale, American customs. They transmit these culturally based customs to their American children and to new converts as if they were an integral part of the religion. The result is a great deal of unnecessary hardship and confusion for a whole new generation of American Muslims.

The attitude of these "emulators" reflects not only a mis-conception of Islam, but also the subconscious misconception that Islam belongs to the

East alone. The Qur'an clearly states that Islam was revealed to all people.[34] That includes the United States, some of whose customs are as worthy of incorporation as those of prior cultures. Without religious education, these American Muslims have no way of finding out which customs are acceptable and which are in conflict with their religious values.

In other words, the existing situation is no longer workable at home; it is also unworkable abroad. The Muslim world is undergoing the pains of both global political and technological marginalization. Muslims are suffering under the weight of outdated authoritarian political systems and are increasingly unwilling to accept the legitimacy of these systems in today's world. (Ironically, however, it is often Western democracies that support these regimes.) The issue of the compatibility of Islam with democracy and human rights is thus a live issue for a large number of Muslims who are no longer willing to accept their existing political order without fundamental modifications.[35]

American Muslims are well-positioned to study the jurisprudence of Islamic democracy without fear of repercussions. Unlike many of their brothers and sisters abroad, they can vocally argue, using the finest traditional religious sources, that hereditary rule is not acceptable in Islam, that each ruler must be freely chosen by the people, and that such a ruler must serve the people's interests not his own.[36] Once formulated, these views will find their way to other Muslim countries, connect with local progressive Islamic jurisprudence, and energize the democratic movements there. Furthermore, the American Muslim effort will not be open to the Third World critique of advancing Western hegemony, nor will it be vulnerable to refutation by pointing out the shortcomings of American democracy. The form of democracy being advocated by American Muslim jurisprudence would be fully rooted in the Qur'an itself, a revelation that transcends national borders.

PERSONAL STATUS CODES

Muslim family laws (referred to as "personal status codes") as well as the court system that applies and enforces them have created serious problems for women around the world.[37] Consider for example, the following true story. A young Egyptian woman complained to me that her divorce case has been languishing in court for over seven years. Despite the fact that her husband was caught committing adultery and has never supported her financially, it took the court several years to declare a divorce. The husband, however, decided to appeal the decision. Consequently, the woman remains unable to remarry

until her divorce is declared final. Since that may take a few more years, she may have lost her fertile years by the time she is legally able to remarry.

This situation is very troubling, given the precedent that *Khalifa* 'Omar set. On one of his famous evening walks around town he overheard a woman recite a heartbreaking poem describing the emotional difficulties she was facing because of the extended absence of her husband. Since her husband was in the army, *Khalifa* 'Omar decided not to keep his troops away from their wives for more than six months at a time in order to preserve the wive's chastity.[38] 'Omar's point of view was adopted by traditional scholars who recognized the extended absence of a spouse as grounds for judicial divorce (*"tafriq"*).[39]

Another piece of significant information comes from the *sunnah* of the Prophet himself. A woman called Habibah asked the Prophet for his permission to divorce her husband, Thabit. She noted that Thabit had no moral or religious shortcomings but that she could not stand him (*"la utiquhu"*).[40] The Prophet asked her whether she was willing to return to Thabit his garden, which he had given to her as *mahr* (dower).[41] She enthusiastically agreed to give that back. The Prophet then asked Habibah to return the garden to Thabit and instructed Thabit to accept the garden and divorce his wife.[42] The whole event was over in a few minutes. Today's Muslim courts, however, make young women vulnerable to temptation and loneliness by not following the *sunnah* and offering them a prompt resolution of their marital situation.

The story about Habibah and the Prophet is also useful for examining the wife's right of *Khul'* (repudiation) in Muslim countries. This right, based on Habibah's story, permits the wife to divorce her husband at will, so long as she returns to him his *mahr.* This right is parallel to the right of the man to divorce his wife at will. Personal status codes in most Muslim countries have interpreted the right to *Khul'* so as to require the husband's consent. As a result, the wife is often either unable to divorce her husband at all or is reduced to buying his consent by paying him an amount exceeding her *mahr,* in contravention of the Prophetic tradition.[43]

Muslim women can protect themselves from such problems by simply writing in their marriage contract a condition that permits them to divorce the husband at will. This approach is legally different from *khul'* in that it is part of the Islamic marriage contract executed by the couple. The condition usually states that the woman retains her *'ismah* (control over her own marital status) or, depending on the jurisdiction, that the husband delegates his right of divorce to his wife (*tafwid*).[44] The problem with this approach, however, is that not many women have the negotiating power to include the con-

dition. Furthermore, society as well as religious authorities discourage women from including it. For example, when I was preparing to insert this condition in my own marriage contract, the imam officiating over the ceremony stopped me. He claimed that the condition was invalid. After a lengthy argument, in which I pointed out to him that women in my religious family have consistently included this condition, the imam finally accepted. His acceptance was hastened by the fact that one of the marriage witnesses supported my argument. The witness was a well-known Muslim lawyer. Another woman with less information about 'ismah or a less authoritative witness may have had greater difficulty in protecting her rights. This would have made her vulnerable to the consent interpretation of Khul' and to lengthy divorce proceedings in the event her marriage fails.

It is also worth noting that some schools of thought have developed rules that make it hard for the woman to retain her right to divorce after the marriage is consummated.[45] Such problems must be pointed out in an international Islamic debate about the rights of women. Muslim jurists must be encouraged to adopt that jurisprudence that provides Muslim women today with the full extent of their Islamic rights in a world full of patriarchal hurdles.

Generally, current personal status codes provide patriarchal interpretations of Islamic principles.[46] The misery created by these laws and interpretations is real and in need of immediate attention. Western feminists have recently focused on this issue and many of them have offered secular solutions. But *secular solutions do not count for people of faith.* These solutions abandon the very premises to which Muslim women have chosen to adhere.

CONCLUSION

The possibilities for advancing Muslim women's rights and aiding in the emergence of indigenous forms of democracy in the Muslim world are limitless. To achieve these goals, however, we need to look at the world in a new way. Muslim societies abroad need to rediscover Islam in the age of democracy and human rights. The West, and in particular America, needs to rediscover Islam not as a threatening "Other" but as part of the original civilizational and spiritual heritage of the West. In the United States, we have one additional dimension. American Muslims today are only one link in the line of Muslims who helped build this country. We had predecessors who were brought to this land involuntarily. Some of these predecessors were literate; some were even leaders of their African tribal communities.[47] They had to endure the tyranny of

slavery.[48] Nevertheless, they contributed significantly to building this country. The nation as a whole owes a lot to the efforts of these early Americans.

One more issue remains: Having extolled the virtues of American democracy, it is important to note that Muslims in America are not full beneficiaries of it. For example, under new laws that affect them disproportionately, Muslims in the United States have been denied important due process protections.[49] As a result of this state of affairs, the issue of Muslim civil rights in the United States has added a whole new dimension to the Muslim women's struggle for their human rights.[50] Of course, the proper response to civil rights problems at home is not to become cynical about American democracy but rather to contribute actively toward its improvement.

NOTES

1. Gisela Webb, ed., *Windows of Faith* (working title), (Syracuse: Syracuse University Press, forthcoming).
2. In one salient example of this attitude, American secular feminists were averse to including Muslim women wearing *hijab* (head cover) in a demonstration that took place in Washington, D.C., several years ago in support of Bosnian women. In another example, a conference on Islam organized by an American secular feminist organization did not include a single woman wearing *hijab.* The audience included a large number of such women who were frustrated and upset by the omission.
3. Seyyed Qutb, *Dirasat Islamiyah* (Cairo: Dar al-Shuruq, 1987), pp. 119–23.
4. *Ibid.,* p. 121–22.
5. *Ibid.,* p. 119–20.
6. *Ibid.,* p. 120.
7. For example, I was contacted by a group of American Muslim businessmen who had devised a corporate structure that better approximated, in their view, Islamic values of justice and fairness. Also, several Islamic financial and banking institutions have been established in the United States. These institutions are designed to be simultaneously competitive in the capital markets and in compliance with Islamic values.
8. That passage was discussed in my *Islam, Law and Custom: Redefining Muslim Women's Rights,* 12 Am. U. J. Int'l L. & Pol'y 1, 25–34 (1997).
9. For the press release that was prepared by this author and issued at the Forum by the American-based "Karamah: Muslim Women Lawyers for Human Rights," see <http://www.karamah.org>.
10. Sheikh Sa'id Fayez al-Dakhil, *Mawsu'at Fiqh 'Aisha Um al-Mu'mineen,* (Beirut: Dar al-Nafa'is,1993), pp. 82, 83–84, 85–86, 87–88.
11. *Ibid.,* 532.
12. *Ibid.,* 542–44; 545–46; *Islam, Law and Custom,* p. 12.
13. See, e.g., Ahmad Shalabi, *Al-Tarbiyah wa al-Ta'lim,* in 5 *Mawsu'at al-Hadharah al-Islamiyah,* pp. 343–44 (Cairo: Maktabat al-Nahdha al-Nabawiyah, (exp. 8th ed.), 1987. See also, Muhammad al-Sakhawi, *Al-Daw' al-Lami',* esp. vol. 12 (Beirut: Dar Maktabat al-Hayat [15th century, reprint], n.d.).
14. The only work I was able to locate so far was *Kitab al-Nasa'ih al-Muwqithat: Fima Yakhtuss bi al-Nisa' Min al-Wajibat wa al-Mandubat wa al-Watha'ef al-Mustahsanat,*

unpublished manuscript with commentary by Abdullah Abdullah Ahmad al-Huthi, San'aa, Yemen, p. 30–33 (on file with author).

15. *Ibid.,* 94; 289–90. The fully stated rule allows a woman to travel with her husband or a *mahram.*

16. Nazirah Zein al-Din, *Al-Sufur wa al-Hijab,* published by her father, Sa'id Bey Zein al-Din (Beirut, 1929), dedication.

17. *Ibid.,* esp. pp. 30–34; 180–89.

18. See, generally, Nazirah Zein al-Din, *Al-Fatat wa al-Shuyukh,* published by her father, Sa'id Bey Zein al-Din (Beirut, 1929).

19. See, e.g., Subhi Mahmassani, *Muqaddimah fi Ihya' 'Ulum al-Shari'ah* (Beirut: Dar al-'Ilm li al-Malayin, 1962), pp. 28–9.

20. Elsa M. Harik and Donald G. Schilling, *The Politics of Education,* (Athens, Ohio: Ohio University Center for International Studies, Africa Series No. 43, 1984), 27. See also Mas'ud Mujahid, *Al-Jaza'ir 'Abr al-Ajyal,* (Jerusalem: Dar al-Aytam al-Islamiyah al-Sina'iyah, n.d.), pp. 355.

21. *The Politics of Education,* p.27. See also, *Al-Jaza'ir 'Abr al-Ajyal,* pp. 355.

22. *The Eloquence of Silence: Algerian Women in Question,* (New York: Routledge, 1994) p. 62. See also, *Al-Jaza'ir 'Abr al-Ajyal,* pp. 237–39, 354–55. For another perspective on this problem, see *The Politics of Education,* pp. 2–3, 6–12, 15–17, 23–26, 30.

23. For a discussion of this point, see Marnia Lazreg, *The Eloquence of Silence,* esp. pp. 59–62, 67, 79. See also, *Al-Jaza'ir Abr al-Ajyal,* p. 35.

24. *The Eloquence of Silence,* pp. 59–61. See also *Al-Jaza'ir 'Abr al-Ajyal,* pp. 239.

25. Keith Hodkinson, *Muslim Family law: A Source Book* (London: Croom Helm, 1984), pp.1–13.

26. For a detailed discussion of Islamic constitutionalism and the historical crisis of authority, see Azizah Y. al-Hibri, "Islamic and American Constitutional Law: Borrowing Possibilities or a History of Borrowing?" 1 U. Pa. J. Cont. L.—(1999), 111–34. See also Azizah Y. Al-Hibri, *Islamic Constitutionalism and the Concept of Democracy,* 24 Case W. Res. J. Int'l L. 1, 1–27 (1992).

27. See, e.g., Hussein Zein, *Al-Islam wa al-Fikr al-Siyasi al-Mu'asser* (Beirut: Dar al-Fikr al-Hadith, 1997), pp. 45–48.

28. See John Esposito, *Islam: The Straight Path* (New York: Oxford University Press, 1991), p. 84. See also *Muqaddimah fi Ihya' 'Ulum al-Shari'ah,* p. 20–21.

29. Abu Hamid al-Ghazali, *Ihya' 'Ulum al-Din* (Cairo: Matba'at Mustafa al-Babi al-Halabi, 11th century, reprint, 1939), vol. 1, p.50.

30. Mahmassani agrees that a person engaging in *ijtihad* need not have a comprehensive knowledge of all matters of jurisprudence. *Muqaddimah fi Ihya' 'Ulum al-Shari'ah,* p. 29.

31. See *Islamic Constitutionalism,* p. 8.

32. See *Muqaddimah fi Ihya' 'Ulum al-Shari'ah,* p. 40. See also Taha Jabir al-Alwani, *Usul al-Fiqh al-Islami* (The International Institute of Islamic Thought: Herndon, VA, 1990) 34–36; Muhammad Abu Zahrah, *al-Shafi'i* (Dar al-Fikr al-'Arabi 1948) 28, Muhammad al-Najjar, *Al-'Umm* (Maktabat al-Kulliyat al-Azhariyah: Cairo, 1961) Introduction; 'Ala' al-Deen as-Samarqandi, *Tariqat al-Khilaf Bayn al-Aslaf* (Dar al-Kutub al-Ilmiyah: Beirut, reprint, 11th century, 1992)13.

33. Qur'an 49:13. For more on the importance of this point to Qur'anic philosophy, see the author's contribution on "Modesty," *The Oxford Encyclopedia of the Modern Islamic World,* (Oxford: Oxford University Press, 1995), vol. 3, pp. 126–27.

34. See, e.g., Qur'an 39:41;14:1; and 2:213.

35. Some Muslim groups, such as Tanzim Islah-i-Paksitan (Organization for the Reform of Pakistan), have argued that democracy is an un-Islamic Western concept because it

leads to a state governed by the will of the people, as opposed to Divine Will. See discussion of this group's views in Ishtiaq Ahmad's *The Concept of An Islamic State: An Analysis of the Ideological Controversy in Pakistan* (New York: St. Martin's Press, 1987), esp. p. 88. I have argued in *Islamic Constitutionalism,* pp. 16–20, that this argument, while based on correct premises, is conceptually confused.

36. See *Islamic Constitutionalism,* pp. 11-13.

37. For a detailed discussion of these codes, see *Islam, Law and Custom,* p. 10–23.

38. Jamal al-Din al-Jawzi, *Tarikh 'Omar bin al-Khattab,* (Beirut: Dar al-Ra'ed al-Arabi, 1985), pp. 76–78.

39. See, e.g., Muhammad Abu Zahrah, *Al-Ahwal al-Shakhsiyah* (Cairo: Dar al-Fikr al-'Arabi, 3rd ed., 1957), pp. 366–67.

40. Abu Abdullah al-Bukhari, *Sahih al-Bhukhari bi Hashiat al-Sindi,* (Beirut: Dar al-Ma'rifah, n.d.), vol. 3, p. 273. See also, Abu Abdullah Ibn Majah, *Sunan Ibn Majah,* (Beirut: Dar al-Kutub al-'Ilmiyah, n.d.), vol. 1, p. 663. Al-Bukhari provides another account of the story. Al-Bukhari, p. 273. According to the second account, the woman wanted a divorce from her husband because she feared that staying with him would drive her away from her religion (suggesting that the antipathy between them may cause her to go astray). Ibn Majah provides both accounts but adds that the Prophet ordered Thabit not to take from his wife more than the garden he gave her.

41. It is inaccurate to translate *Mahr* as dower. *Mahr* is best viewed as the amount a woman receives as a gift from her prospective husband. The money is the personal property of the woman and may not be touched by either her father or, later, her husband. She could demand it prior to the marriage or demand that part of it be delayed. If no term is specified, the *mahr* becomes due upon the husband's death or divorce. In the first case it becomes a senior debt of the estate, paid in addition and prior to the wife's inherited share in the estate. In the second case, it becomes a lump sum alimony. For more on this, see, e.g., *Al-Ahwal al-Shakhsiyah,* esp. pp. 169-208; see also my contribution to the *Symposium on Religious Law,* 16 Loy. L. A. Int'l & Comp. L. J. 1, 67–70 (1993).

42. Ibn Qudamah, *Al- Mughni,* (Beirut: Dar al-Kitab al-'Arabi, (12th century), n.d.), vol. 8, pp. 173–75, 182–83.

43. *Ibid.*

44. For more on this, see this author's *Marriage Laws in Muslim Countries: A Comparative Study of Certain Egyptian, Syrian, Moroccan, and Tunisian Marriage Laws,* 4 Int'l Rev. Comp. Pub. Pol'y 227, 235 (1992).

45. *Ibid.*

46. See, generally, *Islam, Law and Custom.*

47. Robert J. Allison, *The Crescent Obscured,* (Oxford: The Oxford Press, 1995), pp. 91. Michael A. Gomez, *Exchanging Our Country Marks,* (Chapel Hill: The University of North Carolina Press,1998), p. 61. See also, Fareed H. Nu'man, *The Muslim Population in the United States* (Washington, D.C.: The American Muslim Council, 1992), esp. pp. 20–22.

48. Thomas Jefferson viewed this system of slavery as bringing back to America the very tyranny it had revolted against. He argued that only a prodigy would survive slavery unmarred. Thomas Jefferson, *Notes on the State of Virginia* (Philadelphia: R. T. Rawle, 1801), 319–22. See also *The Crescent Obscured,* p. 88.

49. This is most salient in the use of secret evidence in immigration cases. See, e.g., the new Antiterrorism and Effective Death Penalty Act of 1996, Pub. L. No. 104–2, 110 Stat. 1262 (codified as amended in scattered sections of 8 U.S.C.A.). See also, "On Secret Evidence," *Washington Post,* editorial, page A18, October 21, 1997.

50. See, e.g., "Islamic Emblem of Faith Also Trigger for Bias," *New York Times,* November 3, 1997, Section A, col. 1.

PRACTICE

9

YOM HASHOAH IN THE CAPITAL ROTUNDA

Deborah E. Lipstadt

AT NOON ON APRIL 24, 1979 approximately one thousand people gathered in the rotunda of the U.S. Capitol building for an unprecedented ceremony: an official commemoration of the Holocaust by the U.S. government. The Atlanta Boy's Choir sang songs composed in the ghettoes during the war. A cantor, himself a survivor of the Holocaust, adapted the text of the *El molei rachamim,* the ancient memorial prayer for the dead, to the occasion as he asked for God's mercy for the innocent men, women, and children who died at the hands of the Nazis in death camps such as Auschwitz, Maidanek, and Treblinka and in other cruel and vicious ways. A seven-branched menorah was lit. The service concluded with a rabbi reciting the *Kaddish,* the traditional prayer recited by those who are mourning family members. The *Washington Post* noted that, as the words of this prayer "rang out strongly in the echoing rotunda, people here and there in the audience joined him and a great murmur rose."[1]

The fact that this service took place in the rotunda, which is arguably America's most sacred public space, made this a particularly auspicious event. The presence of the president and vice president of the United States, cabinet officers, the speaker of the House, the senate majority leaders, more than one hundred members of Congress, and foreign dignitaries added further luster to this event. Also present were survivors of the Holocaust and members of the newly formed President's Commission on the Holocaust.

While the opening of the United States Holocaust Memorial Museum fourteen years later, almost to the day, on a rainy April morning would have a greater long-term impact on the country's cultural life, given the

number and diversity of visitors who pass through the museum's doors, in symbolic importance a service in rotunda carried equal if not greater significance.[2] Using the rotunda as a site for this service was noteworthy in that until that point in time it was used most frequently when a great national leader or a former member of the Congress lay in state. (There had been a total of just twenty-four such funerals by 1978.) When new statues were installed on the Hill they were officially "received" in the rotunda. In 1976, during the American bicentennial, the Magna Carta was displayed there. It was, in fact, the impact of the ceremony surrounding the arrival of the Magna Carta on then Congressman James Blanchard that lead to the idea of holding a *Yom HaShoah* ceremony in the rotunda. When Blanchard, who would eventually become Governor of Michigan, proposed the idea at a meeting of the Holocaust Commission, he envisioned that the Holocaust would be "lying in state" in the rotunda during such a ceremony.[3]

How did it come to pass that *Yom HaShoah,* an event which was barely on the American Jewish radar screen—much less the secular American one—less than a decade earlier, was officially commemorated by the U.S. government in this revered place? What prompted the Congress, which must decide who will use this space, to unanimously support this decision? And what does the unambiguously Jewish ceremony, which was held in this sacred but common space, tell us about the nature of American Jewish identity in the late 1970s?

There are those who contend that the White House and Congress supported Holocaust commemoration simply because it was politically efficacious to do. Within the American Jewish community many believe that the Carter administration's interest in Holocaust commemoration constituted an attempt to pacify an influential and politically significant group of Americans. This paper shall argue that the Holocaust-related actions by both the White House and the Congress resulted from a complex set of developments that reflected deep-seated changes in American society, changes that far transcended the narrow parameters of American Jewish life. It was an attempt to pacify an influential political group. But it was also far more than just that.

The fact that a *Yom HaShoah* commemoration was held in the rotunda and attended by the leading political figures of the nation is particularly noteworthy, since throughout the 1950s and most of the 1960s this day was barely on the Jewish communal or theological agenda. It certainly was

not on the American federal or state calendar. (That would change markedly by the mid-1980s, by which time, virtually every state in the union had an official commemoration of some sort in which leading political and religious figures participated.) Prior to the 1970s there were virtually no more than a handful of commemorations of *Yom HaShoah*. Those Holocaust commemorations that were held were generally organized and attended by survivors. Non-survivors, such as Rabbi Irving "Yitz" Greenberg, who attended remembered feeling like they "were crashing a funeral."[4] There were a scant number of books, conferences, speeches, and museums dedicated to exploring the history and significance of the Holocaust. American Jews and refugees who had come to this country during the 1930s discouraged survivors who arrived in the late 1940s and early 1950s from discussing their experiences except with one another. They were told that Americans Jews and non-Jews were not interested. Even American soldiers who entered the camps during the final stages of the war were encouraged by family and friends not to speak of the experience when they returned home.[5]

By the 1970s tremendous changes had occurred on both the foreign and domestic front. Holocaust survivors, most of whom had come to this country in the 1950s penniless and in a state of emotional disarray, were older. They had established their families and achieved a measure of psychological and financial stability. Moreover, the first generation of survivors' children born in the immediate aftermath of the war were reaching adulthood. Some pressed their parents to speak of their experiences. Beginning in the 1970s children of survivors began to recognize that they shared certain common experiences. Some began to write articles and books about this. They organized conferences exploring different aspects of their experiences as children of survivors.[6] This was also the period when courses on the Holocaust began to be offered in colleges and universities. Instructors often asked survivors to come and speak to their classes. Many of these survivors had rarely—if ever—discussed their experiences outside the narrow confines of their family. They found themselves speaking to audiences of college students who knew little, if anything, about the Holocaust. All these activities further inclined survivors to the act of public remembering. But this alone would not have led to a rotunda commemoration attended by the president, vice president, and other lofty officials.

The developments that resulted in the changes in America's commemoration of the Holocaust far transcended both the survivor commu-

nity and the Jewish community. In the wake of the Six Day War, the Holocaust and Israel began to assume a more prominent place on the American Jewish agenda. Jews, emboldened by Israel's decisive victory, felt freer to advocate a pro-Israel foreign policy. While they had long supported such a policy, they had done so far more quietly than would be the case after 1967. During the latter part of May 1967, as war loomed between Israel and her Arab neighbors, rabbis and Jewish communal leaders had begun to talk about the Holocaust. Many of the sermons and speeches given prior to the beginning of the June 1967 war expressed the fear that another tragedy of Holocaust-like proportions was in the offing.

When, rather than a tragedy, a tremendous and unimagined military victory ensured American Jews found themselves in a state of euphoria. They were now convinced that unlike Massada, Israel would not "fall again." For many Jews this marked the psychic end of the Holocaust. It was not by chance that in the late 1960s and early 1970s *Yom HaShoah* commemorations became increasingly common elements on Jewish communal calendars. In their fund raising and political efforts on behalf of Israel, American Jews linked the devastation of the Holocaust with the need for a secure State of Israel.

At the same time the first post-Holocaust generation was coming of age. These articulate, well-educated baby boomers, felt entirely Americanized. In contrast to their immigrant parents and grandparents, they were far more unlikely to have been personally touched by anti-Semitism. Unlike generations of American Jews before them, they were far less likely to have had to select a college or a profession based on latent American anti-Semitism. Unlike previous generations of American Jews they felt an unprecedented sense of entitlement, i.e., nothing in America should be off limits to them simply because they were Jews.

They were, to be sure, strongly influenced by both the *sturm and drang* of Vietnam protests and the tactics of African-American students on campus. The latter, as a means of expressing their heightened ethnic identity, called for Black Studies programs which, among other things, addressed the tragedy of slavery. A cadre of highly identified Jewish baby boomers, many of whom were graduate students in Jewish Studies, used this opportunity to differentiate themselves from their parents' behavior. With a self-assuredness that was fed by both cockiness and historical myopia, activist American Jewish youth of the late 1960s and early 1970s used the Holocaust as a point of comparison and declared that previous genera-

tions had been "Uncle Jakes" during the Holocaust, afraid to speak out and
willing to turn their backs on European Jewry because they were more
concerned about what Americans might think of them. These young peo-
ple accused their parents of having failed their fellow Jews with their
wartime silence. The perception that their parents had failed when a pre-
vious generation of Jews had called out for aid motivated many of them to
become involved in the Soviet Jewry movement. "Never should it be said
of us that we stood silently by as our parents did thirty years ago," one
Jewish activist rather self-righteously intoned at a community rally in 1972
at Boston's Faneuil Hall.[7]

These young people also believed that the previous generation had
created an American Judaism that was characterized by an exaggerated
concern about the non-Jewish world. According to this generation of post-
Holocaust highly educated and identifying Jews who became activists after
1967, their parents and grandparents cared too much about "*ma yomru
ha-Goyim?*" (How will the non-Jews world interpret Jewish behavior?)
According to the Jewish youth of the Vietnam protest generation, instead
of worrying about "What would the non-Jews say?" they should have wor-
ried about how to build a vibrant American Judaism.

In their critique of their parents' failures these activists tended to
ignore the fact that the America in which they were raised and in which
their lives were shaped was dramatically different from the America of the
1930s and 1940s when their parents were coming of age. The increased
prominence of the Holocaust on the American Jewish agenda was a result
not only of changes in American Jewish life and identity but in the
American social and political sphere. Communism, while still America's
main political enemy, did not convey the frightening specter on either the
foreign or domestic scene that it had in the 1950s. Consequently recount-
ing the wrongs of Germany was no longer perceived by mainstream
American political interests as a dissident act as it might have been per-
ceived in the immediate aftermath of World War II particularly during the
Berlin airlift.

On the domestic front, increased preoccupation with America's record
of racial discrimination and opposition to the Vietnam war cast a shadow
on mainstream American culture and values. At the same time and par-
tially as a response to these developments, particularism was emerging as
an increasingly common motif in American society. Various groups, both
ethnic and religious, felt free to express their particular identities and to

call attention to their own history of victimization in a way that they have never felt before. This was also the time, it should be noted, that the homosexual community was becoming increasingly open and militant. Having been or being a victim no longer constituted, *ipso facto,* a badge of shame. Victimization allowed one to claim a higher moral ground than the majority society. African Americans, Jews, women, gays, lesbians, Native Americans, Japanese Americans and others called attention to their history of suffering and to America's complicity in that suffering.[8]

Not by chance did Elie Wiesel, in his remarks in the rotunda, stress America's failure to help the victims of the Holocaust during the war and ask why Capitol Hill had been silent when word of the annihilation of European Jewry reached it.[9] The burden of shame was now placed squarely on the shoulders of not just the perpetrators and their accomplices but also those who stood silently by. The wrongdoings of the latter were writ large in the annals of the Holocaust. There is a certain irony inherent in this situation. It was the perception that America had failed the victims that made the Capitol Rotunda, America's most sacred public space, a fitting location in which to engage in Holocaust commemoration. The rotunda ceremony became both a commemoration and an expiation of guilt. It did not just celebrate the home America had offered the survivors but reminded this nation of its failure to open its gates at these crucial moments. For both the victims and their heirs victimization was no longer a shameful thing. What was shameful was the refusal to acknowledge one's history and identity. For American Jews acknowledging the Holocaust became a means of connecting with their Jewish identity. For Americans, both Jews and non-Jews, acknowledging America's failures became a means of uncovering America's true past.

It was against a background of these social and political changes that the White House began in 1978 to discuss establishing a Holocaust memorial. The immediate impetus for a Holocaust memorial was political. White House officials were seeking a way to repair the relations between the Carter administration and the American Jewish community. In 1977 Ellen Goldstein, a White House staff member, wrote a memo to Mark Siegel, the White House liaison to the American Jewish community, in which she suggested that the President might "begin to heal the rift" between himself and American Jewry by visiting a Brooklyn Holocaust center on his next visit to New York City.[10] (Shortly after he entered the White House Jimmy Carter expressed support for a Palestinian homeland.

American Jews felt his support of Israel was lukewarm at very best.) While it is true that the immediate impetus behind the suggestion that the president show his interest in the Holocaust was political, what is striking is that a decade earlier no one in the White House would never have considered a *Holocaust* memorial to be an appropriate way of repairing a political rupture with the American Jewish community. The existence of political tensions was far less noteworthy than was the choice of a Holocaust memorial as a means of assuaging those ill feelings.

In 1978, a year after Goldstein wrote her original memo, in the wake of the much discussed march of a group of Nazis through the streets of Skokie, Illinois, a suburb of Chicago with one of the largest survivor populations, William Safire wrote a column in the *New York Times* lamenting the fact that America had no national memorial to the Holocaust. Ellen Goldstein sent a memorandum to Stuart Eizenstat, Carter's Domestic Policy Advisor suggesting that building a museum would be both a way of honoring Israel's thirtieth anniversary and of demonstrating American support of Israel's "birth and continued life." At the outset some White House officials were concerned that this would look like, in Goldstein words, "glib public relations."[11] Despite these concerns and the fear that this might look like a "tacky effort to ride the coattails of the tv show," the idea for a Holocaust memorial was adopted by the White House because, as Eizenstadt scribbled on a note to Bob Lifschutz, "our relations with the Jewish community need every little boost possible."[12]

Eizenstadt together with Ed Sanders, who had replaced Marl Siegel as liaison to the Jewish community, were highly identified members of the Jewish community. They fully understood the moral and historical importance of Holocaust commemoration. As committed Jews, they were anxious to see this effort succeed for deep-seated personal reasons. As committed Americans, they felt it to be something that was in total harmony with American ideals. But as seasoned political activists they also understood its political potential.[13] Throughout the Carter White House's difficult relationship with the Holocaust Commission and its successor, the Holocaust Council, these various strains—the moral, historical, and ethnic—were in continuous conflict with one another. As Stuart Eizenstadt observed after he left the White House, whenever a government takes action there are political calculations that must be taken into consideration.[14] But fifteen years after leaving the White House Eizenstadt still remained bewildered at the degree to which something as ostensibly free of controversy as the Holocaust became

politicized.[15] While there were individuals in the Administration for whom this was primarily a political endeavor, for those most closely associated with the establishment of the Holocaust Council it was far more than just that. It was because Eizenstat, Siegel, Sanders, and some of their White House colleagues had been moved by considerations that transcended the political that they worked as hard as they did to keep the White House committed to this effort. By so doing they tested the patience of a number of their White House colleagues including their boss, the president, who seemed close to canceling the effort on a number of occasions.

In the spring of 1978 NBC broadcast its mini-series *Holocaust*. Despite being both a historically and dramatically flawed program that glossed over many of the worst excesses of the Holocaust, it had a tremendous impact. Today the show appears downright silly. However, it is not unreasonable to surmise that had it more graphically addressed the horrors of the Holocaust, as Spielberg did fifteen years later in *Schindler's List*, Americans might not have watched. Neither the audience nor the Hollywood entertainment industry were "prepared" for anything even close to Spielberg's uncompromising confrontation with the Holocaust. The very soap opera quality of NBC's *Holocaust* made it accessible to a massive audience, much of whom might have turned away from the more explicit images that Spielberg included in his movie. NBC's *Holocaust* paved the way for *Schindler's List*.

Among those who watched the show were Senator John Danforth and his family. So "moved" was the Senator by it that shortly thereafter he introduced a resolution establishing the weekend of April 29 as "Days of Remembrance of Victims of the Holocaust." He chose the date to coincide with the liberation of Dachau by American forces. Danforth had a number of objectives for this day. He wanted the American people to both "honor the memory of the victims of the Nazi concentration camps" and to "reflect upon the destructive nature of bigotry and the danger of tyranny throughout history." Danforth believed that every American needed "to take *personal* responsibility for the meanness of spirit in... [their] own lives" and that a Day of Remembrance would serve that purpose.

Danforth, who eventually agreed to move the date so that it would coincide with the date on the Jewish calendar that was commemorated as *Yom HaShoah*, saw Days of Remembrance in a specifically religious context. He insisted that a series of consecutive days be set aside so they would always coincide with a weekend. He wanted the commemoration to be observed in synagogues and churches. Danforth, who was also an ordained

Episcopalian minister, believed that "Religious leaders of every faith, [were]... best equipped to make Days of Remembrance significant periods of reflection."[16]

For Danforth, as a Christian, the Holocaust had a special significance. In his National Cathedral sermon on the Sunday following the rotunda service, he unapologetically linked the history of Jewish persecution to the actions of Christians and noted that "religious persecution of any kind is flatly contrary to the most fundamental beliefs of Christianity." He explained that two days were selected for Days of Remembrance to allow for consideration of the Holocaust from "at least two points of view: Jewish and Christian."[17]

Danforth's resolution passed the Senate with overwhelming support. The White House, which had already announced its intentions to appoint a Commission to seek ways to commemorate the Holocaust, agreed, at Danforth's request, to broaden the Commission's mandate to include incorporating ways to commemorate Days of Remembrance.[18] Though there was no opposition to this plan in the White House, in recommending to the president that he endorse Danforth's resolution, White House staff members took note of "the Resolution's importance to its sponsor, Senator Danforth, and his undecided position on the gas bill."[19] Politics could not be ignored.

But other complications were destined to develop. Seymour Bolton, the White House staffer originally assigned to this project, had developed a particular antipathy toward Eli Wiesel. This antipathy was rooted in their dramatically different definitions of the Holocaust. Bolton, who saw this endeavor in primarily political terms, was intent that the Holocaust Commission and its successor, the Holocaust Council, include representatives of a variety of ethnic and religious groups. He did not want it to focus exclusively or even primarily on the tragedy that befell the Jews, particularly since the other groups including Ukrainians, Estonians, Lithuanians, and Poles, among others, wanted to be around the table. For him Jews were one group of victims among many others.

Wiesel and those closest to him on the Commission believed the Holocaust to be primarily a Jewish tragedy in which not all the victims were Jews but all Jews were victims. They felt that those who sought to give this event a more universal definition were rewriting history and ignoring the way the Third Reich had made Jews the focus of their animus. Nazi Germany had not conducted a war against many peoples of whom some happened to be Jews. It had fought both a conventional war and a war against the Jews.

To have created a Holocaust Commission and to ignore this fact would have been, in the eyes of Wiesel and many of the Jews on this body, to decimate historical truth. But this was more than just a different interpretation of history. Wiesel was particularly horrified by the notion that representatives of these ethnic groups, groups which had not been targets of the Final Solution and many of whose members had actively participated in the killing, would sit on the Commission. This issue repeatedly threatened to derail the entire project. Relations between Bolton and Wiesel became so acrimonious that Bolton eventually asked to be removed from the project.

But Bolton was not simply expressing his own views when he fought for a non-Judaeocentric definition of the Holocaust. He believed that he was carrying out Jimmy Carter's mandate to stress the universal aspects of this event when he maintained that Jews were one group of victims among many others.[20] Bolton, it should be noted, was Jewish as were Eizenstat and Sanders. But unlike them, he had not been an active and committed leader of the Jewish community. The Jewish aspect of his identity did not seem to play as prominent a role as it did for the other two While House aides.

Apparently, for President Carter commemoration of the Holocaust was part of the seamless fabric of his struggle for human rights. This explains, in part, his great desire for as universal a definition of the event as possible. President Carter may have found the definition of the Holocaust as something that had claimed eleven million victims—six million Jews and five million others—particularly appealing. While still acknowledging that Jews had lost the most victims, such a construction removed the Holocaust from the "narrow" confines of a particularistic tragedy and gave it a more universal meaning.

In contrast to President Carter, for Wiesel the Holocaust was an unambiguously Jewish event. He was adamantly opposed to a construct of the Holocaust that diminished the Jewish aspect of the event. He feared, as he noted at meeting of the Holocaust Commission, that eventually people would speak of eleven million undifferentiated victims.

Wiesel did not ignore the Nazis' other victims. He chose the following definition of the Holocaust to include in the report of the President's Commission, "the systematic state-sponsored murder of six million Jews by the Nazis and their collaborators; as night descended millions of others were killed as well." His definition suggested a priority of intentialization of victims and not necessarily a chronology of when they were killed. In other words, the Nazis may have killed many others, e.g., handicapped,

Poles, Soviet POWs, and may have killed them before they killed the Jews. But their primary victim was the Jew.

This debate, over which a great deal of energy and passion was expended, sometimes seemed to have more to do with politics than with history. It is ironic that it consumed so much time and energy and became a lightening rod to exacerbate the differences between Carter and Wiesel. It is ironic because the number that was debated—five million non-Jewish victims—is today known to have little basis in fact. But in 1979 it was the "accepted" number of non-Jewish victims. It was reached by adding together the approximate death toll of the Soviet POW's, the Gypsies, handicapped, and non-Jewish Poles. The five million figure seems to have originated or, at the least, been popularized by Simon Wiesenthal as a way of ensuring non-Jewish interest in the Holocaust. Given the president's desire to make this as universal an endeavor as possible, this almost—but not quite—equal breakdown between five and six million was most convenient.

For Wiesel it had the exact opposite impact. Moreover, the Carter administration's behavior in conjunction with the numbers debate did not assuage Wiesel's fears. The original draft of the Presidential Proclamation on "DOR of Victims of the Holocaust," which was released in the beginning of April, included the following sentence: "This terrible legacy has left deep emotional scars with the Jewish people and with all mankind." When the proclamation was issued "the Jewish people" had been omitted from it and the sentence was redrafted to read: "Their legacy left deep moral scars on all humankind."[21] Moreover, when Carter originally announced his intention to create a Commission he spoke only of the "six million." Subsequently, in the Executive order creating the commission, he made reference to "those who perished." But in the rotunda he heightened Wiesel's fears when he said of the Holocaust, "the sheer weight of its numbers—eleven million innocent victims exterminated—six million of them Jews."[22] Wiesel's fears were further realized when the *Atlanta Journal* gave the following headline to its article on this event:

Holocaust:
Remembering the 11 Million[23]

About a week before the ceremony Bolton complained to Ed Sanders, White House Liaison to the Jewish Community, about the planners' failure to "maintain a delicate balance between the Holocaust as a tragic episode in Jewish history and the universal significance of the event and its mean-

ing to all mankind." He was particularly annoyed by what he described as "Wiesel's decision to light six candles for the six million Jews who were exterminated and one candle for all the other five million non-Jews who perished during the Holocaust, as well as the Armenians."[24]

There is another irony here. Whereas Bolton was angry about Wiesel's decision to leave *only* one candle for the non-Jewish victims and the Armenians, others in the White House were also annoyed, not by the loss of perceived "balance," but by the decision to broaden the parameters of the event and include Armenians all together.[25]

Commission Chair Elie Wiesel, Commission Director Rabbi Irving "Yitz" Greenberg, and Deputy Director Michael Berenbaum, were responsible for forging the ceremony. Once these men realized that April 24th was Armenian Genocide day, they considered it a foregone conclusion that the Armenians would be included in the ceremony. According to Michael Berenbaum disregarding would have meant that the "Jews were inside while the Armenians were left outside" on the day commemorating their slaughter by the Turks.[26] Not only did those organizing the day include references to the Armenians in the service but Irving Greenberg wrote to editorial page editors nationwide calling attention to the confluence of the two events.[27] It is true that had the dates not coincided the Armenians probably would not have been included. However, according to Greenberg, by including the Armenians the organizers were not equating the two tragedies but demonstrating the inevitable results of the world's failure to learn anything from the Armenian genocide. Including the Armenians served another unspoken purpose, it demonstrated that the Jews were not focused only on their own suffering. It allowed Wiesel to be selectively inclusive, i.e., it was a way of including others but not necessarily the "others" that the White House wanted included, i.e., Poles, Ukrainians, etc. In the eyes of many of the survivors involved in this effort, to have included members of these ethnic groups, some of whom had shed Jewish blood, as representatives of the victims would have been the equivalent of equating the perpetrators and their accomplices with the victims.

Even though Armenian participation was limited to a candle lighting and a prayer by a cleric of Armenian descent the Turkish embassy protested to the State Department.[28] The White House recognized that it was too late to change the program but they worked to diminish the attention given to the Armenians. The original draft of the president's remarks contained a direct reference to the Armenian genocide. It noted that it was "especially

fitting also that we recall today the terrible beginning sixty-four years ago of the genocide against the Armenian people"[29] At the suggestion of National Security Adviser Zbignew Brezezinski and the State Department, the references were eliminated.[30] The relevant sentence now reads

> So it is fitting also that we recall today the persecution, suffering and destruction which has befallen so many other peoples in this century, many of whose representatives have joined us at this observance today.[31]

But it was not only references to Armenians that were declared off limits. The speechwriters were also instructed not to address the issue of the German statute of limitations.[32] At this time the White House was under pressure from both Jewish and veterans groups to urge Germany not to let its normal statue of limitations apply to Nazi war criminals. (Had that happened it would have become impossible to prosecute these criminals.) The National Security Council and State Department opposed Carter taking any public action on this matter. They wanted the president to say nothing. (They even opposed the president congratulating Chancellor Schmidt when the debate ended and the Bundestag decided that the statute would not apply to Nazi war criminals.[33]) National Security Council and State Department officials feared that the German public would perceive of any American comments on this matter as foreign interference in their country's democratic parliamentary process. It might appear as if Chancellor Schmidt had succumbed to American pressure. That, in turn, might politically impair Schmidt's ability to accede to Carter's other requests on foreign policy matters. One of the major issues then under consideration was the stationing of American missiles on German soil.

When the issue of the statute of limitations was being debated in the press, the White House was able to remain silent—despite the pressure of both Jewish and veterans groups—without incurring any political costs because of its creation of a Holocaust Commission. No one could accuse the Carter administration of being insufficiently concerned about the Holocaust and the crimes committed by Germany. Therefore, those calling on the White House to urge Germany to act on the matter had relatively little political leverage.

The speechwriters were also instructed not to address the issue of the Justice Department's plans for action against Nazi war criminals in the United States. Shortly before this ceremony, in response to intense com-

plaints from members of Congress, veterans, and Jewish groups about the abysmal efforts the Federal government had made at tracking down and prosecuting war criminals in this country, the Congress had authorized the establishment of the Office of Special Investigations (OSI), an arm of the Justice Department dedicated to finding war criminals who had entered the country illegally. Though the White House gave every indication of vigorously supporting the OSI, those in the President's inner circle took a much dimmer view of its prospects for success. This was reflected in the scribbled note one White House insider sent to the speechwriters preparing the president's remarks for the rotunda. He warned them to stay away from the issue of a "few remaining war criminals in the United States" as the latter would not "amount to much."[34]

The unambiguously Jewish nature of the ceremony may constitute the most significant symbolic moment of the entire event. Despite the fact that the commemoration was held in America's most important common space the organizers felt no compunctions about structuring this as a traditional Jewish memorial service. Those responsible for designing the service understood the Holocaust to be an unambiguously Jewish tragedy, a fact that made White House staffers, Bolton most prominently among them, decidedly uncomfortable.

In fact, the particularity, as opposed to universality, of this service was significant not because of its connection with the debate over the identity of the victims, i.e., the five million versus six million imbroglio. The Jewish nature of this service commands itself to our attention because it is indicative of the degree to which those who organized it and many members of the Commission felt entirely comfortable as Jews and as Americans. They felt no need to balance or diminish the religious nature of the commemoration or to create a quasi-ecumenical service. Nor did they feel any need to let America "off the hook" for its own wartime failures. They had turned the teaching of the nineteenth-century Jewish enlightenment thinker, Y. L. Gordon, "be a Jew in your home and a man in the street," on its head. While some—though certainly not all—of the Jews gathered that day in the rotunda had the skills to be Jews in their homes, by participating in this service they acted as Jews in an unambiguous and unapologetic fashion in America's most significant street.

The ceremony in the rotunda in April 1979 was a commemoration not only of the victims of the Holocaust but the degree to which America and American Jewry had changed since that tragedy.

NOTES

1. *Washington Post,* April 25, 1979, D1.
2. In the five years since it opened the museum has averaged two million visitors a year.
3. When he accepted the appointment to head the Commission, Wiesel had asked the president for a special session of the Congress, something that the president could not arrange. The Capitol Rotunda services was in lieu of that session. Interview with Michael Berenbaum, November 4, 1997. Blanchard's remarks in President's Commission on the Holocaust transcript, February 15, 1979, p. 140. Edward T. Linenthal, *Preserving Memory* (New York, 1995), p. 27.
4. Linenthal, p. 6.
5. Dorothy Rabinowitz, *New Lives* (New York, 1976). American soldiers often recalled, when they were interviewed thirty years after the war, being discouraged by their family members from discussing what they had seen when they entered the concentration camps. *Witness to the Holocaust Collection,* Emory University.
6. Deborah Lipstadt, "The Children of Jewish Survivors of the Holocaust: The Evolution of a New-Found Consciousness," *Encyclopedia Judaica Yearbook,* 1989, [Keter, 1990], pp. 139–50.
7. That same activist, the author of this article, has long since learned that history is far more complicated than she assumed it was in 1972.
8. My thanks to Hasia Diner for helping me develop this point.
9. The *Washington Post* story on the ceremony carried the following headline: "The World Knew and Kept Silent," *Washington Post,* April 25, 1979, D1.
10. Ellen Goldstein to Mark Siegel, June 21, 1977, Domestic Policy Staff, Stuart Eizenstat: Holocaust Memorials, 5/78–9/78, Carter Presidential Archives.
11. Goldstein to Eizenstat, March 28, 1978, Domestic Policy Staff, Eizenstat: Holocaust, 5/78–9/78, Carter Archives. By this point in time Siegel had left the White House in protest over its Middle East policy and the sale of sophisticated fighter aircraft to Saudi Arabia. He felt that he had been betrayed by the NSC about the offensive, rather than defensive, nature of such weapons.
12. Handwritten note 4/26/1978 attached to Lipshutz and Eizenstat to President Carter, April 25, 1978, Lipshutz File, Holocaust Memorial Council 4/77–12/78, CF, O/A 437, Box 18, Carter Archives.
13. Eizenstat to Wiesel, February 15, 1980, WHCF, Executive File, CO 54-2, box CO-27, 1/1/79- 6/30/79, Carter Archives.
14. Interview with Stuart Eizenstat, Miller Center Interviews, Carter Presidency Project, vol. XIII, January 29–30, 1982, p. 59, Carter Archives.
15. Stuart Eizenstat to Deborah Lipstadt, October 1995.
16. *Keeping in Touch . . . by Senator Jack Danforth"* for release week of 6/5/78. *News from Senator Jack Danforth* for release week of 5/18/78. Files of United States Holocaust Memorial Museum.
17. *Cathedral Age,* vol. LIV, no. 2 (Summer 1979): pp. 10–13.
18. Goldstein to Eizenstat, August 15, 1978, Domestic Policy Staff, Eizenstat, Holocaust Commission O/A 6242 [2], Carter Archives.
19. Eizenstat and Goldstein to President Carter, September 15, 197, Domestic Policy Staff, Eizenstat, Holocaust, 5/78–9/78, Carter Presidential Archives.
20. Conversation with Michael Berenbaum, October 30, 1998.
21. Bennet, to McIntryre, March 15, 1979, Office of the White House Press Secretary, WHCF, Exec. HO/D 1/20/77–1/20/81 Box FG 231. Compare this to "Days of

Remembrance of Victims of the Holocaust, April 28 and 29, 1979," by the President of the United States of America: A Proclamation, #4652 , *Administration of Jimmy Carter,* 1979, April 2, 1979.

22. *Report to the President: President's Commission on the Holocaust,* Washington, D.C., September 27, 1979.

23. *The Atlanta Journal,* April 24, 1979, p. 2A.

24. Bolton to Sanders From Seymour Bolton, April 16, 1979. Lipshutz File, Holocaust Memorial Commission, CF O/A 437, Box 18, 1–9/79.

25. Sanders to President Carter, April 23, 1979. Special Advisor to the President Moses, Holocaust Memorial Council, 1/2/78- 4/27/79, #7. Carter Archives.

26. Interview with Michael Berenbaum November 4, 1997.

27. Memorandum to: Editorial Page Editors, from Irving Greenberg, April 9, 1979. United State Holocaust Memorial Museum Archives.

28. The Turks were not alone in their criticism. According to Yitz Greenberg the Israelis, particularly those associated with Yad Vashem were also distressed. Greenberg Interview, October 10, 1997.

29. Draft #2, 4/19/79, Speechwriter Chronological File: Remarks Holocaust Observance, Capitol Rotunda, BA 4/24/79.

30. Sanders and Aronson to President Carter, April 23, 1979, Special Advisor to the President Moses, Memos: Presidential, 2/12/79–4/14/80, #10, Carter Archives.

31. Draft #1, #2, 4/19/79, Speechwriter Chronological File: Remarks Holocaust Observance, Capitol Rotunda, BA 4/24/79, Carter Archives.

32. See undated and unsigned handwritten notes attached to copy of Bolton to Sanders, April 16, 1979. Speechwriter Chronological File: Remarks Holocaust Observance, Capitol Rotunda, BA 4/24/79, Carter Archives.

33. Simmons to Eizenstat, September 7, 1979, WHCF, Executive, JL3, 8/1/79–9/30/79.

34. See undated and unsigned handwritten notes attached to Bolton to Sanders, April 16, 1979. Speechwriter Chronological File: Remarks Holocaust Observance, Capitol Rotunda, BA 4/24/79, Carter Archives.

1 0

"PLENTY GOOD ROOM..."
IN A CHANGING BLACK CHURCH[1]

Cheryl Townsend Gilkes

> *There's plenty good room*
> *Way in the Kingdom....*
> *Choose your seat and sit down!*

—Traditional Negro Spiritual[2]

TWO-THIRDS OF THE WAY THROUGH the twentieth century, the activisms of the 1960s changed the entire society and its diverse spectrum of religious experiences. Some thought these changes significant enough to be called a revolution.[3] The black community, in many ways, most directly experienced many of the problems—for instance, Jim Crow, poverty, institutional racism, and conscription for the war in Viet Nam—that gave rise to the movements of the 1960s. While civil rights and black power activism in the black community provided models for other groups as they addressed their particular hurts and needs,[4] these revolutions and movements of the 1960s sparked controversies and conversations within the religious communities of black America and encouraged the growth of a new black consciousness.[5] As a result, the denominations and congregations controlled by black people in the United States underwent profound changes; the Negro Church ceased to be and the black church was born.[6]

Influenced by Malcolm X, leaders of the Student Nonviolent Coordinating Committee started a black power movement that sought to increase economic position, political power, and cultural self-awareness of black Americans.[7] That movement mobilized, reorganized, and inspired black people to transform old organizations and create new ones within the communities they sought to control. In the context of continued subordination, powerlessness, and aggressive state repression, black churches

and mosques maintained their historic role as the public sphere,[8] while the convocations of the black church addressed this new emphasis on power and self-definition and coped with social change.

The most visible recent change in American religion was the emergence of the megachurch.[9] Although African Americans are only 12 percent of the U.S. population, they are 25 percent of its megachurch congregations. These congregations are bursting with crowds of black baby boomers, or so-called buppies, who have "come home" to church.[10] The fascination on the part of the press with these very prominent churches often has obscured the older traditions on which they are built and the deeper networks in which they are embedded—traditions and networks that have historically nurtured and challenged American religious culture. Although megachurches are harbingers of more profound changes affecting all black churches in the United States, their newness is more apparent than real. The emergence of a wide variety of new churches and the dramatic transformation of a significant number of old ones at a time when the black community itself is experiencing a major socioeconomic restructuring invites questions about the current state of African American religion. This chapter seeks to identify significant features shaping the contemporary black church[11] or "the church of what's happening now."[12]

The civil rights and black power movements changed black communities, and the subsequent rise in black consciousness shook black churches to their very foundations. These changes in consciousness occurred when the consequences of the civil rights movement fostered the economic and occupational mobility of a significant segment of the black population.[13] At the same time that this indigenous black middle class grew, changes in the immigration laws opened the doors to an African and Caribbean immigration that changed black neighborhoods, churches, and cultural expression, reinforcing the Afrocentric emphases of many congregations. The mobility—both socioeconomic and geographic—of younger black people meant that, as had happened during earlier migrations, significant numbers of black Americans switched congregations, carrying diverse denominational and local traditions into the more Anglo-conformist, mainstream congregations and thus reorganizing and sometimes reinventing African-American tradition. Their increased education contributed to the professionalization of the laity. The larger numbers of church members with graduate and professional degrees offered and demanded new levels of teaching and service, contributing to a proliferation of innovative and diverse ministries and sending their pastors into doctoral and other graduate programs in response to these new

demands.[14] As has been the case historically, gender relations were profoundly implicated in all of these changes. Controversies and conflicts surrounding the black family, intimate relations, and sex roles engendered both an assertive emergence of the black church's historic womanist infrastructure and a rhetorical and organizational attention to the problems of black males.

Overall, this black church "of what's happening now" is an absorbent and adaptive institution that both fosters social change, pursuing the "dual agenda" of social justice and economic equity,[15] and mediates and interprets the impact of structural transformations on diverse, dynamic, and disadvantaged black communities. As Roof and others have pointed out, major social changes since World War II have reshaped and restructured American religion overall.[16] However, the demographic trends pointing to a shrinking white American mainline have not applied to black churches. These churches held their memberships during and after the crises of the 1960s,[17] but those segments of the black church often dismissed as "sects and cults" and portrayed as deviant[18]—preferably referred to as the "Sanctified Church"[19] by black Christians—actually grew in size and in prestige, sharing equally in the status and culture of the black church's denominational mainstream.[20] After sketching the impact of the 1960s on the black church, this essay points to these changing trends—heightened cultural and sociopolitical consciousness, rapid mobility, revitalization, professionalization, and gender relations—as aspects of church organization and ethos that both reflect and nurture, through a dynamic and adaptive interaction, the growth and revitalization of congregational life and community presence.

BEYOND THE BLACK MEGACHURCH

There has always been an edifice complex in the study of black churches in the United States. First it was storefronts; now it is megachurches. The emergence of megachurches in black communities builds upon an older but unrecognized feature of black church history. At key points in the history of black Americans, the large congregations of the black church have been the primary gathering place from which black Americans asserted their humanity and adapted to changing conditions in a racist society.

Social scientists and journalists tend to define a megachurch as a congregation of more than three thousand members.[21] However, the black church has a tradition of large churches that precedes the Civil War. Albert Raboteau points out, "town churches... drew slaves from both town and country,

swelling in size to hundreds and in a few instances, thousands of members."
One could perhaps persuasively argue that First African of Richmond,
Virginia, with its membership of 3,260 in 1860 would certainly qualify as a
megachurch.[22] Clarence Taylor, in his model study of *The Black Churches of
Brooklyn*, identifies a fair number of congregations whose memberships
exceeded three thousand in the first half of the twentieth century.[23] Before
1940, northern migration brought the memberships of Holy Trinity, Bethany,
Concord, and Mount Lebanon Baptist Churches to memberships of 3,100,
3,600, 8,600, and more than 4,000 respectively. When the late Adam Clayton
Powell, Jr., assumed the pastorate of New York City's Abyssinia Baptist Church
in 1937, "the church had ten thousand members and was one of the largest
Baptist congregations in America."[24]

Contemporary megachurches have usually grown quite rapidly,
attracting quite a bit of attention and, occasionally, hostility in their com-
munities. Although they are manifestly middle class, their worship style
reflects the older tradition of the Sanctified Church and other shouting
churches. Their music is the best gospel music, and the preaching there is
some of the best biblically based preaching to be heard. Furthermore, most
black megachurches offer a high degree of affirmation of a black identity
in a hostile white society. The church reminds its members, "who they are
and whose they are," as a counterforce to oppressive social, economic, and
cultural circumstances that may make them want to forget.

These megachurches are the most visible evidence of a revitalization and
reorganization of black church life that has been taking place since the late
1960s. There are many other black churches that have experienced explosive
growth in both inner-city and suburban locations without becoming
megachurches. Their rapid rates of growth point to other, more complex fea-
tures shaping trends in black churches. These other features—such as con-
gregational culture, volunteer, and professional roles, class structure, and
theological and cultural values—may point to a larger set of concerns
throughout the black community and provide a better portrait of religion in
the entire African-American experience since "the revolution" has come.

CIVIL RIGHTS, EMPOWERMENT, AND BLACK CONSCIOUSNESS

"When the revolution came,"[25] according to the poet Carolyn Rodgers, a new
generation of African Americans questioned the political relevance of black

Christian organizations, beliefs, and practices, especially the love ethic of the civil rights movement, challenging the hegemony of the black church in African-American life and culture. The Black Muslims (the Nation of Islam), "the largest indigenous population of Americans who have become Muslims," nurtured this challenge.[26] Members of the Nation of Islam often engaged in a practice called "fishing," where they stood outside of black Christian congregations as the Sunday service ended, haranguing church members about the contradictions of Christianity in white America. Spike Lee's film *Malcolm X* depicted Malcom X as offering one such typical challenge:

> You think you are Christians, and yet you see your so-called white
> Christian brother hanging black Christians on trees.... That white
> man...has done every evil act against you. He has everything while
> he is living and tells you to be a good slave and when you die you
> will have more than he has in Beulah's land. We so-called Negroes
> are in pitiful shape.... Come out of the sky. Build heaven on earth.
> Islam is the black man's true religion.[27]

The Black Muslims directly addressed the discontents of the ghetto and dissented from the ethical emphases of Martin Luther King, Jr., and the Southern Christian Leadership Conference.

The civil rights movement changed America, achieving what Lewis Killian called an "impossible revolution" by overthrowing a body of law in a nation supposedly under the rule of law.[28] The civil rights revolution was the most significant mobilization of the black church;[29] it brought the ethics, traditions, and practices of the black church into the foreground, placing a harsh spotlight on the segregated Sundays of American Christians. Violent reaction to a decidedly Christian civil rights movement was usually expressed in church burnings and bombings, and the dissenters pointed to such violence as more reason to criticize and belittle the love ethic of black Christianity. The Black Muslims' criticisms were carried forward by Malcolm X, the Student Nonviolent Coordinating Committee, and others in what came to be called the black power movement.[30] They articulated the problems of institutional racism, internal colonialism, and economic justice as the central issues to be addressed by black power. They also countered the cultural humiliation and assaults on self-esteem embedded in America's history of racism with calls for black pride.

Black churches responded with organized challenges to white churches through the National Committee of Black Churchmen and demands for reparations as they promoted a revolution within.[31] The transformation

was so profound that C. Eric Lincoln described the moment as a change from Frazier's "Negro Church"[32] to "the Black Church." He wrote:

> The "Negro Church" that Frazier wrote about no longer exists. It died an agonized death in the harsh turmoil that tried the faith so rigorously in the decade of the "Savage Sixties," for there it had to confront under the most trying circumstances the possibility that "Negro" and "Christian" were irreconcilable categories. The call to full manhood, to *personhood*, and the call to Christian responsibility left no room for the implications of being a "Negro" in contemporary America. . . .
> The Negro Church accepted death in order to be reborn. Out of the ashes of its funeral pyre there sprang the bold, strident, self-conscious phoenix that is the contemporary Black Church.[33]

The successes of the civil rights movement highlighted deeper social problems and revealed a legacy of economic inequality, political exclusion, and cultural humiliation. Voter registration and political organization revealed the connections among political powerlessness, economic disadvantage, miseducation, and the larger structured outcomes that came to be called institutional racism.[34] The new militant black power rhetoric also masculinized the language of black liberation at precisely the same moment that white women began to challenge sexism in America and the U.S. government published a report on black families that vilified black women, interpreting their labor history as a force emasculating black men.[35]

New and expanded opportunities changed the class configurations and collective consciousness of congregations and other organizations as professionalized activists and activist professionals joined the leadership class formerly monopolized by pastors and their allies. "When the revolution came," brothers and sisters in black churches were forced to reposition themselves in a space that was itself shifting. While black churches, in contrast to white churches, did not lose their memberships, the generation we now call baby boomers experimented with a wide variety of organizations and spiritual perspectives before returning "home."[36]

MOBILITY, MIGRATION, AND THE CRISIS OF CONNECTEDNESS

Shortly after World War I, a Baptist deacon in Little Rock, Arkansas, admonished his daughter as she prepared to migrate north with her husband, a

Pullman car porter, "Don't ever forget your church and the NAACP [National Association for the Advancement of Colored People]." As I recorded her life history I was surprised at how similar was my own father's admonition during the 1960s as I prepared to leave home for college: "I don't care what you decide to believe, remember you can't get anything done in the community without the church." The perception of the church as a source of connection and activist efficacy had not changed across those two generations as the eighty-seven-year-old community and church mother and the twenty-seven-year-old sociology graduate student faced each other across a cassette tape recorder.

Migration, mobilization, and movement are themes that define and describe the black experience and that cluster around the points in black history where class composition and black occupational attainment changed substantially. According to Bart Landry, 90 percent of the black population remained in agricultural and service work until World War I.[37] Two world wars and restrictive immigration made black northern migration and entry into the industrial sector possible. The actual "emergence of a new black middle class" was prompted by "two simultaneous and powerful forces within American society: prosperity and the civil rights movement."[38] In the 1960s, this middle class doubled to 28.6 percent of the black population and then grew during the 1970s and early 1980s to 37.4 of the black population.[39] These changing class configurations changed black churches. Greater educational opportunities and career choices fostered a great deal of geographic mobility. This new prosperity also prompted suburbanization and, as large black middle-class populations moved to the suburbs, usually black suburbs, some churches followed.

The old and new black middle classes met in the churches. Some of the most vibrant black megachurches had former identities as "silkstocking" congregations of the "old" black elite or black bourgeoisie[41] and were transformed by massive infusions of these economically mobile younger people. They were historic congregations and small, having fewer than one hundred members. They were part of either predominantly white denominations or established black denominations when a new pastor, who represented the civil rights and black power generation's consciousness, was either called or assigned. While methods of recruitment and revitalization varied, these pastors drew members of the new black middle class who were college students, former members of the Nation of Islam, newly affluent middle-income families, self-critical members of the black bourgeoisie, and migrant and immigrant black professionals seeking a new church home. In some cases, these

congregations were spaces where the new and old middle classes and elites had the opportunity to integrate and socialize with each other. In one southern congregation, whose leadership was historically tied to a black-owned insurance company, the church's revitalization and transformation was so sudden and abrupt that working-class members of other churches would come to visit just to see for themselves that the members were really shouting and saying "Amen" and that a more vibrant worship style was actually taking place. The church had outgrown its building and moved to a larger more suburban setting. At the end of a particularly exciting church service at the new site, a church leader, a member of the old elite, said to me, with tears of joy streaming down his face, "This used to be the First Church of the Frigidaire!"

Some churches in deteriorating inner-city locations made a conscious effort to reach out to newer networks in the neighborhood as the older church population became commuters from suburban locations. Such centrally located churches also attracted black professional members from the suburbs whose only experience of a black majority was in their Sunday morning service. For black professionals who worked in overwhelmingly white settings, the cultural comfort of these black churches provided therapeutic relief from the micropolitics of being black in a white and unpredictably hostile world; this was especially true for women.[41]

African Americans have traditionally felt deep anxiety over social class divisions, and such anxiety is evident in the popular culture. The negative interpersonal consequences of social mobility where children return from college ashamed of their parents' speech patterns and country ways and where middle-class congregations attempt to suppress the ecstatic expression of their members are sung about in gospel music and preached about from pulpits. E. Franklin Frazier's critique of the old black middle class, *The Black Bourgeoisie*, was so well popularized among African Americans that a pejorative term, "bourgie," emerged and became a hit record by rhythm and blues singer, Gladys Knight. A culturally relevant religious explanation of one's good fortune in the face of so many who had been left behind became necessary. The nature of black social mobility is so precarious ("one paycheck away from poverty") that prosperity is both a blessing and a problem in theodicy. Some of the newer churches or newly expanded congregations became places where an explicit doctrine of prosperity was preached. For African Americans, such a doctrine was a departure from more traditional liberationist and perseverance themes. Such preaching facilitated psychological relocation and integration in the world of affluence.

Mobility in the black community, in terms of geographic and social relocation, has always produced a crisis in connectedness. For members of Frazier's "black bourgeoisie," staying connected to the African-American mainstream sometimes meant membership in two churches, what black people jokingly called a church of "the masses" and a church of "the classes." The rhetoric of civil rights and black power fostered a moral position of solidarity across social class. Affluent black Americans felt more direct social pressures than their white counterparts to maintain a bond with their "brothers and sisters" who do not have their talents, skills, education, or simply good luck. Because of the recency of middle-class expansion, the vast majority of members in the black middle class have siblings and other kin who are not only not middle class but who also embody the problems of disadvantage, disorganization, and deprivation. The crises of these poor relations may punctuate and disrupt the lives of the affluent, whose response may be shaped by a deep sense of obligation to unusually strong kinship bonds.[42]

Since before the end of slavery, black communities have enforced the expectation that the educated should lead by teaching and sharing skills. Churches became the setting where such connectedness across class boundaries was fostered. In the revived and expanded churches, this may be done through a wide variety of social programs or ministries. In some cases, black churches have developed private schools. After-school and career-day programs for young people provide mentors who serve as models for occupational attainment and success. Overall, the church became the site for personal, social, and cultural integration and reintegration as class configurations changed.

REORGANIZATION AND REINVENTION OF TRADITION

The growth and mobility of the black middle class in the context of a post-civil-rights- and post-black-power-era church sparked a rediscovery of black tradition. One heard a renewed and transformed gospel music shaped by musicians trained in both the folk traditions of the Sanctified Church and the classical music theory of the conservatories.[43] The black power movement's insistence on black pride prompted many African Americans to cease feeling ashamed of their old-time religious ways. The cultural renewal that came with celebrations of Black History Month and the emphasis on black theology in the academy also encouraged a reinvention of the black church as a social and cultural center. Such cultural

renewal prompted Trinity United Church of Christ in Chicago to declare that its members were "unashamedly Black" as well as "unapologetically Christian." Murals and stained glass windows with black and brown faces appeared in place of or alongside more traditional images of a white Jesus.

The reorganization and reinvention of tradition were manifested in the revitalization and revival of churches often labeled "seditty," "bourgie," or "dead."[44] In their study of more than two thousand churches, Lincoln and Mamiya noted the rise of what they called "neo-Pentecostalism" in black churches.[45] Styles of worship that had come to be associated with the Holiness and Pentecostal denominations and congregations "over in the Sanctified Church," could be seen and heard in the traditionally middle-class churches of the 1970s and 1980s. While Lincoln and Mamiya focused on the rise of this phenomenon in the African Methodist Episcopal (AME) Church, it was something that occurred in churches of various denominations and sizes that experienced growth and revitalization as their middle-class memberships grew. Congregations in historically black denominations changed, and black congregations in historically white denominations became more "black," defining their blackness in terms of their commitment to the traditional ecstatic style that emphasized what Du Bois called "the religion of the Spirit."[46]

College men and women who grew up in the Sanctified Church attended black and white colleges all over the United States. Like most college students, the break from home sometimes meant a break from the home church. The revived and renewed black churches often provided a special call to come home, albeit to a new place, and also provided a space to be black without white hostility and pejorative assumptions. Bishop John Bryant of the AME Church, identified by Lincoln and Mamiya as an exemplar for this neo-Pentecostal movement, recruited undergraduate, graduate, and professional school students to one of his early pastorates, a pastorate that became a magnet for a nationally connected corps of new clergy.[47] In addition to AME students, his efforts attracted Pentecostal, Holiness, Baptist, and other students who brought with them a love of ecstatic worship and a wide variety of talents, including musical ones. These new members reclaimed traditions familiar to those raised in "shouting churches" and essentially revived a dead church. Members of the local community jokingly referred to the church as "AMEP" or "African Methodist Episcopal Pentecostal." Sometimes the term "Bapticostal" was also used.

Another source of transformation and revitalization of mainline black churches came from seminarians crossing denominational lines in order to

complete internships in approved church settings. Since many black male seminarians arrived at seminary fully ordained, they were not bound to their denominational body in order to fulfill the internship requirements for graduation. Black female students seeking ordination were able to seek out less sexist and more welcoming settings in which to explore their vocations and become ordained. Students from the Sanctified Churches often found that there were no approved settings in their own traditions but their preaching skills and other talents opened doors for them in the approved mainline Baptist, Methodist, and African Methodist traditions. These seminarians articulated an ecstatic tradition that older members longed for, securing opportunities for pastoring early in their careers. The permeability of black denominational boundaries that facilitated the adjustment to urbanization and migration for earlier generations served the same purposes for "the golden cohort" as they moved into new church settings with their upwardly mobile age peers—both as ministers and congregants. Combined with an emphasis on the Spirit, these relocations led to denunciations of denominationalism, reflecting a resolution to what Lincoln and Mamiya have called "the challenge of black ecumenism."[48]

PROFESSIONALIZATION OF THE LAITY

There is a saying in the black church that "your gifts will make room for you." A larger educated and talented black middle class meant a larger pool of talent available to serve their churches. The quality of services and this educated laity's demands for professionalized, high-quality service, especially from their clergy, increased dramatically. These demands coincided with the challenge of black power advocates to assume "community control" and to build "black institutions." The poet Carolyn Rodgers describes this process better than any sociologist when she writes:

> and when the revolution came
> the militants said
> ... we got to
> build black institutions where our children
> call each other sister and brother
> and can grow beautiful, black and strong
> and grow in black grace.... [49]

Well-educated black professionals, whose sensibilities and spirituality had been shaped by the *zeitgeist* of black power, returned to church either

with the realization that the church embodied the ideals they had valorized through their political activities or with the determination to make the church fulfill its potential in the black community and the world. Rodgers described these consequences in her poetry:

> ... the militants looked around
> after a while and said hey, look at all
> these fine buildings we got scattered throughout
> the black communities some of em built wid schools and nurseries
> who do they belong to?
>
> and the church folks said, yeah.
> we been waiting fo you militants
> to realize that the church is an eternal rock
> now why don't you militants jest come on in
> we been waiting for you
> we can show you how to build
> anything that needs building
> and while we're on our knees, at that.[50]

The dramatic increase of black participation in higher education that followed the civil rights movement provided a more highly credentialed clergy. Historically, a significant portion of African-American clergy pursued their religious vocations as adults engaged in other occupations, often, as jokes and folklore implied, while plowing, planting, or picking in the hot sun. Now African-American women and men were answering their calls to Christian ministry while "trespassing" in the corporations and institutions of hostile white privilege where the taint of affirmative action dismissed and trivialized their considerable educational and professional achievements.[51]

Revival and renewal within these churches challenged members to use their gifts and talents in the service of the church. Those gifts and talents came with a larger number of graduate and professional degrees. Church nurses' units no longer consisted of nurses' aids and licensed practical nurses, but also registered nurses with college degrees. Their traditional roles as attendants to worshippers overcome by the Spirit continued, but they added blood pressure screenings, health fairs, and health education to their repertoire. Doctors and lawyers offered their services as mentors to young people. Accountants and other business professionals assumed roles on trustee boards and as church treasurers. Young professionals with chil-

dren willingly taught Sunday school, and large churches staffed their independent schools from their congregations. Church social service and counseling centers also found highly talented and credentialed professionals among their members.

Pastorates in Protestant churches had always represented what sociologists call a "two-person career."[52] They comprised pastors and their wives. Pastors' wives were often missionaries, music directors, stewardesses, deaconesses, and other highly visible church workers who functioned as leaders of the female infrastructure that was the proverbial backbone of the church. They taught the Sunday school and represented their churches at the conferences and convocations that constituted the black church regionally and nationally. Usually the pastor's wives also had professional employment outside the church as nurses, teachers, or social workers. More recently, those second persons in the clergy career had graduate degrees and professional careers in law, medicine, and business; they were a resource for the church and a model for the members. An increasing number of these women discovered their own vocations for Christian ministry, carving out new careers as their husbands' co-pastors or in settings independent of their husbands.

The black church had always been characterized by its traditions of biblical literacy. Even during slavery and immediately afterward, those few who could read made it their business to teach others and to read the Bible for themselves and their communities.[53] The rise of the Sanctified Church beginning at the end of Reconstruction in the South was accompanied by elaborate biblically based defenses of that church's ecstatic worship, "in the Spirit," which included shouting and the holy dance.[54] These same shouting saints pushed their children and grandchildren to secure as much education as circumstances would allow. The countercultural dimensions of black religion and the effectiveness of preaching depended heavily on an understanding and knowledge of the Bible that was widely and deeply shared. In the aftermath of the civil rights movement, black church members were as well educated as the majority of their clergy or sometimes better educated. The emphasis on Bible study and on teaching in the context of preaching was not simply an expression of Bible-believing fundamentalism;[55] rather this emphasis represented an extension of a highly elaborated biblically based worldview.[56] The "churches of what's happening now," the churches with reorganized and revived traditions and a newly expanded professionalized laity, emerged as congregations with an explicitly stated thirst for sophisticated biblical knowledge.

MILITANT MANHOOD AND WOMANIST
INFRASTRUCTURE IN CONFLICT

One of the most poignant and lasting images of the civil rights movement is a long line of garbage workers in Memphis, Tennessee, wearing signs saying, "I AM A MAN." Between 1965 and 1968, black power advocates transformed the language of America, nearly erasing the term "Negro" from the consciousness of white and black America and replacing it with the term "black." The problem of the Negro became the problem of "the Black Man" and the rhetoric of black revolution was heavily masculinized. The Nation of Islam had long claimed the term "black," accepting the label "Black Muslims," and declaring Islam to be the "religion of the Black Man."[57] Indeed the organization of African-American religion became so gendered that Lincoln and Mamiya point to "the phenomenon of more black males preferring Islam while more black females adhere to traditional black Christianity" as a serious challenge facing the black church.[58] The challenge of Islam, with its male-centered analysis of the black condition, entered the mainstream of black struggle at precisely the same moment that U.S. government reports and social policy targeted the black family and the too-prominent role of educated black women in their families and society.[59]

Ironically, the proportion of black men entering the ministry dropped even as black church memberships stayed stable and began to grow.[60] As Lincoln and Mamiya point out "there has been an increased interest in the ministry among black women, and the decade of the 1980s has shown the largest and most dramatic increases in black women seminarians in major divinity schools."[61] Although, Lincoln and Mamiya continue, "black women are stepping forward to offer their participation in the leadership of the most historic and most independent institution in the black community,"[62] they do so, in the words of AME pastor, Vashti Murphy McKenzie, "not without a struggle."[63]

Women historically have been the most important agents of organizational integrity in the black churches and communities.[64] Their role as educators shaped the leadership of women's departments and auxiliaries throughout the diverse denominations.[65] Church women took early responsibility for leadership, first during slavery as preaching women and through a specialized "women's network,"[66] and later in the local and national communities through an elaborate network of clubs, national organizations, community education, and sophisticated political lobbying.[67] Secular and

sacred organizations have been served by and have depended upon an extensive "womanist" infrastructure that remained "committed to survival and wholeness of entire people, male and female."[68] Much of the leadership of these church women took place in settings outside the church precisely because they were blocked from the pulpits within the church. Rather than defecting from their churches, women stayed and built additional organizations that accommodated their gifts for leadership.

The masculinization of the civil rights and black power struggle came precisely at the wrong moment in African-American history. Targeted by both social science and popular culture as deviant and emasculating, black women were challenged to justify their femininity[69] at the same time that they were making the greatest gains ever in education[70] and a large feminist movement helped to increase the occupational and professional attainment of all women. College educated black women, unusually suited to take advantage of these new opportunities, began closing the income gaps between themselves and white women and accounted for the economic gains experienced by working-class and middle-class black families.

Emile Durkheim, once observed that "all the men..., on the one hand, and, on the other, all the women form what amounts to two distinct and even antagonistic societies...." In spite of their competition, "these two sexual corporations" saw themselves as mystically joined together through a common totem.[71] Durkheim's observation almost defines gender relations in the black church. Historic ritual rivalries through Men's and Women's Days, with women usually eclipsing men in their ability to raise funds, are merely hints of deeper antagonisms, what sociologist Orlando Patterson calls African Americans' "gendered burden of history."[72]

The revitalized churches of late twentieth-century black America contain large groups of exceptionally well-educated women at the same time that the concern for the crisis surrounding black men has gripped all of black consciousness. Many black megachurches have large staffs that include women. One newsmagazine story featured the picture of the ministerial staff of an eighteen-thousand-member church, where the pastor's wife served as co-pastor and nearly half of the staff was female.[73] Although most black megachurches have a men's ministry or fellowship, where wives serve as co-pastors there are several vibrant women's ministries whose annual conferences and convocations attract a national network of women leaders and participants.[74] Probably the most masculinist of the black megachurches, St. Paul Community Baptist Church in Brooklyn, pastored by Rev. Dr. Johnny Ray

Youngblood, has a ministry to men, the Eldad and Medad ministry, that speaks explicitly to the reclamation and healing of black men. This church also employs a minister to women as part of its professional staff.

Black women take seriously their own issues and problems, and they also pay special attention to the problems of black males in their conferences, national organizations, writings, and everyday lives.[75] Ironically, the concern that black women evince for the emergencies facing black men—criminalization, joblessness, poverty, hyperghettoization, and social isolation[76]—is not reciprocated by a similar concern for black women by the male leadership of black churches. The perception that black women have survived and succeeded obscures the realities of poverty, welfare, social isolation, joblessness, and single parenting that create unparalleled stress in black women's lives.[77] The irony is that while some social scientists may argue that the better mental health of black women indicates that black men "are not only far behind their white male counterparts, but also significantly worse off than African American women,"[78] women's better mental health and educational achievement may indeed be a product of their overwhelming commitment to their churches. For black women the black church not only continues to function as a therapeutic community,[79] but the church also reinforces women's sense of importance by thriving because of women's gifts and support in ways that are observable to the entire community in spite of the institutional sexism.

CONCLUSION: MIGHTY CAUSES ARE STILL CALLING

African-American Christianity, in spite of, and perhaps because of, dissenting and competing perspectives, remains a vital cultural force in the United States;[80] its style and leadership have profound impacts on American religion and the larger society. As America turns to the twenty-first century, the black church is advancing through its third century. The new types of twenty-first century churches and their practices are embedded in a historical self-consciousness that encourages the elaboration and revitalization of African American folk traditions. The highly visible and vibrant black megachurches have their antecedents in the institutional churches that responded to "the great migration," but they incorporate and exploit the growth of education, skills, and middle-class mobility at a larger scale that is new and unprecedented. Because churches are the sites for the working and reworking of tradition, they provide a unique opportunity for understanding human agency in the context of changing social forces and structures. The success of the civil

rights movement, the new movements and consciousness it produced, the newly expanded middle class, and the changed institutional arrangements serve to make the black church a more complicated and conflicted context for human agency and creative spirituality.

These changes and their incorporation point to the continuing importance of the black church as a dynamic and adaptive site for the production of culture and social changes. Praying at Atlanta University between 1909 and 1910, W. E. B. Du Bois declared, "Mighty causes are calling us—the freeing of women, the training of children, the putting down of hate, murder, and poverty—all these and more."[81] Du Bois's prayer articulated the tasks facing the black church at the beginning of the twentieth century. The "mighty causes" that call us now are remarkably similar; they remain the "dual agenda" of economic equity and social justice.[82] Addressing these social needs must be done at the same time the black church does the taken-for-granted work of religion: producing and defending the sacred over against the profane, creating and maintaining appropriate ritual, prescribing and interpreting human life events, and articulating myth, doctrine, and ethics—all of this in a context of crisis and change.

The black church currently is faced with a serious crisis of gender relations. More than any other African-descended group in the New World, the black communities and churches in the United States have been shaped by the status and agency of women. The current assertive prominence of women as clergy and educational leaders in the "churches of what's happening now" is rooted in the leadership of earlier generations of women. Some of these current women clergy have come to the revitalized Baptist and Methodist churches from the Sanctified Church where earlier generations of Baptist and Methodist women found room for their gifts and voices in the face of discrimination and lost skirmishes over the pulpit. This special religious history and women's ability to maintain autonomous religious and secular organizations have existed alongside of their auxiliary and backbone service to the church, service resulting in a womanist infrastructure securing the organizational integrity of churches and other black-led associations. This womanist infrastructure finds itself facing an emergent militant black manhood that is highly ambivalent about the importance of the church's women's history.

The black church "of what's happening now" claims connection with and responsibility to the new urban poor—those left behind by the recessions of the 1970s and 1980s and the deindustrialization of the American economy. The issues of poverty, youth education, and black families, along

with the new ways in which institutional and interpersonal racism assaults the lives of black Americans remain central to the "mighty causes... calling" the black church. According to Andrew Billingsley, "the Black Church is at the leading edge of the African American community's push to influence the future of its families."[83] The successful response of clergy in the Greater Boston area to the problems of youth violence, the rapid organization of relief through South Central Los Angeles churches during the 1992 disaster, and the high visibility of black churches in southern California as the cutting edge for ethnic diversity within congregations point to the potential of the black church as it faces the twenty-first century.

In the most critical moments of African-American life and history, the most defensible and most helpful institution was the black church. There is every reason to conclude that the black church will continue to be one of the most potent forces for positive social change in a setting of continued social inequality. The ability of black churches to adapt to changing circumstances and the increased self confidence that the professionalized laity and mobilized women bring to the institution mean that black churches can be increasingly assertive in their engagements with public policy. Success in addressing social problems will require that black churches maintain their independence from white intrusion and control, and resist the white hegemony of anti-feminist backlash and conservative biblicism. The historical role of black churches in creating a globalized Pentecostalism currently provides a context for black people to negotiate relationships with newer black and brown communities in the United States from Africa, Latin America, and the Caribbean.

Overall, the black church appears to be persisting in its tradition of adapting to social change at the same time that it pursues the "dual agenda" of civil justice and socioeconomic equality, the "mighty causes" that continue to call. Both the revival and reclamation of tradition across denominational lines and the invention of new ways of worship demonstrate that the diversity and unity of the black church still create spaces where black Americans and their allies may "choose your seat and sit down." Adaptation guarantees that there is still "plenty good room."

NOTES

1. Earlier versions of this paper were presented to the Howard University School of Divinity, Harvard University's Center for Literary and Cultural Studies (Conference: One Nation Under God?), and the Eastern Sociological Society. The author wishes to acknowledge the research assistance of Angela Crandon, Melissa Geathers, Amy Rowe,

and reference librarian, Charles Lakin. I am deeply indebted to my colleague, Constantine Hriskos for his valuable comments and criticisms. I also wish to thank a number of church pastors who shared their time and information for this essay.

2. Traditional Negro spiritual. While wordings of the spirituals vary widely, this particular reconstruction depends upon John Lovell, Jr., *Black Song: The Forge and the Flame, The Story of How the Afro-American Spiritual Was Hammered Out* (New York: The MacMillan Company, 1972), 280.

3. Lewis M. Killian, *The Impossible Revolution Phase 2: Black Power and the American Dream* (New York: Random House, 1975).

4. Doug McAdam, *Freedom Summer* (New York: Oxford University Press, 1984); Nathan Glazer, "The Issue of Cultural Pluralism in America Today" in *White Ethnics: Their LIfe in Working-Class America*, ed. Joseph A. Ryan, (Englewood Cliffs, NJ: Prentice-Hall, Inc, 1973), 168–177; Vine Deloria, *We Talk, You Listen: New Tribes, New Turf* (New York: Dell Publishing Company, 1970).

5. C. Eric Lincoln and Lawrence H. Mamiya, *The Black Church in the African American Experience* (Durham, NC: Duke University Press, 1990), 164–95.

6. C. Eric. Lincoln, *The Black Church Since Frazier* (New York: Schocken Books, 1974).

7. Mary King, *Freedom Song; A Personal Story of the 1960s Civil Rights Movement* (New York: William Morrow and Company, 1987); Stokely Carmichael and Charles V. Hamiliton, *Black Power: The Politics of Liberation in America* (New York: Random House, 1967).

8. Evelyn Brooks Higginbotham, *Righteous Discontent: The Women's Movement in the Black Baptist Church, 1880-1920* (Cambridge, Mass.: Harvard University Press, 1993).

9. Scott Lee Thumma, "The Megachurch as a Modern Social Phenomenon," in *The Kingdom, Power, and Glory: The Megachurch in the Modern World* (Ph.D. diss., Emory University, 1996), 429–526.

10. Beverly Hall Lawrence, *Reviving the Spirit: A Generation of African Americans Goes Home to Church* (New York: Grove Press, 1996); Wade Clark Roof, *A Generation of Seekers: The Spiritual Journeys of the Baby Boom Generation* (San Francisco: HarperCollins Publishers, 1993).

11. Lincoln and Mamiya, *The Black Church.*

12. The phrase, "the church of what's happening now," originated with the late comedian, "Flip" Wilson. Members of a black suburban church in New England applied the phrase to their congregation in its early years. While it would not be considered a megachurch simply because of its numbers (under three thousand), it experienced the rapid growth characteristic of more prominent megachurches. The phrase has been heard at several other congregations I have visited that have been identified as megachurches in the press. The New England congregation illustrates a problem with the focus on the megachurch as a phenomenon of numbers, as opposed to growth rate, social location, and social composition. As a proportion of a very tiny black population, it is a megachurch and all of the other features of the larger churches are a part of its life. The need for a measure of church population and growth that is proportional to the demographics of metropolitan communities represents a significant research project waiting to be pursued. See also my previous discussion in Cheryl Townsend Gilkes, "The Storm and the Light: Church, Family, Work, and Social Crisis in the African-American Experience," in *Work, Family, and Religion in Contemporary Society*, ed. Nancy Tatom Ammerman and Wade Clark Roof, (New York: Routledge, 1995), 180–86.

13. William Julius Wilson. *The Declining Significance of Race: Blacks and Changing American Institutions.* (Chicago: University of Chicago Press, 1978).

14. Drawing primarily pastors of these new and renewed Black Churches, several Doctor of Ministry programs, modeled on the Martin Luther King Fellows Program of

Colgate Rochester Divinity School, have provided very direct mentoring for these newer pastors by nationally respected pastors of the prominent older black churches that qualified as megachurches before there was such a word. Some of the most prominent black megachurches in America are pastored by women and men who were in a mentoring relationship with the late Rev. Dr. Samuel Dewitt Proctor, pastor emeritus of the Abyssinian Baptist Church in New York City, a church whose membership of over 10,000 during the 1950s made it one of the largest churches in the United States under the pastorate of Congressman Adam Clayton Powell.

15. Dona Cooper Hamilton and Charles V. Hamilton, *The Dual Agenda: The African American Struggle for Civil and Economic Equality* (New York: Columbia University Press, 1997).

16. Roof, *A Generation of Seekers.*

17. Norval D. Glenn, "The Religion of Blacks in the United States: Some Recent Trends and Current Characteristics. *American Journal of Sociology* 83(2):443-45l (1977).

18. Joseph R. Washington, Jr., *Black Sects and Cults* (New York: Doubleday and Company/Anchor Books, 1973).

19. "Sanctified Church" is an indigenous African-American term that denotes historically or predominantly black holiness and pentecostal denominations and congregations. It is used by both the "saints" (members of these churches) and others.

20. Lincoln and Mamiya in *The Black Church* point to the prominence and importance of black Pentecostals through their discussion of the growth of the Church of God in Christ.

21. Thumma, *The Kingdom, Power, and Glory*; Hamil R. Harris, "Growing in Glory: ... the Generation of the Megachurch." *Emerge: Black America's News Magazine* 8(April 1997): 48–53; Adelle M. Banks, "Megachurches at the Epicenter of African-American Middle Class." Religion News Service (May 13 1997); Deborah Kovach Caldwell, "More Than Worship: Black Megachurches Offer Broad Ministries to Burgeoning Middle Class." *The Dallas Morning News* (Sunday, May ll, 1997).

22. Albert J. Raboteau, *Slave Religion: The Invisible Institution in the Antebellum South* (New York: Oxford University Press, 1978), 196.

23. Clarence Taylor, *The Black Churches of Brooklyn* (New York: Columbia University Press, 1994), 86, 144.

24. Will Haygood, "Keeping the Faith." *American Legacy: A Celebration of African American History and Culture* (Winter 1988), 26.

25. Carolyn Rodgers, "and when the revolution came," in *how i got ovah: new and selected poems* (Garden City, NY: Doubleday and Company, 1976), 66.

26. Lincoln and Mamiya, *The Black Church*, 388–89; Lincoln, *The Black Muslims.*

27. Spike Lee with Ralph Wiley, *By Any Means Necessary: The Trials and Tribulations of the Making of Malcolm X* (New York: Hyperion, 1992), 246.

28. Killian, *The Impossible Revolution.*

29. Aldon Morris, *The Origins of the Civil Rights Movement: Black Communities Organizing for Change* (New York: The Free Press, 1984).

30. Mary King in *Freedom Song* points out that the entire leadership of the Student Nonviolent Coordinating Committee (SNCC) was present at Malcolm X's funeral in 1965. That segment of civil rights leadership, ultimately lead by Stokeley Carmichael, often debated the tactics of non-violence and the Christian and philosophical underpinnings of those tactics. For an extended understanding of the dimensions of the cultural conversation that took place during this period, the series of video recordings produced by Henry Hampton for Blackside, titled "Eyes on the Prize," is most helpful.

31. Gayraud S. Wilmore, and James H. Cone, *Black Theology: A Documentary History, 1966-1979.* (New York: Orbis Books, 1980).

32. E. Franklin Frazier. *The Negro Church in America*. (New York: Schocken Books. 1974 [1963])

33. Lincoln, *Black Church Since Frazier*, 105-6; italics are in the original.

34. See the following for extended discussions of institutional racism, particularly its formative definitions, and the events that prompted these analyses: Carmichael and Hamilton, *Black Power*; Louis L. Knowles and Kenneth Prewitt, *Institutional Racism in America* (Englewood Cliffs, NJ: Prentice-Hall, Inc., 1969); King, *Freedom Song*; Sidney M. Wilhelm, *Who Needs the Negro?* (Garden City, NY: Doubleday and Company, 1971); William Julius Wilson, *Power, Racism, and Privilege: Race Relations in Theoretical and Sociohistorical Perspectives* (New York: The MacMillan Company, 1973); Malcolm X and Alex Haley, *The Autobiography of Malcolm X* (New York: The Grove Press, 1964).

35. Toni, Cade, *The Black Woman: An Anthology* (New York: New American Library, 1970); Cheryl Townsend Gilkes, "'Some Mother's Son and Some Father's Daughter': Gender and Biblical Language in Afro-Christian Worship Tradition," in *Shaping New Vision: Gender and Values In American Culture*, ed. Clarissa Atkinson, Constance H. Buchanan, and Margaret Miles, (Ann Arbor, MI: UMI Research Press, 1987), 73-99; Cheryl Townsend Gilkes, "'Liberated to Work Like Dogs!': Labeling Black Women and their Work," in *The Experience and Meaning of Work for Women*, ed. Nia Lane Chester and Hildy Grossman, (Hillsdale, NJ: Lawrence Erlbaum Associates, Inc., Publishers, 1990), 165–88.

36. Lawrence, *Reviving the Spirit*; Jacqueline Trescott, "Spiritual Reawakenings: Finding Refuge in Books and Retreats." *Emerge: Black America's News Magazine*, (April 1997), 54–59.

37. Bart Landry, *The New Black Middle Class* (Berkeley: University of California Press,1987), 19-20.

38. Landry, *The New Black Middle Class*, 70; see also William Julius Wilson, *The Declining Significance of Race: Blacks and Changing American Institutions* (Chicago: The University of Chicago Press, 1978).

39. Landry, *The New Black Middle Class*, 194, 218.

40. E. Franklin Frazier, *The Black Bourgeoisie: The Rise of a New Middle Class*. (Glencoe, Illinois: The Free Press, 1957).

41. Cheryl Townsend Gilkes, "The Black Church as a Therapeutic Community: Areas of Suggested Research into the Black Religious Experience." *The Journal of the Interdenominational Theological Center* 8(1):29–44 (1980); Daphne C. Wiggins, *"Where Somebody Knows My Name": A Social and Cultural Analysis of Church Attendance among African American Women* (Ph.D. diss., Emory University, 1997).

42. Robert B. Hill, *The Strengths of African American Families: Twenty-Five Years Later* (Washington, D.C.: R and B Publishers, 1997).

43. Two national organizations, the National Convention of Gospel Choirs and Choruses and the Gospel Music Workshops of America, have very large youth departments. Since most young people in black churches join or socialize with the junior/youth/ young adult choirs, the choirs function as age-graded features of the church's social organization, fostering a solidarity among generational cohorts while providing essential socialization in the folk traditions of the church. These choirs are also the conduits into the churches of more recent trends in contemporary gospel music. It is in these settings where every kind of musical skill is often encouraged.

44. The spelling of seditty varies across African American dictionaries. Geneva Smitherman spells it "sadiddy" and defines it as "snooty, uppity-acting, [and otherwise putting on airs]" in *Black Talk: Words and Phrases from the Hood to the Amen Corner* (Boston: Houghton Mifflin, 1994), s.v. "sadiddy."

45. Lincoln and Mamiya, *The Black Church*, 385-388.
46. W. E. B. Du Bois, *The Gift of Black Folk* (Millwood, NY: Kraus-Thomson Organization Limited, 1975 [1924]).
47. Lincon and Mamiya, *The Black Church*, 385-386.
48. *Ibid.*, 391.
49. Rodgers, "and when the revolution came," 66-67.
50. *Ibid.*
51. Gwendolyn M. Parker, *Trespassing: My Sojourn in the Halls of White Privilege* (Boston: Houghton Mifflin and Company, 1997).
52. Hanna Papanek, "Men, Women, and Work: Reflections on the Two-Person Career" in *Changing Women in a Changing Society*, ed. Joan Huber, (Chicago: University of Chicago Press, 1973), 90–110.
53. Janet Duitsman Cornelius, *When I Can Read My Title Clear: Literacy, Slavery, and Religion in the Antebellum South* (Columbia: University of South Carolina Press, 1991); Leon F. Litwack, *Been in the Storm So Long: The Aftermath of Slavery* (New York: Vintage Books, 1979).
54. Cheryl Townsend Gilkes, "Race Relations, Afro-American Church History, and the Contradiction of the Sanctified Church" (paper presented to the Bunting Institute of Radcliffe College, March, 1984); Charles Harrison Mason, "Is It Right for the Saints of God to Dance" in *History aand Formative Years of the Church of God in Christ with Excerpts from the Life and Works of Its Founder, Bishop C. H. Mason*, ed. German O. Ross, J. O. Patterson, and Julia Mason Atkins, (Memphis, Tenn.: Church of God in Christ Publishing House, 1969), 36–37.
55. Nancy Tatom Ammerman, *Bible Believers: Fundamentalists in the Modern World.* (New Brunswick, NJ: Rutgers University Press, 1987), 87.
56. Cheryl Townsend Gilkes, "Mother to the Motherless, Father to the Fatherless: Power, Gender, and Community in an Afrocentric Biblical Tradition," *Semeia: An Experimental Journal for Biblical Criticism* 47 (1989): 57-85; Cheryl Townsend Gilkes, "Mis-Readings for Justice: The Bible and the African American Cultural Imagination" (Paper presented at the annual meeting of the Society for the Scientific Study of Religion, November 5, 1994).
57. Lincoln, *The Black Muslims in America.*
58. Lincoln and Mamiya, *The Black Church*, 391.
59. Gilkes, "Liberated to Work Like Dogs."
60. Glenn, "The Religion of Blacks in the United States."
61. Lincoln and Mamiya, *The Black Church*, 401.
62. *Ibid.*
63. Vashti M. McKenzie, *Not Without a Struggle: Leadership Development for African American Women in Ministry* (Cleveland, Ohio: United Church Press, 1996).
64. Du Bois, *The Gift of Black Folk*; Cheryl Townsend Gilkes, "'If It Wasn't for the Women...': African American Women, Community Work, and Social Change" in *Women of Color in the U.S. Society*, ed. Maxine Baca Zinn and Bonnie Thornton Dill, (Philadelphia: Temple University Press, 1993), 229–46.
65. Higginbotham, *Righteous Discontent*; Evelyn Brooks Barnett, "Nannie Helen Burroughs and the Education of Black Women" in *The Afro-American Woman: Struggles and Images*, ed. Sharon Harley and Rosalyn Terborg-Penn, (Port Washington, NY: Kennikat Press, 1978), 97–108; Prathia LauraAnn Hall, *The Religious and Social Consciousness of African American Baptist Women* (Princeton Theological Seminary, Ph.D. diss., 1997).
66. William L. Andrews, Editor, *Sisters of the Spirit: Three Black Women's Autobiographies of the Nineteenth Century* (Bloomington: Indiana University Press, 1986); Bettye

Collier-Thomas, *Daughters of Thunder: Black Women Preachers and Their Sermons, 1850-1979* (San Francisco: Jossey-Bass Publishers, 1997); Deborah Gray White, *Ar'n't I A Woman: Female Slaves in the Plantation South* (New York: W.W. Norton and Company, 1985).

67. Paula Giddings, *When and Where I Enter: The Impact of Black Women on Race and Sex in America* (New York: William Morrow and Company, 1984); Jualyne E. Dodson and Cheryl Townsend Gilkes, "Something Within: Social Change and Collective Endurance in the Sacred World of Black Christian Women" in *Women and Religion in America: Volume Three—The Twentieth Century*, ed. Rosemary Radford Ruether and Rosemary Skinner Keller, (San Francisco: Harper and Row, Publishers, 1986), 80-128.

68. Alice Walker, "Womanist" in *In Search of Our Mothers' Gardens: Womanist Prose* (San Diego: Harcourt Brace Jovanovich, 1983), xi-xii.

69. Cade, *The Black Woman.*

70. Landry, *The New Black Middle Class*, 207–9.

71. Emile Durkheim, *The Elementary Forms of Religious Life*, trans. Karen E. Fields, (New York: The Free Press, 1995), 167.

72. Orlando Patterson, "The Crisis of Gender Relations among African Americans" in *Race, Gender, and Power in America: The Legacy of the Hill-Thomas Hearings*, ed. Anita Faye Hill and Emma Coleman Jordan, (New York: Oxford University Press, 1995), 93.

73. Harris, "Growing in Glory."

74. Margaret Elaine McCollins Flake, *Preaching Healing to Hurting Women: A Womanist Hermeneutical Approach to Ministry to African American Women* (United Theological Seminary, D. Min. Thesis, 1995).

75. Marita Golden, *Saving Our Sons: Raising Black Children in a Turbulent World* (New York: Doubleday, 1995); Iyanla Vanzant, *The Spirit of a Man: A Vision of Transformation for Black Men and the Women Who Love Them* (San Francisco: HarperCollins, Publishers, 1996).

76. William Julius Wilson, *The Truly Disadvantaged: The Inner City, the Underclass, and Public Policy* (Chicago: University of Chicago Press, 1987).

77. Flake, *Preaching to Hurting Women*; Irene Browne, "The Black-White Gap in Labor Force Participation among Women Heading Households," *American Sociological Review* 62(2):236-252 (1997).

78. Patterson, "The Crisis of Gender Relations," 61.

79. Gilkes, "Therapeutic Community."

80. Du Bois, *Gift of Black Folk*; Nathan O. Hatch, *The Democratization of American Christianity* (New Haven: Yale University Press, 1989); Joseph E. Holloway, Editor, *Africanisms in American Culture* (Bloomington: Indiana University Press, 1990); David W. Wills, "The Central Themes of American Religious History: Pluralism, Puritanism, and the Encounter of Black and White" in *African-American Religion: Interpretive Essays in History and Culture*, ed. Timothy E. Fulop and Albert J. Raboteau, (New York: Routledge, 1997), 9–20.

81. W. E. B. Du Bois, *Prayers for Dark People*, ed. Herbert Aptheker, (Amherst: University of Massachusetts Press, 1980), 21.

82. Hamilton and Hamilton, *The Dual Agenda.*

83. Andrew Billingsley, *Climbing Jacob's Ladder: The Enduring Legacy of African-American Families* (New York: Simon and Schuster, 1992), 349.

CREMATION AMERICAN STYLE: CONSUMERS' LAST RITES

Stephen Prothero

WHEN PAUL BRYAN, the immediate past-president of the Cremation Association of America, stepped to the rostrum at the Congress of the International Cremation Federation in Berlin in June 1963, the C.A.A. (now the Cremation Association of North America, or C.A.N.A.) was commemorating its golden anniversary, and a cremation boom was about to begin. But Bryan saw little cause for celebration. Cremation, he noted, was suffering from "declining acceptance" in the United States. "There is still a strong and emphatic feeling," he said, "that cremation is a pagan practice, that those devoted to their religion and the Christian way of life both abhor and decry." He then launched into a Jeremiad, mourning the lost enthusiasm of Gilded Age cremation reformers. Bryan's speech, like other lamentations for lost Edens, dug deep into hyperbole. But Bryan exaggerated little about cremation's dire straits.[1]

Cremation was introduced to modern America in 1876, and grew rapidly in the last two decades of the nineteenth century.[2] By 1900, Mt. Auburn Cemetery, the nation's first and Massachusetts's finest rural cemetery, offered cremation in addition to burial, and more than ten thousand Americans had chosen to be cremated at one of the nation's twenty-five crematories. Not until the twenties, however, did the rate of cremations to deaths hit 1 percent. When World War II ended in 1945, the cremation rate stood at 3.7 percent. In 1963, after minor fluctuations, it was 3.7 percent still. That figure, moreover, seemed more likely to fall than rise. The booming postwar economy had produced an affluent society. Garish and expensive were in; simplicity and economy were out. In the age-old battle between purity and pollution, pollution was winning. Automobiles, those great definers of design (and belchers

of impurity), recalled neither the Shakers nor the Puritans but the Baroque. For undertakers, cemeterians, and florists, the postwar period was a wonderful opportunity for gaudy excess. While the Civil War had ushered in the golden age of the embalmer, World War II brought on a second wave of undertaking prosperity. At least until 1963, the funeral industry served up to virtually all its customers the funerary equivalent of the sinuous chrome bumper, the erotic headlamp, and the oversized tail fin. In this industry, too, conspicuous consumption was the order of the day. It was not, to say the least, a cultural moment friendly to the growth of cremation, a practice that for roughly a century had allied itself with values such as naturalness, simplicity, economy, and purity. In the summer of 1963, however, Pope Paul VI and the British satirist Jessica Mitford entered the picture. In November, so did Lee Harvey Oswald. Together Mitford, Paul VI, and Oswald—the sixties' unlikeliest bedfellows—unwittingly conspired to rescue a dying rite.[3]

AGGIORNAMENTO AND THE AMERICAN WAY OF DEATH

On May 8, 1963, in the midst of the Second Vatican Council (1962–65), which would inaugurate a period of *aggiornamento* ("updating") in the Roman Catholic Church, the Supreme Congregation of the Holy Office (now the Sacred Congregation for the Doctrine of the Faith) endorsed an "Instruction with regard to the Cremation of Bodies." On July 5 of that year, Pope Paul VI endorsed the measure, which relaxed the 1886 ban against cremation codified in Canon 1203 of the *Corpus Juris Canonici* ("The bodies of the faithful must be buried; their cremation is forbidden"). But this was no ringing endorsement. The Pope and the Holy Office urged Roman Catholics to continue to practice burial, and they outlawed cremation in cases where it was chosen as a deliberate affront to doctrines such as the bodily resurrection. Church officials also banished cremated remains from the funeral mass and forbade priests from accompanying corpses to crematories and conducting services there. Nonetheless, after the summer of 1963, Catholic cremationists were no longer branded publicans unworthy of last rites. The Church still preferred burial, but cremation was no longer a sin. In a groundbreaking decision that effectively put an end to a century of religious condemnation of cremation, disapproval grudgingly gave way to toleration.[4]

In the summer of 1963, just months after the Pope relaxed the cremation ban, Jessica Mitford's *The American Way of Death* hit the bookstores.

At the time, Mitford thought her rant at the funeral industry might stir polite cocktail party conversation among "Unitarians, earnest consumer advocates, university eggheads, and the like." Instead it shot to number one on the *New York Times* bestseller list, transforming the British-born writer into the Ralph Nader of the death care set. Piggybacking on Mitford's celebrity, CBS aired a documentary, "The Great American Funeral"; MGM called in Mitford to consult on "The Loved One," a film starring Liberace, the doyen of 1950s excess, as a sleazy casket salesman; and NBC wrote an ambulance-chasing schemer of a funeral director into "The Exploiters," an episode of its Dr. Kildare soap opera. Prompted by the press, which coronated Mitford as the "Queen of the Muckrakers," the public received *The American Way of Death* as a revelation. But Mitford was no pioneer.[5]

The first family in a long line of American Mitfords were New England's Puritans, who passed no fewer than three laws in the eighteenth century prohibiting "Extraordinary Expense at Funerals." At least in their first American generation, Puritan funerals were simple, short, and to the point. And the point was this: Since death comes to everyone, each of us should live every day in preparation for it. Staunch critics of what they saw as the hyper-ritualization of both Catholicism and Anglicanism, the early Puritans shaved death rites to the bone—no scripture, no sermons, no prayers for the dead. Death was to be accepted as part of life. There was nothing to be gained by making a fuss over it.[6]

Of course, for undertakers, who emerged as professionals after the Civil War, there *was* something to be gained. So Gilded Age funeral reformers, Puritanism's nineteenth-century heirs, did their best to make sure undertakers' profits were kept to a minimum. These reformers regularly upbraided undertakers for fleecing the unsuspecting bereaved. Cremationists, who entered the debate in the 1870s, hammered home the point that cremation was less expensive than burial. That it was "cheaper to live than to die" was a major theme of a pro-cremation series published by the *New York World* in 1874, and lampooning undertaking as "the dead-surest business in Christendom" was a duty Mark Twain took up with glee in 1883 in *Life on the Mississippi*. "As for me," Twain concluded there, "I hope to be cremated."[7]

Critics of the high cost of dying multiplied in the twentieth century. In *Funeral Management and Costs* (1921), Quincy L. Dowd wrote that "it is impossible to state the problem of burial burdens in all its horrible details." A 1928 study done by John Gebhart for the Metropolitan Life Insurance Company documented the high cost of dying. So did *Burial Reform and*

Funeral Costs (1938) by Arnold Wilson and Hermann Levy. In 1944, the Federal Council of Churches published the results of its own survey on funeral costs. "Are Funerals Being Commercialized?" it asked. The answer, of course, was yes.[8]

CAVEAT EMPTOR: CONSUMERS' LAST RITES

There is an important distinction, however, between Mitford and earlier critics of funeral costs. Before World War II, cremationists and other funeral reformers offered little advice on how to shop for a coffin or how to calculate the costs and benefits of embalming. They cast their revolt against funerary extravagance largely in aesthetic rather than economic terms. They were not consumer activists. After World War II, however, complaints about vulgarity gave way to complaints about cost.

The consumer revolution took its cue from the critique of "conspicuous consumption" presented by American social critic Thorstein Veblen in *The Theory of the Leisure Class* (1899) and was aided by the foundation of the Consumers' Union and the inauguration of *Consumer Reports* in 1936. It did not take off, however, until the focus of the American economy shifted from production to consumption after World War II. As Americans learned how to shop for automobiles, toasters, and washing machines, the centuries-old lament of funeral extravagance was reborn as a consumer critique. In the late 1940s, articles such as "The Vicious Scandal of Funeral Fees" and "It's Cheaper to Live" began to appear increasingly regularly in popular magazines. A play about an unscrupulous undertaker, "The Biggest Thief in Town," hit Broadway. In 1959, only two years after the publication of *The Hidden Persuaders*, Vance Packard's landmark critique of Madison Avenue's contributions to conspicuous consumption, sociologist Leroy Bowman wrote *The American Funeral: A Study in Guilt, Extravagance, and Sublimity.* The *Saturday Evening Post* ran an article in 1961 asking, "Can You Afford to Die?" In 1963, Ruth Harmer wrote *The High Cost of Dying.*[9]

Mitford's tome, therefore, was not a book with a revolution in it. It was far too derivative for that. But it was witty and wicked and was reviewed (favorably) in all the right places. One of the book's key claims was that the supposedly "traditional American funeral"—what Mitford later described as "the full treatment display of the embalmed and beautified corpse reposing on an innerspring or foam-rubber mattress in an elegant 'casket,' 'visitation' of the deceased in the mortuary 'slumber room,' an open-casket ceremony at

which the mourners parade around for a last look at a burial vault that allegedly affords 'eternal protection,' elaborate 'floral tributes' from family and friends, a 'final resting place' in a 'memorial park' or mausoleum"—was actually a recent invention. Not until Victorian times, Mitford wrote, did the simple deathways of the Puritans begin to give way to the "baroque wonderland" of the modern American funeral home. But what delighted the critics most was Mitford's smart satire of funeralese—the morphing of dying into "passing away," corpses into "loved ones," undertakers into "morticians," embalming schools into "colleges of mortuary science," ashes into "cremains," the "Snodgrass Funeral Home" into "Little Chapel of the Flowers."[10]

What finally sold the book to American readers, however, was Mitford's ability to distill the public's vague sense of dissatisfaction with funerals into two clear complaints. The first was economic: Funeral directors were sleazy salesmen fattening their wallets by ripping off the unsuspecting relatives of the corpse. The second was aesthetic: The fare those hucksters were selling was as tasteless as their tawdry chapels. Happily, Mitford had a clear solution to both problems: inexpensive yet dignified funerals. The best way to avoid getting swindled into buying a monument to bad taste, Mitford said, was to forego the Cadillac funeral for the postmortem equivalent of the Volkswagen Bug. In order to do that, however, you would have to take your business not to your local undertaker but to a not-for-profit funeral or memorial society.

MEMORIAL SOCIETIES

Funeral directors who read Mitford's book as an extended advertisement for funeral and memorial societies were not far wrong. Mitford dedicated the book to her husband, Robert Treuhaft, an Oakland lawyer and a major player in the Bay Area Funeral Society who first got Mitford interested in writing a death industry exposé. The last two chapters of *The American Way of Death* are given over to the memorial society movement, and the book concludes with a list of memorial societies in North America and an appendix on "How to Organize a Memorial Society."

The memorial society movement can be traced to the burial cooperatives of the American frontier, the mutual cremation societies of the Gilded Age, the burial clubs of medieval Europe, and even the burial assistance compacts of the Israelites in captivity in Babylon, but its more recent roots go back to Seattle, Washington, and 1937, when the Reverend Fred Shorter and other members of his nondenominational Congregational Church of the People

began to meet to discuss alternatives to the burying regime. As advocates of inexpensive yet dignified death rites, Shorter and his congregants were attracted to direct cremation: quick and inexpensive cremation performed without embalming, viewing, an expensive coffin, or a funeral. They considered starting and running their own crematory, but decided instead to establish a nonprofit funeral cooperative owned and run by members. On January 12, 1939, the People's Memorial Association was organized as the first memorial society in the United States. Shortly thereafter, the P.M.A. contracted with James C. Bleitz of the Bleitz Funeral Home, who agreed to pick up members' corpses, cremate them, and return the cremated remains. The cost was only $50 for members (who also paid a $1 membership fee).[11]

Both the P.M.A. and the memorial society movement grew slowly at first. But in the late fifties, as newspapers and magazines decried the high cost of dying, both expanded rapidly. P.M.A. membership jumped from 650 in 1952 to more than 7,000 in 1960. Buoyed by the publication of *The American Way of Death,* and the first edition of Ernest Morgan's memorial society primer, *A Manual of Simple Burial* (1962), membership swelled to 30,000. In 1997, the P.M.A. claimed roughly 85,000 members, and its bill for direct cremation—still handled by the Bleitz Funeral Home—was $497. Although the organization, which bills itself as "a non-profit consumer organization for simplicity, dignity, and economy in funeral and memorial arrangements," now offers burial as well as cremation services, approximately 90 percent of P.M.A. members choose to be cremated.[12]

The P.M.A. spawned a variety of imitators, which came together in 1962 to form the Continental Association of Funeral and Memorial Societies (now Funeral and Memorial Societies of America). One year later, Mitford's book listed fifty-nine such organizations in the United States alone. Some of these associations, like Gilded Age cremation societies, limited themselves to educating the public about simple and inexpensive alternatives to what one sympathizer characterized as the "barbaric funeral ceremony complete with gussied-up bodies, expensive caskets, parades, and regalia." But most, like the P.M.A., went further, contracting with local funeral directors to provide members with simple, inexpensive death care at a fraction of the going rate. Some, like the P.M.A. in its formative years, offered cremation only. Others offered simple burial and body donation. All consumer cooperatives, however, were forceful advocates for the dignity, propriety, and economy of cremation. All championed spiritual over material values, criticizing the traditional funeral as materialistic and praising cremation as spiritual. Most

were staffed entirely by volunteers, and many were led by Unitarians, Quakers, and other liberal Protestants. Members suggested charitable donations in lieu of flowers, scattering in lieu of urns, the memorial service (whose defining feature was, and is, the absence of corpse and casket) in lieu of the funeral director's funeral. "Honor the memory," their slogan went, "not the remains!" Because of their shared commitment to cremation, these societies functioned as an important adjunct to the crematory infrastructure constructed in the first half of the twentieth century. While they did not typically construct the "bricks and sticks" of crematories, their vast network of grass-roots organizations spread the gospel of the dignity, simplicity, and economy of cremation.[13]

THE F.T.C. AND THE N.F.D.A.

As public opinion galvanized against the funeral directors, state and national legislators began convening hearings on funeral costs and Protestant, Catholic, and Jewish clergy started speaking out against funeral fraud. In 1964, the attorney general of New York State recommended a law requiring undertakers to provide an itemized list of funeral costs; the Anti-Trust Subcommittee of the U.S. Senate held hearings on funeral industry collusion; and Minnesota's Father Alfred Longley, in an endorsement of memorial societies printed in *Ave Maria*, reminded his readers that "the Cross had no innerspring mattress." In January 1966, Moses I. Feuerstein, the president of the Union of Orthodox Jewish Congregations of America, denounced the public ogling of embalmed corpses and the "lavish floral displays and unholy musical extravaganzas" of American funerals as a "desecration." Later that same year, John J. Krol, the Roman Catholic Archbishop of Philadelphia, told the National Catholic Cemetery conference that funeral directors were conning "emotionally charged and grieving relatives" into wasting money. American burial, he said, is ruled not by spirituality but by "extravagance, escapism and commercialism."[14]

The funeral industry debate of the 1970s was dominated, however, not by clergy but by the Federal Trade Commission (F.T.C.), which began to investigate the cost of dying in 1972. For nearly a century, America's funeral directors had counted on the licensing authority and the good graces of state legislators to protect their industry and its profits. Now the machinery of government seemed to turn against them. In 1972, California required its funeral directors to provide consumers with an itemized price

list of its products and services. The F.T.C. followed suit. After an exhaustive inquiry, it issued in August 1975 what *Business Week* characterized as a "blistering report." That report included this list of proposed regulations:

> Prices must be itemized.
> Permission of next of kin must be obtained before embalming.
> Prices must be quoted over the telephone if requested.
> The most inexpensive casket must be displayed along with the others.

This F.T.C. proposal would have outlawed as well both false claims (e.g., that certain caskets could provide everlasting protection from the elements or that embalming was legally required) and efforts by undertakers to blackball cut-rate funeral homes and cremation providers.[15]

In the summer of 1978, after more hearings, the F.T.C. released its 526-page final report on what was by then a $6 billion industry. The *New York Times* summarized the litany of funeral industry abuses uncovered by the F.T.C. like this:

> removing bodies from hospitals without authorization and refusing to release them to their families; embalming without permission; misrepresenting the legal requirements, hygienic value and preservative properties of caskets and vaults; persuading survivors that an expensive casket is needed to transport a body to be cremated; overcharging for such things as flowers and clergy; failing to itemize clearly the prices of the elements in the funeral ritual; harassing undertakers who try to sell low-cost funerals.[16]

In this report, the F.T.C. proposed a more lenient set of rules, but it added several additional proposals, including a regulation that would have outlawed "misrepresenting the need of a casket for cremation, particularly when cremation is not preceded by a ceremony or a viewing." The agency also strongly suggested the use of rental caskets for cremations, but stopped short of requiring them on its mandated price list. Echoing Mitford, the report concluded that "the practices addressed by the rules are not isolated occurrences confined to an unethical few. In fact, the most significant funeral problems which consumers face are practices which are widely used and even condoned by a large percentage of the nation's 20,000-plus funeral homes."[17]

In the face of muckraking by someone of Mitford's talents, the grassroots organizing muscle of the likes of the Continental Association of Funeral and Memorial Societies (C.A.F.M.S.), and findings by an agency as powerful

as the F.T.C., industries charged with high crimes against consumers have a few options. One is to offer up a *mea culpa* along with an argument against outside interference: Mistakes were made, there might be an unscrupulous operator here and there, but the industry is basically sound, and its problems can be easily resolved internally (or, if necessary, through a regulatory compromise). When the tide of public opinion turned against them, the N.F.D.A. and the American Cemetery Association (now the International Cemetery and Funeral Association) would have been well-advised to demonstrate the professionalism they had won nearly a century earlier by admitting to an error or two and making a show of internal reform. But they reformed little and admitted less. Convinced Mitford had drawn first blood in a bout for their good name, they launched a public relations blitz intent on defending the American way of life against atheists, "burial beatniks," and other cheapskates. But this effort did little other than fatten Mitford's royalty checks and pump up public sympathy for what N.F.D.A. executive secretary Howard Raether dismissed as the "disposal movement." In many respects, the funeral industry was its own worst enemy.[18]

Back in the early 1950s, *American Cemetery*, irate that America's journalists had described "cemetery profiteers" as "on a par with the body-snatching morticians," had reacted to a spate of negative publicity with a show of astonishing tactlessness. Rather than responding to specific charges, it smeared the smearers as "anti-American." According to the *American Cemetery*, the *American Mercury* author had connections "with various organizations generally regarded as communistic," and his article was "slanted along the lines of communistic thinking." A cartoon in another issue of *American Cemetery* likened a *Collier's* author to Stalin. "Attacks on American standards of burial," the caption read, "are in line with the Communist program to break down confidence in the American way of life." James B. Utt, a Republican congressman from California, brought the red-baiting into the 1960s when he branded Mitford a "pro-Communist, anti-American" and blasted her book for striking "another blow at the Christian religion." The *American Funeral Director* was a bit more measured; it judged her politics "more than slightly pink in hue" before settling on the epithet of "liberal." In the world according to *American Cemetery* and *American Funeral Director*, Mitford didn't just want to bring down the costs of funerals, she wanted to bring down Christianity and America as well.[19]

As the F.T.C. kept the spotlight on the funeral industry in the 1970s, there was no shift in the halls of the N.F.D.A. or A.C.A. away from con-

frontation and *ad hominem* arguments. Red-baiting had gone out of fashion, but not rhetorical excess. Funeral directors, rather than cooperating with the F.T.C. on regulations it could stomach, dug in their heels, dispatching lobbyists to Washington and angry letters to the editor protesting the socialization of funerals. Once again the attack was handled with all the nuance of a bare-knuckles brawl. *American Funeral Director* denounced the F.T.C.'s hearings as an "expensive and hypocritical charade." *Mortuary Management* complained that the F.T.C. was foisting its "agnostic, atheistic ways on the God fearing, traditional family-oriented American." The N.F.D.A. called the F.T.C.'s 1978 report "shrill, unfair and lopsided." In addition to denouncing its critics as unpatriotic, the funeral industry and its friends defended the traditional American funeral as integral to old-time religion and the American way of life. Rev. Paul Irion, who had previously written an N.F.D.A. brochure entitled "The Funeral: An Experience of Value," argued in *The Funeral: Vestige or Value?* (1966) that what Mitford and the memorial societies really wanted was "to do away with the funeral altogether." Roger L. Waltrip, chairman of the Houston-based funeral conglomerate, Service Corporation International (SCI), read F.T.C. investigating attorney Arthur R. Angel the same way. "Angel just doesn't like funerals, period," he said.[20]

In an effort to shore up what they saw as America's eroding commitment to funerals, Waltrip and Irion insisted that the funeral was no passing fad. While Mitford saw the funeral, in Irion's words, as "a vestige of past eras, an anachronism, a wasteful, unneeded, empty ceremony that outlived its usefulness long ago," they recognized its social, psychological, and religious value. To go over to the Mitford side was, from this perspective, tantamount to denying death. While the traditional funeral fostered acceptance of death by forcing would-be deniers to gaze at the embalmed and coffined corpse, pray over the departed soul, and watch the casket lowered into the ground, cremation and the memorial service fostered denial by banishing the body from last rites. This denial bred not only individual neurosis but also social chaos. "Disposal funerals," moreover, bordered on heresy, since according to Irion both procedures encoded a Greek understanding of the self (as spirit only) rather than the proper Judeo-Christian understanding of the self as spirit and body knit together into one psychosomatic being.[21]

In an effort to rescue Americans from this pathological (and heretical) denial of death, the N.F.D.A. published a barrage of pro-funeral, anti-memorial society brochures, including "What About Funeral Costs?" and "Why Do We Have Funerals Anyway?" *The Director*, an in-house N.F.D.A.

organ, repeatedly invoked the authority of anthropologists, psychologists, theologians, and sociologists in an effort to prove that "where there is a death there should be a funeral . . . where there is a funeral there should be a body," and where there is a body there should be a casket. The alternatives were all "maladaptive and neurotic responses."[22]

Convinced that "the funeral is a rite for the dead and a RIGHT of the living," the N.F.D.A. urged Congress to block the F.T.C. from implementing its proposals. Because of the power of the funeral lobby, the F.T.C. regulations of 1978 already amounted to little more than simple disclosure requirements. "Undertakers would still be allowed to peddle those solid brass coffins guaranteed to withstand a direct hit by a nuclear warhead," wrote the New York Times, "but they would also be required to show grieving relatives the plain pine box." But funeral directors fought even these watered-down rules. Federal regulations would not merely gut the American way of life, they argued, they would raise costs and reduce choices too. Better to leave the regulating to state boards stacked with funeral directors.[23]

Besides, the funeral directors claimed, funerals were not really so expensive after all. Following a strategy utilized as early as 1876 by the Catholic periodical the Boston Pilot, the N.F.D.A. commissioned its own studies on the cost of dying, which turned out to be a bargain after all. 1978 findings issued shortly after the F.T.C. report fixed the average adult funeral bill for 1977 at only $1412, up a paltry 5 percent over the previous year's average. And this $1412 figure (which did not include costs for vaults, cemetery services, monuments, clergy honoraria, flowers, burial clothing, or obituary notices) was not all profit, since funeral directors incurred at least sixty different types of expenses, including furniture depreciation, automobile repairs, stationery costs, and owners' "total salaries, and bonuses and/or other compensation." Add that all up and the pre-tax profit was only $90 per funeral.[24]

The war between the funeral industry, on the one hand, and Mitford, the memorial societies, and the F.T.C., on the other, produced no clear victors. While the F.T.C. investigated and the N.F.D.A. stonewalled, little changed. In 1974, the New York Public Interest Research Group found in a study of funeral practices that two-thirds of undertakers did not cooperate in providing mandated price information over the phone. In 1978, a three-part investigative series on the funeral industry by the New York Times uncovered evidence of "body-snatching (one undertaker claiming a body before a competitor), price gouging, misrepresentations of the need for embalming and, on occasion, assaults on the cultural and religious beliefs of people trying to cope

with the death of a loved one." In a May 1981 series called "The Death Merchants," the *Chicago Sun-Times* concurred. "Deception, fraud, scare tactics, outright lies," it editorialized, "almost nothing is beneath these vultures as they seek to peck the last dime of profit from a bereaved relative."[25]

Like America's earliest cremationists, who seemed fonder of talking about cremation than actually building crematories, the F.T.C. did a lot more investigating than acting. Not until July 1982, nearly two decades after the publication of Mitford's book, did the F.T.C. finally adopt a modified trade rule. But it postponed enforcing that rule until 1984. Since that time, enforcement has been unenthusiastic at best. The F.T.C. had brought only a few dozen formal enforcement cases against recalcitrant funeral concerns as of 1997. Meanwhile, the average undertaker's bill had risen, according to the N.F.D.A.'s own estimates, from roughly $1000 in 1963 to nearly $5000 (cemetery expenses excluded) in 1997.[26]

BAKE AND SHAKE

If the hue and cry that followed the publication of *The American Way of Death* did little to modify the behavior of undertakers or cut funeral costs, it did a lot to promote cremation. Mitford, who devoted a full chapter of her book to the subject, was an outspoken champion of cremation as an inexpensive alternative to burial. Her advocacy of memorial societies, moreover, accelerated cremation's growth, since most C.A.F.M.S. members championed the practice. In the two decades after the appearance of *The American Way of Death*, funeral directors and cemetery managers focused on attacking the F.T.C. and defending the old-time funeral. There was an occasional article on cremation in *Casket & Sunnyside* and *American Funeral Director* in the 1960s and 1970s, but for the most part the funeral industry ignored the subject. Its fixation on the evil triumvirate of Mitford, the memorial societies, and the F.T.C. created an opening for a new brand of death care entrepreneurs who viewed the average cost of funerals as opportunity rather than scourge. In an effort to capitalize on the popularity of nonprofit funeral and memorial societies, many of these profit-making cremation businesses masqueraded as cooperatives. Two of the most successful, the Telophase Society and the Neptune Society, called themselves societies and charged membership fees. By offering no-frills cremations *sans* funeral, plot, marker, and bouquets, these businesses threatened not only funeral directors but also cemeterians, monument

makers, and florists. They also solidified the century-old association between cremation and eccentricity.

The Telophase Society was the brainchild of biochemist Thomas B. Weber, who got into the cremation business in San Diego, California, in 1971 after running into roadblocks while trying to cremate his dead father. His oddly named business—"telophase" refers to the final stage in cell division—pioneered direct cremation for profit. Operating out of a modest storefront, it charged members (who initially paid a $10 initiation fee) $250, or roughly the equivalent of the Social Security death benefit. Weber, who did not run his own crematory until 1974, would pick up the corpse, bring it to a crematory for incineration, and then scatter the ashes, typically at sea. The Telophase Society offered one-stop-shopping but only one package. If you wanted cremation preceded by a funeral or followed by burial, Weber would direct you to somebody else. Any memorial service you might desire was strictly up to you.

In 1977, the San Francisco–based Neptune Society entered the direct cremation business. Its C.E.O. was the eccentric Dr. Charles Denning, a goateed chiropractor who was dubbed the Colonel Sanders of the funeral industry until someone came up with an even better name: "Colonel Cinders." A pioneer in both direct cremation and the fun funeral, Denning distinguished himself from Weber by offering a complete cremation menu rather than just one cut-rate course. A popular extra (for an extra fee, of course) was a lavish, scattering bash aboard his 100-foot, teak-paneled yacht, the *K-thanga* ("swift lady" in Swahili), skippered by Captain Denning himself. Denning's dapper outfits, a far cry from the staid suits of the grim Midwestern funeral director, were West Coast casual. By the end of the decade, Denning's laid-back approach had trounced not only the funeral directors in his area but also Weber's austere minimalism. In 1980, he handled more corpses than any other business in California except Los Angeles's massive Forest Lawn Memorial Park.[27]

Predictably, funeral directors and other death care providers reacted to the success of direct cremation by disparaging the Telophase and Neptune Societies as "bake and shake" and "burn and scatter" outfits that treated deceased loved ones, literally, like trash. It's "just a disposal service," said one funeral director, "a completely pagan method of disposing of remains." But funeral directors did more than call Weber and Denning names; they tried to legislate them out of business. Shortly after the Telophase Society opened for business in 1971, the California Funeral Directors Association found a

sympathetic Republican legislator to sponsor a bill which, by classifying "cre-
mation clubs" as funeral homes, would have subjected cremationists to the
regulations of the undertaker-controlled state Board of Funeral Directors
and Embalmers. After the bill passed both houses, but before it was signed
into law, consumer groups cried foul. "It's like having the railroads regulate
the airlines," said Weber. The Telophase Society eventually lost the battle but
after applying for and receiving a funeral director's license Weber was back
in business. Still the harassment did not stop. The state Board of Funeral
Directors and Embalmers sued him, as did the Cemetery Board, which tried
to classify his business as a cemetery. Eventually he prevailed in roughly thir-
ty lawsuits, defeating efforts to force him to build an embalming room and
chapel he would never use.[28]

Critics of direct cremation also took a page out of the books of Gilded
Age cremationists by attacking direct cremation as ghoulishly insensitive. In
the nineteenth century, cremationists had reveled in rehashing tales of the
wormy horrors that lay in wait for a buried corpse. Now funeral directors,
armed with stories about the postmortem misadventures of cremains, waged
their own war by anecdote. In a debate with Mitford in *Good Housekeeping* in
1968, freelance writer Kate Holliday complained that the urn of a departed
friend "clunked and rattled" and looked like "a can of tar." In 1976, *American
Funeral Director* gleefully reported that the Post Office had lost an urn in
shipping. Three years later the *AFD* devoted a series of articles and editorials
to a cremation scandal in St. Petersburg, Florida. The cremated remains of
dozens of the dead had been found spilling out of large trash bags near the
garage of a man who worked part time scattering ashes in the Gulf of Mexico.
It was, *American Funeral Director* concluded, a "callous desecration."
Christian critics weighed in too. In *Cremation: Is It Christian?*, James W.
Fraser answered the question posed in his title with an emphatic "no."
According to Fraser, cremation was "of heathen origin, an aid to crime, a bar-
barous act, also anti-Biblical." "To a person of refined Christian culture," he
wrote, "it must be most repulsive to think of the body of a friend being treat-
ed like a beef roast in an oven, with all its running fats and sizzling tissues."[29]

Neither the ineptitude of the Post Office nor the clumsy impiety of the
occasional scatterer did much, however, to stall cremation's growth in the six-
ties and seventies. In a 1970 report on the growing popularity of cremation,
N.F.D.A. executive secretary Howard Raether claimed it was "clear that most
of the American public does not want cremation. There have been cremation
societies for more than 100 years, and there is certainly no strong move in that

direction." Raether was wrong, at least about the trend. After the appearance of Mitford's book in 1963, the cremation rate turned gently upward, hitting 4.5 percent in 1969. The angle of ascent steepened in the 1970s, as the rate reached 6.5 percent in 1975 and 9.4 percent in 1979. The number of crematories expanded too, nearly doubling from 238 in 1963 to 506 in 1978. In the late seventies, membership in the Telophase Society topped twenty thousand. So did membership in a similar direct cremation firm, the St. Petersburg-based National Cremation Society. In the early eighties, an estimated 170 memorial societies claimed 750,000 members, the overwhelming majority of them pro-cremation. Thanks to the Pope, the "Queen of the Muckrakers," and direct cremation entrepreneurs, American cremation was rising to the challenge posed by Bryan at the Berlin cremation congress of 1963.[30]

A NEW PURITANISM

Both long-term and short-term factors played a role in the post-1963 cremation boom. The influence of Mitford, the F.T.C., and the memorial society movement would seem to suggest that cremation benefitted primarily in this period from economic considerations—that cremation won its popularity by riding the wave of consumerism in the 1960s and 1970s. There is some truth to this claim. The public debate was dominated by consumer calculations. Changes in the treatment of the dead continued to be proposed on behalf of the interests of the living, but now the financial rather than the physical well-being was said to be at stake. In 1977, the editors at *Consumer Reports* published a book called *Funerals: Consumers' Last Rights.* Once *Consumer Reports* was training death rites buyers to act like consumers, it was only natural for some to select the cheapest way to go. Moreover, after the F.T.C. required funeral directors to include a cremation option on a mandated price list, selecting that way became much easier. "You can get yourself cremated for about $250," someone told a Northwestern University researcher in a study on death attitudes published in 1981. "Why pay $3500?" Another factor was the rise of environmentalism, which achieved national recognition when the United States first celebrated Earth Day on April 22, 1970. Since the late-nineteenth century, cremationists had portrayed burial as land-hungry. Cremation, they argued, consumed far less land. In the 1970s, environmental considerations became important to many Americans choosing cremation. "Save the land for the living" emerged as a popular pro-cremation slogan.[31]

While both consumer and environmental considerations clearly played a part in cremation's rapid growth, each of these factors can be overplayed. Although finances were, as a *New York Times* article from 1970 on the rise of cremation noted, a "principal reason" for cremation's growing popularity, they were not *the* principal reason. The most important cause of the cremation boom was neither money nor land but style. Cremation gained at the expense of burial not so much because it was cheaper or greener but because it was more refined. Or, as a woman interviewed for the *Times* article testified, "It just seemed a lot purer."[32]

The American Way of Death has been hailed as a consumer classic on par with Ralph Nader's *Unsafe at Any Speed*. It succeeded, however, because of its aesthetic critique. As an Englishwoman and a former communist, Mitford believed funerals should be performed at low or no cost to the consumer, preferably as a public service. Yoking death to profit was, to her, unseemly. But hers was not a view many Americans shared in 1963, and fewer share it today. When activist Herb Klein sent out a call in 1975 for a "cremation crusade" for legislation for "free cremation for all who choose it," few Americans answered the call. American citizens do not believe their government should foot the bill for their death rites, and they do not expect funeral homes to be run as charities. Where Mitford and her American readers came to a meeting of the minds was in their shared sense that the American funeral had become a tacky affair. The flaw in Mitford's villains was not ethical but aesthetic. Americans have been ambivalent about greed since the wealth of the robber barons and the depredations of the slums arose simultaneously in the Gilded Age. But they are not ambivalent about bad taste, and as Mitford repeatedly demonstrated the American way of death had become by the early sixties a boulevard to bad taste—the funerary equivalent of boorish burlesque. The vice of Mitford's villains—the funeral directors, cemetery managers, monument makers, and florists—was not avarice but vulgarity. The virtue they lacked was refinement, not charity. In the end humor rather than indignation carries *The American Way of Death*, which eggs on its readers not so much to scorn as to laugh at the ill-bred funeral director and his ill-appointed chapels.[33]

Mitford was lionized, in short, because the cultural tide was turning. Less than a year after Pope Paul VI lifted the ban on cremation and only months after the publication date of *The American Way of Death*, President Kennedy was killed on November 22, 1963, in Dallas, Texas. Looking back at that moment through the prism of the Vietnam conflict and the flurry of succeeding assassinations—of Malcolm X, Rev. Martin Luther King, Jr.,

and Robert Kennedy—the sixties seem to have begun not on January 1, 1960, but on November 22, 1963. On that day, America began to turn from optimism toward cynicism, from conformity to nonconformity, from excess toward simplicity. The new cultural mood seeped into all areas of American life, including the funeral industry, which after 1963 witnessed what even the N.F.D.A. recognized as a "shift toward simpler... and less expensive funerals." This shift, however, was gradual.[34]

In 1963, cremating a fallen president, especially a Catholic president, remained unthinkable. Kennedy's obsequies were dignified, but by no measure simple. A caisson pulled by six gray horses transported the body of the martyred president in a mahogany coffin from the White House up Pennsylvania Avenue to the Capitol. Enlisted men carried the coffin up thirty-six marble steps, placing the president's body in the center of the rotunda on the same catafalque that had supported Abraham Lincoln's corpse nearly a century earlier. After a series of eulogies, over 100,000 mourners filed past the coffin, which in a nod to the emerging funerary style was closed. The next day, the body was borne to St. Matthew's Cathedral for a traditional requiem mass. Hundreds of millions worldwide then watched on television as the president's body was carried in a state procession to Arlington National Cemetery and buried with full military honors. Fifty jets, one for each state, roared over the grave site. Military men performed a twenty-one-gun salute. An Army bugler played taps. Then Mrs. Kennedy, Senator Edward Kennedy, and Robert Kennedy lit the eternal flame at the head of the President's grave, and Cardinal Cushing sprinkled holy water on the coffin, which was promptly lowered into the ground and covered with earth.

The obsequies that followed President Dwight D. Eisenhower's death in 1969 were, by contrast, a model of the emerging austerity. While Kennedy's funeral, by fixing the minds of Americans on death and conspiracies, helped create a vast audience for Mitford's fulminations, Eisenhower's funeral demonstrated that Mitford's Puritanical style was in ascendance. Like Kennedy, Eisenhower lay in state in the Capitol. His life was celebrated at a funeral service at Washington's National Cathedral. But rather than being interred in Arlington National Cemetery, Eisenhower chose to be buried alongside his boyhood friends at the Chapel of Meditation in his home town of Abilene, Kansas. This time the coffin was simple: an $80 G.I.-style casket. The service, held on the library steps, was brief. And the family requested that donations be sent to charity in lieu of flowers.[35]

Both Mitford's reputation and the cremation alternative benefitted from, even as they contributed to, this new mood. When *The American Way of Death* appeared, Mitford was a VW Bug sort of gal in a Cadillac culture. But by the time it was being read widely, Cadillacs were going out of style. Propelled by a brilliant advertising campaign that urged Americans to "Think Small," Bugs were selling fast. Thanks to Mitford, the memorial societies, and the F.T.C., burial and the "traditional American funeral" were losing the aesthetic high ground to cremation and the memorial service. After 1963, many self-respecting Americans wouldn't be caught dead in an "Eterna-Crib" casket. Excess had lost its dignity, and the funeral directors were the high priests of excess. The high priests of simplicity were Thomas Weber and Charles Denning, nonconforming direct cremation providers who came to prominence as minimalism overtook the American art scene, the counterculture hit the cover of *Time,* and "small is beautiful" became a countrywide cliché.

During their three-front battle with Mitford, the memorial societies, and the F.T.C., some funeral directors took Mitford to task not for her communism but for her ethnocentrism. One told the *New York Times* she was pushing "a white, Anglo-Saxon Protestant view of funeral ritual with no regard for ethnic, racial, or religious considerations." More recently, the *Funeral Monitor* called her a closet aristocrat. "The common folk invariably came off in her writings as a good-natured subspecies in clear need of a firm hand from those like herself who were more informed and knowledgeable," it wrote. "It is hardly the democratic ideal." There is some truth in both charges. Mitford claimed to be pro-choice in death rites, but it is hard to read her work without coming away with the impression that she regarded the old-fashioned funeral as anything other than vulgar. Like the cremationists of the Gilded Age, she was a refiner of American deathways who was convinced she knew what was best for poorly educated and working-class corpses. Though branded a communist, she was really a Puritan, a reincarnation not of Karl Marx but of Cotton Mather, who like other Puritan divines believed in simplicity in death rites. Like the Puritan preacher (and the nineteenth-century cremationist), Mitford was no denier of death, no friend of the postmortem euphemism. She too was wary of priestcraft and ritual. The priests she opposed, however, were the funeral directors, and the rites she condemned were the overwrought ceremonies of the American way of death.[36]

If cremation in the 1870s was a modern revival of a Hindu and Greco-Roman practice, cremation in the 1970s was a modern revival of Puritanism. It owed much of its success to a revival of Puritan simplicity.

At least in that sense, it was both quintessentially American and undeni-
ably religious. Mitford and her pro-cremation contemporaries diverged
from Puritan divines (and Gilded Age cremationists), however, in their tol-
erance of postmortem merry-making. Puritan elites wouldn't have railed
so much against funeral fun if workaday colonists weren't getting a little
tipsy at the funeral feast. Such revelry would have irked Cotton Mather, but
Mitford wouldn't have minded it in the least.

JOHN LENNON'S WHITE BALLOONS

Thanks to Mitford and her allies, an alternative to the American way of death
emerged in the 1960s and 1970s. Thumbing its nose at the establishment, this
countercultural alternative typically incorporated cremation rather than bur-
ial, and the memorial service rather than the funeral. In an age that celebrat-
ed the living body, this alternative insisted on memorializing not the dead
body but the living spirit of the person. Rather than gazing with their eyes on
an embalmed corpse, nonconforming mourners were urged to recall with
their hearts and minds the still-living spirit of the dead. "We honor the mem-
ory of the dead person," Thomas Weber had said, "not the cadaver."[37]

This emerging alternative went mainstream after the death of Beatles
superstar John Lennon, who in the evening of December 8, 1980, was shot
four times just outside his New York City home by a deranged fan wielding
a .38-caliber charter Arms Undercover revolver. Lennon's shocking murder,
which for many recalled the assassination of President Kennedy, instantly
transformed him from a member of the Beatles into an American icon—a
symbol of the death by violence of the hope and optimism of the 1960s.
Yoko Ono, Lennon's wife and a singer herself, had obviously been influenced
not only by consumer critiques of burial but also by the countercultural
commitments of Mitford and the memorial societies. In lieu of flowers, she
asked mourners to donate to the Spirit Foundation, the charitable arm of the
multimillion dollar Lennon/Ono empire. And she wanted no public funer-
al. Lennon's fans, however, would have none of that. The Beatles star had not
yet been pronounced dead when admirers began to gather in an impromp-
tu vigil outside the emergency room door at Roosevelt Hospital. When they
finally got word that their hero had died, they memorialized Lennon in
prayers and song until dawn. Outside Lennon's apartment building, fans
placed daisies, roses, carnations, and evergreens in the wrought-iron gate. As
radio stations played Lennon's music without commercial interruptions, the

gate was covered with flowers, poems, photographs, and paintings. One student, recalling Lennon's interest in Transcendental Meditation and the Hare Krishnas, meditated in yogic postures. Others wore black armbands.[38]

After witnessing this outpouring of grief and affection, Ono announced a memorial service slated for Sunday, December 14. Intriguingly, no site was announced for the service, which was to take place everywhere anyone gathered to remember Lennon's spirit. "Pray for his soul from wherever you are," Ono said. Convinced that family, friends, and fans alike should revere Lennon's eternal spirit rather than his material remains, Ono saw to it that her husband's body was not part of the rite. Packed in a body bag and driven from the office of the Medical Examiner in Manhattan to the Frank E. Campbell Funeral Home, it was placed in a white casket before being driven randomly around town in a hearse (an effort to shake the paparazzi) before being delivered to the Ferncliff Crematory in Hartsdale, New York.

On Sunday, December 14, millions gathered to commemorate Lennon's spirit. The biggest American gathering was in Manhattan's Central Park, where roughly 100,000 congregated around a bandshell decorated with evergreens. In keeping with the cremationists' bias for spirituality over materiality, the only tangible witness to the dead singer on display in Central Park was a poster-size image of Lennon in his trademark glasses. Once again, Beatles melodies consoled the crowd. Then everyone fell as silent as Quakers for ten minutes of prayer and meditation. CBS cut into its National Football League game to carry the rite, radio stations across the country participated by broadcasting ten minutes of silence, and in cities and towns throughout the world fans of all races and creeds gathered in living testimony to Lennon's belief in the universal brotherhood and sisterhood of humanity. Back in Central Park, in the midst of the silence, a bouquet of white balloons ascended skyward in testimony to the purity of Lennon's departing spirit. Looking up, Ono thought, "I saw John smiling in the sky."

Lennon's cremation seems to have taken place on the afternoon of December 10, 1980, but newspaper reports do not describe it in any detail. This is not surprising, since it was not a public event. In fact, it was not even a private event. In keeping with contemporary practice, there were no prayers, no eulogies, no music at the crematory. By 1980, cremation itself had become a purely technological and secular exercise. Lennon's cremation would seem to signify, therefore, the secularization of cremation. But does it? His cremation was, admittedly, an irreligious affair. And his funer-

al was undoubtedly idiosyncratic. But what did Ono's "no public funeral" pronouncement do? And how did cremation function in the worldwide process of memorializing the passing star? Both served to divert attention from Lennon's bullet-ridden body to his spirit. A body, after all, must be somewhere; a spirit can be everywhere. By banishing the body from the funeral, Ono demonstrated her conviction that the self is essentially spiritual. And by relying on fire and heat to free his spirit to fly to what she awkwardly termed "the big upstairs," she demonstrated her belief in the immortality of the soul. John Lennon, she was saying, lives.

Lennon's cremation does highlight an important turn in American religion and culture. But that turn is not secularization. It is instead the rise of religious pluralism and the concomitant customization of religious ritual. In the same period Americans were following Lennon into religious alternatives such as Transcendental Meditation, they were crafting more personalized alternatives to the cookie-cutter funeral. As the public power of the Judeo-Christian tradition faded, and belief in hell virtually disappeared, the belief in the traditional Jewish and Christian conception of the self receded too. Many if not most Americans continued to view themselves as psychosomatic unities—messy mixtures of body and soul—but an alternative self-conception was edging its way from the margins to the mainstream of American culture. Like Lennon and Ono, many Americans—including many liberal Protestants, Catholics, and Jews—were embracing an alternative view of the self as essentially spiritual. "I have a body, but I am a soul," they were saying. And they wanted their exits from the world of bodies to reflect both their alternative spiritualities, and their unique spirits. At least for them, white balloons resonated as metaphors. And customized cremation was the perfect rite.

Since 1980, many American celebrities have followed Lennon's example. In the past few years, Allen Ginsberg, John Denver, Timothy Leary, and Linda McCartney all chose cremation. So did Jessica Mitford, who died of cancer on July 23, 1996, at the age of seventy-eight. Mitford's death rites, like her writings, incorporated equal measures of satire and consumer savvy. In a wry wink at the N.F.D.A., an antique hearse and six black horses pulled her casket through San Francisco's Embarcadero district, all to the strains of a twelve-piece brass band. But after the jazz died down, Mitford (who was not embalmed) was cremated in a $15.45 cremation container. The total bill, which included scattering at sea, was $562.31. Thanks to Mitford, Lennon, Pope Paul VI, and, in an odd way, even Oswald, Kennedy, and Eisenhower, cremation has become a widespread

alternative to burial. In 1997, the overall cremation rate topped 21 percent, as more than one thousand American crematories handled roughly half a million corpses. How fast it will grow in the future is anyone's guess. There are some signs that cremation's growth rate is slowing down, but it has to be good for the industry that the VW Bug is back.[39]

NOTES

1. Paul Bryan, "The Challenge to Cremation in America," paper delivered at the Congress of the International Cremation Federation, Berlin, June 1963.

2. On cremation's early history in the United States, see my "Lived Religion and the Dead: The Cremation Movement in Gilded Age America," in David D. Hall, ed., *Lived Religion in America* (Princeton: Princeton University Press, 1997), 92–115.

3. There are a number of sources for nineteenth-century cremation data. I have relied on John Storer Cobb, *A Quartercentury of Cremation in North America* (Boston: Knight and Millet, 1901), 117–21. See also James R. Chadwick, *The Cremation of the Dead* (Boston: Geo. H. Ellis, 1905), 14–16; Lodovico Foresti, *Statistica delle Cremazioni Eseguite in Europa nel Secolo XIX* (Bologna: Stabilimento Giuseppe Civelli, 1901), 6–10; Sir Henry Thompson, *Modern Cremation* (London: Smith, Elder, & Co., 1901), 16, 25; "Cremation Statistics—1885–1935," *Pharos* 2.4 (July 1936): 25. For more recent figures, I have relied on "Cremation Figures from 1876 to Present," an undated and unpublished paper provided to me by officials at *The Cremationist* magazine in April 1996. I used this data for 1905 on.

4. "Cremation and the Canon Law," *Pharos* 27.1 (February 1961): 3. For subsequent developments, see Rev. John F. McDonald, "A Decade of Cremation in the Roman Catholic Church," *Pharos* 42.1 (February 1976): 35–40.

5. Jessica Mitford, "Death, Incorporated," *Vanity Fair* (March 1997): 110.

6. R. W. Habenstein and W. M. Lamers, *The History of American Funeral Directing* (Milwaukee: Bulfin Printers, 1962), 204.

7. "Cremation: Expense of the Present Mode of Burial," *New York World* (March 8, 1874): 1; Mark Twain, *Life on the Mississippi* (New York: Harper & Row, 1951), 350, 353.

8. Quincy L. Dowd, *Funeral Management and Costs: A World-Survey of Burial and Cremation* (Chicago: University of Chicago Press, 1921), 3–4; John C. Gebhart, *Funeral Costs* (New York: G. P. Putnam's Sons, 1928); Arnold Wilson and Hermann Levy's *Burial Reform and Funeral Costs* (New York: Oxford University Press, 1938); "High Cost of Dying," *Newsweek* (November 20, 1944): 84.

9. Howard C. Raether includes a comprehensive list of these titles in his *Funeral Service: A Historical Perspective* (Washington, D.C.: National Funeral Directors Association, 1990), 17-25.

10. Jessica Mitford, "The Funeral Salesmen," *McCall's* (November 1977): 190; Jessica Mitford, *The American Way of Death* (New York: Simon & Schuster, 1963), 58, 231, 18–19, 60, 77–78, 236. Reviews included: Orville Prescott, "The High Cost of Dying," *New York Times* (August 28, 1963): 31; Francis Russell, "Merchants of Death," *National Review* 15.16 (October 22, 1963): 362–64; Richard Gilman, "The Loved One Is in the Slumber Room, Laid Out in Style," *New York Times Book Review* (August 25, 1963): 4, 25.

11. Information on the People's Memorial Association comes from its Web site: http://www.peoples-memorial.org.

12. *Ibid.*

13. Dr. Kenneth W. Dumars, Jr., quoted in "Medical Magazine Publishers Memorial Society Propaganda," *American Funeral Director 85.3* (March 1962), 59; Herb Klein, *Don't Waste Your Death... It Could Save a Life!* (Farmington, Michigan: ad-Creators, Inc., 1975). The slogan appears as the epigram to Klein's book.

14. Rev. Alfred C. Longley, "Make Christian Burial Christian," Ave Maria 99.25 (June 20, 1964): 10; "Lavish Funerals Scored by Jews," *New York Times* (January 8, 1966): 13; "Archbishop Scores Burial 'Escapism,'" *New York Times* (October 16, 1966): 62.

15. "Giving undertakers something to cry about," *Business Week* (October 6, 1975): 93. With this 1975 report, the F.T.C. promulgated a consent decree requiring Service Corporation International (SCI), the country's largest death care conglomerate, to issue rebates to customers overcharged, beginning in 1971, for cremations performed by the chain's 139 funeral homes.

16. "Taking on the Undertakers," *New York Times* (July 2, 1978): 4.14.

17. "FTC Staff Report Echoes Earliest Charges, Demands," *American Funeral Director* 101 (July 1978): 18.

18. Mitford, *The American Way of Death,* 265; Howard C. Raether, "There Are None So Lost," *American Funeral Director* 85.11 (November 1962): 48.

19. "Two More Magazines Publish Attacks on Burial Practices," *American Cemetery* 23.8 (August 1951): 23; "Collier's Fails to Correct Untruths in Davidson Story," *American Cemetery* 23.7 (July 1951): 21; "Jessica Mitford Called Pro-Red," *New York Times* (October 18, 1963): 63; "British-Born Mitford Still is Raking in Those Good Yankee Dollars!" *American Funeral Director* 88.7 (July 1965): 39; "Let Us Prove that Funerals Do Not Cost Too Much," *American Funeral Director* 99.5 (May 1976): 49. Mitford had been a member of the Communist Party, as had her husband, Oakland lawyer Robert Treuhaft. Both were called before the House Committee on Un-American Activities in 1952, and they resigned together from the Communist Party in 1958.

20. Charles O. Kates, "We Are No Longer Optimistic," *American Funeral Director* 99 (June 1976): 31; Jessica Mitford, "The Funeral Salesmen," *McCall's* (November 1977): 192, 312; "Regulating Death?" *Newsweek* (July 3, 1978): 59; Paul E. Irion, *The Funeral: Vestige or Value?* (Nashville and New York: Abingdon Press, 1966): 71; "Giving Undertakers Something to Cry About," *Business Week* (October 6, 1975): 93.

21. Irion, *The Funeral: Vestige or Value?,* 7.

22. "Funeral and Memorial Societies and Memorial Services," *Director* 41.4 (April 1971): 5. Howard C. Raether discusses N.F.D.A. brochures in *Funeral Service: A Historical Perspective* (Washington, D.C.: National Funeral Directors Association, 1990), 36–37.

23. "General Comments," *Director* 41.4 (April 1971): 3; "Used Cars, Eyeglasses and Coffins" *New York Times* (November 28, 1978): 22.

24. "NFDA Ratio Analysis Shows Minimal Price Increases," *American Funeral Director* 101.11 (November 1978): 43–44.

25. Gerald Gold, "Wide Range of Funeral Prices Found Here in Consumer Study," *New York Times* (April 7, 1974): 38; Richard Severo, "Disputed Practices of Undertakers Are Defended by Some in Business," *New York Times* (April 24, 1978): 1; The *Sun-Times* series comes in for criticism in "Once Again: Why?" *American Funeral Director* 104.8 (August 1981): 30.

26. The N.F.D.A.'s cost estimate for 1997 was $4,783. See Marlys Harris, "The Final Payment," *Money* 26.9 (September 1997): 88.

27. Jessica Mitford, "Bake and Shake," *New York* (January 21, 1980): 50–52.

28. Consumer Reports, *Funerals: Consumers' Last Rights* (New York: W.W. Norton, 1977), 178; "A move to embalm 'cremation clubs,'" *Business Week* (September 21, 1974): 89. See also "Cheap cremation wins a lease on life," *Business Week* (August 12, 1972): 31.

29. "'Barbaric, nightmarish,' argues Kate Holliday," *Good Housekeeping* (February 1968): 182; "Cremated Remains Lost by Post Office," *American Funeral Director* 99 (June 1976): 16; "One Must Treat the Dead with Reverence and Respect," *American Funeral Director* 103 (January 1980): 39; James W. Fraser, *Cremation Is It Christian?* (United States of America: Loizeaux Brothers, 1985), 19, 11.

30. Steven V. Roberts, "Cremation Gaining Favor in U.S.," *New York Times* (December 6, 1970): 73.

31. Amy Seidel Marks and Bobby J. Calder, *Attitudes Toward Death and Funerals* (Chicago: The Center for Marketing Sciences, J. L. Kellogg Graduate School of Management, Northwestern University, 1982), 157.

32. Steven V. Roberts, "Cremation Gaining Favor in U.S.," *New York Times* (December 6, 1970): 1, 73.

33. Herb Klein, *Don't Waste Your Death... It Could Save a Life!*, 7–8.

34. "A Shift in Attitude on Funerals Noted," *New York Times* (October 28, 1967): 25.

35. "Ritual: A Changing Way of Death," *Time* (April 11, 1969): 60; "The State Funeral of Dwight D. Eisenhower," *American Funeral Director* 92.5 (May 1969): 43, 46.

36. Richard Severo, "Funeral Industry Is Striving to Improve Its Image in Face of Charges of Deception and Abuses of the Public," *New York Times* (April 25, 1978): 20; "Famed Funeral Service Critic Jessica Mitford Dies: A Farewell To Arms," *Funeral Monitor* 5.30 (August 5, 1996): 3. Mitford's long-time assistant, Karen J. Leonard, replies in "'You Only Hurt the One You Love' Dept.: Striking Back For Jessica," *Funeral Monitor* (September 9, 1996): 3–4.

37. Consumer Reports, *Funerals: Consumers' Last Rights* (New York: W. W. Norton & Company, 1977), 176.

38. This account is culled from these sources: Thomas E. Kelley, "Grief for John Lennon Neared Mass Hysteria," *American Funeral Director* (February 1981): 24–26, 70; "Yoko Ono Asks Mourners to Give to a Foundation Lennon Favored," *New York Times* (December 10, 1980): 2.7; "'Beatles' Songs Played In Memory of Lennon," *New York Times* (December 10, 1980): 2.7; Paul L. Montgomery, "Suspect in Lennon's Slaying is Put Under Suicide Watch," *New York Times* (December 11, 1980): 2.3; Clyde Haberman, "Silent Tribute to Lennon's Memory is Observed Throughout the World," *New York Times* (December 15, 1980): 1, 2.8; Yoko Ono Lennon, "In Gratitude," *New York Times* (January 18, 1981): 4.24.

39. "Famed Funeral Service Critic Jessica Mitford Dies: A Farewell To Arms," *Funeral Monitor* 5.30 (August 5, 1996): 1–3.

1 2

FROM MONTICELLO TO GRACELAND: JEFFERSON AND ELVIS AS AMERICAN ICONS

Robert Kiely

WHEN MY WIFE AND I drove across the country last January at the beginning of a spring sabbatical at Stanford, we chose a southern route to avoid snow. Once we decided to visit friends in Charlottesville, Virginia, and to cross the Mississippi at Memphis, we also knew that we had to visit the homes of Thomas Jefferson and Elvis Presley. "You owe it to yourselves," our friends and students said, though the tone was distinct for each place. Monticello was for uplift. Graceland was for laughs. But everyone, even our children, agreed: both places *had* to be seen. It was a kind of patriotic duty.

Teddy Roosevelt said that every American should make a pilgrimage to the Grand Canyon at least once in a lifetime. For him, that great wild place was America's Mecca, a sacred site that lifts the spirit of all who see it and transforms mere patriotism into awe. Although the United States has no state religion—or rather because we have no state religion—Americans tend to transfer our need for a unifying faith, a shareable reverence, onto the landscape or onto secular places and especially buildings associated with persons or events that we can all claim as our own. St. Patrick's Cathedral and the Mormon Tabernacle in Salt Lake City can never compete with the Mississippi River or the Empire State Building as American shrines precisely because they are denominational and therefore signs of our differences rather than our unity.

Jefferson and Elvis, on the other hand, belong to all Americans. Everyone knows who they are and everyone has an opinion about them— an opinion often based on feelings more than information. In a 1997 *New York Times* review of a biography of Jefferson entitled *American Sphinx*, Brent Staples wrote, "In ten years as an essayist for this newspaper, I have

never been so blistered and rained upon as after writing about Thomas Jefferson. The barest mention of the man brings e-mail, letters, and phone calls on a volcanic scale . . . professors picking nits and gridning axes . . . militarists claiming his words as a license to blow up buildings. . . . Debunkers condemn him as a bigot. . . . Bank presidents, cab drivers, college freshmen will have their say—as if speaking on Jefferson were their sovereign right."[1]

In her book *American Scripture*, the historian Pauline Maier writes that she once nominated Jefferson "as the most overrated person in American history" not out of animus but because of "the extraordinary adulation (and sometimes execration) he has received and continues to receive."[2]

Everyone knows that teenage girls once adored Elvis. But it is less well known that a month after he enlisted in the army, male enlistment increased by 28 percent. (Even his entering the army became every American's business. His draft board received hundreds of letters, some suggesting that he be sent somewhere dangerous in the hope that he would be shot. One letter writer chastized the Memphis Draft Board, with an odd rhetorical question: "You didn't put Beethoven in the army, did you?" The draft board answered, "Beethoven was not an American. And, besides, he would not have been eligible because he was deaf."[3]) In the early days before he was known as the "King," the most common epithets for Elvis were "innocent," "sweet," "angelic." His first manager, Sam Phillips, said he was the personification of American "innocence" and that he had an intuitive ability to convey his "appreciation of the total spirituality of the human experience." [4]

But also from the very beginning, there were those who regarded Elvis as "depraved" and "satanic." Frank Sinatra mixed sour grapes with glass houses when he called Elvis's singing "brutal, ugly, degenerate, and vicious."[5] The *Los Angeles Mirror-News* compared Elvis's concerts to the "screeching uninhibited party rallies which the Nazis used to hold for Hitler."[6]

Though their contributions to American culture are obviously radically different, Jefferson and Elvis have some surprising things in common. They have both become icons, images and mirrors of certain American ideals and anxieties that transcend their own historical moments and defy the efforts of critics to reduce them to the dimensions of ordinary mortals. "Elvis lives," as the saying goes, not only in his music but under the wigs of a thousand impersonators and in the daily sightings reported faithfully in tabloids read by millions of Americans.[7]

Jefferson lives too, perhaps less flamboyantly, but more effectively in our ideals of individualism and equality as well as in our dreams of versatility.

When President Kennedy welcomed American Nobel Laureates at a dinner in their honor, he flattered the nation as well as his guests when he said, "There has not been so much talent in the White House since Jefferson dined alone."[8]

No American beyond a certain age—say mid-primary school—can possibly avoid coming into contact with the traces of the works and words of Jefferson and Elvis. Even those who fail to study American history or refuse to listen to rock and roll, cannot avoid being imprinted with fragments—"we hold these truths to be self evident". . . "You aint nothin but a hounddog". . . "life, liberty, and the pursuit of happiness". . . "love me tender, love me true." That these fragments derive from utterly different lives and contexts is, of course, important. But so is the fact that for many Americans, they are like pseudo-genes, small bits of our inherited identity, specks of emotion and consciousness that belong to us before we know what they are or where they came from.

Jefferson and Elvis were both rebels of a particularly American variety. There is not an iota of Robespierre or Trotsky in either of them. Mild, peace-loving, even shy, they both lived in turbulent times and made important contributions to the ways in which Americans behaved and thought about themselves. Historians of early America and of rock and roll almost universally agree that Jefferson and Elvis have been given more credit than they actually deserve for being the "creators" of movements that they merely interpreted and translated into terms that were understandable and increasingly popular. Maier argues that the Declaration of Independence was not the work of one man but of hundreds.[9]

Similarly, though Elvis is still popularly thought of as the inventor of rock and roll, he actually followed and learned from a number of mostly black performers including Fats Domino, Little Richard, Chuck Berry, and the Ink Spots.[10] Nevertheless, there is no sign that the iconography of Jefferson as ideological parent of our democracy and Elvis as the King of Rock and Roll is likely to be affected one way or another by what historians say.

One of the most endearing and American qualities that Jefferson and Elvis share, revolutionary inclinations notwithstanding, is their agreement with the philosophy of Dorothy in *The Wizard of Oz* that "home is best." Monticello and Graceland are eminently powerful and magnetic sites because they are larger than lifesize lifemasks of their extraordinary owners and brick and mortar "proof" that, despite fame and fortune, Paris and Las Vegas, these two Americans were orthodox homebodies in choosing Charlottesville and Memphis as the homes of their heart, and their final resting places.

As should be the case in going on a pilgrimage for the first time, nothing quite prepared me for Monticello or Graceland nor for the almost grim rather than laughable differences between them. Though Jefferson was in serious debt over his continual improvements on the house and property, Monticello gives an appearance of beautiful simplicity and modesty.[11] It may have *been* an extravagance, but it does not *look* extravagant. Against the giant tulip poplars, cedars, and larch trees and the great slope of mountain rising beyond the garden, the house almost looks small. Its rooms are flooded with light through generous windows even in midwinter.

Like the trees and shrubs, all of which were brought to the mountain from great distances, the furnishings (many of Jefferson's own design) and paintings (mostly brought back with him from Paris) do not crowd or clash with one another. They all look as though they are where God originally placed them. Indeed Jefferson sounds like Zeus describing Mount Olympus when he writes to Maria Cosway in 1786: "And our own dear Monticello; where has nature spread so rich a mantle under the eye? mountains, forest, rocks, rivers. With what majesty do we there ride above the storm! How sublime to look down into the workhouse of nature . . . !"[12]

Graceland is on a noisy highway named after Elvis and surrounded by miles of neon-lighted motels and fast-food joints.[13] In early February the huge airport terminal–like waiting room across the street was nearly empty, but you still had to get your tickets there, rent the required earphones there, and wait for the required van to take you on the two-minute ride up the driveway to the front door. The lawn was patchy brown and the house, built in the 1930s for a doctor, could have been in Brookline.

An extremely thin, uniformed woman in what appeared to be a trance, recited a memorized welcome to our little group and told us to turn on our earphones and do only and exactly what we were told. Then she disappeared and we were led by the recorded voice to peek into rooms that we were prevented from entering by velvet cords. A hush fell over us as we piously eyed plush wall-to-wall carpets and a fifteen-foot sofa (made to Elvis's order) so freshly and plumply upholstered that it was impossible to believe that anyone had ever used it. The companion of one woman whispered something to her, but she frowned and turned up the volume on her earphones, "Shhh, he's singing to me!"

At Monticello, the young guide could have been a graduate student or an assistant professor. She seemed to know everything about Jefferson, answered our questions at great length, and encouraged us to wander about the house and grounds and ask whatever we liked. She talked as if

she had been in conversation with Jefferson recently and therefore knew what he had been thinking and doing. We were allowed to ramble freely through Jefferson's private suite of rooms; we were shown his library, his cabinet or study and his tiny alcove bed almost in arm's reach of his writing desk. This was his "sanctum sanctorum," "holy of holies," the guide said respectfully. "Sanctum sanctorum" is also what the official guidebook by Nichols and Bear call this area of the house.[14]

The choice of words is not accidental. In a church or synagogue, this would be the tabernacle or the ark, the center and heart of the building where the scriptures or sacrament are kept. In Monticello, the simplicity and orderliness are breathtaking. The proximity of bed, desk, and books is the perfect image of a man wedded to ideas. Jefferson's sanctuary was a quiet refuge but also the center of a dynamo. At this desk, we were told, he received word of the completion of the Louisiana Purchase agreement. In this bed, he dreamed of a great American university. If Jefferson did have affairs with his slaves or anybody else, he must have used another bed because this one is very narrow. On the other hand, if an idea came to him in the middle of the night, he could jot it down without going very far.

It would be hard to say which room is the heart of Graceland. Elvis had his own taste, but unlike Jefferson, he also had an interior decorator, a former Lipton tea salesman. A huge white piano is at one end of the pastel living room; a glossy table sits on a marble slab in the dining room; there is a soda fountain in the T.V. room; the billiard room is swathed with colorful material meant to resemble a shiek's tent; the jungle room has an artificial waterfall dribbling down one wall and dark furniture carved in the shapes of exotic animals and plants. In many rooms, the windows are covered so that no light can enter. Nothing looks natural. Colors are vivid, metallic, electric. Nothing looks comfortable. It is like a mausoleum. A house of death.

We were not shown Elvis's bedroom ("I will probably have a black bedroom suite trimmed in white leather," he told a friend shortly after purchasing Graceland[15]) or his much mythologized 8-foot-square bed. One biographer claims that Elvis's "inner sanctum" was his enormous bathroom with black padded toilet, two television sets, and several gilded armchairs. It is the room where Elvis died of an overdose of drugs on August 16, 1977, a date of no other significance in American history.[16] Jefferson, as everyone knows, died in bed of natural causes on the 4th of July 1826.

It is at this point on our double house tour that someone is bound to say, "These two men have absolutely nothing in common," or "The lives of

these two and the houses they inhabited are clear evidence of the decline and fall of American civilization." When I came up to the cashier in the Harvard Book Store with a stack of books on Jefferson and Elvis, the clerk laughed: "Jefferson would have been disgusted by Elvis," he said, "and Elvis, I guess, would have found Jefferson a bore." As I have mentioned this project to friends and colleagues, some have found it an amusing impossibility, something that cannot be done. Here are two American icons maybe, but incomparable figures that have nothing to say to one another. A few people even thought it was a kind of sacrilege, an insult to Jefferson, a mockery of Elvis.

The more I encountered such reactions the more interested I became in the comparison, not only because professors of English are trained to compare and contrast almost anyone and anything, but because an interesting question of cultural history began to emerge. After the White House, Graceland and Monticello are the two houses most frequently visited by Americans. What does this mean? Is this a funny accident of our history? Is there no link between the two places other than a network of interstate highways? Is the popular culture of mid-twentieth-century America utterly unrelated to the ideals and experiences of our founding fathers? Is our cultural history simply a series of discontinuous moments and miscellaneous heroes?

Some postmodern critics would say that all history is pretty much like that, but a tendency—more than a tendency, a political necessity,—for Americans has always been to seek out coherent narratives that can include us all. Some of the earliest and most persistent of such narratives have been biblical in origin. William Bradford and the pilgrims in Plymouth Plantation saw themselves as the children of Israel fleeing the armies of Pharoah. African-American slaves too reclaimed the Book of Exodus as a paradigm for their own plight and their hope for liberation.

Borrowing freely from this tradition, I would like to propose that Jefferson is a "patriarch" of the Old Dispensation and Elvis a "prodigal son" and "suffering servant" of the New Dispensation. In his old age, Jefferson became known as the Sage of Monticello. In his prime, fans began calling Elvis the King. Jefferson's title was meant literally; Elvis's, even on the part of his admirers, has always been touched with democratic irony. It demands a redefinition of kingship as, in the New Testament, it does when Jesus says to Pilate, "It is you who say that I am a king."

Like Moses, another man of the mountain, Jefferson was a poor public speaker, a figure associated with the written not the spoken word. In ancient Jewish tradition Moses is the author of Genesis and Exodus and,

of course, the bearer of the Law, the ten commandments (though Moses undoubtedly had the help of even more collaborators than did Jefferson). In American tradition, Jefferson is the author of the "American Scripture," the indelible outline of our rights and most essential communal beliefs. (Jefferson displays a familiar Mosaic preoccupation when he writes, "It can never be too often repeated, that the time for fixing every essential right on a legal basis is while our rulers are honest, and ourselves united."[17])

Maier compares the display of the Declaration of Independence in the National Archive with a "pre–Vatican II altar" of her "Catholic girlhood"; its frame is like a "tabernacle or perhaps a monstrance, the device used to display the host on special days of adoration."[18] Despite his dislike of religious idolatry, Jefferson did little to discourage the use of religious language in reference to the Declaration, which he called "an instrument" worthy of "reverence" because it is a pledge of a "sacred determination," a "holy purpose."[19]

In painting and statuary Jefferson is either ageless or old. Though we are told that he gambled and was reckless as a young man, we cannot and do not wish to imagine Jefferson as a young buck. Nick Nolte's attempt to portray a young middle-aged *Jefferson in Paris* was an unmitigated disaster. The actor appeared to have confused Jefferson with Gerald Ford stumbling about the Bois de Boulogne proving how difficult it is to wear the shoes (or the wig) of a sacred icon with impunity.

As a patriarch, Jefferson belongs to all Americans, but he belongs to us collectively, not individually. We relate to him as a people not singly. He has about the same amount of personal and erotic appeal as Father Abraham. I think this is why it is difficult to situate his alleged extramarital affairs with Maria Cosway and the slave Sally Hemmings within what we normally think of as a private life. The iconic Jefferson had no private life. His bed, his desk, his books, his house are open for all to read. He preached economy and spent more than he had. He favored the abolition of slaves but did not free his own slaves. It seems certain that he fathered children with Sally Hemmings and that he did not grant her or them the same status or indeed place in his own heart as his white wife and children. This seems as arbitary and unjust as Abraham's banishing of his son Ishmael, born of the slave Hagar. According to the Book of Genesis, the consequences of Abraham's actions were disastrous for Israel, but for Bible readers, religious or not, it is impossible to address Abraham's action as though it were a matter of individual moral choice precisely because the figure of Abraham represents a people not a person.

When the African-American historian John Hope Franklin said that he "forgave" Jefferson, he showed the decency of his own character but did not touch Jefferson's, whose transgressions, like his personal identity, keep receding into the common patriarchal mists of his time.[20] I think most of us cannot forgive Jefferson his sins against liberty because they are not forgiveable and, anyway, we cannot get hold of him. Insofar as Jefferson's sins remain unforgiveable and unfathomable, they do not make him more human, more like us, but ever more remote, more terrible, the father we all claim but who like the God of Moses, did not apparently claim or choose all of us.

I do not wish to suggest that Elvis was a "Christ figure," though finding Christ figures everywhere was a favorite occupation of literature professors who were his contemporaries in the 1950s. But I do think that in his own imagination and in that of many of his worshippers, Elvis inhabited a gospel world not a Torah world. He was a man of the spirit not of the law, a "voice crooning in the wilderness," not a bearer of the written word or the author of sacred scriptures. The name "Graceland" itself, though originally taken from the name of the wife of the doctor who built the house, is right for Elvis and, like so many accidents of his life, has taken on a religious connotation. Indeed, its coincidental origin is all the better since in Christian theology, grace is a gift not a reward. Grace is "amazing" precisely because it is not expected or earned. We are always reminded of how hard Jefferson worked (that he was up with the sun, read Greek and Latin, studied botany, wrote hundreds of letters, etc.). Whereas the legends about Elvis are of his carousing all night and sleeping all day. In fact, Elvis was not a lazy man. His hours were not the same as Jefferson's but they were often long and demanding. Never-theless, the iconic Elvis is not a busy bee. Talent and success are supposed to have just happened to him. Like grace.

The shrine that most resembles the tabernacle of the Declaration of Independence is not inside the main house of Graceland, but in a separate building where Elvis used to play racketball and where now his gold and platinum records and fancy costumes are displayed behind glass. A gold record does not give the viewer much to look at other than a label and its glittering roundness. The original Declaration of Independence, even encased in a tabernacle, invites reading. Tourists squint and mouth words as they look. The worshippers of the golden record can only contemplate in silence. The appeal of the round object is mute, mystical. The viewer's eye is drawn to the center of each disk to the label where we find the title of the song and Elvis's name, often in larger print.

Jefferson's appeal is centrifugal, like that of the Hebrew patriarchs whose legacy was to be multiplied like the stars. Jefferson's accomplishments lead us away from the individual and out to the nation that he helped shape, to the university he founded, to the inventions and furnishings he designed, to the gardens he planted. The attraction of Elvis is centripetal. Like the labels on his gold records, and like Jesus in the New Testament, everything leads back to him. Monticello stands gloriously on its own, alive and inviting without the physical presence of its famous designer and inhabitant. Graceland without Elvis is a sad mausoleum, an empty tomb forever awaiting the resurrection. The costumes also on display behind glass without Elvis are sad shrouds, relics to be wept over. (Elvis was reading a book on the shroud of Turin when he died.[21])

In biblical terms, Elvis seems to me not Jefferson's opposite or a sign that Jefferson's hopes for America have failed. I see Elvis as Jefferson's "natural son," a product of Jeffersonian America that Jefferson may not have foreseen or wanted, but one that belongs to him nonetheless. Surely, Elvis's story is a genuine rags-to-riches success, an only in America myth that depends heavily on belief in equal opportunity for all and the resources of natural talent that can be found in the population at large. Elvis was no more hypocritical than Jefferson and many other Americans, past and present, who believe in democracy but live beyond their means in aristocratic splendor. Jefferson may have had better taste than Elvis, but both wanted it both ways—to live like kings while being regarded as ordinary citizens. In many ways, Elvis's body, not his house, was his Monticello. Well before he was famous, as early as age fifteen and sixteen, he began to dye his dirty blonde hair black, to wear mascara, and to dress up in bolero jackets and pink pants that set him apart from his generation. But then Jefferson's Palladian facade was also a facade, a carefully designed exterior meant both to hide and reveal the inner man.

Even in religious terms, Elvis and Jefferson have much in common. Jefferson could not abide theology and what he considered the futile abstract doctrinal debates among sects, but he was more than a Deist. He was a practical humanistic Christian, a man of faith in God, especially in a God that favored America and hard work. When Natalie Wood dated Elvis, she said that she found him too religious for her taste and that on their dates, he frequently recited the Lord's Prayer. But Elvis's Christianity was neither exclusive nor dogmatic. He may have grown up in the Bible Belt, but he was not a fundamentalist. He seems to have had a genuine love of Jesus and a relative indifference to sectarian doctrine. At his grave there are

both Catholic and Protestant markings, a simple stone and epitaph in the Protestant mode, and next to it a Sacred Heart of Jesus statue.

But nothing makes Elvis more of a "natural son" of Jefferson than his ambiguous relationship to African Americans and African-American culture. Elvis never denied that he loved gospel music as he heard it in both black and white churches growing up in Mississippi and Tennessee and that his own style was heavily influenced by it. He never denied either that some of his recordings were beat by beat, word by word copies of recordings by black groups. But his career blossomed in the 1950s in the South where entertainment, like much else, was segregated.[22]

Sam Phillips, Elvis's first promoter, recalls having to reassure listeners to Elvis's first records on the radio that the singer was white. Though he, like Elvis, believed in Jefferson's "equality of man," "I had to keep my nose clean... They could have said, 'Why should we give this nigger-loving son of a bitch a break?'" Phillips goes on to say that though he and Elvis never discussed it, he believed Elvis understood the evasiveness with which he treated the black influence. "It was almost subversive, sneaking around through the music... but we hit things a little bit... I knocked the shit out of the color line."[23] One can take Phillips's words as a liberal boast or as an unwitting admission that he and Elvis whitewashed black music, sold the white public, largely ignorant of black music, not a bill of rights but a bill of goods.

In 1955, *The Memphis Press-Scimitar* ran a picture of Elvis after a particularly successful concert. The caption read, "A white man's voice singing negro rhythms with a rural flavor has changed life overnight for Elvis Presley."[24] Once again, the implications are ambiguous. There is no doubt that Elvis is benefitting from the exchange; there is less clarity about whether he is promoting or coopting black music, making it acceptable to white audiences because it is transmitted (and somehow purified and improved) by a white voice. Here too there is an irony, because radio listeners who had never seen the young Elvis thought his voice sounded "colored."[25]

Only this year has there been a new release of recordings of Elvis singing gospel throughout the course of his career. In over four hours, it is possible to hear the Elvis of 1955 on through to the Elvis of the mid and late seventies. The transformation (decline) in the voice is noticeable, but even more striking is the showtime Las Vegasizing—some would say "whitening"—of the gospel tunes, the additions of huge choruses and orchestras with corny frills and untraditional harmonies. But it is still wonderful to hear the young unspoiled Elvis singing gospel as he first heard it and admitted to a gospel singer in 1955,

"This is my favorite music." "Why, you white nigger," the singer replied, "if that's your favorite music, why don't you do that out yonder?"[26] At first Elvis did, but as his fame grew, he and his managers thought that his white audiences did not want to be reminded of the black connection quite so blatantly.

Jefferson's contradictory words and acts in regard to race and slavery continue to haunt his reputation. Nothing, to my mind, is more troubling and enduring than the words he (and his fellow drafters) agreed to leave out of the Declaration of Independence, though they appeared in the original draft: "He [George III] has waged cruel war against human nature itself, violating its most sacred rights of life and liberty in the persons of a distant people who never offended him, captivating and carrying them into slavery in another hemisphere."[27] Even if these words had been allowed to stand, there seemed to have been no intention on Jefferson's part to acknowledge his own complicity and that of many of his fellow patriots in the English king's cruelty "against human nature."

I do not think an easy case can be made that would indict either Jefferson or Elvis as fully, cruelly, deliberately, consistently bigotted. Neither was an extremist. What they have in common, I suggest, is also a trait that mirrors America, especially white America, to itself: their compromised attitude toward race, their silences, their failures to act, their inconsistencies, their willful evasiveness. Unfortunately, as long as they are regarded as sacred cows rather than men, that compromise also becomes untouchable, even sanctified and sanctioned.

A final question. Would Jefferson have had anything to say to Elvis and Elvis to Jefferson? Jefferson loved to give advice and often did to his nephew and daughter and friends. His advice to one protégé might well have been sent to Elvis: "Your love of repose will lead, in its progress, to a suspension of healthy exercise, a relaxation of mind, an indifference to everything around you, and finally to a debility of body."[28]

Elvis, ever the repentant prodigal son, wanting desperately to please an emotionally distant father, his audience, even Richard Nixon and J. Edgar Hoover, might sing Jefferson a love song and a promise he could never keep:

My darling, you hold the key.
Any way you want me, well,
That's how I will be.

The unexpected rotaries, short cuts, and dead ends between Monticello and Graceland turned out to be instructive. Perhaps it is not really so sur-

prising that a project begun as a lark became more and more serious as I approached and crossed the Mason-Dixon Line, the Mississippi River and further on, another Continental Divide. Whether we have conceived of them in regional or racial terms or in the categories of high and low culture, Americans have often simultaneously laughed at and worried about those things that have separated and united us. *E pluribus unum* is a vision and an unstable paradox that has been, and always should remain, open to question and interpretation. A national ideal that is at the same time a source of pride and anxiety calls for examination not just reaffirmation. There are clearly some invisible yet binding links, some common genealogies that Americans have been less ready to acknowledge and analyze than others. But painful or ridiculous incongruities, acknowledged or not, have a way of making themselves felt. It was only after I had begun writing this paper that I remembered that Bill Clinton's middle name is Jefferson and was told that the Secret Service's code name for him in his first term was Elvis. One name may have been given in solemn hope; the other as a joke. Both names— taken together as labels for the same person—say much about the man and the nation that chose him as its president.

NOTES

1. Brent Staples, Review of *American Sphinx: The Character of Thomas Jefferson*, *The New York Times Book Review*, March 23, 1997.
2. Pauline Maier, *American Scripture: Making the Declaration of Independence* (New York: Alfred A. Knopf, 1997), xvii.
3. Peter Harry Brown and Pat H. Broeske, *Down at the End of Lonely Street: The Life and Death of Elvis Presley* (New York: Dutton 1997), 137.
4. Peter Guralnick, *Last Train to Memphis: The Rise of Elvis Presley* (Boston: Little, Brown and Company, 1994), 121.
5. Brown and Broeske, 128.
6. *Ibid.*, 130.
7. Considerable critical attention has been paid in recent years not just to Elvis's life and music, but to his extraordinary popularity during his lifetime and the mythology that has grown around him since his death. Among some of the most probing examinations of the Elvis phenomenon are Albert Goldman, *Elvis* (New York: McGraw Hill, 1981); Marcus Greil, *Dead Elvis: A Chronicle of a Cultural Obsession* (New York: Doubleday, 1991); Jerry Hopkins, *Elvis: The Final Years* (New York: St. Martin's Press, 1980); and Jac L. Tharpe, ed., *Elvis: Images and Fancies* (Jackson: University Press of Mississippi, 1979).
8. Scholarship on Jefferson is, of course, extensive, but of particular value in assessing the paradoxes in the Jefferson legacy are: Daniel J. Boortsin, *The Lost World of Thomas Jefferson* (Chicago: The University of Chicago Press, 1981); Andrew Burstein, *The Inner Jefferson: Portrait of a Grieving Optimist* (Charlottesville: University Press of

Virginia, 1995); Joseph J. Ellis, *American Sphinx: The Character of Thomas Jefferson* (New York: Alfred A. Knopf, 1997); and Jay Fliegelman, *Declaring Independence: Jefferson, Natural Language, and the Culture of Performance* (Stanford, Cal.: Stanford University Press, 1993).

9. Maier, *American Scripture*, xiv.

10. Brown and Broeske, 77.

11. Two informative books on Monticello are James A. Bear, Jr., ed., *Jefferson at Monticello* (Charlottesville: University Press of Virginia, 1967), and Jack McLaughlin, *Jefferson at Monticello: The Biography of a Builder* (New York: Random House, 1988).

12. Adrienne Koch and William Peden, eds., *The Life and Selected Writings of Thomas Jefferson* (New York: Random House, 1993), 371.

13. Graceland's status as a shrine has attracted increasing attention among journalists, critics, and scholars. Recent books on the subject include: Chet Flippo, *Graceland: The Living Legacy of Elvis Presley* (San Francisco: Collins, 1993); Harold Loyd, *Elvis Presley's Graceland Gates* (Franklin, Tenn.: Jimmy Velvet Publications, 1987); Margo Green, Dorothy Nelson, and Darlene Levenger, *Graceland* (Mich.: Trio Publishing, 1994); and, of particular interest, Karal Ann Marling, *Graceland: Going Home with Elvis* (Cambridge, Mass.: Harvard University Press, 1996).

14. Frederick D. Nichols and James A. Bear, Jr., eds., *Monticello: A Guidebook* (Monticello, VA: Thomas Jefferson Memorial Fund, 1993), 29.

15. Gurelnick, *Last Train*, 396.

16. Brown and Broeske, 412–18.

17. Koch and Peden, 256.

18. Maier, *American Scripture*, xiv.

19. Maier, *American Scripture*, 186.

20. As part of his commentary on Ken Burns's PBS documentary *Thomas Jefferson*, Franklin said, "I am a forgiving man, therefore, I forgive him."

21. Brown and Broeske, 412.

22. On Elvis's debt to Southern Black church music and blues, see: Michael Bane, *White Boy Singin' the Blues* (New York: Penguin Books, 1982); Jess Stearn, *Elvis: His Spiritual Journey* (Norfolk: Domming, 1982); and Steve Turner, *Hungry for Heaven: Rock and Roll and the Search for Redemption* (London: W. H. Allen, 1988).

23. Guralnick, *Last Train*, 134.

24. *Ibid*, 162.

25. *Ibid*, 101.

26. Brown and Broeske, 66.

27. Koch and Peden, 26.

28. *Ibid*, 634.

1 3

PRACTICING CHRISTIAN ROCK

Barbara Claire Freeman

After all, in poets love has its priests, and sometimes we hear a voice who knows how to defend it; but of faith one never hears a word. Who speaks in the name of this passion?

—*Søren Kierkegaard,* Fear and Trembling

"**F**OR TWENTY-FIVE CENTURIES, Western knowledge has tried to look upon the world. It has failed to understand that the world is not for the beholding. It is for hearing. It is not legible, but audible."[1] Thus begins Jacques Attali's path-breaking study *Noise: The Political Economy of Music* in which Attali argues that music does not just reflect society, but, through organizing and distributing noise, foreshadows new social formations in prophetic ways. Music is at stake in the multifarious games of power, whether that power takes the form of totalitarian government or the more subtle but no less pervasive force of political economy in modern parliamentary democracies. In order to analyze and interpret the diverse cultural practices of a particular society we must, according to Attali, "learn to judge a society by its sounds . . . by listening to noise, we can better understand where the folly of men and their calculations is leading us, and what hopes it is still possible to have,"[2]

If Attali is indeed correct it follows that the work of cultural analysis must proceed by hearing and listening as well as by seeing and beholding, for the unique sounds a given culture produces may tell us as much—if not more—about its functioning then would an exclusive focus upon what its members see. Accordingly, I will begin to focus this discussion of contemporary religion by asking that we listen to and compare two examples of popular music—rock 'n' roll and Christian Rock. For although there is no consensus about what to call it, we can learn a great deal about contemporary religious practices by listening to that genre of music variously called "Contemporary

221

Christian Music," "Christian Pop," and "Christian Rock." Auditors and critics who write about and/or listen to, but do not otherwise participate in this genre, call it Christian Rock or Christian Pop, while members of the subculture who actually produce it use the term "Contemporary Christian Music" or employ the acronym CCM—which is also the name of the monthly magazine that is the *Rolling Stone* of the Christian Music Industry.[3] My purpose, however, is not to ask generic questions about the nature of rock music or to adjudicate competing definitions of secular versus with what, since I am not a practitioner, I will henceforth call "Christian Rock," but to ask what listening to examples of both secular and Christian rock might teach us about the practice of religion in contemporary U.S. culture.[4]

One of the biggest differences between hearing Christian and secular Rock is that while the former depends upon understanding specific thematic and evangelical content, the latter most frequently obscures verbal meaning and privileges the experience of listening to a distorted and highly amplified sound. Although it was written thirty years ago, Greil Marcus's definition of "a great rock 'n' roll song" continues to strike me as definitive: "A great rock 'n' roll song can't be written or sung because if it is great rock 'n'roll the music dodges the message and comes out in front, especially if the message is clear and unmistakable. The idea must be virtually lost in the music before it is worth reaching for, or be so simple and emotional that 'words' and 'ideas' become music themselves."[5] Kurt Cobain, the co-founder, songwriter, and lead singer of the legendary band Nirvana, makes much the same point: "Music comes first," he says, "lyrics are secondary."[6] Discussing Nirvana's lyrics in the album *In Utero*, rock journalist Catherine Turman concurs, "Funny thing is, you can't hear the lyrics, you can't remember the lyrics, but you still love the songs, remember the songs . . . it's just very powerful, very primal, and very liberating."[7]

Christian rock, however, plays itself out according to a very different set of rules. The genre is defined by the fact that its lyrics proclaim a "Christian" message that is conservative, evangelical, and fundamentalist, with particular insistence upon the capacity of Jesus to save those who believe in Him. Lyrical and thematic content rather than musical form is Christian Rock's distinguishing feature. *The Rolling Stone Encyclopedia of Rock & Roll* defines Christian Rock as "pop or rock with a specifically Christian, oftentimes conservative message. Within the genre are artists whose identification with the term range from the doggedly rigid underground (Petra, Carman, Phil Keaggy, Sandi Patti) to the mainstream crossovers (Amy Grant, Stryper, King's X) to the secular pop artists who express their Christian faith in more universal terms (U2, Van Morrison,

Bruce Cockburn, T Bone Burnett)... the Christian-rock arena encompasses nearly every pop music style...."[8] William D. Romanowski, one of Christian rock's most authoritative historians, also emphasizes its hybrid nature: "CCM resists clear definition (but)... is essentially a mixture of popular musical styles and religious lyrics. Songs are usually autobiographical, expressing the need for personal salvation or praising God."[9] He also points out that even the original Jesus musicians of the late '60s and early '70s "treated rock music as a neutral form of communication that merged with the sacred gospel message. Jesus rock... was less a musical hybrid than a co-optation of existing rock music for evangelistic purposes."[10] In a recent article on Christian Pop, *New York Times* music critic Jon Pareles makes much the same point. According to Pareles, the fundamental message of the genre is that "Christian pop tries to keep up with secular trends. There is Christian grunge, Christian rap, Christian country.... Much of it is unabashedly imitative, attempting to counterfeit the sounds and images of a chosen genre while the words proselytize. A child who liked Nirvana, parents are advised by newsletters or store clerks, may also accept DC Talk or Jars of Clay... the message of Christian rock is that embracing Christ brings comfort... the actual music is both imitative and ecumenical."[11] Although it may be every bit as difficult for the auditor to understand the lyrics of, for example, a heavy metal Christian rock song as those of a secular one, the song's very membership in the genre of Christian rock depends upon what its lyrics say, as distinct from its music or performance.

Whereas rock 'n' roll began as an innovative synthesis of indigenous musical styles that fused music and lyrical content in profoundly original ways, Christian rock, which began as an instrument of conversion, thinks of music primarily as a tool that can be employed to convey a Christian message.[12] The content of the music is central to its origin and purpose, which is entirely evangelical.[13] In the 1970s and early 1980s a Christian music industry formed around Jesus musicians' vision of using rock music as an alternative to the secular entertainment system.[14] Baptizing the music with Christian lyrics was a way of legitimating it for born-again hippies and gaining a foothold in the youth market. The movement grew to include an array of independent record labels supported by like-minded believers and a large audience who attended the special festivals and concerts the CCM record companies sponsored. By the mid-1980's and early 1990s this industry had grown to include its own production and distribution companies, evolving from a fledgling adventure "among a small group of long-haired Jesus musicians into a multi-million dollar business."[15] The Christian Music establishment understands

music as a vehicle for evangelism in the youth culture just as the secular rock industry understands it as a commodity from which to create profit, but the former seeks not only to obtain financial profit from the music it produces and sells to major record companies, it also profits by gathering new members into the religious communities in which it is embedded. At the 1989 Gospel Music Association in Nashville, for example, Dan Harrell, co-manager of Amy Grant, argued that the goals of music and business are "exactly the same—market share."[16] But whereas secular record companies want merely to make money, the CCM movement seeks to convert souls as well as market sound.

Whether you call it Christian Rock, Christian Pop, or CCM, this musical practice has been very much in the news of late. On the very same weekend— August 2 and 3, 1997, to be precise—both the Sunday *New York Times* and the *San Francisco Chronicle/Examiner* featured stories on its growing popularity and commercial success. The title of Pareles' *New York Times* article, "In a Higher Realm on the Pop Charts," attests to the fact that Christian rock, once the exclusive practice of the "Jesus Movement" begun by Larry Norman and other young Christians in the late '60s, has by the end of the '90s, gone big time. And although reporting upon the three day "Spirit West Coast Christian Rock Festival" held in Monterey, California, from July 31 to August 2 occasions Don Lattin's front page San Francisco Chronicle article, Lattin emphasizes that CCM has become "the fastest-growing segment of the mainstream music industry. Gospel rock CDs are going platinum . . . and they're topping the charts as major record companies gobble up obscure Christian labels."[17] He points out that many Christian rock bands such as DC Talk and Jars of Clay "have successfully crossed over into mainstream radio, MTV, and such pillars of the rock establishment as *Rolling Stone* magazine." [18]

According to Peter Furler, the thirty-year-old leader of the enormously popular Christian rock group the Newsboys—the band's latest album *Take Me to Your Leader* sold 500,000 copies shortly after its release, earning it a "Hot Shot Debut" on the billboard charts and a gold record—music comes directly from a specifically Christian deity: "God," says Furler, "created music." Furler also makes proclaiming God's immanence part of his performance: At the "Spirit West" Festival in Monterey he ran to the edge of the stage, leaned out to a jumping, floating "throng of ecstatic teenage rock fans," and screamed: "God is not a secret . . . God is not a secret to be kept."[19] (It is perhaps no accident that "God is not a Secret" is the title and lead song of the Newsboys latest CD.) The corporate world would seem to agree, for major record companies, who are not exactly in the business of glorifying God, are buying Christian

labels and cashing in on a rapidly growing market. (Virgin Records, for example, recently signed the Newsboys.) Missy Baker, publicist for ForeFront Records, sees an enormous potential for Christian pop/rock crossovers into mainstream music: "The boom in this industry is like what happened ten or fifteen years ago with Garth Brooks and country music," she says. "What separates the new gospel wave from earlier manifestations of Jesus and gospel music are the sheer number of bands, their solid fan base, their growing presence in the music industry, and the spread and popularity of Christian rock music festivals."[20] Although it took over four years for Amy Grant's album *Age to Age*, which was released in March 1991, to become the first contemporary Christian album to sell over a million copies, by August 1997 Bob Carlisle's album *Shades of Grace*, released in April 1996, had sold 1.2 million albums.

Whether or not this recent trend is evidence of a lasting Christian rock conquest, its rising popularity is perhaps symptomatic of the genre's uniformly reassuring message. The lyrics of "Stomp," a hit song by the Christian rock group God's Properties, which aims to please Christian hip hop fans and has sold phenomenally well—according to Soundscan's tabulation of album sales through July of 1997 it had sold over 700,000 records—provides a paradigm of this straightforward and unequivocal message: The song begins by asserting, "Jesus, your love is so amazing/it gets me high, up to the sky" and proceeds to assure the listener that "Jesus (will) take the pain away."[21] The lyrics of Christian Rock songs insist that Christianity brings pleasure, safety, and invulnerability to the faithful and that the Church provides a public space in which to find respite from suffering. The very unambiguity of its message helps explain both Christian Rock's popularity and its commercial and evangelical success. Interviewed in *Rolling Stone* magazine, Jesus musician Chuck Girard affirms, "When you ask somebody what our songs are about there's no ambiguity. It's right there in plain simple language with no deep intellectual vibes. What we're saying is Jesus, one way. If you want the answer, follow it."[22] Although it is of course the case that secular rock music's commercial success is equally ideological, and indeed is sometimes even occasioned by appeals to an unambiguous, pure, and natural sexuality that promotes the inherent goodness of sexual expression, the genre of secular rock does not depend upon or adhere to endorsing any one single, unequivocal message.

But if, as ethnomusicologist Thomas Cushman affirms, musical styles can, like religion, "serve as rituals which affirm the identities of the group members who articulate them," then music is not simply a neutral form of communication that can be used to accommodate and purvey any message

whatsoever, but rather, as Attali argues, an organizing structure that conveys affect, binds communities, and both reflects and creates a variety of subcultures.[23] Contemporary popular music is a form of communication that creates socially shared meanings and groups that did not exist prior to its performance and production. In this sense secular rock music and culture must also be understood, and is frequently described, as a form of religion. Indeed, the very etymology of the word "religion"—it derives from the Latin *religionem* and means "to bind together"—suggests a link between rock music and religion, for both serve to constitute subcultures as well as express them. In *Rock My Religion*, for example, Dan Graham argues that in the 1950s a new kind of religion called rock 'n' roll emerged that "turned the values of traditional American religion on their head."[24] Patti Smith also connects the practice of rock with religion: She affirms that "My belief in rock and roll gave me a kind of strength that other religions couldn't come close to."[25]

It is important, however, to emphasize another connection between the development of rock music and religious practice, for rock 'n' roll, which attained ascendance as the dominant form of popular music in the United States in 1958, originated in black American religious experience and tradition.[26] The music that in the late 1950s became so popular with white middle- and upper-class teenagers was black music performed mainly by both black and white musicians, but whether or not it was performed by white musicians such as Bill Haley, Buddy Holly, Jerry Lee Lewis, and Elvis Presley, or black musicians such as Chuck Berry, the Coasters, Fats Domino, Little Richard, and the Platters, only the white musicians crossed over to hit the top of the white pop charts. Nonetheless rock music is deeply rooted in, if not a direct product of, the black American musical tradition, particularly the music that grew out of and developed within the contexts of black Christian religious practices and institutions. *The Rolling Stone Illustrated History of Rock & Roll* makes this point in one simple, emphatic sentence: According to rock historian Robert Palmer, rock music "certainly would not have developed had there been no African-Americans."[27]

Although the blues, a form of black secular music that originated in slave experience and is frequently described as coming "from the cotton patch," was also a fundamental influence, rock 'n' roll would not exist without the music that developed as part of Christian worship in black Baptist, Methodist, and Pentecostal Churches.[28] There are also important historical connections between the development of Black American music and the Christian Church, for by the beginning of the nineteenth century blacks had begun to adapt

Christian songs to their own music and culture: As the nineteenth century unfolded, the slave population of America was drawn more and more to Christianity.[29] No discussion of rock music can underestimate the importance of African-American music and experience. Although one might argue that rock music begins with Elvis Presley's popularization and successful marketing of what had been an exclusively black musical tradition, it is nonetheless the case that African-American history, the Christian religion, and the development of rock are so interwoven that one could not exist without the other. Rock as we know it would not exist without African Americans.

But although Christian and secular rock music both serve to create communities and subcultures, it is nonetheless important to assess their important differences, for the ethics, values, politics, and ideologies of secular rock are fundamentally different from those that Christian rock affirms.[30] First and foremost, rock music and culture function as an alternative religious practice by providing a kind of knowledge and experience Christian rock precludes, for it endorses a sexuality that has nothing to do with the anti-sexual ethos that, in evangelical fundamentalism, binds reproduction to marriage and sex to sin. In so doing it offers a critique of the belief system and sexual practices upon which Christian Rock and evangelical fundamentalism depend. It is no accident that the verb "to rock" was used in blues songs of the 1940s and 1950s as a slang word that meant "to have sex" long before it became the name for a musical rhythm marked by a driving, accentuated beat, for rock music and culture continues to celebrate precisely what the vast majority of Christian denominations condemn as a sin: sexual pleasure outside the confines of heterosexual marriage. Secular rock stars and groups such as the B52's, Erasure, k d lang, Melissa Etheridge, Pansy Division, and the Pet Shop Boys celebrate the very homosexualities that Christian rock considers deviant and worthy of damnation. Moreover, while evangelical fundamentalism and Christian rock appeal to a moral code that legislates behavior in the name of a higher power that can punish or reward the individual in a life after death and in so doing effectively separate the domain of the spirit from that of the flesh, in secular rock they conjoin. The structure of the music and live performance destroys the very distinction between sexuality and sin upon which conservative forms of institutionalized Christianity depend.

Rock music's diverse representations of and attitudes toward sexuality are most apparent when we compare the contrasting performance styles employed by Christian and secular rock videos. Simon Frith points out that "an important part of rock performance is the kind of body movement or

dance it provokes in its performers and participants," and we can see striking differences in the performance styles and body language employed by DC Talk and Nirvana, two extremely successful examples of Christian and secular rock groups. DC Talk's style and performance is profoundly asexual; while Nirvana's—whose name itself suggests a religious crossover, though obviously not a Christian one—is flagrantly sexual.[31] We can also note important differences in the film techniques and camera angles their videos employ: In Christian Rock videos the camera stays focused above the waist and the performers tend to move only their upper body; in secular rock the camera emphasizes the performer's suggestively erotic movements, with particular attention to gyrating hips and pelvic thrusts.[32] Rock concerts and videos thus perform a sexuality that heightens and intensifies libidinal energies, and celebrates an eroticism that surges between the singers, musicians, and audience. The rock concert provides a total spectacle in which the audience becomes part of the performance by establishing an intimate relationship between the bodies of the musicians playing and the bodies of the audience members moving in response. Spectators become participants as the audience moves with the lead singers and musicians, a movement that is reminiscent of the clapping hands and swaying bodies employed as part of worship in Baptist and Pentecostal churches. But although secular rock singers and musicians usually move in ways that suggest sexual activity and/or arousal, Christian rockers rarely do. The body language employed by Christian rock musicians minimize sexual provocation; the rhythms they produce are often barely strong enough to move or dance to. Christian and secular rock music, videos, and performance thus invite us to do dramatically different things with our bodies.

I would like to believe that such performances also dramatize what it might mean to practice a certain kind of faith in the United States during the last years of the twentieth century. I am thinking of faith as a passion and as embodied in the kind of practice secular rock occasionally performs. Secular rock music and culture leaves open a place from which to explore what both Christian rock and evangelical fundamentalism preclude: an ethics of, and commitment to, risk, eroticism, and uncertainty. Kierkegaard famously reminds us that "without risk there is no faith and the greater the risk, the greater the faith," thus affirming the passionate performances a certain Christianity continues to enact.[33] In *Fear and Trembling* he describes the "leap of faith" that only a "knight of faith" can make as "being able to fall down in such a way that the same second it looks as if one were standing and walking."[34] We may regard Courtney Love's stage-diving as an enactment of the Knight's leap of faith precisely because her performance

takes the kind of risk that Christian rock performers do not. In the videotape of Crashdog's live performance of "Voice of Defiance," which to the best of my knowledge is the only example of stage-diving by a member of Christian rock group on tape, the leap itself is never seen. The camera shows the lead guitarist only after he has already jumped into the arms of an audience that holds him securely aloft before they return him to the stage; he is held so gently that he can continue to play the guitar for the few moments that he is in the air.[35] By contrast, Love's stage-diving affirms a faith that Christian rock videos and performance exclude, and it is perhaps no accident that Love began to stage-dive only in the months following her husband Kurt Cobain's suicide.[36] In a parody of Christian baptism, Love first sprinkles water on her audience. She then leaps off the stage without knowing whether or not she will fall, be mauled, assaulted, and/or caught and supported by her audience.

We might find in Love's stage-diving a particular instance of a secular, but profoundly "Christian," rock: one that repeats and parodies traditional Christian rituals such as baptism in order to dramatize the risk, surrender, and uncertainty upon which faith depends. Such a parody functions not to dismiss faith but rather to pay homage to it: Love's leap dramatizes Kierkegaard's "leap of faith" because its sheer affirmation of risk can only be one of faith. It might even allow us to define rock as a form of secular religion that sustains such leaps of faith on the part of both the performers and audience, a leap that connects artist and audience and in so doing binds them to one another. By proceeding without a safety net, be it a belief in the afterlife or a preexistent moral code that will tell the individual how to live, secular rock allows the practice of a kind of faith that Christian rock denies. In presenting the stage-diver's leap as an act whose outcome is safe and assured, the Christian rock performance robs it of risk: Assured of salvation and eternal life before the leap occurs, the leaper will and cannot be harmed. Reassurances that God's "love" will make everything all right take the place of fear and trembling. If the Christian rocker leaps at all, he does so secure in the knowledge that God is there waiting to break his fall. But nothing waits to break Love's fall except for a perhaps impossible faith that did not exist prior to the moment when she throws herself into the audience, where she is alternately groped, kissed, held, and almost dropped. If we become acquainted with ourselves and our fate by encountering that which we cannot not risk, secular rock occasionally performs these moments for us. In so doing it allows us to witness ourselves at play, if not exactly in the fields of the Lord, then at least in those of our unique dreams, hopes, and desires.

NOTES

1. Jacques Attali, *Noise: The Political Economy of Music*, trans. Brian Massumi (Minneapolis: University of Minnesota Press, 1992), 3.

2. Ibid., 3.

3. I employ the definition of "subculture" proposed by the editors of *The Subcultures Reader*: "Groups of people that have something in common with one another (i.e., they share a problem, an interest, a practice) which distinguishes them in a significant way from the members of other social groups." Sarah Thornton, "General Introduction," in *The Subcultures Reader*, ed. Ken Gelder and Sarah Thornton (New York: Routledge, 1997), 1.

 By "rock music" I mean a tradition of popular music that applies to post-1958 derivations of rock and roll; I employ the term "secular rock" to describe rock music that, whatever its theme, is not produced by any Christian religious organization or consumed by specifically Christian religious denominations as part of worship or evangelical practice.

4. Pierre Bourdieu describes the notion of "practice" through recourse to a musical paradigm: "Practice unfolds in time and it has all the correlative properties, such as irreversibility, that synchronization destroys. Its temporal structure, that is, its rhythm, its tempo, and above all its directionality, is constitutive of its meaning. As with music, any manipulation of this structure, even a simple change in tempo . . . subjects it to a destructuralation that is irreducible to a simple change in an axis of reference." Pierre Bourdieu, *The Logic of Practice*, trans. Richard Nice (Stanford: Stanford University Press, 1990), 81.

5. Greil Marcus, "A Singer and a Rock and Roll Band," in *Rock and Roll Will Stand*, ed. Greil Marcus (Boston: Beacon Press, 1969), 97–98.

6. Kurt Cobain, *Nirvana: Live!Tonight!Sold Out!!*, prods. Tina Silvey and Tommy Blatnik, dir. Kevin Kerslake, 83 minutes, Geffen Home Video, 1994, videocassette. Here Cobain remarks that most of the lyrics he writes "are just contradictions . . . I'll write a few sincere lines and then I'll have to make fun of it with another line, you know, like a rebuttal or something."

7. Catherine Turman, Ibid.

8. "Christian Rock," *The New Rolling Stone Encyclopedia of Rock & Roll*, ed. Patricia Romanowski and Holly George-Warren (New York: Simon and Schuster, 1995), 180.

9. William D. Romanowski, "Contemporary Christian Music: The Business of Music Ministry" in *American Evangelics and the Mass Media*, ed. Quentin J. Schultze (New York: Academic Books, 1990), 143.

10. Ibid., 149.

11. Jon Pareles, "In a Higher Realm on the Pop Charts," *New York Times*, August 3, 1997, H26.

12. For comprehensive histories of rock and roll, see Paul Friedlander, *Rock and Roll: A Social History* (Boulder, CO: Westview Press, 1996); Greil Marcus, *Mystery Train: Images of America in Rock 'n' Roll Music* (New York: Penguin Books, 1997); Anthony De Curtis, James Henke, and Holly George-Warren eds., *The Rolling Stone Illustrated History of Rock & Roll* (New York: Random House, 1992); and Simon Frith and Andrew Goodwin eds., *On Record: Rock, Pop, and the Written Word* (New York: Pantheon Books, 1990).

13. For a variety of perspectives on the history and development on Christian rock, see Paul Baker, *Contemporary Christian Music: Where it Came From, What it is, Where it's Going* (Westchester: Crossway Books, 1979); Charles E. Fromm, "New Song: The Sound of Spiritual Awakening, A Study of Music in Revival" (paper presented to Oxford Reading and Research Conference, Oxford, England, July 1983); and Steve Lawhead, *Rock Reconsidered: A Christian Looks at Contemporary Music* (Downers Grove: Intervarsity Press, 1981).

14. For an excellent study of the Jesus Movement, see Edward E. Plowman, *The Underground Church: Accounts of Christian Revolutionaries in America* (Elgin: David C. Cook Publishing Co., 1971) and Steve Turner, *Hungry for Heaven: Rock 'n' Roll & the Search for Redemption* (Downers Grove, Intervarsity Press, 1995).

15. Romanowski, 143. For a massive study of the Christian music industry from its infancy into its own subcultural niche, see William D. Romanowski, "Rock 'n' Religion: A Socio-Cultural Analysis of the Contemporary Christian Music Industry" (Ph.D. Diss., Bowling Green State University, 1990).

16. Quoted in Quentin J. Schultze and William D. Romanowski, "Praising God in Opryland," *Reformed Journal*, November 1989, 13.

17. Don Lattin, "Rock (Music) of Ages," San Francisco Chronicle, August 2, 1997, 1.

18. Ibid., A13.

19. Ibid., A13.

20. Ibid., A13

21. Pareles, 26.

22. Quoted in Patrick Corman, "Freaking Out on Jesus," *Rolling Stone*, June 24, 1971, 25.

23. Thomas Cushman, "Rich Rastas and Communist Rockers: A Comparative Study of the Origin, Diffusion and Defusion of Revolutionary Musical Codes," *Journal of Popular Culture* 25, no. 3 1991): 27.

24. Dan Graham, Rock My Religion, ed. Brian Wallis (Cambridge, Mass.: MIT Press, 1993), 85.

25. Ibid., 85.

26. For general discussions of the influence of African-American music and culture on the development of rock and roll, see Simon Frith, *Sound Effects: Youth, Leisure, and the Politics of Rock 'n' Roll* (New York: Pantheon Books, 1981), 12–38; Theodore Gracyk, *Rhythm and Noise: An Aesthetics of Rock* (Durham, NC: Duke University Press, 1996), 125–147; Charles Hamm, *Music in the New World*, (New York: W.W. Norton & Co., 1983), 110–39, 378–87, 618–27; and Robert Palmer, "Rock Begins," in DeCurtis et al., *The Rolling Stone Illustrated History of Rock & Roll*, 3–16.

27. De Curtis et al., 4.

28. Robert Palmer, *Deep Blues* (New York: Penguin Books, 1981), 34. For another excellent history of African-American experience and the development of the blues, see Giles Oakley, *The Devil's Music: A History of the Blues* (New York: Da Capo Press, 1997).

29. For discussions of African-American religion and the history of Black Gospel music, see Viv Broughton, *Black Gospel: An Illustrated History of the Gospel Sound* (New York: Sterling Publishing Company, 1985) and Alan Young, *Woke Me Up This Morning: Black Gospel Singers and the Gospel Life* (Jackson: University Press of Mississippi, 1997).

30. For discussion and debate regarding Christian rock and "Christian values," see Basil Cole, OP, *Music and Morals: A Theological Appraisal of the Moral and Psychological Effects of Music* (New York: Alba House, 1993) and Andrew L. Minto, "Is 'Christian Rock' a Contradiction?" in *The Homiletic and Pastoral Review* XC, no. 7 (April 1990).

31. Frith, *Sound Effects*, 9.

32. Compare, for example, the body language, movement, and live performance styles of Nirvana's "Smells Like Teen Spirit" and "Lithium" with DC Talk's "So Help Me God" and "Luv is A Verb." *dc Talk: Welcome to the Freak Show*, prod. DC Talk, 1 hr. 16 min., ForeFront Communications Group, 1997, videocassette and Nirvana, *Live! Tonight! Sold Out!!*, above.

33. Søren Kierkegaard, *The Present Age*, trans. Alexander Dru (New York: Harper & Row, 1969), 82.

34. Søren Kierkegaard, *Fear and Trembling*, trans. Walter Lowrie (Garden City, NY: Doubleday & Co., 1954), 52.

35. Crashdog, "Voice of Defiance," *Pet Projects*, prod. and dir. Mike Hertenstein, Grrr Records, videocassette.

36. *Hole: Washington, D.C., September 28, 1994*, 65 min., Addicted II Video, 1996, videocassette. Kurt Cobain committed suicide on April 5, 1994.

CONVERSION

1 4

MORMONISM AND OTHER NARRATIVES OF THE LIVING DEAD

William R. Handley

T'S SUNDAY, AND AS THEY DRIVE PAST an American flag in a ceme-
tery, Johnny and Barbara are going to visit their father's grave. While
Barbara piously kneels and prays at the grave in ritual respect for the dead,
Johnny mocks Barbara's piety. "Not much sense in my going to church," he
declares. Alluding to an ancient fear that the dead might seek revenge upon the
living, he says with exaggerated spookiness, "They're coming to get you, Bar-
ba-ra."[1] But it's Johnny, not Barbara, "they" first kill in this opening scene of
the 1968 cult classic horror film *Night of the Living Dead*: the unburied dead
have come back to life and are indiscriminately cannibalizing the living, who
are told by radio that they will have to forego "the dubious consolation of a
funeral service" and instead burn or shoot in the skull the newly but still liv-
ing dead. Unlike the traditional vampire who has supernatural power, these
living dead are a mix of ordinary people, albeit lacking the services of a good
mortician, walking around in a kind of trance, impelled neither by revenge
upon the living nor by any supernatural force: they just need food—human
flesh. And it's all downhill from the start, for everything fails to save or explain:
science, religion, the media, the government, reason, pragmatism, sacrifice,
heroism, the nuclear family, and romantic love.[2] The innocent and the guilty,
the selfish and the brave, the young and the old all lose; Barbara, despite her
Christian piety, is in the end devoured by her once protective brother, who
becomes the fulfillment of his own jokingly paranoid prophecy. Even a moth-
er's love fails when her daughter takes a trowel to her despite her pleas, and the
father, "an unpleasant WASP *paterfamilias*," according to one early review, dis-
covers "that his daughter has risen from the dead and is devouring her moth-
er in the cellar. . . . The American family is really in trouble."[3]

Other viewers of the film have offered broader, less sanguine exegeses: "*Night of the Living Dead* offers a thoroughgoing critique of American institutions and values," "undercuts most of the cherished values of our whole civilization," and marks "the failure of religion in a secular age"— though dead people that can walk might hardly seem secular.[4] *Variety* was morally outraged at the makers when their film appeared and raised doubts about "the moral health of filmgoers who cheerfully opt for unrelieved sadism." Made for $114,000, the film has grossed more than $30 million worldwide and inaugurated the modern era of the American horror film.[5] According to the maker of the film, George Romero, the living dead are a "new society" that "attacks every aspect of our society and all the mores down to religion and concepts about death" and yet he goes on to say that the living dead are "our neighbors," even that they are "us."[6] ("Fear thy neighbor as thyself" might be the moral of the story.) Or, as Elliott Stein argued in 1970, they are "the silent majority." Elsewhere, Romero has asked rhetorically, "'Have we conjured up creatures and given them mystical properties so as not to admit that they are actually of our own race?'"[7] All this, in a cheap independent horror film shot in Pittsburgh.

A vision of social collapse, the film appeared at a time of national turmoil. Though faced with the common threat of a massive and persistent group of flesh–eating zombies, the living cannot get along with each other and no one survives, except for a posse of somewhat zombie–like, redneck folk who cover the countryside at the film's end and shoot the living dead on sight. They also shoot the sole survivor of the terrible night at the farmhouse, the film's only admirable—and only black—character, whom the killers mistake for one of the justifiable targets—or don't.[8] The unprecedented apocalyptic extremity of the film, visualizing cannibalistic grandmothers and collapsing the secular and the religious into horror, serves as an inversion of, companion to, and measuring stick for the other extreme cultural narratives I want to examine.

How cultures represent an afterlife and imagine the fates of the dead is revealing about what the living value by its absence if not by its living presence or practice. Acting on behalf of the dead in the afterlife is as old as human culture: archeological evidence suggests that Neanderthals buried their dead with ceremony and, modestly, with food and possessions to be used in the next world.[9] In the context of American ideology's assertion of the individual rights to life, liberty, and the pursuit of happiness, death is, in principle, a triple threat that has elicited inventive and widely

diverse responses, a few distinctive cases of which are my subjects here.[10] I call these cases extreme because of their corresponding utopic and dystopic visions and the optimism and apocalyptic dread that inspire them. These cultural exhibits alternately imagine human beings' instrumental power (acting as effective agents or instruments of divine or historical will) beyond the grave for the sake of eternal progress for the dead, instrumentality in promoting an eschatological escalation to the grave, and, in the case of *Night of the Living Dead*, catastrophic social failure and individual helplessness before the grave—in no case do they exhibit acceptance (the dead do not just die), even as they all exhibit American cultural and historical anxieties.

I want to put different genres and categories, such as "cults" and "religions," on the same interpretive plane with each other in order to situate culturally the absolute supernatural claims of religious belief, understood in this instance as narratives about ultimate ends taken on faith by individuals. I take seriously the shared etymological root of "cult" and "culture"—Latin *cultus*, to worship, from the past participle *colere*, to cultivate—and hence want to cultivate an understanding of the mediated powers of representation that circulate not only in organized religions and cults but in those leaderless, unorganized cultural audiences and consumers that are, in this country, largely religious. Just as worship is etymologically cousin to cultivation, the work of culture tills the soil for cults, which are and have long been the seeds of religion (Christianity, after all, was once a cult). To study religious culture in America is, I believe, to make strange bedfellows of various groups or individuals and their discourses about themselves and about each other, to put into dialogue explanatory, though often to others occulted, group narratives and narratives about groups. In doing so I mean to explore the social content that such groups "cannibalize" in their narratives for the undead and the living dead—both the living who are not yet dead and the dead that still have a vital cultural role to play in life in terms of the narratives articulated about them. Such cannibalizing of social meaning is both hopeful and fearful, since it stakes instrumental bets on where we are headed or at least what we mean to ourselves. Both extreme cases—faith in utopic human instrumentality and the rapturous faith of eschatological paranoia—have, like Johnny and Barbara, a sibling relationship in American culture, the ambiguities, contradictions, and rivalries of which reinforce absolute narratives and extreme measures.

My materials have presumptions that differ from my own: whereas orthodox religious beliefs rely on narratives of faith or certainty and some empirical social disciplines rely on narratives of verifiability, literary study finds in ambiguity a source of and not a roadblock to knowledge and value. I would like to demonstrate how I see that value by giving attention to Joan Didion's essay "The White Album," in which she both practices and thematizes ambiguity in writing of an American culture freighted with paranoia, dogmatism, and social anomie and upheaval as she marks for herself, and the sixties, a kind of crisis of faith in promises and received belief. "We tell ourselves stories in order to live," she opens her essay, which she began writing in 1968 (also the year of Romero's film) and finished ten years later. The essay is a struggle to make sense of a time "when I began to doubt the premises of all the stories I had ever told myself, a common condition, but one I found troubling." Didion approaches her disparate materials—radical political movements, her own medical diagnoses, the murder of Sharon Tate and six others by Charles Manson and his followers, Scientology, Mormonism, The Doors ("missionaries of apocalyptic sex" who suggest "some range of the possible just beyond a suicide pact"), and other forms of both idealism and eschatological dread—as stories without explanatory narratives or as explanatory narratives that are little help to the living, at best only provisionally so. We tell ourselves that "it makes some difference" which narrative we choose to explain the story of, say, "the naked woman on the ledge outside the window," whether she is "a victim of accidie," whether she is about to "commit a mortal sin or is about to register a political protest . . . we look for the sermon in the suicide, for the social and moral lesson in the murder of five."[11] Yet her succeeding episodic essay offers no such sermons, only accounts of "ambiguous paranoia" or "quite unambiguous" prophecies of doom or rapture, such as The Doors' music, which "insisted that love was sex and sex was death." Overwhelming the reader with stories of which she cannot make a meaningful accounting, she only represents the full ambiguity and struggle of her and others' search for narratives. So when a baby-sitter tells her that "she saw death in my aura," she recalls "chatting with her about the reasons this *might* be so" and then, possibly finding ambiguous comfort in her meticulous eye and use of words (or comfort in ambiguous words), "going to *sleep* in the *living* room" (emphasis added). After describing her packing routine as a reporter (she brings all necessities except a clock), she writes, "this may be a parable, either of my life as a reporter during this period or of the period itself." Even

medical science cannot offer her unambiguous prognosis: "I might or might not experience symptoms of neural damage all my life. These symptoms, which might or might not appear, might or might not involve my eyes Their effects might be lessened by cortisone injections, or they might not. It could not be predicted 'Lead a simple life,' the neurologist advised. 'Not that it makes any difference we know about.' In other words," she writes, "it was another story without a narrative."[12]

Didion's circumspect, ambiguous account of her experience contrasts sharply with the untroubled certainty of others: a musician calls "to tell me how to save myself through Scientology . . . and how I might become a Clear." A Mormon motel manager asks Didion, while she is doing a piece for *Life* magazine about the storage of VX nerve gas at an Army Arsenal, "If you can't believe you're going to heaven in your own body and on a first-name basis with all the members of your family, then what's the point of dying?" "I present this to you," she writes, "as a more cogent question than it might at first appear, a kind of koan of the period." If this paradoxical riddle can produce enlightenment, it might be because it teaches contextually the greater social insufficiency of absolute narratives, especially at a time of tremendous social change and contradiction: After all, what does it mean to write "for *Life*" about deadly nerve gas? What does it mean to live, not only if we all have death sometime in our "aura," but especially if religious and political cultures chant eschatological narratives or triumphally progressivist ones that involve "acceptable loss" and beliefs that one is "better dead than Red"—or the belief that a Sunday school teacher expressed when I was fourteen that it would ultimately "be better if you died than if you lost your virginity before marriage"?

Didion's image of the naked woman on the ledge tests the ambiguous possibilities for narrative certainty concerning the world around us, as does the Mormon's question. But Didion's uncertainty, like the reader's, is called into being by reading the presumed certainty of the woman who is about to put her body on the line and of the Mormon who lays out his narrative of going to heaven "in your own body." Those readings produce ambiguity and paradox: the woman clearly has a narrative to tell, but it is unclear what, and the Mormon assumes a clear narrative but asks a rhetorical question that implies there is no point (no reason?) in losing your body if you do not believe you will keep it. (Do we have a choice?) Each has implicitly an absolute yet inscrutable narrative answer to the question "what is the point of living?" and although one seems pessimistic and the other optimistic, both center on the transformation of death, not on the possibilities for meaning or change in the

ambiguous and uncertain process of living. "We tell ourselves stories in order to live," Didion asserts. The corollary might be that we tell ourselves narratives because we will die—and sometimes we will die because of them.

Whether they are absolutely "true" or "false" (in either case, verification is difficult), such unconditional narratives usually offer compensators to those who subscribe to them in their faith. I borrow the term compensator from the sociologists of religion Rodney Stark and William Sims Bainbridge. Citing the mundane but central axiom about human behavior, assumed in fields such as microeconomics, learning psychology, and sociology, which says that human beings seek what they perceive to be rewards and try to avoid what they perceive to be costs, Stark and Bainbridge distinguish between rewards that are scarce but immediately available to many (wealth, health, power, etc.) and those that are not directly available to anyone in the natural world (such as eternal life). As a result of wholly unavailable rewards, the absence of which fuels desire for them, human beings create and exchange compensators. People may experience rewards, "but they can only have faith in compensators. *A compensator is the belief that a reward will be obtained in the distant future or in some other context which cannot be immediately verified,*" in return for rewards or value surrendered now.[13] I would modify this definition by observing that compensators are not simply claims or promises but narratives in which people invest their bodies and acts, whether in going to church or synagogue or in crossing an ocean and then walking a thousand miles to Utah, as ancestors of mine did in "the Gathering of Zion" in the nineteenth century. In other words, desire for a particular reward is not sufficient to produce faith; only a narrative that directly invests the body with a role to play in it will produce an investment of faith. That role may involve ritual, the regulation of desires that disrupt or distract from the narrative's *telos,* dietary restrictions, or anything else in which a person suspends, represses, or directs the body's activities in concordance with a compensatory narrative. Stark and Bainbridge do not emphasize the role of narrative so much as the role of supernatural assumptions in authorizing or legitimating such narrative. Religions, they assert, are "*human organizations primarily engaged in providing general compensators based on supernatural assumptions.*"[14] Religions may also provide specific compensators for desired, available rewards (communal belonging, money, etc.), but this is not what primarily distinguishes them from other organizations.

I was raised in the Mormon church, an organization, belief, and a way of life that offers more specific and general—and more glorious—compen-

sators with more clear and demanding instructions on how to get the promised rewards than most religions in America. By "glorious," I mean, for example, that Mormonism posits the possibility not only for salvation and progress *after* death, but the potential for men and women to people and rule other worlds as gods if they progress far enough in this life and beyond. Along with the Mormon belief that human beings are born without Original Sin, the faith in eternal progress has fueled anti-Mormon sentiment among some Christians—and perhaps for this reason, the Mormon president Gordon B. Hinckley seemed reluctant to discuss it in a 1995 interview with Mike Wallace on "60 Minutes." For myself, the immediate value that had to be sacrificed for the greatest, unavailable rewards proved personally too great: it meant giving, over the course of my life, more than time and commitment, and even more than giving up my freedom. (Besides, isn't it the case that "the truth will set you free"?) It meant, in part, having to give up learning the courage to face my deepest fears and the responsibility for my own freedom, which is not to say that being a practicing Mormon does not require courage and responsibility. It also meant having to take the Mormon narrative of things seriously in its own terms and conditions, and I found that I could not conform—commit my body, mind, and life—to an absolute truth or totalizing narrative, especially since the world is full of narratives that compel interest and that call each other into question. If the costs of conforming seemed high, however, the costs of not doing so seemed higher. Not only did I fear what members of my congregation might feel about me if I did not serve a two-year mission at nineteen "to preach the gospel," which I did not do when the time came, but the greatest damnation in the Mormon scheme of things, for anyone, is reserved for those who bear witness to the truth and then reject it: they are said to suffer "spiritual death" in the afterlife and to cast themselves into "outer darkness." But I was lucky to have parents who never pushed me to believe or to serve a mission and fully supported me when I did not, just as they supported my brother when he did.

I was also lucky because it was my mother who gave me *The Brothers Karamazov* to read when I was seventeen, a reading experience that demonstrated to me the ethical value of putting narratives into conflict with each other. In Dostoevsky's novel, Ivan, the intellectual, debates belief with his religious brother Alyosha, particularly the narrative, for faith, which says that all human sin and suffering in this life will ultimately meet eternal peace, reconciliation, and harmony in the spiritual world since God's understanding and forgiveness are infinite. What struck me, reading this section of

Dostoevsky's novel ("Rebellion"), was that Ivan does not say to Alyosha "your religious narrative is not true"—the question I had anguished over, given Mormonism's absolute claims to truth and the consequences of rejecting it. Instead, he says, in effect, "even if this narrative of eternal peace is true, I want no part of it if such ultimate harmony requires or even permits the murder of even one innocent child," *even if* that child were to forgive its tormentor in the afterlife.[15] In the terms which I have introduced, Ivan rejects the compensators of Alyosha's religion because the sacrificed value is too high; even a narrative of vengeance cannot erase the particular suffering that has already happened. For me, two narratives clashed and I began my long fall through the breach between them. Ever since I read this novel, I have sought the clash between narratives, their limits and failures and ambiguities, over the satisfactions of any real or imagined general compensators— even though Ivan did not turn out so well in the novel, while Alyosha did.

It took me some time to return to Mormonism as an object of relatively dispassionate study, to find it compellingly interesting in the context of American culture. The "Mormon" church (the Church of Jesus Christ of Latter-day Saints) is the most successful of the few sects that have arisen in this country and that survive today; it is the first or second largest church in nine western states and the fifth largest religious organization in the United States, with ten million members worldwide.[16] Deeming it "the most original and ambitious version" of what he calls, following Tolstoy, "the American Religion," a variation on Gnosticism, Harold Bloom gives particular attention to a Mormon ritual that marks, for my purposes here, a case of utopic human instrumentality beyond the grave: baptism for the dead. In characteristic overdrive, Bloom writes, "a religious critic, struggling to comprehend the really shocking spiritual ambition, indeed the aggressive drive, of Mormon baptism for the dead, is unlikely to find any true parallel to it in modern religious history."[17] And despite Bloom's own anxieties of influence, he is probably right. The Mormon practice derives from Joseph Smith's interpretation of the final verses of the Old Testament, verses which haunted Smith (as they did James Joyce after him). Malachi 4:4-5 reads:

> Behold, I will send you Elijah the prophet before the coming of the great and dreadful day of the Lord:
> And he shall turn the heart of the fathers to the children, and the heart of the children to their fathers, lest I come and smite the earth with a curse.

What became the basis for one of the most hopeful, ambitious practices in American religious life is couched in a threat of damnation—and an eschatological promise.

For Mormons, Malachi's prophecy began to be fulfilled when Jesus, Moses, and Elijah appeared to Joseph Smith in the temple in Kirtland, Ohio, on April 3, 1836 and gave him "the keys of this dispensation," or priesthood authority. (One of the curiosities of this Mormon narrative is the implication that Jews need not leave an empty seat at the Passover table for Elijah: he has already shown up.) In order to solve the problem of how to save all of the generations of humanity who were born too soon to hear of the true Church, Joseph Smith inaugurated baptisms for the dead, in which the living stand in by proxy for the dead in the baptismal font: what is key is the responsibility the living have over the spiritual future of the dead in the afterlife, who are given, at the moment of immersion, the opportunity for salvation. In this utopian American religious ritual (equal opportunity for salvation for all for all time), not only is death defeated through resurrection, but so is history itself through the instrumental power of the living on behalf of all ancestors (the "fathers" to whom Elijah is to "turn the heart of the children"). Though salvation is available to all individuals in this schema, the family is chiefly exalted in this extended reunion in the afterlife, made possible through the priesthood of living fathers and sons. Additionally, it is only through men's priesthood and marriage in the temple that godhood in the eternity is possible: the living do not just baptize the dead by proxy in Mormon ritual, they also remarry ("seal" the relationship between) husbands and wives who are dead so that their marriage, and hence spiritual progress, can continue in eternity. This is certainly one reason why many Mormon adherents, especially converts, find comfort in a narrative in which to include their families' stories and in which to invest their bodies, while many non-Mormons are offended by this ritual on behalf of their own ancestors, each one of them potentially if not already baptized by name. For Bloom, "the palpable sincerity and intensity" of Mormon faith is nowhere demonstrated "more overwhelmingly than in the immense effort that goes into baptism for the dead" in temples around the world, around the clock.[18] Toward this effort the Mormon church has developed the largest genealogical library in the world, not "remotely comparable" to any other, containing nearly two billion names stored in a granite mountain vault south of Salt Lake City that is meant to withstand nuclear war.[19] (To paraphrase Didion's Mormon: what's the point of nuclear war if the names of the dead do not survive us?)

What this practice may or may not do for the dead, who may or may not be watching and waiting, is not my interest; rather, how does this Mormon perspective rewrite history? Clearly, it would seem, the living can choose to give priority to some important historical figures, in addition to their immediate ancestors. Indeed, Thomas Jefferson and all the other signers of the Declaration of Independence appeared to Wilfred Woodruff in the temple in St. George, Utah and *asked* to be baptized in 1877. ("Did they sign the guestbook?" a friend asked me.) "The spirits of the dead gathered around me, wanting to know why we did not redeem them ... 'nothing has ever been done for us. We laid the foundation of the government you now enjoy,'" wrote Woodruff, who would later, as Mormon president, ban the practice of polygamy in 1890 so that Utah could join the Union. "I straightaway went into the baptismal font and called upon Brother McAllister to baptize me for the signers of the Declaration of Independence, and fifty other eminent men [including] Columbus ... I then baptized him for every President of the United States, except three," including Buchanan, whose policies had been anti-Mormon.[20] Having long been viewed as outside the American mainstream, if not outside American culture entirely, and long desiring acceptance from a nation that had persecuted them, Mormons would find comfort and validation in knowing that the founding fathers had turned their hearts to the children, and the children had turned theirs to the founding fathers, making the Mormon family an American one and "saving" the nation's fathers for Mormonism. In response to this patriarchal emphasis, I have been told, Mormon feminists have been baptized by proxy for Virginia Woolf and Joan of Arc, among others. (Despite the feminist intention, it is difficult to imagine Woolf as a member of the Grateful Dead.)

Reinscribing the stories of famous individuals is one result of this Mormon narrative and ritual. In March 1978, I wrote in my diary about my one experience of this practice, and I can hear a faint disappointment that I had not been more involved in American history than I was:

> We packed up and went to the Temple ... for the baptisms. The boys got to go first for once. I prayed and tried to get the spirit. I was fourth, and baptized and confirmed fifteen men. One's name was John Hancock ... born in 1684. But it couldn't be the famous one.

I remember how dedicated it felt, at the age of fifteen, to drive with my friends in a bus twelve hours round-trip to the nearest Mormon temple (in Washington, D.C.) to spend fewer than twenty minutes in a baptismal font

supported by twelve plaster oxen while a man immersed me and conferred baptism on fifteen dead men whose names flashed, one by one, on the video monitor above to read and insert into the baptismal prayer (which reads, "Having been commissioned of Jesus Christ, I baptize you for and in behalf of [name], who is dead, in the name of the Father, and of the Son, and of the Holy Ghost"). I remember feeling disappointed that John Hancock was not the one who signed the Declaration of Independence. I remember wondering if my body at the moment of immersion was no longer my body but the dead man's whose name had just been spoken. And I wondered, as I caught my breath, if the dead were watching me as I looked at (or through?) the video monitor's chlorine-induced penumbra after repeatedly emerging from the waters of baptism by proxy for the dead.

A similar co-optation of the dead in the name of American paternal fundamentalism, as it were, is also on display in some of the Forest Lawn cemeteries, in which the built environment only makes sense, in the context of the memorial park's basic function, as an implied narrative that both sanctifies those buried there and comforts and uplifts the living. At Forest Lawn Hollywood Hills, which is across the freeway from the Disney Animation Studios, one can visit a functioning replica, only slightly reduced in scale, of Boston's Old North Church, across from which towers a statue of George Washington with four of his staff at the base. A plaque narrates their military importance. This is not a veteran's cemetery: it's an American cemetery, and the installation of signs of the republic's birth gives rebirth to the American narrative of freedom in the context of the grave. Philippe Ariès found in what Forest Lawn represents "traces of the mentality of the French Enlightenment"—confidence in man, his goodness, and his happiness.[21] And more than confidence: an injunction to perpetuate them beyond the grave. Just as Mormons "strengthen the family" beyond the grave and extend rights of life eternal, liberty to choose, and joy and happiness to the dead, so does Forest Lawn not only comfort the living with American values, but, with its "pre-need" sales of family plots, it emplots a family reunion beyond the grave in a representational bosom of American democracy.[22] At the same time that it serves the family, Forest Lawn offers "very individual" treatment for the loved one in the preparations for burial. In the campy 1965 film version of Evelyn Waugh's 1948 novel *The Loved One*, Liberace plays the funeral director who asks the family member if his loved one was a sensitive man, since a rayon casket lining "chafes, you know." He recommends silk. Creature comforts and consumerism for the dead: the venal practices so much criti-

cized by Jessica Mitford in 1963 in *The American Way of Death* (recently revised and posthumously published) earn money not simply because the bereaved are too bereaved to fight or care or compare prices. They also involve recognizable narratives that reassure customers that the monetary sacrifice will provide some familiar compensators for their loss—consumerist, patriotic, and even entertainment values—in the context of what is most often a deeply de-familiarizing and upsetting experience.

Confronting unconventional explanatory narratives such as that of the Mormons is for many also a de-familiarizing experience that demands an explanatory narrative of its own. Whether humor, a wicked strain of which runs through Jessica Mitford's book, or indignation, the often visceral responses to the cultic behavior or beliefs of others are as telling about the groups we do or do not belong to, or the narratives we do or not subscribe to, as our responses to death. Just as members of a faith often "contain" other human beings, living and dead, within a narrative of ultimate ends, secular and religious people alike contain unconventional religious groups within explanatory narratives—or less than explanatory, derogatory epithets. When Dennis Rodman blamed his less than successful basketball playing on "these f___ing Mormons" after a playoff game with the Utah Jazz in Salt Lake City, it was possible that his antipathy was due to the fact that until 1978 black men were not allowed to hold the priesthood in the Mormon Church. But the coach of the Chicago Bulls, Phil Jackson, offered a less than explanatory or understanding statement: "To Dennis, a Mormon may just be a nickname for people from Utah. He may not even know it's a religious cult or sect or whatever it is."[23] In my years in a Connecticut high school, I was perceived as a kind of representative Mormon and was offered numerous explanations for what it was I believed in or belonged to: It was of the devil, a fraud, not Christian, racist, derivative of Calvinism, or as a fellow student who was an atheist said to my brother in response to learning that Mormons believe God is a physical being, "f___ing pagan." On the first weekend of freshman orientation at Stanford University, as my dormmates and I sat around a fire on the beach and told jokes in order to get to know each other, one joke put into question how much I wanted to be "known." "What is a tragedy?" one student asked. Answer: "A busload of Mormons falls off a cliff, and there is one empty seat." No one did anything but laugh; I said nothing. Though I feared being labelled first and last as a Mormon by my new friends should I admit to membership, I had just been so labelled, interpellated into some kind of subject position: that empty seat, I realized, was not filled by me, just as in

the Mormon scheme of eternal progress, I had missed the train and was headed toward spiritual death. To recall the Mormon motel manager's question in Didion's essay: *What is the point of dying if you do not believe*—and what is the point of the bus crashing if you were not on it?

Unconventional groups whose members commit their lives and bodies in belief systems of ultimate ends experience degrees of tension with the environment and test the limits of tolerance in a religiously pluralistic society.[24] But that test is greatest for those "destructive" cults in which members do not just subscribe to absolute narratives and commitment, but who take their bodies, like the naked woman on the ledge in Didion's essay, to the furthest edge of commitment through suicide. Cult suicide is, one could say, as much a form of absolute non-participation with the environment as it is an extreme form of eschatological hope and dread, proof that the bodies of believers have been completely circumscribed by a narrative, and not necessarily just the cult's. In response, the living inscribe variously explanatory or occult narratives on corpses, often in order to put a distance between their narratives about themselves and the narratives the dead subscribed to.

Freud observed of groups "the lack of independence and initiative in their members, the similarity in the reactions of all of them, their reduction, so to speak, to the level of group individuals," characteristics he found in the constitution of human society, reminding us, if we need to be reminded, of "how little originality and personal courage are to be found in it, of how much every individual is ruled by those attitudes of the group mind [such as] class prejudices, public opinion, etc."[25] The American ideology of individualism, originality, and personal authenticity would seem to oppose the claims of the group. Yet traces of this ideology, I believe, can be found where, at first, it may seem least apparent: in the formation of cults that reject the social environment in which they exist. What makes cults so difficult for most Americans to understand and tolerate is not that they are the enemies of individualism or other American values, but precisely that they can be their ideological agents. What disturbs many, in other words, is that cult followers proclaim their individual volition and happiness in belonging to these groups and in rejecting the social environment, as did the Puritans, and thereby call into question the very meaning of individualism and individual religious rights, especially when individuals choose the right to die. Under the right of religious freedom, American ideology becomes the enabling instrument both for the cult's rejection of American society and for the exercise of the cult's principles, while freedom is seen by outsiders, espe-

cially those engaged in religious or secular anti-cult movements, to be relin-
quished (through brainwashing, coercion, abduction, etc.).[26]

In their book *Why Waco? Cults and the Battle for Religious Freedom in
America*, James Tabor and Eugene Gallagher argue that "the intensity of
commitment demanded by some religious groups, particularly when it
results in purportedly strange forms of behavior, disturbs many Americans."
The common understanding of cults

> as dangerous to both individuals and society is indeed accurate but not
> for the reasons usually given Their very existence calls into question,
> as it is meant to do, what we hold most important and what our society
> values above anything else [T]he eagerness to condemn "cults"
> masks an unwillingness to confront ourselves and to question our soci-
> ety. . . . Cults are "dangerous". . . not merely for what they might do to
> an unfortunate few, but for what they actually do to an uneasy many.[27]

The protection of religious freedom in America has often run up against the
old question of what religion is, where it ends, and where cults and deviants
and heretics begin. Whether deployed by anti-cult movements, cults them-
selves, or sociologists of religion, rhetorics of exclusion and inclusion, like the
use of inherently unstable categories like "cult," often make "other" that which
is already ingrained in the culture and make "mainstream" that which might
well be, from a variety of points of view, deeply estranging. Take, for example,
the fact that in a recent poll, 61 percent of Americans say they believe in the
Second Coming of Christ, 34 percent think He will come within a few
decades, and 53 percent believe some world events of this century have ful-
filled biblical prophecy.[28] These beliefs, though arguably "mainstream," not
only might seem strange to non-believers, but they also do not seem to
incline most believers toward a sense of identification with someone like
David Koresh, a man immersed in such assumptions, as Tabor and Gallagher
observe. In describing the disquieting "threat to religious freedom posed by
the contemporary war on cults," the authors argue that sponsors of anti-cult
legislation "portray new and unconventional religious groups as a social
problem and a threat to individuals There is no effort made to define a
'cult' with any precision or to distinguish it from a new or unfamiliar religious
movement that might be seen in a positive light. The assumption is that
everyone knows what a 'cult' is and that no one would want his or her chil-
dren to be involved in one."[29] "I don't like cults," says the Jewish character
Louis to the Mormon Joe in Tony Kushner's *Angels in America*. When Joe

responds, "The Church of Jesus Christ of Latter Day Saints is not a cult," Louis offers a definition broad enough to include most religious groups in America: "Any religion that's not at least two thousand years old is a cult."[30]

The fear of "extreme" cults is not only because of a need to extricate them from the established religious faiths whose narratives they in part share or the fact that they take eschatological narratives even more seriously than the "religious." It is also because of how cults confront Americans with the contradictions of their shared social or ideological beliefs—such as freedom of religion that is yet combined with selective religious intolerance. These beliefs are clothed in universal, progressive, and eschatological narratives and carry a concomitant paranoia about the fractures in the culture that produce and sustain them. Jim Jones and Charles Manson, for example, were both preoccupied with the specter of nuclear holocaust and both had paranoid fantasies of an all-out race war (Jones thought whites would win; Manson, blacks). Because each sensed impending large-scale social death, particular deaths could be rationalized according to narratives of mystical destiny, claims of self-infliction, even to "natural causes"—Jones' cover-up for his own acts.[31] Manson claimed that the killings of Sharon Tate and the six others would cause whites on a large scale to blame the deaths on blacks and would thus incite all-out race war—murder as an instrument in hastening the apocalypse.

Apocalyptic paranoia is the corollary to delusions of omnipotence and omniscience—and not just for cult leaders, as Didion demonstrates through the pervasive paranoia and dread in "The White Album" as she is confronted on all sides with American religious and political narratives of doom or utopia that are anything but culturally "other." The extreme group narrative and measures of Peoples Temple, the most traumatic instance of cult suicide this century,[32] produced in their wake defensive assertions from all quarters that sought to demonstrate how one or another religious or social group's narrative was precisely different from Jonestown's. As David Chidester argues in his persuasive study of Jonestown, "most political commentators on the Jonestown event engaged in some form of political distancing. Americanists insisted that Jonestown was not American; socialists argued that it was not socialist. Both ends of this political spectrum endeavored to lay blame on the other for the political disaster."[33] Chidester writes that Michael Novak, for example, "castigated socialism" and argued eschatologically that it "inevitably leads to the effective equivalent of suicide in the submersion of individualism in the collective identity." In contrast, Gordon K.

Lewis argued that Jonestown was a symptom of the mass anomie and alien-
ation in modern western capitalist societies. Jonestown underlines, he wrote,
"the moral emptiness and spiritual vacuity" of life in America, and he argued
that the wealthiest of societies "is at the same time the most deeply unhappy
of those societies."[34] Yet Jonestown itself was constructed as an antidote to
spiritual vacuity and social conflict and anomie. Jonestown nurse Annie
Moore, twenty-four years old, wrote in a notebook as she prepared to die,
"Jim Jones showed us all this—that we could live together with our differ-
ences—that we were all the same—human beings." According to Chidester,
Moore wrote that "Jonestown had been the most peaceful, loving commu-
nity that had ever existed, a paradise that had eliminated racism, sexism, elit-
ism, and classism. . . . 'We died,' she concluded, 'because you would not let us
live.'"[35] The aim of Chidester's study is not only to demonstrate, as he states,
that "the Jonestown dead were human dead," but also to make them "appear
more familiar in the context of American historical experience." Rather than
an aberration, Jonestown is a recent instance, he argues, "of a religiopolitical
utopianism that was integral to the original colonization of America and
that has surfaced periodically throughout American history... in the theo-
cratic experiment of the Massachusetts Bay Colony... in American civil reli-
gion, in the various utopian communities of the nineteenth century, [and]
in new religious movements of the 1960s and 1970s."[36] In making alien
rather than familiar the corpses produced by radical religious commitment,
we cannibalize their proper social meaning.

Familiarization was not the effect of the image staring out from grocery
check-out shelves on the cover of *Time* regarding the Heaven's Gate suicides
(April 7, 1997 issue): an image of the cult's leader, Marshall Herff Applewhite,
wide-eyed and zombie-like, mediated (blurred) by the vibrating lines and
lurid colors of a video image, with the sensationalist yet punning words, given
the group's then notorious web site, "INSIDE THE WEB OF DEATH." Yet to
one of their neighbors, "they were very nice people."[37] The cheerful chat on
the videos the members made, in order to explain their extreme plan, exhibits
another form of distancing: they were not to be compared to Jonestown, one
member said; this was everyone's free, considered, and happy choice. The
video footage inside the home of the uniformly draped corpses (is this what
unity looks like?) felt disturbing yet familiar—a kind of "America's strangest
home video"—and for that reason, and because no flesh was visible, the
broadcast "house tour" distanced us from the human tragedy, as one com-
mentator remarked of the rooms filled with corpses that it was a "peaceful"

scene. But what distinguished Heaven's Gate from Jonestown, in part, and what kept a certain levity in the air for the living, is that while both groups felt salvation could not be found in this world, Heaven's Gate had an appointment with a spaceship. In that detail, in the absolute literalism and technological faith of its narrative of the afterlife, Heaven's Gate exhibited a distinctively American utopianism that finds echoes in the fact, for example, that Timothy Leary, who advised us to "turn on, tune in and drop out" had his ashes sent into orbit in a kind of confrontation with the universe. The same fate befalls Aimée Thanatogenos, former First Lady Embalmer of Whispering Glades, at the end of the 1965 film version of *The Loved One*, while the Blessed Reverend shouts at lift-off "Resurrection NOW!" into a microphone on live television, which the English nephew of the dead loved one watches as he is about to board a plane and leave the United States (and as "America the Beautiful" plays on the soundtrack): technology as transcendence or escape for the age of instant gratification.

I began this essay with a vision of eschatological dread and the complete failure of human instrumentality not only regarding death but even in just getting along in small groups,[38] in a film in which not only do the living not survive death in any recognizable form, but the dead do not survive it either. Without the authority of religion or science, which by their absence all the more calls up a need for explanatory narratives in the face of death, *Night of the Living Dead* leaves us most memorably with an image of the Group drained of any volition in or understanding of their apocalyptic role, like the middle-class Americans in Nathanael West's *The Day of the Locust* who "had it in them to destroy civilization," individuals of different shapes and faces who all lack a story.[39] Not only does the Mormon notion of ancestors' "turning hearts" become in Romero's film the living dead's groping hands and hungry mouths turned on the living, but the assurance in Malachi that "the great and dreadful day" will come seems fulfilled in visions such as Romero's, but without exegetical confirmation that it supernaturally matters. In other words, in draining his film of signs of any conventional, explanatory authorities, Romero, who was raised Catholic, authorizes his own paranoid narrative of doom. In that narrative, individuals and their values lose their conventional supports and are devoured by their neighbors. All bodies are put on the line (or the pyre), but without narrative succor.

I would like to end with one individual's vision of instrumentality over death that is at once dystopic and utopic, paranoid and hopeful, and that is profoundly antisocial yet saturated by American symbolic culture. It is from

the diary, written in the early 1990s, of a paranoid schizophrenic woman in Los Angeles who calls herself "St. Becky" and who writes what she calls "prayers." These prayers have a metonymic sweep that makes it impossible to distinguish her psyche from the external world or to distinguish television from divinity or her body from technology. Both the poetry and the pathology of her prayers are seen in the externalizing of her psyche onto America and the cosmos, which already constitute her psychic projections. In the context of the cases I have discussed of group narratives that posit human power beyond the grave or before the apocalypse, "St. Becky" brings these divergent American narratives together: her prayers for salvation and physical perfection and transcendence are joined to prayers that ask God to destroy "darker races" by means of "fireballs." The yearning for innocence and a cleansed, perfected self is coupled with pleas to God to vitalize and resurrect, via technology, her already technologized body.

> God, cause all these prayers to work quickly and cause this my machine to be constantly on. Cause these or my prayers to cause all space and time to warp for my effect and cause these words or the levers of my machine to work perfectly. Quick God, please cause television to cause these words to happen. Please cause all film-stars of the Earth to cause these words to happen. . . . Please cause television to cause my whole physical-flesh Self to be its youngest, cutest, prettiest, thinnest, skinniest, slenderest, slimmest, 21 year old looking forever-young and beautiful Self. Please cause television to have deeper-waves and to cause my brain and body and mind and spirit to pulse like a beating-heart or to glow like dreams and to help me to fulfill all of my physical and verbal and mental skills perfectly. Please cause television to cause me to be as big as the universe or as invisible as Almighty God and cause it to send me into super-powerful, super-natural, outer-space resurrection forever. . . . Please dearest God Almighty, show us the gateway to all-times or the supernatural tractor-tow-beam to your Heavenly Ark-spacecraft.[40]

The cultural context in which I have placed "St. Becky's" prayer would make of her more than a clinical instance of paranoid schizophrenia, since her dreams of omnipotence and transcendence are not just staples of some fringe cults but the delusions of late-night infomercials—and the narrative aspirations of some religions. Her language integrates what is often divorced in the cultural structures of American experience, particularly in any naive

divorce of the religious from more "secular" forms of culture or from fringe cults (as I have often divorced my critical work from my past religious life). No member of a group, she is by definition not a member of a cult, and yet her occult beliefs are authentically religious as she experiences them. Like the Internet user might be, "St. Becky" is an American child of the Cartesian self, exploring strange new worlds where few have gone before, a Gnostic Christian aboard the starship Enterprise who wants to put distance between herself and others: "Please help to keep all of us from crowding, because my mysterious red, white, and blue country which fixes my location in the city of Los Angeles, is becoming very crowded and . . . it's becoming very hard to have your own piece of private-space." Her fear of the American crowd is expressed in a language crowded with American cultural images and motifs; her distancing and difference from others is achieved by an identification with American symbolic culture. A rhetorical televangelist with a poetic sensibility, though not a political one, more akin to Allen Ginsberg than Tammy Faye Bakker, "St. Becky" writes where compensators of faith and American culture meet and bleed into each other, and where those who study culture struggle to make sense of the American religion.

NOTES

1. Freud writes in *Totem and Taboo* of this fear that "the dead, filled with a lust for murder, sought to drag the living in their train. The dead slew. . . . Later, the malignity of the dead diminished [but originally] *all* of the dead were vampires, all of them had a grudge against the living and sought to injure them and rob them of their lives. It was from corpses that the concept of evil arose." *The Standard Edition of the Complete Works of Sigmund Freud*, Vol. XIII, trans. James Strachey (London: The Hogarth Press, 1955), 59.

2. All of these categories' failures are implicit in the plot. Although a television reporter announces that it is radiation from a Venus space probe that seems to have caused the living dead, George Romero, the film's maker, has said he "really didn't mean that to be" since in the original cut there were multiple, conflicting scientific explanations. Interview with Dan Yakir, "Morning Becomes Romero." *Film Comment* (May–June 1979): 60.

3. Review by Elliott Stein of *Night of the Living Dead* in *Sight and Sound* (Spring 1970): 105.

4. Gregory Waller, ed., *American Horrors: Essays on the Modern American Horror Film* (Urbana: University of Illinois Press, 1987), 4, 17, 28.

5. Stein, 105; Waller, 2. David Pirie has called it "'probably the only truly modernist reading of the vampire myth.'" Cited in Barry Keith Grant, "Taking Back the *Night of the Living Dead*: George Romero, Feminism, and the Horror Film" in Grant, ed., *The Dread of Difference: Gender and the Horror Film* (Austin: University of Texas Press, 1996), 202. In addition to Grant's article, see Gregory A. Waller's chapter "Land of the Living Dead" in his *The Living and the Undead: From Stoker's* Dracula *to Romero's* Dawn of the Dead (Urbana: University of Illinois Press, 1986): 272–327, and Robin

Wood's "Apocalypse Now: Notes on the Living Dead" in *American Nightmare: Essays on the Horror Film* (Toronto: Festival of Festivals, 1979): 91–97.

6. Interview with Dan Yakir, 60–65.

7. George A. Romero and Susanna Sparrow, afterword to *Martin* (New York: Day Books, 1980): 210. "We're them and they're us," says Barbara in the film, whatever that is meant to mean.

8. In his 1970 review, Stein describes the plot in which all of the living are murdered and eaten by the ghouls "except Duane Jones, a black—he is shot down by the police, his 'saviours.'. . . The main character is black—but not only is the point not rubbed in— it's not mentioned once." More recently, R. H. W. Dillard writes, "Perhaps the only unusal thing about [these ordinary Americans] is that no one of them ever comments about one of their numbers being black, especially in the light of his assuming a nat-ural leadership." (Waller, ed., 19.) Waller writes in *The Living and the Undead*, "this murder evokes American racism at its deadliest," a topic, he writes, that Romero returns to in *Dawn of the Dead*.

9. Rodney Stark and William Sims Bainbridge, *The Future of Religion: Secularization, Revival, and Cult Formation* (Berkeley: University of California Press, 1985), 7.

10. For a compact introduction to the most extensive studies on Western attitudes toward death, see Philippe Ariès' *Western Attitudes toward Death: From the Middle Ages to the Present* (Baltimore: Johns Hopkins University Press, 1974), which concludes with a chapter outlining the "interdiction of death in order to preserve happiness" in the twentieth century and its American variation (94). Ariès' claim in this book has been followed by a flood of materials that have qualified and critiqued and added to it, especially with regard to ethnic differences in American responses to death. For a study in this regard, see Richard A. Kalish and David K. Reynolds, *Death and Ethnicity: A Psychocultural Study* (Los Angeles: University of Southern California Press, 1976).

11. Joan Didion, *The White Album* (New York: Farrar, Straus and Giroux, 1979), 11.

12. Didion, 20, 36, 46–47.

13. Stark and Bainbridge, 6.

14. *Ibid.*, 8.

15. Ivan cites incidents that Dostoevsky had read about in newspapers; in one, soldiers throw babies into the air in front of their mothers and then "catch" the babies on their bayonets. In another, they tell a young boy to run, and while his mother is forced to watch, set a pack of dogs on him.

16. D. Michael Quinn, "Plural Marriage and Mormon Fundamentalism," *Dialogue: A Journal of Mormon Thought* 31.2 (Summer 1998): 1. According to some sociological definitions, Mormonism was not a sect but a cult, since it did not emerge by means of a schism from a dominant religion, and is now either a "religion," an "unconventional religion," a "cult" or an "established cult," depending on who you read (see fn. 24). I use the term "sect" therefore advisedly here. Members of the principle organization of "Mormonism" call themselves the true and restored Church of Jesus Christ of Latter-day Saints. ("Mormon" is a "gentile" moniker, derived in the nineteenth century from the notorious "new scripture" of the Book of Mormon.) Conceiving themselves then and now as the true Christian church, they were seen as a threat to American civiliza-tion in the nineteenth century, including by the federal government, as they are today demonized by some Christian groups, including the Southern Baptists. Despite a vigor-ous public relations campaign by the Mormon church to convince the world they are Christians, and despite the fact that Larry King had recently married a Mormon, when he interviewed the Mormon president Gordon B. Hinckley on "Larry King Live" in September 1998, he said, "You're not Christian, right?" Non-Mormon scholars of

Mormonism have argued that Mormonism is as distinctly different from Christianity as Christianity was different at its formation from Judaism. See Jan Shipps' important study, *Mormonism: The Story of a New Religious Tradition* (Urbana: University of Illinois Press, 1985) and Rodney Stark, "The Rise of a New World Faith," *Review of Religious Research 26* (September 1984), in which Stark estimates a worldwide membership of 265 million by the year 2070. Following Shipps, see Harold Bloom, *The American Religion: The Emergence of the PostChristian Nation* (New York: Simon and Schuster, 1992). For studies of the long history of Mormon-American tension and Mormon assimilation, see Armand Mauss, *The Angel and the Beehive: The Mormon Struggle with Assimilation* (Chicago: University of Chicago Press, 1994); Kenneth H. Winn, *Exiles in a Land of Liberty: Mormons in America, 1830-1846* (Chapel Hill: University of North Carolina Press, 1989); and Marvin S. Hill, *Quest for Refuge: The Mormon Flight from American Pluralism* (Salt Lake City: Signature Books, 1988). For a cultural analysis of the pervasive demonization of the Mormons in the nineteenth century, and of how American ideology squared anti-Mormon sentiment with Jeffersonian tolerance, see Terryl L. Givens's *The Viper on the Hearth: Mormons, Myths, and the Construction of Heresy* (New York: Oxford University Press, 1997).

17. Bloom, 122.

18. *Ibid.,* 120. "At an enormous expense in time and in money, the Mormons work constantly at baptizing the dead, their own ancestors *and others,* since Smith insisted that the dead were free to accept or refuse what is done for them in the temples. Many Gentiles (a category which, to Mormons, includes Jews) are at the least nervous, if not indignant, at this apparently forced conversion of their ancestors, and are not particularly pacified by Mormon assurances that there is perfect free will in the spirit world." Jewish Americans have, however, recently been successful in lobbying the Mormon church to abandon baptisms for Jewish ancestors. Bloom quotes the then President of the Mormon church, Spencer W. Kimball, at the dedication of the Mormon temple in Washington, D.C. (which rises like Oz next to the Beltway parkway) in 1974: "The day is coming not too far ahead of us when all temples on this earth will be going day and night. There will be shifts and people will be coming in the morning hours and in the day hours . . . because of the great number of people who lie asleep in eternity and who are craving, needing, the blessings we can bring them" (122).

19. Alex Shoumatoff, "The Mountain of Names," *The New Yorker,* May 13, 1985.

20. *Journal of Discourses by Brigham Young, His Counselors, and the Twelve Apostles,* Reported by D. W. Evans, Geo. F. Gibbs, and others. vol. 19. (Liverpool: William Budge, 1878), 229.

21. Ariès, 95.

22. The ministerial edict upon entering "Whispering Glades," Evelyn Waugh's depiction of Forest Lawn, is chanted on perpetual replay, in the 1965 film version, by Jonathan Winters: "Stranger, enter these gates and *be happy."* Jessica Mitford writes, "If there are skeptics who think that Mr. Waugh may have been guilty of exaggeration, a visit to Forest Lawn should set their minds to rest." See "Shroudland Revisited" in *The American Way of Death Revisited* (New York: Alfred A. Knopf, 1998): 101–10.

23. *The Salt Lake Tribune,* June 13, 1997, p. B1.

24. Tension with the social environment is one of the most common characteristics of cults, according to sociologists as well as religious and secular anti-cult organizations, but the other characteristics are many and often contradictory in the collective literature, often within the same studies. Stark and Bainbridge, among the most exacting, nevertheless make some silly distinctions: Mormonism in Utah is not a cult because it is the dominant religious group, while Mormonism is a cult outside of Utah. Hence,

when my family moved from Utah to Pennsylvania, we moved from being members of a religion to being members of a cult. Even so, the greatest degree of Mormon and non-Mormon tension is in Salt Lake City, Utah, where the Mormons hold relatively so much power. The definition of a cult as a religion without political power (see Tabor and Gallagher below, who quote, in an epigraph, Tom Wolfe) does not square with Stark and Bainbridge's grouping of Mormonism as a cult outside Utah: certainly it has significant power in Washington, for example, that Satanists, Witches, and flying saucer groups (among others in their list of cults) do not. The definition of a Christian campus ministry seems most accurate: somewhat misleadingly but approvingly citing Melton (below), they claim that "in effect, a 'cult' is any group stigmatized as a 'cult.'" {Ronald Enroth & Others, *A Guide to Cults and New Religions* (Downers Grove, Illinois: InterVarsity Christian Fellowship of the United States of America Press, 1983): 11.} Regardless of what this might tell us about the effects of a "moral majority" in defining things, one wonders what to make of a religious group that rejects much of a culture, like the Southern Baptists, who have rejected even the Disney corporation, if religions (as opposed to cults) are "culture-accepting" in this book's view. Another study states that both "cults and sects" experience a greater degree of social tension than "a church" and are rejected by society "as misguided crackpots. The faith of a cultist or sectarian is not understood by the larger society to be a 'true faith,' but rather a confused, heretical, or foolish collection of beliefs." What the "larger society" is in the most diversely religious country in the world is an interesting question, as is the question of what name-calling has to do with consensus or history. After all, the Jews have an older religion than any Christian church: Would they be deemed in any serious sense more "cultic" than fundamentalist Christians if the fundamentalist Christians were a "larger society" than the Jews? For definitions of cults, see Stark and Bainbridge, 19-37; J. Gordon Melton, *Encyclopedic Handbook of Cults in America:, Revised and Updated Version* (New York: Garland Publishing, Inc., 1992); and William J. Whalen, *Strange Gods: Contemporary Religious Cults in America* (Huntington, Indiana: Our Sunday Visitor, Inc., 1981). For debates about religion and power in American culture, see Thomas Robbins and Dick Anthony, eds., *In Gods We Trust: New Patterns of Religious Pluralism in America*, 2e (New Brunswick, NJ: Transaction Publishers, 1990), especially pp. 1–60, 409–72, and 199–344 ("Spiritual Innovation and the New Age").

25. Freud, *Group Psychology and the Analysis of the Ego.* Trans. and ed. by James Strachey (New York: W. W. Norton & Co., 1959), 62, 63.

26. This double-edged status of new religions in America is relevant to the Mormons. R. Laurence Moore argues in his 1986 *Religious Outsiders and the Making of Americans,* that "Mormons followed a lesson, already by their time well established in American experience, that one way of becoming American was to invent oneself out of a sense of opposition. This was perhaps the most useful consequence of America's voluntary system of church formation. The American mainstream, certainly its religious mainstream, never meant anything except what competing parties chose to make of it. It was not a fixed thing. It was an area of conflict. In defining themselves as being apart from the mainstream, Mormons were in fact laying their claim to it." Cited in Bloom, 88.

27. James D. Tabor and Eugene V. Gallagher, *Why Waco? Cults and the Battle for Religious Freedom in America* (Berkeley: University of California Press, 1995), 175–76.

28. See Jeff Sheler, "Waiting for the Messiah," *US News & World Report,* December 19, 1994, pp. 62–71.

29. Tabor and Gallagher, 173, 174.

30. *Part Two: Perestroika* (New York: Theater Communications Group, 1994): 67 (Act III, Scene 2). Despite their different group identities, Joe's and Louis's betrayals of others initially bind them in fear to each other through identification. Tony Kushner's play, in part, serves to confuse and realign group identities and beliefs for the sake of progress for the living and explicitly not (as seen by its use of Mormon belief vs. Mormon history) for the dead.

31. Robert Endleman, *Jonestown and the Manson Family: Race, Sexuality, and Collective Madness* (New York: Psyche Press, 1993), 164.

32. The *New Republic* argued that Jonestown triggered a collective experience of devastation greater than anything concerning the United States since the assassination of John F. Kennedy. Cited in John R. Hall, *Gone from the Promised Land: Jonestown in American Cultural History* (New Brunswick, NJ: Transaction Books, 1987); xii.

33. David Chidester, *Salvation and Suicide: An Interpretation of Jim Jones, the Peoples Temple, and Jonestown* (Bloomington: Indiana University Press, 1988), 164. For a subsequent study with an extensive bibliography on Jonestown, see the collection edited by Rebecca Moore and Fielding McGehee III, *New Religious Movements, Mass Suicide, and Peoples Temple: Scholarly Perspectives on a Tragedy* (Wales, UK: The Edwin Mellen Press, Ltd., 1989). See also Judith Mary Weightman, *Making Sense of the Jonestown Suicides: A Sociological History of Peoples Temple* (Lewiston, NY: The Edwin Mellen Press, 1983) and Umberto Eco's essay "The Suicides of the Temple," in which he puts Jonestown in the context of American culture, in his *Travels in Hyperreality*, trans. William Weaver (New York: Harcourt Brace Jovanovich, 1986): 95–102.

34. Chidester, 164.

35. *Ibid.*, 160.

36. *Ibid.*, 165.

37. *The Boston Globe*, March 30, 1997, p. A12.

38. In a recent article in the *New York Times* entitled "Horror as an Everlasting Failure to Communicate," Peter M. Nichols writes, "In Romero movies, trouble is always snowballing, unstoppable in the face of misinformation, paranoia and mistaken impressions, distrust and plain stupidity." He quotes Romero as saying his films are about the human failure in communicating in the face of anything "out of the ordinary" and the "unwillingness to accept change." Sunday, July 12, 1998, AR 24.

39. *Miss Lonelyhearts & The Day of the Locust* (New York: New Directions, 1962; orig. pub. 1939), 142.

40. Unpublished ms. Edited by David Michalek. I have deleted the quotation marks from the diary that surround every noun and adjective. They do not have the effect of the academic quotation marks that suggest an ironic distancing. Instead, they suggest a faith in a meaning that lies beyond received terms or beyond language, as if they are words that have yet, like her wishes, to "happen" ("cause television to cause these words to happen"). In any case, her punctuation, like her faith, expresses alienation.

1 5

AMERICAN HERITAGE[1]

Peter S. Hawkins

BY THE MID-1980s, the "televangelists" were suddenly everywhere:
on the air, in the newspapers, dropped into dinner-table conversa-
tion, and fixed by magnet to refrigerator doors. Where had they
come from? Religious programming was by no means new to TV, though
in the beginning it was dominated on the networks by mainstream
efforts—Archbishop Fulton Sheen's hypnotic talking head or Sunday
morning shows like the arty, high-brow *Lamp unto My Feet*. Such pro-
grams were aired as a public service and carefully monitored for content
and style by the watchfully liberal National Council of Churches. There
turned out, however, to be a different kind of TV audience for religious
programming, one that found nothing in the innocuous network shows
that had anything to do with sin and salvation. Fundamentalists, con-
vinced alike of the damnation of the unconverted and the danger of "back-
sliding" among the twice born, wanted a call to repentance, not continuing
education that stayed purposefully vague about Jesus. TV, therefore, was a
field white unto harvest, and evangelicals of every stripe rushed to bring in
the sheaves.

The line of televangelists presiding over what came to be called the
Electric Church began with the itinerant preacher Rex Humbard, who in
1952 established a weekly program for shut-ins on an Akron, Ohio TV sta-
tion.[2] Two years later, Humbard encouraged the faith healer Oral Roberts
to televise his dramatic prayers for healing and the ecstatic testimonies of
people who flung aside their wheelchairs or felt a goiter disappear in a
minute. At the same time, Billy Graham was broadcasting less antic but no
less spectacular urban crusades. Yet another slew of preachers contrived to

bring the stay-at-home viewer to "live" worship services designed primarily for TV consumption, such as those currently broadcast from the corporate park "studio" of Robert Schuler's Crystal Cathedral or from the neocolonial campus of Jerry Fallwell's Thomas Road Baptist Church.[3] While these ministries attained enormous success in the 1980s, the possibilities inherent in television were exploited more fully by the Pentecostal and Charismatic preachers who, because of their greater emotional appeal, found ways to heat up the screen.[4] In this regard I am thinking not only of Oral Roberts but also of the triad of ministries that captivated national attention in the spring of 1987: Jimmy Swaggart, Pat Robertson, and the Bakkers—Jim and Tammy Faye.

It was in early March of that year that the dean of the Yale Divinity School funded my visit to a pair of these ministries. My charge? "Find out what they are doing and what, if anything, we can learn from them." The assignment required something of a stretch. Although a practicing Christian, I knew little about American revivalism or Pentecostal religion; I scarcely ever watched television. Nonetheless, I set out with Margaret Mead in mind: I would aim for the anthropologist's cool, the outside observer's respectful distance. (Mead's thorough misunderstanding of Samoa has recently been exposed; let the reader judge my own reliability as an objective witness.)

The trip began with an overnight stay at Pat Robertson's Christian Broadcasting Network, whose sprawling eleven-building complex in Virginia Beach was home not only to an imposing television studio but since 1977 to the red brick, white column campus of CBN (now Regent) University. The atmosphere of the place was friendly and "tasteful," with smiling students and production assistants all apparently engaged in carrying out the words inscribed over the studio's main entrance: "This Gospel of the Kingdom shall be preached in all the world for a witness unto all nations" (Matthew 24:14).[5]

Language about kingdoms and nations abounded at CBN, whose founder and chancellor was shortly to run for President on the Republican ticket, vowing to "rule" America as God's own regent. One was frequently reminded, moreover, of the United States' ordained place in a succession of theocracies and covenants: The mantle that once graced ancient Israel had been passed on to the United States. Nor was this connection merely an analogy limited to the biblical kingdom of David and Solomon. A display case in the university's rare book library juxtaposed two facsimile docu-

ments, the constitutions of the United States and of the state of Israel. The chapel Bible, moreover, was open to King Solomon's prayer at the dedication of the Temple (I Kings 8: 25): "There shall not fail thee a man in my sight to sit on the throne of Israel." I marveled at this choice of Scripture: Apparently no one saw any incongruity between CBN's architectural evocation of colonial America and this monarchial discourse about thrones, kings, and dynastic succession.

Scarcely less provocative than such hints of Judeo-Christian theocracy were the signs of another preoccupation, the imminent end of the world at Christ's return. In the lobby of the CBN studio building, for instance, there was a mural of the "Triumph of the Armageddon" to remind passersby of the final battleground, the conflict of Gog and Magog. Across from the Jefferson-inspired library, a metal sculpture splayed across a brick wall showed the Four Horsemen of the Apocalypse at full gallop toward the cataclysmic future. My student guide was unfazed by these reminders of the end time: She explained that pre-millennial horror would be but the harbinger of post-millennial glory, when servants of Christ achieve positions of influence in society (presumably as chancellors and presidential "regents"), thus preparing the world for the Second Coming.

Jim and Tammy Faye Bakker's empire was a Magic Kingdom of another sort, a realm free of millennial concerns and only lightly touched by right wing politics. Nonetheless, despite a chasm of taste and class, there was an overlap with Pat Robertson and his world. In the mid-1960s the Bakkers began their TV career with a "gospel" puppet show on CBN. Soon thereafter, Robertson noted Jim Bakker's talent for weeping on camera during fund-raising drives and allowed his protégé's ambitions to soar beyond kiddy evangelism. One of Bakker's persistent dreams was of a Johnny Carson-style talk show produced for Christians—a staple of the Electric Church now but unheard of then. The dream came true in the form of CBN's still-running *700 Club,* which was conceived, originated, and first hosted by Jim Bakker.

Inevitably, tensions developed with Pat Robertson, who wanted to be Johnny Carson himself, not play the part of Ed McMahon. There was also the matter of style. Robertson was the son of a Virginia senator and a graduate of Yale Law School, who dressed in pin stripes even when praying away a hurricane from the coast of Virginia. He was charismatic with class. Jim and Tammy, however, were Midwestern Pentecostals who brought with them the common touch of humble origins, at once down home and

nouveau riche, glittering, and gay.[6] In any event, after seven years at CBN
the Bakkers left Virginia Beach in November 1972—and apparently just in
time. On somebody's orders their studio set was destroyed, the puppets
hacked into pieces, and years of videotapes erased.

After a brief stint in southern California with Paul and Jan Crouch's
Praise the Lord show, the Bakkers relocated to Charlotte, North Carolina. As
part of that move, they brought the name PTL with them, interpreting it
alternately as "Praise the Lord" and "People that Love." They also hosted the
PTL Club together, with Tammy Faye happy to play her zany second fiddle:
"He's the straight man," she explained, "and I'm kind of his funny little per-
son."[7] The Bakkers' ministry rapidly outgrew both its initial home in a for-
mer furniture showroom and, shortly thereafter, the twenty-five-acre site of
"Heritage Village"—a small campus of neo-Georgian buildings that Jim
envisioned as "a miniature version of Colonial Williamsburg,"[8] with a
knock-off of the Bruton Parish church housing a state of the art TV studio.
The name of the new enterprise, with its deliberate looking backward to an
American Heritage of small-town Christian living, set a nostalgic tone com-
patible with the Bakkers' particular brand of intimacy. Yet, the outreach of
this PTL "village" was aggressively global, its broadcasting equipment top of
the line. Once you opened the doors of an eighteenth-century-style church,
you entered the world of twentieth-century technology.

Despite the ministry's prevailing mood of financial crisis, with Tammy
often in tears and Jim preaching the imminent doom not of Armageddon
but of the program's monthly bank statement, PTL prospered in the late
1970s beyond anyone's calculations. The same might be said of the other
televangelists, who also targeted solitary people connected to the world
through their television sets—people who wanted to be "partners" in
something larger than themselves, who welcomed the follow-up letters and
mementos routinely sent to "club members." However, Jim Bakker's boy-
ishness and apparent vulnerability, not to mention the roller coaster emo-
tions of Tammy Faye, offered something not found elsewhere in the more
macho world of the televangelists. The Bakkers made their own niche in
the market.[9]

Once PTL received the first-ever private satellite license for world
broadcasting, the ministry had a network that would eventually reach
1,300 cable systems serving thirteen million households nationwide.[10] In
1984, PTL had two-thousand employees and an annual payroll of $30 mil-
lion; by early 1987, it was worth $172 million. With assets growing,

Bakker's visions also increased and multiplied. Impelled by a sense of manifest destiny for "Heritage," he was especially susceptible to the lure of real estate, the prospect of making a world that his far-flung villagers could think of as home. "We wanted to find something that would contain all of the parts of the ministry and we could bring everybody together and it would be large enough to fulfill the vision God had laid on my heart, and the vision of a people place that would be like the old fashioned campgrounds, only be modern and up to date."[11]

Determined in January of 1978 to build this Jerusalem in Carolina's green and pleasant land, he located an abandoned industrial park just over the border from Charlotte, in Fort Mill, South Carolina. The 2300-acre spread was to have at its hub a "Total Living Center," where volunteers would serve as telephone counselors twenty-four hours a day and from which the broadcast studio would proclaim the Good News according to PTL. Bakker also hoped to establish "Heritage University," no doubt wanting to match the institutions founded by men he considered to be his peers: Robertson's CBNU, Swaggart's Baton Rouge Bible College, Oral Roberts's University in Tulsa, Falwell's Liberty Baptist College. Heritage University failed to gain accreditation, but other projects flourished: a retreat with 1600 camp sites ("Fort Heritage Center"), a variety of housing and food services, many opportunities for shopping, an open-air amphitheater, the five-hundred-room "Heritage Grand Hotel," a water park (complete with wave machine and 163-foot slide), a dinner theater, and, most importantly, a large television studio—the "Big Barn Auditorium"—that also served on Sundays as the "Heritage Village Church."

Back in Charlotte, Bakker had made much of his ministry's support for local pastors and their congregations: He was not out to establish a rival church. That policy changed, however, with the development of Heritage USA. Bakker, of course, had spiritual reasons for the move: "The older I get, the more I see the need for a church. The more I want to be a part, the more I need the brethren. They can offer a kind of instant barometer on what I'm doing."[12] He envisioned a faith community that was more extended family than parish church, that was "all-encompassing, not just a part or compartment of life, but life itself, all of life, with nothing left out."[13] Along with these lofty motives, however, he also saw that as a church—with boundaries blurred between a Christian congregation and an amusement park or shopping mall—PTL could avoid state tax regula-

tion of its fund-raising, limit its property tax, and avoid filing the returns that the IRS requires of tax-exempt organizations. Most importantly, by operating exclusively for "religious, charitable, or educational purposes," PTL could claim exemption from income tax.[14] Everything was religious, and "total living" made wild financial sense.

In masterminding the 2300-acre parish he called "Heritage USA"—a town-country name that seemed to announce the newest state in the Union—Bakker's initial goal was to build a "unique twenty-first century Christian retreat and campground, and so much more."[15] It is this latter phrase, with its tantalizing suggestion of an inexhaustible "more,"[16] that suggests how his dream of territorial expansion went far beyond a "modern and up to date" makeover of the Pentecostal camp meetings he had known in his childhood. In those woodsy tent cities, with their rows of tiny shacks and communal outhouses, evangelists held forth in the Tabernacle on the evils of the world: dancing and card-playing, smoking and drinking, movies and provocative popular music, "mixed bathing," cosmetics, jewelry and immodesty for women, profanity and pride for men. Indeed, "worldliness" itself was the great Satan.[17] Yet, for Jim Bakker—and, even more dramatically, for Tammy Faye—seeing Heritage USA as a twenty-first-century camp meeting actually represented a radical transformation of the twentieth-century model they both knew. Post-war prosperity had worked against the austere ways of fundamentalist life, which had ennobled poverty during the years of the Depression by making it Christian and counter-cultural. Another corrosive force on the old religion was television itself: While attendance at movies or nightspots had once been easy to monitor in small communities, no church elder would know what danced across the home screen when the drapes were drawn.

The Bakkers themselves had undergone this sea change in sensibility; now, with Heritage USA, they were in a position to offer their house rules to anyone who wanted to join the "PTL Club" or, better yet, make a pilgrimage. Rather than calling down the fires of heaven to purify and perfect the faithful, they offered everyone a "baptism of pleasure."[18] The severe restrictions of fundamentalist Law were no longer binding in what turned out to be a new age of Grace. Therefore, Tammy Faye could wear her wigs and apply her Kabuki makeup, dressed to kill.[19] Likewise, everyone could be half-naked and swim together in the water park. No more campground shacks or tents or outhouses; instead, "modern and up to date" hotel bathrooms would be appointed with gold fixtures, and the family dog, like the

Bakkers' own Snuggles, housed with air conditioning. Only the best was good enough. Christians were meant not to suffer soul-strengthening deprivations but to go first class. They were children of a wealthy Father who wanted them not only to make it to heaven but also to "make it" in the world. More was, in fact, more.

The "Prosperity Theology" that authorized this carnival of consumption was by no means the brainstorm of the Bakkers.[20] It had been brewing since the sixties, and both Oral Roberts and Pat Robertson had already proclaimed the Gospel of Health and Wealth, charging Christians to "Expect a Miracle," to "Name it and claim it." God did not want any of the beloved to be sick or poor. After all, hadn't Christ said to his apostles, "I have come that they might have life, and that they might have it more abundantly" (John 10:10)? The abundant life might mean being unencumbered by arthritis or cancer; more often than not, however, it entailed a financial windfall. Gone was the industry of the Protestant work ethic. The faithful could prosper by doing almost nothing other than praying and sending a monthly check of $15 to the TV ministry of their choice. Making that minimal deposit on their inheritance, they would first give God "seed money" and then let the stock broker from heaven harvest an incredible return. This was the experience the Bakkers themselves spoke and wrote about with authority—the meteoric rise from basement to penthouse that enabled them to leave behind what Jim described in *You Can Make It* as the "atmosphere of negativism and self-pity" (37) he and Tammy had imbibed as Pentecostal youths: "Whatever you give to God, He will give back to you many times over. That's the secret of financial success—you can't outgive God" (88–89). One had merely to "Let go and let God," taking care only about the details. If you wanted a camper, Bakker frequently said, be sure to specify the color. Otherwise, the Lord would have to choose the color for you.

By the time Heritage USA hit its stride in the mid-'80s, Bakker had succeeded in creating a utopia for the Prosperity Theology, "an ideological place where ideology is put into play . . . a stage for ideological representation."[21] However, this was quite definitely Ideology Lite. Without Robertson's political drive to reign as God's regent over a kingdom where righteousness ruled and Scripture was law, Bakker wanted only to retrofit an America suited to newly middle-class Pentecostals and their Charismatic peers. With the Fourth of July as PTL's High Holy Day—its parades and fireworks "all part of our 'Passover'. . . when we remember

how God has miraculously delivered us from our enemies"[22]—he offered his public an easy-going Beulah Land. Accused early on that PTL was only Disneyland in disguise—the *Chicago Tribune* would call it the birthplace of "recreligion"[23]—Bakker and his associates joyfully accepted the analogy, claiming that Heritage USA was as good as anything to be found in Anaheim or Orlando; in fact, it was even better, being focused (however fuzzily) on the Spirit. Justifying the $10 million water park and its "surfing wave," PTL vice president Richard Dortch would claim, "I think if Jesus lived on this earth today, he'd want a water park for kids to come to;"[24] according to Bakker himself, "If the Bible says we are to be fishers of men, then a water park is just the bait. And I don't see anything wrong in using some pretty fancy bait."[25] Indeed, no cost *should* be spared. As PTL's authorized picture book put it, "Our lodging accommodations, restaurants, shops and recreational facilities offer all the enjoyment to which our guests and congregations are *entitled*—without any of the dross that mars the meeting places of the secular world."[26] As a spokesman explained to me during my own visit, "We give Christians what they want—the chance to shop, eat and pray."

This dizzy-making convergence of activities is precisely what I found first-hand at Heritage USA, a place where people felt free to pray together when waiting on line in the Heavenly Fudge Shoppe or to lick their "Angel Taste" cones while watching total-immersion baptisms. PTL religion did not require anyone to be dressed up or buttoned down; nor did it expect any decorum apart from the cheerfulness that everywhere prevailed. In this extraordinarily labile environment, nothing stayed in place or made particular sense as sacred or secular. Indeed, for the faithful this blurring of boundaries was a sign that God was "all in all." In any event, my three-day visit presented me with a welter of ways to understand Heritage but with no clear-cut identity for it. Was it a Disney World for liberated Fundamentalists, a church, a theme park, a gated community, a shopping mall (with discount "Goodie Barn"), a country club, headquarters for several "compassionate caring" social welfare efforts, a pilgrimage destination, the hub of a broadcasting empire? Or was it Jim and Tammy's Marriott version of Versailles—a gilded, mirrored court where any paying guest, on special days like Christmas or Jim Bakker's January 2nd birthday, could admire the dapper Sun King in white tie, laugh with his ebullient queen ("la reine s'amuse"), or observe the royal children stepping in front of the camera or into the recording studio?

This surfeit of identity and function may account for some of the difficulty I had in orienting myself while at Heritage. To be sure, there was no question as to whose Magic Kingdom this was: Jim and Tammy's billboard heads greeted the driver who pulled off I-77 and then entered what many people sincerely considered Holy Ground; those cartoon faces were also there at the exit, smiling above the words the couple always used at the end of their PTL show, "GOD LOVES YOU, HE REALLY DOES." In between entrance and exit, however, the first time visitor was somewhat at a loss. Descriptions I've checked against my own notes often speak of one building or another as a "center," a "hub," or as the "heart of Heritage"; yet, in my own experience there was no center to hold onto.

Anthropologist Susan Harding has noted that Bakker was a Master Builder without a master plan, an architect who successfully added one fantasy to another, but without hierarchy of symbol or significance to his building program or any set of priorities.[27] Heritage seemed to be largely driven by Bakker's unconscious, and was therefore open to all kinds of interpretation; divining his conscious motivation for this or that feature of the place was another matter. Faced with the 163-foot water slide, as well as the fountains sprinkled generously throughout the property, Frances FitzGerald looked to Bakker's Pentecostal roots for a theological interpretation. Rather than mere decoration, she says, the presence of falling water was intended to evoke both the "early rain" of the Holy Spirit at the first Pentecost (Acts 2) and the "latter rain" that Pentecostals believe will presage Christ's Second Coming.[28] Maybe. This particular religious spin certainly enriches one's experience of Heritage, and may well have functioned subliminally for Pentecostal visitors as a sign of the Spirit's abundance within the "campground." But given Bakker's own lack of interest in either historical or theological matters, it seems to me quite as likely that there is a simpler explanation, and one that owes more to marketing than to theology. Bakker recognized the drawing power of water-based amusement parks in the South, and understood the cachet of Heritage having reflecting pools and fountains similar to the ones gracing corporate headquarters across the sunbelt. Sometimes a water park is just a water park.[29]

Lacking a clear place to start my tour, I decided to check in at the Heritage Grand Hotel, "four stories of brick and glass and stone unable to make up its mind between Renaissance and Georgian colonial" (James, 6). Hearty majordomos, all silver buttons and tassels, greeted arrivals ("God

loves you!") underneath a port-cochere filled with cars, vans, and the bustling transfer of luggage. I was impressed with the cross section of ages and the numbers of African Americans. People treated apparent strangers as if they were old friends. Easy to miss in this hubbub, however, was a sculptural group of life-sized figures cast in bronze, placed just to the side of the port-cochere and therefore only steps from the main entrance. Arranged in a rough circle, there were what looked like slaves, one of whom proffered a water basin and towel; on a higher level, a toga-clad figure of authority, who cleansed his hands in that same basin; and on the periphery of the group, a half-naked man crowned with thorns. It took me no time to recognize the scene that the artist had rendered. In a conflation of two moments in the Passion story (Matthew 27 and John 18), Christ stands at the feet of Pilate to receive his judgment. Called to account for himself, he says that he came into the world "to testify to the truth." Pilate then responds immediately with a rhetorical question—"What is truth?"—before washing his hands of the whole sorry business.

Try as hard as I might throughout my stay, I could get no one to give me a rationale for this provocative statuary or to comment on its significance in situ. Everyone seemed blind to its tacit challenge, its posing of the question, "What is truth?" on the very threshold of the Heritage Grand Hotel. The biblical literacy I had assumed here apparently did not extend to "hard sayings," to texts that had some bite in them, to prophetic teaching, to Christ's Passion. Instead, the PTL Gospel seemed to have to do only with love, forgiveness, and the rewards of being God's child; it meant having a nice day.

Once inside the doors of the hotel, a stretch of marble behind the front desk presented in chrome the following handwriting on the wall: WELCOME TO HERITAGE GRAND HOTEL, WHERE JESUS CHRIST IS LORD. The lobby itself was a four-story atrium, decorated with potted palms, Victorian settees, marble-topped tables and gold-framed mirrors. There was a central fountain and, close by it, a raised grand piano, all rococo gilt and worthy of Liberace. A small swimming pool was located at the far end of this common room, far too tiny for laps but, as it turned out, adequate enough for the scheduled baptismal services held in the afternoon and evening. Hanging on the walls (here and elsewhere) were oil paintings of a sinewy, virile young Christ and a woman, who looked like a cross between Farrah Fawcett and country singer Emmy Lou Harris; she turned out to be the Virgin Mary.

Marian imagery surprised me in this setting. I wondered if it represented a welcoming gesture to Mother Angelica and other Roman Catholic Charismatics, or if it suggested the important role played by women in the Pentecostal movement, including the colorful Aimee Semple McPherson and her healing-evangelist successor, Katherine Kuhlman.[30] In particular, I wondered if Mary were on display throughout Heritage because of Tammy Faye. All the other televangelists had wives who stayed discretely behind the scenes; they were mothers of sons being groomed to take over the ministries but were themselves largely invisible partners. Tammy Faye, however, was often center stage, adding a stereotypical feminine touch to the PTL programming as well as to the Heritage decor. She not only was Jim's co-host but had her own madcap TV "House Party," where frivolity, as well as her famous "shopping demon," cheerfully ruled the roost. In addition, women (and African Americans) were well represented on the ministry's board of trustees, were included among the visiting PTL preachers, and comprised half of the stable of "stars" who occasionally left their regular world of telethons, game shows, and reruns to appear as guests of Jim and Tammy. For every Efrem Zimbalist, Jr., Mickey Rooney, Richard Simmons, or Mr. T, there was a Pearl Bailey, an Anita Bryant, a Carole Lawrence, a Della Reese. When I asked spokesperson Neil Eskelin if there were any connection between the images of Mary, the prominence of Tammy Faye, and the distinctive tone of the PTL ministry, he was bemused and derisive about both Bakkers: "Every Mickey needs his Minnie." Still, Tammy's ostentatious "style," her sheer superabundance, struck me as central to everything I saw around me. If she were simply a joke, then Heritage USA was her divine comedy.

Opening up from the atrium-lobby was the Victorian-inspired Main Street shopping arcade. Here Bakker clearly had in mind an indoor version of Disneyland's Main Street, USA, described by Louis Marin as the synecdotal "key" to the whole Disney enterprise, the "part that is as good as the whole": "By the selling of up-to-date consumer goods in the setting of a nineteenth-century street, between the adult reality and the childlike fantasy, Walt Disney's utopia converts commodities into signification."[31] I noted that the "significations" for sale in Heritage were vended from "shoppes" that purveyed a variety of officially Christian goods and services. Retail, in other words, wore its ideology proudly on its sleeve. Bakker products, not surprisingly, were available everywhere: books the couple had written separately or worked on together (such as *How We Lost Weight*

and Kept it Off); inspirational tapes from Jim and vocal CD's from Tammy Faye and the teenage Tammy Sue; and a predictably full line of Tammy Faye cosmetics, along with lingerie and panty hose in colors ranging from "Smoke" and "Toast" to "Fox" and the disconcerting "Bruise." Much of what was sold on the Bakkers' shopping arcade fell under the category of the Kristian Kute: bumper stickers with messages like DON'T BE CAUGHT DEAD WITHOUT JESUS or GET RIGHT OR GET LEFT; a cassette called "Heavenly Touch—Spiritually Inspired Phone Messages for Your Phone Answering Device"; T-shirts that picked up on familiar advertising slogans: JESUS CHRIST—HE'S THE REAL THING; FOR ALL YOU DO, HIS BLOOD'S FOR YOU; OVER 80 MILLION SAVED.

Nonetheless, despite the cornucopia of kitsch known in the trade as "holy hardware,"[32] Main Street Heritage USA aspired to the higher plane of an upscale mall, whose "New York prices" seemed to suggest that for many people the Prosperity Gospel was paying off. Everything, even the Bakkers' freely admitted marital problems, seemed to turn into gold. For instance, troubles between them led to couple counseling. Then, as was to become the norm, private became public. Not only did the Bakkers air their problems on television—"It was like a soap opera with all the dull parts left out"—but they developed weekend "marriage workshops"[33] at the Heritage Grand Hotel. These sessions combined group therapy with "trained counselors," "couples' prayer," and, presumably, sanctioned-sex away from home. Main Street was more than ready to supply the paraphernalia for such workshops, including Tammy Faye "teddies" and all the cosmetic accoutrements intended to keep a husband happy and inventive.

All this was an indication of how the sixties and seventies had radically transformed the way many Pentecostals could approach their sexuality. They were free to embrace the once forbidden lures of worldliness in a safe place where living high on the hog could be seen as a fulfillment of an often cited Scripture: "Beloved, I wish in all things that thou mayest prosper and be in health" (3 John: 2). The Bakkers rode this wave of self-indulgence and capitalized on the life-style transformation it brought about. They saw that piety could be naughty 'n' nice, that renewed couples represented an untapped market.

But Heritage was not only about changing money in the temple. Many people chose to relocate to Fort Mill in order to be part of a Christian community more loving and joyful than the America they had left behind. They served as unpaid volunteers, opening mail and tending the grounds.

Visitors to Heritage learned about PTL's prison ministry, an on-campus home for unwed mothers ("Heritage House"), and a nationwide program of "People that Love" centers praised by President Reagan for providing "food, clothing, furniture, and job-banks at no cost."[34] Daily church services provided traditional evangelical fare that had nothing to do with the Prosperity Gospel. It was in the Upper Room, however, that one saw a kind of religious fervor that stood in sharpest contrast to the frivolities of Main Street or the water park. Despite the ersatz setting of this all-hours prayer center—a "near facsimile" of the site where Jesus allegedly celebrated the Last Supper[35]—it was the most compelling feature of the entire complex. If Heritage had a heart, it was here. A warren of closet doors along one wall turned out to be tiny private places where people could pray, as the Scripture enjoins, "in secret" (Matt. 6: 6). On the other side of the room, a clear plastic chest held myriad hand-written prayer requests deposited through a slot in its top. Next to it, a large screen stretched out along a wall covered with snapshots of old people in wheelchairs, babies on respirators, and spouses who had strayed. It was an iconostasis of broken lives needing to be healed. The whole atmosphere was charged; it felt like a Pentecostal Lourdes, at once embarrassing and poignant.

However extensive the campus of Heritage USA may have been in early March of 1987, Bakker had visions of "so much more." His *grands projets* included additional social ministries: "Kevin's House," for severely handicapped children; "Fort Hope," for homeless men; and a nursing home constructed on an Old West theme: "We're not putting them just on a slab somewhere with their mouths open and flies flying in . . . we're going to build a place where they're going to have fun, we're going to lift them up where they belong."[36] A new feature of the water park would be a four-story Wendy's, built in the form of a giant sand castle. Already rising up next to the Hotel, moreover, was the twenty-one-story "Heritage Grand Towers" being built for time-sharing "life-partners" who would give PTL a one-time gift of $1,000 in return for the guarantee of a free four nights, three days every year. Plans were on display but ground was as yet unbroken for the gargantuan "Ministry Center," inspired by London's 1851 Crystal Palace and intended to accommodate 30,000 people and cost upward of $100 million.

The work of "near facsimile" was meant to continue apace. Not only would the recently salvaged boyhood home of Billy Graham be surrounded by the restored birthplaces of other great preachers—a subdivision of

American evangelism—but "Old Jerusalem" would be built close by the Upper Room. According to the promotional picture book, "Pastor Bakker's dream is to make Old Jerusalem an unforgettable cultural experience for every visitor who has yearned to explore the land of the Bible." Visitors might even stay overnight in the Holy City, in "authentic style lodging facilities." Likewise, Bakker projected a biblical theme park with rides based on "Noah's Ark" and "Jonah and the Whale."[37] This feature of Heritage was to provide meaningful fun that might help the "faith tourist" make an informed choice about the future. According to PTL's director of media services, the proposed "Ride to Remember" would "give people an experience of heaven and hell. Jim really thought people could make a better decision on their eternal fate if they knew what to expect."[38]

No one in the heyday of the mid-eighties could have expected how quickly the PTL bubble would burst.[39] On the March 6, 1987, the night of my arrival, it was revealed that Tammy Faye, for several weeks missing from the program, was being treated at the Betty Ford center in Palm Springs for addiction to prescription drugs. Other revelations quickly followed: Jim's brief affair in 1980 with Jessica Hahn cost the ministry $265, 000 in hush money, while millions of PTL dollars were illegally diverted to the Bakkers' private coffers and spent on their homes, rented jets, and wild shopping sprees. Whereas the extravagance of the couple had long been viewed by the PTL faithful as part of their charm, the massive misappropriation of millions of dollars donated in good faith to foreign missions or to "Kevin's House" unleashed a fury.[40]

The time seemed ripe, moreover, for moral outrage. Only months before the October stock market crash on Black Monday 1987, people were already aware of the consequences of bond trading and bailouts. To many, the often riotous PTL investigations exposed a caricature of this eighties excess, an exposure of the Prosperity Gospel's "cargo cult of junk-bond capitalism."[41] As might be expected, the media reveled in what came to be known alternately as "Gospel-," "Pearly-," "Heaven-," and "Mascara-gate." In particular, the Bakkers' rampant consumerism was itemized with an accountant's zeal. The *Washington Post*'s inventory of the penthouse "Pastor's Suite" in the Heritage Grand Hotel noted "seven bathrooms with Hollywood lights, wall-to-wall mirrors, pedestal sinks and 14-karat gold-plated swan faucets; a master bedroom with king-sized bed, matching white Buddha lamps, mir-

rored fireplace."[42] In the living room, there were ninety-one pink and white pillows, almost $8000 worth of silk flowers, and a seven-foot tall brass giraffe. The clothes closets beggared description.

Less than two weeks after the televised account of Tammy Faye's addiction, Bakker inexplicably turned over his ministry temporarily to a televangelist nemesis, Jerry Falwell—a Fundamentalist of the strict observance, who had no use for the pleasure principle long at play in Heritage. Nor did Jimmy Swaggart, who used his TV pulpit to lambaste not only the water park but "these pretty little boys, with their hair done, and their nails done, calling themselves preachers of the Gospel."[43] Swaggart's suggestion of effeminacy soon became an open indictment: Falwell had proof that Jim Bakker was having homosexual experiences as early as the late 1950s and with growing frequency during his time at Heritage USA. This proved to be the last straw: Jimmy Swaggart called Bakker "a cancer that needed to be excised from the body of Christ"; Falwell said he was responsible for "probably the biggest scab and cancer on the face of Christianity in 2,000 years."

The Assemblies of God, the church that had ordained Bakker, seems to have agreed with this assessment. Granting him the status of bisexual— "an inclusive term for sexual activity with both men and women, though not necessarily at the same time"—the authorities stripped him permanently of his ordination on account of conduct unbecoming: "Forgiving and restoring are a priority with us, but with the ministry, we have very high standards."[44] Bakker initially denied the charges, but in the face of evidence mounting against him soon chose to avoid the issue. He rallied with a sentimental counterattack and, with Tammy's help, gave the faithful remnant hope that someday they would return to PTL—their "baby."[45] This led to the so-called "Holy War" of the televangelists. By May of 1988, the acrimonious free-for-all warranted a three-night series on Ted Koppel's *Nightline.* The second of these broadcasts offered a live interview with Jim and Tammy Faye: 23 million people tuned in—a television audience that broke records—to watch the Bakkers "be themselves, with a touch of remorse, lots of hurting, and lots of love."[46]

Legal investigations of PTL culminated in Jim Bakker's sentencing on October 5, 1989, when he was found guilty on twenty-four counts of fraud and conspiracy.[47] The judge sentenced him to serve a term of more than forty-five years, reduced on appeal to less than five. In subsequent years, the Bakkers divorced, remarried, published their memoirs, and tried independently to launch a talk show or carry on a ministry.[45] Meanwhile,

Heritage USA has passed from one hand to another, to become at present a bedroom community of housing estates within orbit of the Charlotte's sprawl. All the public buildings are derelict, the water park drained dry. Only the outdoor amphitheater continues to function, offering Narroway Production's Scripture-based dramas featuring LIVE ANIMALS. AUTHENTIC BIBLICAL STAGING, REPLICAS OF THE OLD. REFRESHMENTS AND GIFTSHOP.

None of the televangelists emerged from the Bakkers' crisis unscathed. Jimmy Swaggart wielded the terrible swift sword of righteousness only to suddenly find it turned against him: another TV preacher exposed his consorting with prostitutes and quickly brought down his ministry. Oral Roberts was less drastically done in—not by sex but by bad timing. Ascending his Tulsa prayer tower in early March 1987, he refused to come down until the television audience sent in more than a million dollars; otherwise, he said, God would "call me home." Before Roberts's deadline, the money arrived in time from a man in Florida, but his issuing of his appeal just before the Bakkers' situation came to light served to turn him into a laughing stock. Neither Robertson nor Falwell, despite their associations with Bakker early and late in his career, were themselves disgraced. Along with Robert Schuler, however, they found that giving was down after "Gospelgate."

Nevertheless, money has by no means stopped flowing nor has the audience for conservative religious television evaporated. Nor is the Prosperity Gospel without continuing allure. Even now, a Canadian evangelist, Peter Popoff, promises financial miracles to the faithful. An 800-number call can get the viewer a copy of his book, *God Has Promised You Divine Wealth,* as well as a bottle of water from a "miracle spring" located somewhere near Chernobyl; it is guaranteed to yield physical health and "millennial prosperity." What seems to have vanished from the scene, however, is Jim Bakker's vision of a utopian world where consumer dreams come true, every smile says "Jesus,"[49] and "Old Jerusalem" puts you in Bible Country without your having to leave America. This does not mean that the surviving televangelists are averse to real estate or the tourist trade. With the 250-room "Founders Inn" near CBN in Virginia Beach, Pat Robertson has built his own version of the Heritage Grand Hotel. Its lobby does not proclaim that Jesus Christ is Lord; instead, it displays oil reproductions of the Founding Fathers— Washington, Adams, and Madison—along with an original portrait of Robertson himself standing against the background of an American flag.[50]

This iconography, with its overt political evocation of an American Heritage, suggests the overarching preoccupations not only of Robertson but

of Falwell—their passion for Realpolitik rather than utopia, for nations as they are, or, rather, as they stand to be in the near future. Hence the efforts of the Moral Majority, the Christian Coalition, and myriad lobby groups to bring America back to righteousness; likewise, the intense involvement of many conservative Christians in U.S.-Israeli relations. Whereas Bakker had only wanted an Epcot Jerusalem for Heritage USA; Falwell and Robertson have their eye on the holy city itself. Along with many others, they hold that the Israeli capture of Jerusalem in the 1967 Six Day War was the fulfillment of biblical prophecy and a sign that we now stand close to the end of time. Therefore, a scenario is quickly unfolding: "I am one of those who believe," Falwell is quoted as saying in a recent *New Yorker* article, "that the next event on God's calendar is the rapture of the Church."[51] One cataclysmic event is sure to follow upon another: the seven-year Tribulation, Armageddon, the millennial reign of Christ and his regents, and—last but not least—the conversion of some Jews and the annihilation of the rest. Despite this latter prediction, the surviving televangelists have established close ties with the government of Israeli Prime Minister Benjamin Netanyahu and with many right wing Orthodox groups who want to rebuild the Temple—yet another proof that religion makes strange political bedfellows.

How will televangelism respond to the divine agenda of the Last Days? According to a former production manager at CBN, there were top secret plans as early as 1979 to scoop the story, "to televise—to capture—the Second Coming."[52] Cameras would be on-air, live from Jerusalem, with technicians ready to cope with the problems caused by Christ's divine radiance. Robertson has been working toward this moment for a long time: His war chest is also full. In 1989, CBN became the Family Channel and in June of 1997 was sold to Fox for $1.9 billion. The *700 Club* remains on the air, fighting the good fight against homosexuality and advocating for the state of Israel ("Not one inch!"). For years he has also been publishing books whose titles suggest at once his cosmic paranoia and millennial hopes: *The Plan, The Turning Tide, The New World Order, End of the Age.*

Among the indications of the End is the ability of television to simulcast, to bring everyone together so that, as Scripture says, "every eye shall behold." Until CNN had effectively made us into one world, this final condition for the Apocalypse was unmet; at present, however, instant global communication— the funeral of a princess, the sexual investigation of a president—is a matter of course. Every eye *can* now behold. Both Falwell and Robertson are convinced that television is doing its part to bring biblical prophecy to pass and

thus hasten the end. Earlier, radio had served its purpose in disseminating the Gospel, but it is TV's relatively recent discovery of how to make the Last Things available to everyone at once that is ushering in God's kingdom.

In the spirit of this millennial imagining, I fantasize the Last Judgment as an apotheosis of Court TV. Frenetic technicians struggle to deal with the unforeseen effects of supernatural light, as those who have made this final broadcast possible are all gathered on the scene, smiling and radiant before the Lamb's High Throne. Confronting the televangelists face to face, though still not on camera, is the glorified Christ. He is ready to judge the living and the dead. A breathless commentator announces that the Lord is about to speak to these enterprising shepherds of His flock. Every eye beholds. I too am seated before my own screen, bending closer by the minute. I turn up the volume. I listen very carefully to what He has to say.

NOTES

1. I want to thank the following people who helped me, at one stage or another, with this project: Rosalind Brown, William Fore, Gregor Goethals, Rowan A. Greer, Michael Hendrickson, Leander Keck, David Morgan, Martha Smalley, and Nancy Vickers—the first to tell me that there was indeed something called "televangelism."

2. For the history of the TV evangelists, see Jeffrey K. Hadden and Anson Shupe, *Televangelism: Power and Politics on God's Frontier* (New York: Henry Holt, 1988), William F. Fore, *Television and Religion: The Shaping of Faith, Values, and Culture* (Minneapolis, Minn.: Augsburg, 1987), Gregor Goethals, *The Electronic Calf: Images, Religion, and the Making of Meaning* (Cambridge, Mass.: Cowley Publications, 1990), Quentin Schultze, ed., *American Evangelicals and the Mass Media* (Grand Rapids, Mich.: Zondervan, 1990), and Margaret Poloma, *The Charismatic Movement: Is There a New Pentecost?* (Boston: Twayne Publishers, 1982).

3. Frances FitzGerald, "Reflections: Jim and Tammy," *The New Yorker* (April 23, 1990): 45-87, notes on pp. 78-9 how a televangelist's headquarters is the symbolic representation of his ministry. Robert Schuler's Crystal Cathedral "melds perfectly with the prosperous glass-sheathed office buildings of Anaheim, California." Oral Robert's university and hospital complex "look from a distance like a model that some Marriott Hotel architect might enter in a design competition for the first city on the moon." Jimmy Swaggart's Bible College is lush and sensual, but "there is nothing in it to shock conventional sensibilities." Falwell's fundamentalist Baptist church is "an undistinguished building, but one solidly in the Virginia tradition"; his campus is a complex of "low-lying, no-nonsense brick buildings and dominated by a football stadium." By their architecture, ye shall know them. FitzGerald did an earlier study of Falwell's Liberty Baptist Church at the beginning of the 80s in *Cities on a Hill: A Journey through Contemporary American Cultures* (New York: Simon & Schuster, 1981), pp. 121- 201.

4. For clarification of doctrinal and stylistic differences, see *The Dictionary of Pentecostal and Charismatic Movements,* ed. Stanley M. Burgess and Gary B. Metee (Grand Rapids, Mich.: Regency Reference Library, 1988), introductory essay (pp. 1-6), "The

Pentecostal Charismatic Movements" (pp. 130-60), and "Classical Pentecostalism" (219-22). Paul Galloway, *Chicago Tribune* (June 21, 1987, C:1) offers the following glossary of religious groups involved in TV evangelism. *Evangelical* is an umbrella term for Christians who emphasize the final authority of the Bible, salvation through a personal acceptance of Jesus Christ, the need for a spiritually-transformed life, and the priority of missions and evangelism. Billy Graham is an example. *Fundamentalists* belong to an early twentieth century movement that grew up in opposition to liberal theology. They uphold the literal interpretation of the Bible, emphasize a separation from the secular world, and believe in the imminent Second Coming of Christ. A representative is Jerry Falwell. *Pentecostals* also rose up in early twentieth century as a development out of the Wesleyan Methodist and Holiness movements. They emphasize the "gifts of the Holy Spirit," especially the speaking in tongues, as a normative sign of conversion. Pentecostal denominations include the Assemblies of God, which ordained both Jimmy Swaggart and Jim Bakker. *Charismatics* are Pentecostal in their emphasis on speaking in tongues, prophecy and ecstatic worship but belong either to mainline churches (Presbyterian, Episcopal, Roman Catholic) or to independent groups. Oral Roberts (Methodist), Pat Robertson (Southern Baptist), and Jim Bakker fall into this latter category, although Bakker has been described as representing an open-ended movement among Pentecostals that shades into charismatic faith.

5. This commitment continues in the present day: The current CBN web site proclaims that its mission is "to prepare the United States of America, the nations of the Middle East, the Far East, South America, and other nations of the world for the coming of Christ and the establishment of the Kingdom of God on earth."

6. Poloma, *The Charismatic Movement*, p. 181, sees Robertson and Bakker as stylistic opposites, as "Patrician vs. Common Man." Jim Bakker, *You Can Make It* (Charlotte, NC: PTL Television Network, 1983), p. 113, acknowledged his Pentecostal origins but was eager to establish credentials as a tonier Charismatic, and therefore in Robertson's league; indeed, unlike Robertson, he was a Charismatic *avant la lettre*. "I was a Charismatic before the term was invented—when people who received the infilling of the Holy Spirit were Pentecostals. When I was a child it wasn't popular or even socially acceptable to be Pentecostal. Most of these 'fanatics and holy rollers' conducted their services in brush arbors, rag tents, cow sheds, store buildings and little tabernacles—all on the wrong side of town." Pentecostalism as a class identification was something to be left behind.

7. Cited by Gary L. Tidwell, *Anatomy of a Fraud: Inside the Finances of the PTL Ministries* (New York: John Wiley and Sons, 1993), p. 6.

8. Jim Bakker, *Move That Mountain* (Charlotte, NC: PTL Television Network, 1976), p. 171.

9. Looking back on the Bakker's career, Larry Martz and Ginny Carroll, *Ministry of Greed: The Inside Story of the Televangelists and Their Holy Wars*. A Newsweek Book. (New York: Weiderfeld and Nelson, 1988), observe that "Jim and Tammy Show" was "the foundation of the empire, the money machine that pulled in ninety-six million dollars from viewers in 1986 alone. It wasn't just a broadcast religious service, like Jerry Falwell's 'Old Time Gospel Hour,' or the fire-and-brimstone preaching that Jimmy Swaggart sent over the airwaves. 'The Jim and Tammy TV Ministry Hour' began as a talkfest, the kind they had originally created for Pat Robertson and his Christian Broadcasting Network (CBN), but it evolved into a continuing daytime drama, the ongoing story of their lives mixed with segments of gospel music, talk show, and telethon. Beyond the comforts of faith and the reaffirming of Christian values, Jim and Tammy hooked the viewers with their personal crises" (pp. 6–7). As Bakker's building program became increasingly expensive, the television program in many ways came to resemble an infomercial for Heritage USA.

10. These figures are from William E. Schmidt, *New York Times* (Dec. 24, 1985), A: 2. A Nielsen rating cited by the *New York Times* (March 25, 1987), A: 11, gives a much lower figure: 220,000 households compared to Robertson's 309,000, Falwell's 438,000, Roberts's 814,000, Swaggart's 1,046,000, and Schuller's 1,277,000.

11. Bakker's sworn testimony in his criminal trial, cited by Tidwell, *Anatomy of a Fraud,* 26.

12. Cited by Charles S. Shepherd, *Forgiven: The Rise and Fall of Jim Bakker and the PTL Ministry* (New York: Atlantic Monthly Press, 1989), p. 182.

13. *Jim and Tammy Bakker Present the Ministries of the Heritage Village Church* (Toronto: Boulton Publishing Services, 1986), p. 13.

14. See Shepherd, *Forgiven,* pp. 182–183.

15. PTL promotional material cited by Hadden and Shupe, *Televangelism,* p. 127.

16. Umberto Eco, *Travels in Hyper Reality.* Trans. William Weaver (San Diego: Harcourt Brace Jovanovich, 1986), pp. 7–8, ponders the American predilection for "'more'—in the sense of 'extra.' The announcer doesn't say, for example, 'The program will continue' but rather that there is 'More to come.' In America you don't say, 'Give me another coffee'; you ask for 'More coffee'; you don't say that cigarette A is longer than cigarette B, but that there is 'more' of it, more than you're used to having, more than you might want, leaving a surplus to throw away—that's prosperity."

17. Randall Balmer, *Mine Eyes Have Seen the Glory: A Journey into the Evangelical Subculture of America.* Revised edition (New York: Oxford University Press, 1993), pp. 226–45, gives a description of a present-day camp meeting that conveys a lively sense of what the Bakkers were moving away from.

18. See Joe E. Barnhart, *Jim and Tammy: Charismatic Intrigue inside PTL* (Buffalo, NY: Prometheus Books, 1988), pp. 121–30. "The baptism of pleasure" is Barnhart 's phrase.

19. Summarizing a *Charlotte Observer* account, Shepherd, *Forgiven,* pp. 153–54, gives the routine of Tammy Faye's toilette and speculates on its significance: "To her friends and husband, Tammy's makeup was a barometer of her emotional equilibrium. If Tammy left her wigs at home, wore less makeup, and avoided outfits with plunging necklines, she was most likely in good spirits" (p. 154).

20. For the Prosperity Gospel, see Barnhart, *Jim and Tammy,* pp. 96-109), Hadden and Shupe, *Televangelism,* pp. 131–32, and Shepherd, *Forgiven,* pp. 85–86, 132–33.

21. Louis Marin, *Utopics: Spatial Play,* trans. Robert A. Vollrath (London: Macmillan, 1984).

22. *Jim and Tammy Bakker,* p. 192.

23. *Chicago Tribune* (Jan. 17, 1987), C: 13.

24. *Ibid.*

25. *New York Times* (Dec. 24, 1985), A:8.

26. *Jim and Tammy Faye Bakker,* p. 14.

27. FitzGerald, "Reflections: Jim and Tammy," p. 82, cites Susan Harding on this point and draws upon her work-in-progress on fundamentalism (a book not yet published). I have greatly benefited from the two Harding essays: "The World of the Born-Again Telescandals," *Michigan Quarterly Review* 27 (Fall 1988): 525–40 and "Convicted by the Holy Spirit: The Rhetoric of Fundamental Baptist Conversion," *American Ethnologist.* Special Issue: Frontiers of Christian Evangelism 14 (February 1987): 167–81.

28. Fitzgerald, "Reflections—Jim and Tammy," 67–68. About these metaphors of the Pentecostal movement, Edith L. Blumhofer, *Restoring the Faith: The Assembles of God, Pentecostalism, and American Culture* (Urbana: University of Illinois Press, 1993), p. 11, notes: "The closing years of the nineteenth century were the last days, the time of the 'evening light.' To the faithful, the phrase evoked a biblical image of restored perfection. Divine judgment was fast approaching, but so was a renewed experience of apostolic Christianity. Those who basked in the rays of the clear 'evening light' or oth-

ers who anticipated refreshing 'showers' of the 'latter rain' confidently announced with excitement an awe that God was doing a new thing: the church stood on the verge of both history's greatest revival and history's consummation. It was about to enjoy again the full blessings of the primitive faith."

29. FitzGerald, "Reflections—Jim and Tammy," p. 67, says, "Pentecostal churches, if they are affluent enough, tend to have some flowing water about them as a matter of dècor." She mentions the fountains and decorative pools at Oral Roberts University and the indoor fountains in Swaggart's Baton Rouge Bible College. While acknowledging the appeal of water in hot climates, she argues that "the very abundance of it . . . in both complexes not only demonstrates the wealth of the ministries but also symbolizes the abundance of the Holy Spirit around them" (p. 67). What then of Schuller's non-Pentecostal Crystal Cathedral in Anaheim, whose sanctuary is divided by a lengthy pool that erupts into a string of fountains at appropriate times? Her interpretation is suggestive; however, when I visited Heritage and asked about the significance of the water works, no one ever offered Pentecostal teaching as an explanation, nor does it appear in any of the Heritage promotional material I have examined.

30. For the place of women in the Pentecostal movement, see Harvey Cox, *Fire From Heaven: The Rise of Pentecostal Spirituality and the Reshaping of Religion in the Twenty-first Century* (Reading, Mass.: Addison-Wesley Publishing Company, 1995), pp. 123-38, Blumhofer, *Restoring the Faith*, pp. 164-79, and the *Dictionary of Pentecostal and Charismatic Movements*, pp. 893–99. Daniel Mark Epstein, *Sister Aimee: The Life of Aimee Semple McPherson* (San Diego: Harcourt Brace Jovanovich, 1993) explores how one Pentecostal female evangelist negotiated glamour, scandal, and show business. Among the theatrical tours de force produced at her Angelus Temple in Los Angeles—its stage designed by Charlie Chaplin—were "a fully operational Trojan Horse, a Gold Rush town, a giant radio with a moveable dial that caused the biblical scenes to change, and a twenty-foot Easter lily from which Aimee preached in a gown the yellow of stamens. For her sermon 'The Value of a Soul' [there was] an enormous pair of shining balances. On one pan was a pearl (a painted beach ball) depicting the human soul; on the other pan was a wad of money, toy cars, and other symbols of worldly wealth" (p. 425). The set for "Tammy Faye's House Party" was crammed full of such symbols; the television viewer, however, was to take pleasure in the sheer profusion of crystal, copper, curlicues and swags. Rather than being distractions from the spiritual life, they seemed to represent the "first fruits" of the Prosperity Gospel.

31. Marin, *Utopics*, 253.

32. Balmer, *Mine Eyes Have Seen the Glory*, pp. 193-208, describes a typical Christian Booksellers Association convention, where actual books account for only a small percentage of sales. His catalogue of products extends my own observations of what was for sale at Heritage USA.

33. FitzGerald, "Reflections—Jim and Tammy," 73.

34. *Jim and Tammy Faye Bakker*, p. 70.

35. My understanding of the "simulations" at Heritage USA has been helped by the work of Eco, *Travels in Hyper Reality*, pp. 3-58, and Jean Baudrillard, *Simulations*. Trans. Paul Foss, Paul Patton, and Phlip Beitchman (New York: Semiotext(e), 1983.

36. Cited by Shepherd, *Forgiven*, p. 311.

37. *Jim and Tammy Faye Bakker*, pp. 199–203.

38. *New York Times* (June 2, 1987), A:13.

39. Concerning the sudden demise of PTL, FitzGerald, "Reflections—Jim and Tammy," p. 87, notes that "the empires of the nineteen-eighties were themselves insubstantial, largely built on faith—a general but not quite innocent faith in miracles. Like vast balloons, these empires had expanded on the breath of faith until they overextended themselves and burst."

40. Kevin's House was one of the prime examples of the PTL policy of bait-and-switch: money raised for charity or evangelism was used to cover operating expenses or to fund unrelated projects. One of the Bakkers' most successful fund-raising appeals, the effort brought in over $3 million in 1986. $1.5 million was spent on a fourteen bedroom Victorian-style home for handicapped children. It was plagued from the start by design flaws and problems with state licensing, so that only the severely handicapped Kevin Whittum and his sister ever lived there. Never installed were the elevator necessary to make the upper floor accessible or a swimming pool for physical therapy—all promised in the telethons. Instead, $208,000 was lavished on life-sized rocking horses and a white baby grand piano, $130,000 for a duck pond at the adjacent Petting Zoo. See Shepard, *Forgiven*, pp. 419–21, and Tidwell, *Anatomy of a Fraud*, pp. 201–3.

41. FitzGerald, "Reflections—Jim and Tammy," 86.

42. *Washington Post* (May 16, 1987), A: 13.

43. *Washington Post* (April 8, 1987), A:1.

44. An Assemblies of God official, cited in the *LA Times* (May 7, 1987), A:4. See Blumhofer, *Restoring the Faith*, on "The Assemblies of God at the grass roots," pp. 254–60. She also mentions in passing that one of the founders of Pentecostalism, Charles Parham, was accused "of financial irregularity and (from the fall of 1906 and especially in 1907) of sexual misconduct as well as of doctrinal aberrations" (56). Parham and another man "were arrested in San Antonio and charged with 'an unnatural act.' The outcome of the rest is unclear; the charges may have been dropped." This story is covered at greater length by James R. Goff, *Fields White unto Harvest: Charles F. Parham and the Missionary Origins of Pentecostalism* (Fayetteville, Ark: University of Arkansas Press, 1989), pp. 223–27.

45. When Bakker was asked if he were the best person to run PTL, he replied: "I'd think that if my child had a need, I'd call the mother and father to help with that need." *Washington Post* (Oct. 9, 1987), A:1.

46. Harding, "The World of the Born-Again Telescandals," p. 536. In this essay, the author gives a superb analysis of the PTL scandal as it played itself out in the media.

47. Tidwell, *Anatomy of a Fraud*, gives the fullest account of the charges against Bakker.

48. Jim Bakker now works as an unpaid urban minister for the 1,000-member Los Angeles International Church, also known as "The Dream Center." In November 1998 he published *Prosperity and the Coming Apocalypse*. *Parade Magazine* (Nov. 22, 1998): 4.

49. Hunter James, *Smile Pretty and Say Jesus: The Last Great Days of PTL* (Athens, Ga.: University of Georgia Press, 1993), pp. 8–9, reports: "Even as you elbowed your way furtively through the Hall of Faith and squeezed in among a packed audience awaiting an 11:00 A.M. airing of the PTL Club you found yourself unavoidably caught up in the camaraderie of the place. 'Smile pretty and say Jesus!' admonished an advance man as he came out from behind a purple curtain. 'Now is the time for everyone to turn and take their neighbor's hand! Reach out for Jesus! Take the hand of your neighbor! Jesus doesn't want strangers here!' The crowd cheerfully while I busied myself with my notepad."

50. See Alec Foege, *The Empire God Built: Pat Robertson's Media Machine* (New York: John Wiley and Sons, 1996), pp. 55–56, on the Founders Inn.

51. Lawrence Wright, "Letter from Jerusalem: Forcing the End," *The New Yorker* (July 20, 1998): 42–53, tells about the new relationship between groups of radical Orthodox Jews in Israel and their Pentecostal cousins in America. Both groups are interested in rebuilding the Temple and producing the red heifer whose ashes will make ritual purity again possible. The Jews want to welcome the Messiah for the first time, the Pentecostals to welcome him back.

52. For "God's Special Project," or "G.S.P.," see Gerard Straub, *Salvation for Sale: An Insider's View of Pat Robertson's Ministry* (New York: Prometheus Books, 1986), p. 161.

1 6

TWO-POINT CONVERSION

Marjorie Garber

Hail Mary. A last-second pass, usually thrown toward several receivers in an area near or across the goal line in the hope (and with a prayer) that one of them will catch it.

—The Pro Football Fan's Companion

I

THE EMBLEM OF ST. LAWRENCE, one of the most famous of Christian martyrs, is the gridiron. Little did this early deacon of Rome know how pertinent that symbol would become in the last decade of the twentieth century, when football, its coaches, players, and stadiums have become major purveyors of public prayer. But these days the contest is not between the Christians and the lions. Instead the Christians *are* the Lions—and the Bears, and the Panthers, and the Jaguars, and the Saints. And—as we will see—the patriots.

Viewers tuning in at the end of the football playoff games in January 1997, might be pardoned for thinking they had inadvertently pushed the wrong button and wound up on Reverend Jerry Falwell's Christian television station. First, a Jacksonville Jaguars quarterback informed a sideline reporter that God was responsible for the Jags' victory. How did he account for his Cinderella team's success? "Thanks be to God," he said, "There's a bunch of guys on this team that really love the Lord." Then the New England Patriots' Keith Byars, on another network, began his postgame recap with "Thanks be to God from whom all blessings flow" before himself flowing seamlessly, as if it were not a change of subject, into a detailed analysis of passes, tackles, and punts. Not to be outdone, Patriots' owner Bob Kraft came out as a Jew, con-

280

fiding genially to a television interviewer that coach Bill Parcells had told him he had "something Kraft would appreciate" in his pocket. Turned out it was a 'chai, the Hebrew letter that means "life," a pendant given Parcells by a friend from New Jersey, and which he had kept pocketed during the Patriots' lopsided 28-3 victory over the Pittsburgh Steelers. Kraft appreciated the gesture, he said—even though the charm was upside down.

A photograph of a benignly bemused Parcells holding his 'chai in one vast hand was featured on the sports page of the *Boston Globe,* which described the "Hebrew 'chai symbol" as one of Parcells' many "superstitions," noting that baseball player Wade Boggs, formerly of the Red Sox and now of the hated Yankees, draws a 'chai symbol "with his bat in the dirt prior to every at bat." (It is perhaps unnecessary to note that Boggs, like Parcells, is not Jewish.)[1]

Although I reveled, briefly, in this moment of ecumenical team spirit (what might be called "'chai society"), I was struck by the term "superstition." I wondered whether, if a Jewish professional ballplayer like Hank Greenberg or Sandy Koufax had—against all probability—drawn a cross in the dirt with his bat each time he stepped up to the plate; Red Barber would have called it a "superstition." Certainly the word "superstition" is not routinely spoken by television sportscasters on those occasions when I have glimpsed a baseball player, often wearing a cross around his neck, make the sign of the cross before stepping into the batter's box.

As for Parcells, when asked whether (in view of the active discussion of religious faith on the part of players on both teams) he thought God would favor one side or the other, he replied judiciously, "No disrespect to anyone, but it usually works better when the players are good and fast."[2]

But the players' piety has attracted more attention than the coach's realism. "God has certainly played an important role on this football team," announced quarterback Mark Brunell to a reporter. "There's a lot of guys on this team who love Jesus. That's what's been exciting to me: to get to know these guys and play with them, but more importantly, to just get the chance to develop the friendship and closeness that you don't see in a lot of football teams right now."[3]

"I think there's probably ten or fifteen very committed guys on this football team who love God and I firmly believe that's the reason for our success this year."

"God has had His hand on this football team, and the Bible says that He's looking around for people who are going to give glory to Him and who are going to give Him credit. And this football team is doing that, and

I think that's the reason for our success this year." (Note: the following weekend they lost to the New England Patriots.)[4]

Of course, the Jaguars are far from the only ostentatiously devout squad in the league. Members of the Fellowship of Christian Athletes are active in professional, as well as in high school and after-school, sports programs. The other successful 1996 NFL expansion team, the Carolina Panthers, was praised by hometown fans in Charlotte, North Carolina: "This is the Bible Belt, and we've got a praying team," said a waitress at a soul food restaurant near the stadium. Fundamentalist preacher Joseph R. Chambers viewed the Panthers as an affirmation of "conservative values" by "a conservative city that loves the churches on every corner."[5]

The Green Bay Packers' Reggie White has been an ordained minister since his college days at the University of Tennessee. During his years in the National Football League he moved from team to team on what is sometimes referred to as the Reggie White Traveling Ministry before settling with the Packers. "This guy," said a teammate, "is like God in pads. He's the most revered athlete I've ever been around."[6] Some critics took issue with his religious fervor when he declared that God had ordained the Packers' NFC championship victory because that was the role He had cast for them, but in general the media and the fans have shared his teammates' respect. "He rapidly converts the doubters," one sportswriter observed. No one, so far as I know, quoted Psalm 37, "I have seen the wicked in great power, and flourishing like a green bay tree" (Ps. 37:36).

On the eve of Super Bowl XXXI White requested air-time during the postgame ceremonies to say a public prayer before the assembled crowd, and perhaps on national television—if the Packers won. Asked about the precedent of giving a microphone to someone to espouse his private views, White professed surprise, "A lot of people ask me questions about football and religion," he said. "I don't see the problem. Most of you guys [sportswriters and media critics], when we get down in the end zone and pray or get together and pray on the field, you have a real problem when it comes to that."[7] Other members of the Packers' God squad framed their desire for public prayer in terms of rights. "I think it's our right," said receiver Don Beebe. "That's our field. We play football on that field."

The NFL director of communications remarked that if anyone else also wanted to say a prayer to the crowd from the platform after the game there was not much the league could do about it, but another league official

expressed concern that football fans might find themselves unwittingly and unwillingly listening to a televised sermon.[8] Is this a First Amendment issue? Or is the public to be protected from intrusive, perhaps even coercive, prayer?

After Green Bay's Super Bowl victory jubilant fans displayed banners of coach Mike Holmgren, quarterback Brett Favre, star player (and minister) Reggie White, and legendary former coach Vince Lombardi, labeled, respectively, "the father, the son, the holy and the ghost." "It's a spiritual thing for me," said one woman who had waited hours (with 60,000 others of the faithful) at bitter-cold Lambeau Field for the Packers' return. "This is God's team."[9]

The present trend for highly visible postgame prayer huddles in the NFL began with a December 1990 game between the New York Giants and the San Francisco 49ers at Candlestick Park. "Guys from both teams just wanted to make a statement," said 49ers tight end—and evangelical Christian— Brent Jones, who led a group of kneeling players at midfield. The game, which was televised on "Monday Night Football," set a trend in public piety. It's worth noting that the National Football League first opposed the idea, citing a league rule against opposing players "fraternizing" on the field, but an NFL official reversed the ruling after contemplating "the public relations fiasco that would follow a crackdown on prayer." Former 49er Bubba Paris, now an ordained minister and Bible teacher, noted that "you find more Christians on teams with more black players."[10] By "Christians" here, Paris, and many others, mean "evangelical" or "Pentecostal" or "born-again" Christians, who are often more comfortable with public demonstrations of faith than are mainline Protestants or Roman Catholics.

Indeed, Christianity and sports have long been regarded in certain parts of the United States as not only compatible but boon companions. It's no accident that the Super Bowl is played on a Sunday.

"Your Son is our quarterback and You are our coach," intoned the Catholic Archbishop of Miami before a Dolphins football game in the seventies. "We sometimes get blitzed by heavy sorrows or red-dogged by Satan," announced the Archbishop, to the irreverent pleasure of a staff member for the *National Catholic Reporter*. "Teach us to run the right patterns in our life so that we will truly make a touchdown one day through the heavenly gates, as the angels and saints cheer us on from the sidelines."[11] Opinions differ as to which position is the most appropriate for the Heavenly Superstar.

If Jesus played football,
he'd be an end.

begins a poem by Bill Heyen

> After his shower, he'd appear to us
> to pose with us for pictures by his side.[12]

Or, as the country music song has it, "Drop Kick Me Jesus Through the Goal Posts of Life."

Some have suggested that He plays other sports. Baseball star Brett Butler testified, "I believe that if Jesus Christ was a baseball player he'd go in hard to break up the double play and then pick up the guy and say, 'I love you.'"[13]

The Christian sports connection is not exclusively high- or low-church, Catholic or Protestant. The football stadium at Notre Dame is presided over by a huge library mural known as "Touchdown Jesus." In the chapel of the University of the South in Sewanee, Tennessee, is a stained glass window displaying a figure in the vestments of an Episcopal bishop, holding a football in one hand and the Book of Common Prayer in the other. At his feet is a baseball, and a baseball bat is propped against the frame.[14] The Episcopal Cathedral of St. John the Divine contains a sports bay, dedicated in 1928 to such worldly athletes as Hobey Baker, Walter Camp, and Christy Mathewson, which mingles these football and baseball heroes with biblical scenes like Jacob wrestling with the angel.[15]

It is in the evangelical churches and movements, however, that sports and religion have been most directly linked in this century, through the rise of what is now quite frankly described as "sports evangelism." So-called "muscular Christianity," of the sort touted by baseball player-turned-evangelist Billy Sunday, loudly refuted the idea that Jesus was a weakling, a man of sorrows, a loser. "I press toward the mark for the prize of the high calling of God in Christ Jesus" (Philippians 3:14) has been described as the verse that has become "the keystone of muscular Christianity."[16] Athletic skill was a kind of Christian witness, while cheering crowds blended their enthusiasm for sports and—and as—religion.

Christian evangelists in the early and middle part of the century deliberately made use of sporting events and sports celebrities to attract crowds, and especially to win over young men to the cause. The athlete and preacher Gil Dodds ran six laps around the assembled faithful to kick off Billy Graham's revival movement in 1947. Graham himself underscored the disturbing and by now virtually inevitable association of sports, religion, and patriotism, remarking during the Vietnam War that "People who are carrying the Viet Cong flag around the country are not athletes. If our people

would spend more time in gymnasiums and on playing fields, we'd be a better nation!"[17]

Today members of the Fellowship of Christian Athletes bear witness to their faith at sporting events and clinics—sometimes to the dismay of the parents of Little Leaguers inadvertently made to attend a religious rally. It's part of what Frank Deford called "sportianity," in a *Sports Illustrated* article rather pointedly called "Endorsing Jesus."[18]

"Athletics," declared evangelist and educator Oral Roberts, "is part of our Christian witness. . . . Nearly every man in America reads the sports pages, and a Christian school cannot ignore these people. Sports are becoming the No.1 interest of people in America." Sports evangelism, in fact, is a booming business these days. An article suitably titled "From Muscular Christians to Jocks for Jesus" published in *Christian Century* in 1992 noted that "the press and public have struggled to make sense of the increasing number of elite athletes who proclaim their faith in Jesus."[19] Robert Higgs's *God in the Stadium* reported on the Annual Sports Outreach America conference on sports evangelism. For 1995 Super Bowl Sunday, Higgs reports, the Sports Outreach program distributed a twelve-minute video of religious testimony offered by NFL players, which was "shown on huge screens set up in churches for this purpose and for presentation of the game."[20] It doesn't take much to see that "sports evangelism" on television is a version of televangelism, and indeed, as Higgs points out, conservative ministers like Falwell, Roberts, and Pat Robertson are vociferous sports boosters, following in the evangelical footsteps of Billy Sunday and Billy Graham.

This has led to some lively exchanges between church and state, or, at least, between religion and law. Irritated at the theatrical display that had become common practice among players who scored touchdowns, the National Collegiate Athletic Association tried, in 1995, to enforce a "no-gloating" rule prohibiting self-congratulatory victory demonstrations in the end zone. But it soon found itself on the receiving end of a lawsuit from the Rev. Jerry Falwell's Liberty University, whose team customarily knelt in gratitude to thank God for enabling them to score. Liberty's evangelical Christians sued on the grounds that the prohibition violated the 1964 Civil Rights Act and was a form of religious discrimination. The NCAA, fearing that it would be targeted as an enemy of gridiron prayer, revised its ruling to allow players to pray if they did so discreetly: "Players may pray or cross themselves without drawing attention to themselves," wrote Vince Dooley, chairman of the NCAA Football Rules Committee, in a memo to coaches. "It is also permissible for them to kneel

momentarily at the conclusion of a play, if in the judgment of the official the act is spontaneous and not in the nature of a pose."[21] How this distinction would be regulated in church, much less on the football field, was never explained.

As Wendy Kaminer suggests, "Secularists are often wrongly accused of trying to purge religious ideas from public discourse. We simply want to deny them public sponsorship." But "new Christian advocacy groups, modeled after advocacy groups on the left, are increasingly portraying practicing Christians as citizens oppressed by secularism and are seeking judicial protection. The American Center for Law and Justice (ACLJ) founded by Pat Robertson, is one of the leaders in this movement, borrowing not only most of the acronym but the tactics of the American Civil Liberties Union in a fight for religious 'rights.'"[22]

It's not clear how the public (or, for that matter, sports officialdom) would have responded had Reggie White's or Mark Brunell's evangelical energies been put at the service of a different faith—say, Islam. Some small indication might be found in the NBA's suspension of pro-basketball player Mahmoud Abdul-Rauf, who had refused to stand during the national anthem. Abdul-Rauf, a member of the Denver Nuggets team, claimed that paying homage to anything but God was idolatry, and that the American flag was a symbol of oppression. While he was supported by the American Civil Liberties Union and the NBA players' union, some veterans groups called his behavior treasonous.[23] The dispute was resolved when Rauf decided to stand and pray silently during the playing of the anthem, but the entire matter made Muslim groups, members of the fastest-growing religion in the United States (some five million strong), nervous about public perception.

Star status may make a difference. Houston Rockets star Hakim Olajuwon's Muslim religion requires him to pray five times a day—a schedule that is willingly accommodated by his coach and fans. When the city of Houston staged a victory parade for its NBA champs in 1994, 500,000 people waited in the heat of a Texas June for Olajuwon to arrive from his daily devotions. "We're all aware of his prayer schedule this year," said a spokesperson for the mayor a year later, when the parade was planned around the star center's needs.

But Olajuwon differs from Abdul-Rauf in another way: He hasn't linked his own Muslim faith to a critique of the United States and its symbols. The designation "America's team," borne proudly in football by the Tom Landry-led Dallas Cowboys and then claimed by the 1996 Green Bay

Packers, seemed to blend patriotism with religion, and, specifically, with Christianity.

When columnist Rick Reilly complained in *Sports Illustrated* about the intrusiveness—and coerciveness—of public praying during and after pro football games, his critique of "50-yard-line religious sales pitches" was answered in *Commonweal,* a journal edited by Roman Catholic lay people.

"Once upon a time people who thought as Reilly does were content to confine their arguments to cases of coercion in the strict, juridical sense," wrote R. Bruce Douglass, an assistant professor of government at Georgetown, in *Commonweal.* The issue used to be whether public money was used to underwrite the exercise of religion, but now "public expressions of piety" by individuals were under attack. "Just who is it," asked Douglass, "that is being intolerant to whom?"[24]

Reilly had argued that "imposing one's beliefs on a captive audience is wrong, irreligious, even" and suggested that the National Football League ought to outlaw public displays of prayer by players in the huddle or the locker room. At the very least, he thought, television should refuse to broadcast them. As things stood, stadiums full of fans, and millions more watching at home, were subjected to the spectacle of public prayer whether they liked it or not. "It would be just as inappropriate," he said, "for Jewish players to conduct services at the far hash mark or for Muslim players to place prayer rugs under a goalpost and face Mecca." He also had harsh words for players who prayed for results, like the New York Giants team that knelt and prayed as an opposing kicker tried for a last-second field goal. "Is praying for somebody to blow it very Christian?"[25] Reilly asked.

But in a set of moves very like the self-justifications of economic Social Darwinism, not only are gridiron victories ascribed to God, they are taken as evidence that the winners are somehow particularly virtuous, or devout, or Christian. The 1997 Super Bowl Pre-Game Show clinched this point by showing a clip from Kenneth Branagh's film version of Shakespeare's *Henry V* in which the young king rallies his forces, "We few, we happy few, we band of brothers." Later he will exult in victory: "Take it, God, / For it is none but thine." Though Fox TV didn't show this latter moment, the implied parallels were clear—and disturbing. Despite the fact that Grantland Rice's famous rhyme declared that

> When the One Great Scorer comes to write against your name—
> He marks—not that you won or lost—but how you played the game.[26]

Cynical sports journalists are increasingly confronted with public declarations of decisions by the Divine Referee. "This was Jesus Christ working through my players," declared the new coach of the University of Oklahoma football team to ABC-TV after they beat arch rival Texas in overtime. "What role did God play—or not play—in the eight Oklahoma losses this season?" wondered a writer who identified himself "not as an atheist journalist, but as a Bible-reading Christian."[27]

At the same time, evangelical Christianity's receptiveness to the repentant sinner has allowed drug- and sex-abusing athletes to proclaim, publicly, their reformation. At the end of Dallas Cowboys receiver Michael Irvin's five-game suspension for pleading no contest to cocaine possession, he marched to the end zone, knelt, and prayed. No sportswriter present could recall any previous occasion on which Irvin had engaged in public prayer. This is the evangelical obverse of Catch-22; the more errant the sinner, the greater God's victory in winning him over. But if theatricalized displays like step-strutting are banned as unsportsmanlike, what is the place of ostentatious prayer? When the private becomes public, becomes uniform, becomes customary, has a line been crossed? And what kind of line? A goal line? or a foul line?

Another Super Bowl video staple, the clever commercial, spoke directly to this question, when it pictured a locker room full of players being prayed with, or prayed at, first by the coach, and then by a politically correct sequence of multicultural clerics, each in distinctive garb. As the praying droned on and the players yawned, they reached for a snack to keep them awake. The sponsor was Snickers, the candy bar. This may be the only way in which snickering at religious display is permitted to a public audience today.

"It seems a feeble pluralism that cannot encompass a bit of postgame prayer," observed *New York Times* "Beliefs" columnist Peter Steinfels, reporting on the "delicate and slightly unsettling moment" when television cameras in the locker room of new NBA champions the Chicago Bulls caught the victors holding hands and reciting the Lord's Prayer.[28] Where the intrusive glance of the camera has sometimes had to tilt away to avoid disclosing the physical nakedness of the athlete, the camera in the Bulls' locker room offered a glimpse of another kind of intimacy. Was this a kind of voyeurism? Or a kind of exhibitionism?

These are questions to which we shall want to return.

II

At public universities and schools where taxpayers' funds are used, the issue of locker room prayer has attracted some critical attention. The former coach of the University of Colorado football team, Bill McCartney, was accused of giving priority in hiring, recruiting, and playing time to athletes who shared his Christian faith.[29] The American Civil Liberties Union argued that injecting religion into a state-sponsored program violated the constitutional mandate for government neutrality. The worst-case scenario is the succinctly named "no pray/no play" rule. In 1994, students at Memphis State University alleged that the coaches were "attempting to convert the student-athletes to Christianity, to be saved, to be part of the Born-Again movement," and that if they failed to attend coach Ray Dempsey's mandatory prayer meetings they would not get to play. As an attorney in the case observed, financial constraints often limit the student-athlete's capacity to protest: "It is clear that personnel on athletic scholarships are not going to complain."[30] "No pray/no play" is clearly a violation of First Amendment rights. But what about peer pressure and the emotional prestige of the coach?

Coaches often function in loco parentis for athletes, occupying what one observer called, nicely, "the fatherly/motherly position."[31] (I think the observer in question may have meant "fatherly for young men" and "motherly for young women," but the conflation of the two seems entirely appropriate.) The coach is omniscient, omnipotent, nurturing, law-giving, and punishing, the male version of the phallic mother. Who would displease such a figure, the true parent, the chosen leader, the fulfillment and apotheosis of the family romance?

A high school football coach in Florence, Arizona, resigned because the principal sent him a memo saying "there should be no prayer at any school-organized events." Coach Tom Shoemake said he had prayed with his teams before and after games for twenty years.[32]

And then there is peer pressure, the emphasis on being a "team player." While an athlete is technically free to leave the locker room during a team prayer, the social costs are so high that the exercise of this "freedom" is unlikely. Much of the case law that exists deals with high school and elementary school team prayer, in situations that, by the fact of the relative youth of the students, are often held to be more coercive. Though the argument that *televised* prayer is coercive to the at-home viewers has also been persuasively made.

In a Texas case (*Doe v. Duncanville Independent School District*), the court, Jane Doe, and her father John Doe protested the mandatory prayers conducted by the coach of a girls' basketball team at practice and at the end of games. (The visual image conjured by the court's words is striking: "the girls on their hands and knees with the coach standing over them, heads bowed," as they recited the Lord's Prayer in the center of the court.) Such prayers had been recited at basketball games for more than twenty years when the suit was brought. Prayers were also regularly said at pep rallies, at awards ceremonies, before all home football games, and when teams boarded buses for away games. When Jane Doe elected not to participate in the team prayer, her coach made her stand outside the prayer circle. Other students asked her "Aren't you a Christian?"; a spectator at a game shouted "Well, why isn't she praying? Isn't she a Christian?"; and her history teacher called her "a little atheist." The Does sued.

The Court of Appeals held up a lower court's ruling enjoining the school district's employees from leading, encouraging, promoting, or participating in prayer "with or among students during curriculum or extracurricular activities, including before, during and after school related sporting events." Furthermore, noting the "pervasive nature of past school prayer," the school district was instructed to advise students, in writing, that "under the First Amendment of the United States Constitution, prayer and religious activities initiated and promoted by school officials are unconstitutional, and that students have a constitutional right not to participate in such activities." The claim that prayer accomplished the purpose of stirring up "school spirit" was not held to be persuasively secular.

We may notice that the plaintiff in Doe is female. It is not clear whether she was, in fact, "a little atheist" as her history teacher suggested. "Atheist" seems to function here as the "natural" or inevitable opposite to "Christian." It's tempting to remember W. S. Gilbert's mocking verse from *Iolanthe*: "every boy and every gal / That's born into the world alive / Is either a little Liberal, / Or else a little Conservative!" Since "Doe" is a pseudonym that defies religious or ethnic stereotyping, it's also not possible to detect, immediately, whether Jane Doe was Jewish or Muslim, a Buddhist or a Jain. In other team prayer cases, however, the religious identifications of the plaintiffs are more manifest. In two particularly indicative instances, they are Jewish.

Max Berlin was a senior at Crestview High School in Okaloosa County, Florida, and a member of the football team. His sister Tammy was a sophomore at the same school. Through their parents, the Berlins sought an

injunction to prevent the school from offering an invocation, through the public address system, before each home football game. They also filed a motion to prevent the football coaches from leading their teams in prayer before or after the game.

The invocation specifically asked for "sportsmanlike spirit" among players and spectators and for blessings on the players "for we are all winners through Jesus Christ, our Lord." Such an invocation had been offered at Crestview High and other schools in the area for more than thirty years, and the Superintendent of Schools acknowledged to the court that the invocation was, in the court's words, "in keeping with the customs, expectations, and religious traditions of the vast majority of the residents of Okaloosa County, who are Christians" (1988 WL. 85937 [N.D. Fla.]). He also suggested in a public statement that opposition to the invocation was an opposition to "wholesome values." Mrs. Berlin testified that what was offensive to her in the invocation was the reference to Jesus Christ, and that she had felt an animosity from the crowd when she remained seated during the invocation. Tammy Berlin testified that when she walked around rather than stood for the invocation she was treated as an outsider.

After noting that the school district had instructed its football coaches not to pray with their teams before or after games, and not to encourage others to do so (thus rendering part of the motion moot), the judge denied the motion for a preliminary injunction. The invocation could continue, for the time being; the team prayer had to stop.

The Berlins' suit was based upon a sense of their own minority status as Jews, and the ways in which the "customs, expectations, and religious traditions of the vast majority of the residents of Okaloosa County, who are Christians," could all-too-easily slide over into a definition of "wholesome values" that seemed to exclude Jews from wholesomeness (and, indeed, from good "values"). The high school football field became an outdoor church, and Tammy Berlin, like Jane Doe, seemed to be regarded as a little atheist—or worse—because she did not observe its protocols. In another case that turned on religion and sports, however, the entire team was Jewish—and *its* "customs, expectations, and religious traditions" were resisted, and in fact briefly outlawed, by the "secular" regulating agency.

A class action on behalf of male members of the Orthodox Jewish faith was brought against the Illinois High School Association, to which all the public schools and almost all the private schools in the state belonged. At issue

was the Association's rule, newly passed, that prohibited, for safety reasons, the wearing of yarmulkes when playing basketball.

This was, to me, a completely fascinating case. The plaintiffs were two private Jewish secondary schools, whose teams routinely wore yarmulkes attached with bobby-pins. Orthodox Jewish men cover their heads at all times (except when unconscious, under water, or in imminent danger of loss of life) as a sign of respect to God. One of the teams had been part of the association for three years, the other for eight, and during this time players had worn yarmulkes on the court without incident, until 1981, when a problem arose. That year the Association refused to let them play in the championship elimination tournament, held in a prestigious and high-profile location (the University of Illinois basketball fieldhouse), unless they took off their yarmulkes.

The basketball rule book instructed referees to prevent players from wearing any equipment that might cause harm to another player, like forearm guards, plastic or metal braces, headwear, and jewelry. Barrettes made of soft material were legal, as were two-inch wide headbands. The Jewish high schools sought, and the judge granted, an injunction that would allow them to play in the tournament, since the Court pointed out, not only that there were First Amendment considerations, but also that "no rational distinction appeared to exist between a soft barrette attached to the hair with bobby pins or clips and a yarmulke similarly attached."[33]

After the court entered its preliminary injunction order, and while the action remained pending, the National Federation of State High School Associations, of which the Illinois group is a member, sent out a questionnaire to basketball coaches and officials in forty-four states, including Illinois, asking, among other things, whether they approved of the rule permitting soft barrettes. More than 10,000 responses were received: 8,766 said that the rule was satisfactory, 1,476 said that it was not. Nevertheless, in April 1981 the Federation changed its rule. The chairman of the Basketball Rules Committee claimed that it was difficult for officials to distinguish between "hard" barrettes and "soft" barrettes, and that therefore *all* barrettes should be barred.

The court was neither persuaded nor amused. It noted that there was no information presented about injuries that had occurred as the result of wearing either soft barrettes or yarmulkes. "It taxes credulity," wrote District Judge Shadur, "that the change in the rule was not at least in part responsive to the pendency of this litigation." Furthermore, the judge noted, "Under any possible interpretation, for safety and all like purposes

a yarmulke is the functional equivalent (although not of course the religious equivalent) of a soft barrette, not a hard barrette."[34]

There were other disturbing developments. When the results of the questionnaire were submitted, a "typographical error" (the quotation marks are Judge Shadur's) altered the number of "yes" votes approving soft barrettes from 8,766 to 1,766, an "error" that was only caught when the Court's law clerk asked for a copy of the actual document, the "only one not so delivered by IHSA counsel." Describing the behavior of the Federation's Basketball Rules Committee as "clearly disingenuous," the judge observed dryly that "Obviously a six-to-one vote from more than 10,000 knowledgeable basketball coaches and officials in favor of retaining the rule permitting soft barrettes (functionally equivalent to yarmulkes in all respects as to safety) has a devastating effect on the 'compelling necessity' of a new rule to serve IHSA's stated purpose of prohibiting yarmulkes to assure safety."

Nor was this the end of the matter. As the judge quite emphatically went on to note, "it is most troublesome to encounter what appears to be a pretextual basis for the adoption of the current rule."[35]

The claim of those who pushed for a rule change was safety. Slips and falls, the judge agreed, are common to the game of basketball, as are minor injuries. But in fact the Federation did not have on record a single instance of a slip, fall, or injury resulting from either "a yarmulke having come loose and fallen on a basketball court" or "a bobby pin or clip" having fallen. Indeed, in testimony that covered more than 1,300 interscholastic games and many more that were non-interscholastic, no one had ever mentioned a single instance of slippage or injury "from either yarmulkes or their associated bobby pins or clips." Though yarmulkes had fallen onto the basketball court an average of one or two times a game, they had always been promptly picked up.

And, persevered the judge, other things do fall to the basketball court during play, like players' eyeglasses, whether or not they are secured by elastic bands. Likewise, the judge continued, "foreign objects such as paper and coins are unfortunately thrown by fans onto the basketball court from time to time during basketball games, and paper is from time to time left on the court as a result of the incomplete cleaning up of paper detached from pompons left by cheerleaders." All of these would be fully as hazardous as a fallen yarmulke. But "IHSA rules do not prohibit persons wearing glasses from playing IHSA interscholastic basketball. Nor do IHSA rules ban attendance at games or cheerleader participation during games." No, indeed: the Illinois group that sponsors the state tournament, the Elite

Eight, at the basketball fieldhouse of the University of Illinois, does not ban eyeglass-wearers or cheerleaders or fans. But it did—or it wished to—ban the wearing of yarmulkes. For *safety* reasons. Whose safety is being threatened here—and by whom?

Thus, to summarize: During the course of the litigation IHSA changed its view from "yes" to "no" on soft barrettes (and thus on yarmulkes), despite the total absence of any demonstrated safety hazard and the presence of an overwhelming six-to-one vote. It claimed "compelling interests" when none—apparently—existed, as sufficient reason to override the First Amendment rights of the players who covered their heads for reasons of religious faith. Moreover, the Court had "real questions as to the total candor" of those involved in changing the rules in the middle of the legal game. "IHSA's argument involves an impermissible sleight of hand: It falsely equates basketball safety with prohibiting yarmulkes," declared the ruling. "In basketball terms IHSA loses by too many points to making keeping score worthwhile."[36]

With this final slam-dunk the judge blew the whistle on the IHSA. At least on the yarmulke question. But it may be worth noting that this same organization, the Illinois High School Association, has been adamant in its support of football prayer. "The IHSA doesn't have a rule against prayer on the field and shouldn't and never will," said the executive director in November 1996. It's "as appropriate as jumping up and down and yelling 'We're No.1' and cheering." But precisely who is it who comes out number one in this kind of religious demonstration? Ecumenicism? or "Christianity"? Who is to be the judge of what is "appropriate" in the realm of religious cheerleading?

III

Sigmund Freud's "Group Psychology and the Analysis of the Ego" sets forth his general sense that "libidinal ties" link group members, especially in "artificial" (by which he means organized and regulated) groups; his chief examples, in an essay published in 1921 are the Church and the army, both pertinent models for today's professionalized and proselytizing sports teams, whether they are literally pros or just part of a highly developed and well-funded "amateur" sports program.

> It is to be noticed that in these two artificial groups each individual is bound by libidinal ties on the one hand to the leader (Christ, the Commander-in-Chief) and on the other hand to members of the group.

How the two ties are related to each other, whether they are of the same
kind and the same value, and how they are to be described psychologi-
cally—these questions must be reserved for subsequent enquiry.[37]

While it would not be especially helpful to "apply" this Freudian analysis
uncritically to, say, the Jacksonville Jaguars or the Green Bay Packers, it is
worth noting that "leader" and "group" ties are terms perfectly appropriate
to the relationship of the team to its coach, captains, and God, on the one
hand, and to itself ("team spirit") on the other. (We might recall profes-
sional football player Rich Griffiths' testimony, "I don't do it for Coach
Coughlin or for anyone else. I do it for a superior person.")

Robert Higgs notes that "in its early days football was viewed as a substi-
tute for war and as a training ground for war," citing as the three "staunchest
promoters of the football-war metaphor" West Pointer (and first NCAA
President) Palmer Pierce, Douglas MacArthur, and Teddy Roosevelt. "If ath-
letes are soldiers of sorts," remarks Higgs, "then the effort of the FCA
[Fellowship of Christian Athletes] and other proselytizing groups has been to
make them Christian soldiers."[38] Today's vocal and demonstrative Christian
Athletes thus combine the two "artificial groups" that seemed to Freud the
most obvious examples of his "group psychology."

What Freud calls, in a wonderful phase, "the narcissism of minor dif-
ferences" accounts for the enmity that once made the Yankees and the
Dodgers such bitter rivals:

> Of two neighboring towns each is the others most jealous rival; every
> little canton looks down upon the others with contempt. Closely
> related races keep one another at arm's length; the South German
> cannot endure the North German, the Englishman casts every kind
> of aspersion upon the Scot, the Spaniard despises the Portuguese. We
> are no longer astonished that greater differences should lead to an
> almost insuperable repugnance, such as the Gallic people feel for the
> German, the Aryan for the Semite, the white races for the coloured.

Within groups, however, the opposite occurs:

> But when a group is formed the whole of this intolerance vanishes,
> temporarily or permanently, within the group. So long as a group
> formation persists or so far as it extends, individuals in the group
> behave as though they were uniform, tolerate the peculiarities of the
> other members, equate themselves with them, and have no feeling of

aversion towards them. Such a limitation of narcissism can, according to our theoretical views, only be produced by one factor, a libidinal tie with other people.

And what about "team spirit"? Here Freud, again tendentiously, writes of the "desexualized, sublimated homosexual love for other men, which springs from work in common." For mankind as a whole, as for the individual,

> love alone acts as the civilizing factor in the sense that it brings a change from egoism to altruism. This is true both of sexual love for women, with all the obligations which it involves of not harming the things that are dear to women, and also of desexualized, sublimated homosexual love for other men, which springs from work in common.[39]

In other words, men in groups, to use Lionel Tiger's famous phrase, come to love one another, in the process turning their egoism into altruism. Diana Fuss has commented trenchantly on the effort Freud expends to keep the two kinds of love ("sexual" and "desexualized") apart. His view turns on the question of "identification," the "earliest expression of an emotional tie with another person," distinguishing between wanting to *be* and wanting to *have* another person. (Unsurprisingly, Freud's early example is that of the boy who takes his father as his ideal; his later example is the "tie with the leader." For both "father" and "leader" here we may, for our purposes, read "coach" or "captain.") The "mutual tie between members of a group" takes the form, says Freud, of an identification based upon some perceived common quality—a quality which is *not* based upon erotic feelings. "Freud's theory of identification," argues Fuss, "appears as a theoretical *defense* against any eventuality of a nonsublimated homosexual love as the basis of a homosocial group formation. By extracting identification from desire, insisting that a subject cannot identify with another person and desire that person at the same time, Freud is able to conceptualize homosexuality and homosociality as absolutely distinct categories."[40] For Fuss, the supposed distinctness of these categories—like the distinctness of supposed desire and identification—is itself a symptom of their tendency to become both confused and undecidable.

Yet what is most fascinating about Freud's own argument, as Fuss herself notes, is his observation that what he calls "homosexual love" is "far more compatible with group ties" than is hetersexual love, "even when it takes the shape of uninhibited sexual impulses." He himself calls this "a remarkable fact, the explanation of which might carry us far."[41]

* * *

"That the locker room can be an erotic environment is undeniable," observes former sports writer Brian Pronger in *The Arena of Masculinity*, a book about sports and homosexuality.[42] Can the eros of physical sexuality and the eros of religious faith be compared? Or identified? "Men who love football love men," says Mariah Burton Nelson in *The Stronger Women Get, the More Men Love Football.*

On- and off-court physical contact between celebrated "straight" male athletes—like the "customary smooching" between best friends Isiah Thomas and Magic Johnson noted by *Sports Illustrated* (June 27, 1988) under the photo caption "Kiss and Make Up"—has been used, through an elementary paradoxical logic, to shore up the *heterosexuality* of men's sports, analogous to the ostentatious wearing of earrings and necklaces that might be deemed, on less monumental males, overt signs of gay identity and display. It takes a "real man"—which is to say, a heterosexual man—to wear all this expensive jewelry in public. By touching and indeed crossing the line between stereotypical "gay" and stereotypical "straight" costume and practice, male athletes affirm their manliness. As Lionel Tiger noted in 1969, "Men such as war heroes, politicians, sports heroes, who have established themselves as virile, may indulge in public tenderness more easily than persons in less evidently virile occupations, such as poetry, teaching, hairdressing, etc."[43]

Mariah Burton Nelson comments on a photograph of three Texas high school football players, in full football regalia, backs to the camera, holding hands. "Were these same young men to hold hands in a different setting—on a city street, say, or on a beach, without their football uniforms—they would be thought to be gay. They might be taunted by other men—football players, perhaps. Yet in this picture, their handholding projects a solemn, unified sort of group power."[44] "Together," she concludes, "they fall in love—with power, with masculinity. They also fall in love with each other."

What's love got to do with it?

"Language has carried out an entirely justifiable piece of unification in creating the word 'love' with its numerous uses," writes Sigmund Freud. "In its origin, function, and reliation to sexual love, the 'Eros' of the philosopher Plato coincides exactly with the love-force, the libido of psychoanalysis." Indeed, says Freud, "when the apostle Paul, in his famous epistle to the Corinthians, praises love above all else, he certainly understands it in this same 'wider' sense."[45]

Recall here Nelson's description of team bonding: "a solemn, unified sort of group power"; "together, they fall in love." Respected folklorist Alan

Dundes wrote some years ago what he characterized as "a psychoanalytic consideration of American football" in which he pointed out that language like "end" ("tight end," "split end"), "penetration," "go through a hole," etc., was a kind of "folk speech" that suggested "ritual homosexuality." "I have no doubt," said Dundes, "that a good many football players and fans will be skeptical (to say the least)." Even a gay player like David Kopay declined to agree that being able to hold hands in the huddle and "pat each other on the ass" was an overt sign of homosexuality. But Dundes stuck to his argument: "The unequivocal sexual symbolism of the game, as plainly evidenced in folk speech, coupled with the fact that all of the participants are male, makes it difficult to draw any other conclusion."[46]

Easy for him to say. For the average fan, player, or coach, what is difficult is to draw *this* conclusion, or even to entertain the possibility of a subliminal (homo)erotics of male sport. And what is even more difficult is explaining the difference between a cultural practice and a sexual identity. No one—or virtually no one—claims that football players are, as a class, subliminally or overtly gay. Or that they are drawn to football because it affords them an opportunity to pat each others' bottoms or put their hands (expecting the ball) between each others' legs. Reading America's passion for football as a cultural symptom does not threaten anyone's identity, sexuality, future, or faith. Or does it?

I V

Spectatorship in sport, like film spectatorship, has certain mirroring and compromising effects. Laura Mulvey's famous formulation about the "determining male gaze" in cinema, "woman as image, man as bearer of the look," becomes interestingly complicated when the lookers and the looked-at—in and out of what has been dubbed the "looker room"—are male. More than thirty years ago televised sports was characterized by one shrewd observer as "Male Soap Opera."[47] Sociologist Lionel Tiger offered an evolutionary view: "Perhaps we can regard sport spectatorship as a phenomenon bearing the same relation to hunting and male bonding as love stories do to reproductive drives and mate selection."[48] The need to keep identification apart from desire—to insist that you want to *be* Brett Favre and not *have* Brett Favre—produces all-male spectatorship in a very curious space: the displacement of the *permission* to desire onto a nominally desexualized erotic object—Jesus or God—that legitimizes and sacralizes (which is to

say, heterosexualizes) male–male love. By the emotional logic of this position, so long as *someone else* is doing it "wrong," you can be sure you are doing it right. A group of "insiders" depends for its cohesiveness on identifying certain "outsiders," who are either to be permanently excluded for their own good (like women) or, if they meet certain standards, to be converted from error to truth. And in this latter category—the category of the potential convert—we find the usual suspects: homosexuals and Jews. Gay men love other men the "wrong" way. This gives other men permission to love each other—in a way that they can secure as different.

When a Coach Coughlin or a Coach Landry (or, indeed, a "God in pads" like Reggie White) leads a team in prayer, the term "love" circulates freely in the huddle. And the idea that God (or Jesus) is the real captain, or quarterback, the Landrys and Coughlins and Whites merely apostles, is familiar, as we have seen, from the way they think and speak. Coach Bill McCartney, late of the University of Colorado, took this erotics of football from the locker room to the bleachers, with remarkable—and disquieting—effect.

Since 1990, an all-male, all-Christian organization called the Promise Keepers, founded by Coach McCartney, has been holding its rallies in stadiums across the country. Linked to other right-wing groups espousing causes from the teaching of creationism in the schools to the denunciation of abortion and homosexuality, supported by evangelical and politically conservative ministers Jerry Falwell and Pat Robertson, the Promise Keepers gets much of its emotional mileage out of the pep-rally scenario of coach and fans. *New York Times* columnist Frank Rich, formerly assigned to the paper's theater beat, accurately gauged the level, and nature, of PK's appeal when he made a field trip to New York's Shea Stadium, home of the hapless Mets. There he found "some 35,000 standing, waving guys shouting their love to Jesus at a decibel level unknown even in Shea's occasional brushes with a pennant race. During a marathon rally of sermonizing, singing and praying, the men also repeatedly sobbed and hugged each other—or, more joyously, slapped high-fives while repeating the chant, 'Thank God I'm a man!'"[49] The Promise Keepers Rich met were, he thought, "more motivated by a Robert Bly-esque hunger to overcome macho inhibitions and reconnect with God than by any desire to enlist in a political army. But an army PK most certainly is. Its preachers sound more like generals and hard-charging motivational cheerleaders than clergy. Every music cue, crowd maneuver, and sales pitch for PK paraphernalia is integrated into the show with a split-second precision that suggests a Radio City reli

gious pageant staged by George Patton." In the Promise Keepers, Freud's two characteristic groups, the Army and the Church, come together.

Other media observers have seen the atmosphere at PK rallies as "equal parts religious revival, inspirational pep talk and spiritual support group."[50] "As a man," said one of the nearly 50,000 who attended a session at the Thunderdome in St. Petersburg, Florida, "you get trained for your job, you get trained for athletics. But who trains you to be a Christian man?"[51] Roaming among book exhibits that feature works like *What Makes a Man* and *Strategies to a Successful Marriage,* as well as copies of Promise Keepers' own magazine, *New Man,* sporting T-shirts that declared (in a faint echo of muscular Christianity's defensiveness) "Real Men Love Jesus," the audience (congregation? fans?) testified to the pleasure of meeting in all-male groups. "In our church, there are more women than men," reported one Florida man. "To see this, it's awesome."

For some Americans, and other world citizens too, the Promise Keepers only became visible on the national scene in October 1997 when they held a rally on the Washington Mall. But the movement began in Boulder, Colorado, with a conference of 4,200 Christian men in the university's football stadium. Upon this rock—or boulder—McCartney built his church. The following year there were 22,000; the year after that, 50,000. Founder Bill McCartney quit his $350,000 job as Colorado's football coach and went into the Promise Keeping business full time. He called the movement an opportunity for men to "walk in Christian masculinity." The Promise Keepers went national (72,000 men in the Silverdome in Pontiac, Michigan; 52,000 at RFK stadium in Washington, D.C.; thirteen cities in the Summer and Fall of 1995) and planned expansion overseas. Participants, who paid $55 apiece for the privilege of attending, bought Promise Keepers books, tapes, T-shirts, caps, did "stadium waves," sang, prayed, held hands, and embraced.[52]

This fellowship of men, who often embrace one another and speak in a rhetoric of love, is part of a movement that is, officially, anti-gay. Any gay men who show up are candidates for double conversion—to born-again Christianity and to heterosexuality—with counselors on hand to assist in making the change. Coach McCartney, whose movement is dedicated to "uniting men through vital relationships to become godly influences in their world," drew administrative and student ire when he was at the University of Colorado for publicly denouncing homosexuality as "an abomination of almighty God" and for endorsing Colorado's proposed amendment that would have barred laws protecting homosexuals from

discrimination. The University's president, the ACLU, student groups, and Representative Pat Schroeder all deplored McCartney's use of his university role for political and ideological ends: The conservative group called Colorado for Family Values had listed him as a board member, and identified him as Colorado's football coach. A student leader commented that McCartney was "spreading gay hatred and bigotry and gay bashing at an institution of higher education," and asked rhetorically, "You tell me if that is good Christian values and what we should be teaching at a university."

One might think that Coach McCartney's departure from coaching was hastened by the restrictions the state University placed on his role. But he himself claims that he founded the movement—and turned away from coaching—because he suddenly realized that his wife was unhappy. Although he tells this story at every rally, with his wife by his side (sometimes he kisses her onstage to punctuate his story), he doesn't usually report that his unmarried daughter "gave birth to two children, both fathered by players on McCartney's teams." (Since McCartney had, when at the University of Colorado, criticized homosexuals as people who do not reproduce and want equality with people who do, it is perhaps possible to see this family "expansion team" as consistent with, rather than a violation of, his own beliefs.)

It's fascinating to imagine what the church and the media's response might be to stadiums full of *women*, 50,000 strong, chanting in concert and declaring themselves dedicated to social change. "Mass hysteria" is the phrase that comes to mind. One has only to think of all that file footage on women and girls weeping and screaming at the sight of the Beatles—or, for that matter, the young Frank Sinatra. One of Freud's examples of "group psychology" is in fact "the troop of women and girls, all of them in love in an enthusiastically sentimental way, who crowd round a singer or a pianist after his performance. It would certainly be easy for each of them to be jealous of the rest; but, in the face of their numbers and the consequent impossibility of their reaching the aim of their love, they renounce it, and, instead of pulling out one another's hair, they act as a united group, do homage to the hero of the occasion with their common actions, and would probably be glad to have a share of *his* flowing locks. Originally rivals, they have succeeded in identifying themselves with one another by means of a similar love for the same object."[53] When a woman's version of the Million Man March was organized it attracted relatively few participants—and almost no media attention. Was this because the event was so decorous, with so little in the way of "acting out"?[54] Would anyone take a group of

50,000 sobbing, praying, and embracing women seriously as a sign of moral progress? Or would they be regarded as symptoms of cultural crisis, of *lack* of moral strength and emotional self-control?

And if you find this scenario hard to imagine, try replacing the 50,000 singing and chanting heterosexual men with 50,000 gay men. "We're number one" in this context would surely be taken as a sign of group narcissism, as a decadent conspiracy, and as a desperate plot against the moral fiber of the nation. Even if they prayed. And especially if they embraced each other.

V

Ruminating on the peculiarities of "normality" in human sexual life, Sigmund Freud had, on one memorable occasion, rather witty recourse to the figure of conversion. "In general," he remarked, "to undertake to convert a fully developed homosexual into a heterosexual does not offer much more prospect of success than the reverse, except that for good practical purposes the latter is never attempted."[55] For Freud the Jew, the concept of conversion—forced conversion—was, we can presume, already heavily freighted. "The conversion of the Jews" was a long-term project for Christianity, a project so proverbially formidable that the poet Andrew Marvell could equate it with eternity ("And you should, if you please, refuse / Till the conversion of the Jews"), so ideologically desirable and hotly contested that it formed a central tenet of Protestant Evangelism in England from the time of the French Revolution to the end of the nineteenth century. "In the vocabulary of a Christian," wrote Lewis Way, a member of the London Society for Promoting Christianity amongst the Jews, in 1831, "conversion does not stand opposed to *toleration* but to *persecution*."[56] In the vocabulary of football, conversion is a way of scoring points: the "extra point" earned by a kick after a touchdown, or the "two-point conversion" scored by running or passing. Modern-day evangelicals, from the Promise Keepers to the more mainline Protestant denominations, have their own kind of two-point conversion: point one, the conversion of the homosexuals; point two, the conversion of the Jews.

When the 14,000 delegates to the Southern Baptist Convention met in New Orleans in June 1996 they affirmed their support for a major campaign to convert American Jews to Christianity. (Delegates called on the same occasion for a boycott of Disney because of its alleged pro-gay stance in producing the TV series *Ellen* and allowing benefits for same-sex partners of Disneyland employees. Both points of the "two-point conversion" were thus

expressly on the agenda.)[57] Lawyer Leonard Garment wrote eloquently in the *New York Times* that the resolution was "the latest in a centuries-old line of conversion efforts whose history is so distasteful as to make the Baptists' action profoundly offensive." "In the simple conversionist view," Garment explains in a tone that is carefully, passionately, dispassionate, "Christianity is the natural, necessary culmination of Jewish history. It makes Judaism unnecessary and obsolete. The persistence of Jews who choose to remain Jews poses a challenge to this idea of inevitability. Thus, the argument goes, intensive conversion efforts must be made." Moreover, he noted, the Baptists' mission is specifically targeted at Jews. Their resolution "does not declare that the growing Muslim population in the United States is in special need of spiritual improvement. Only the Jews merit this honor."[58] That persistent and defining evangelical activity, the conversion of the Jews, long regarded as the millenarian missionary moment, was, it seemed, once again at hand.

The evangelism resolution itself had an oddly defensive-aggressive tone, demonstrating perhaps that, as the sports truism goes, the best defense is a good offense. "There has been an organized effort on the part of some either to deny that Jewish people need to come to their Messiah, Jesus, to be saved; or to claim, for whatever reason, that Christians have neither right nor obligation to proclaim the gospel to the Jewish people," it declared. This latest mission to the Jews was thus somehow both anti-conspiracy ("an *organized* effort *on the part of some*") and a matter of civil rights (refuting the "claim, *for whatever reason,* that "Christians *have neither right nor obligation* to proclaim the gospel to the Jewish people"). What might appear to Jews as intrusive and unwelcome spiritual bullying is summarily redefined as a courageous act of conscience. In this latest confrontation between Christians and lions it was the Lion of Judah who was subject to attack.

We might note that the rise of "muscular Christianity" took place at about the same time as the physician Max Nordau's call, in Germany, for the appearance of a "new Muscle Jew." Sports were part of the regimen recommended by turn-of-the-century Zionists for rebuilding the bodies and spirits of Jews worn down by ghetto life. German-Jewish gymnastic competitions and Nordau's invitation to the playing fields of Berlin and Vienna were part of a systematic plan for incorporating healthy minds and bodies and overcoming the perceived divide between "muscle Jews and nerve Jews"[59]—a view held both by political and by medical commentators. ("They have been little inducted, during their pilgrimages, into the public games of the countries in which they have been located," wrote a sympathetic American observer in

1882 in a book called *Diseases of Modern Life.*)[60] Thus the Jewish Olympic athlete was perceived as something of an anomaly.

But the key distinction here, of course, is that modern Judaism is emphatically not a missionary or evangelical religion. As anyone knows who has contemplated becoming a Jew, the rabbis ordain a period of intensive study, and in general converts are discouraged unless they can prove a sustained and informed interest in the faith. "I don't want to speculate why Jews don't evangelize," said a Southern Baptist spokesman, "but if your religion is so great, why aren't you on the street evangelizing?"[61] This perceived "exclusiveness" has been held (like so much) against the Jewish religion from time to time. "Unlike that of proselytizing religions," writes James Carroll, "the Jewish ethic boils down to the injunction: Let other people be other people." Carroll, a columnist and essayist, suggests that Jews have been so hated in history "because they have refused to make an absolute of group identity, thereby calling into question, by their very existence, the rigid intolerance of groups that do exactly that."[62] What is completely out of the question, in any case, is the idea of a football field full of persons "called" to Judaism, or a sudden onset of faith. Jewish athletes may be heroes, loners, or role models—but they are not, by the very nature of the Jewish faith, agents of conversion.

We noticed in our discussion of Freud's "Group Psychology" that the narcissism of small differences made neighbors into rivals, and that "the libidinal constitution of groups," as he put it, the (carefully desexualized and spiritualized) "love" that is often expressed by team members for one another, is a way of overcoming rivalry, of turning "egoism" into "altruism"—or at least into points on the board. "We're number one" is, when you stop to think about it, a slightly paradoxical chant, numerically speaking. "Identification" produces group identity, which produces "love."

What makes a group a group, though, or a team a team, turns out to be as much rivalry or aggression as love. As Freud remarks with deceptive matter-of-factness in *Civilization and Its Discontents*, "It is always possible to bind together a considerable number of people in love, so long as there are other people left over to receive the manifestations of their aggressiveness." (Are you listening, sports fans?)

"In this respect," he continues, with equal urbanity, "the Jewish people, scattered everywhere, have rendered most useful services to the civilizations of the countries that have been their hosts; but unfortunately all the massacres of the Jews in the Middle Ages did not suffice to make that period more peaceful and secure for their Christian fellows. When once the Apostle Paul

had posited universal love between men as the foundation of his Christian community, extreme intolerance on the part of Christendom towards those who remained outside it became the inevitable consequence."[63]

Let us return then, briefly, to the Promise Keepers. What are the promises the Promise Keepers promise to keep?

With Robert Frost's refrain ("I have promises to keep, And miles to go before I sleep") and J. L. Austin's speech-act theory in mind, I had blandly (and as it turned out, blindly) assumed that a promise was a kind of ethical, and indeed largely secular, declaration or assurance, made by one person to another. I had imagined that all these men in football stadiums, who wept and shouted that they had been bad husbands and bad fathers, were promising to reform their conduct toward their (absent) wives and children. And so they may, in part, be doing. But *promise* is also a religious term. The rainbow, I was taught as a child, was God's promise to humankind that there would never be another Flood. And America, I was also taught, was the Land of Promise, to which my (as it happens, Jewish) ancestors came to find freedom and opportunity.

In today's majoritarian religious parlance, however, it seems that *promise* is a word with what has become an increasingly specific Christian meaning. "The word *promise* in the New Testament," says Cruden's concordance to the Bible, "is often taken for those promises that God made to Abraham and the other patriarchs of sending the Messiah. It is in this sense that the apostle Paul commonly uses the word *promise*." Jesus, in short, is the promise. Romans 4:13: "For the promise, that he should be the heir of the world, was not to Abraham, or to his seed, through the law, but through the righteousness of faith." Galatians 3:16: "Now to Abraham and his seed were the promises made. He saith not, And to seeds, as of many; but as of one. And to thy seed, which is Christ." Promise = eternal life through Jesus Christ.

Now, this understanding of the "promise" as not—despite what one might at first think—an equal-opportunity opportunity, so to speak, but rather a specifically *Christian* notion, brings with it a number of potentially dangerous side effects. Look what happens, for example, to the question, not only of the Promised Land (the state of Israel, the place of the Messiah) but also of the Land of Promise (the United States of America). It becomes, as Pat Robertson, Missisippi Governor Kirk Fordice, and others have been all-too-quick to claim, a "Christian nation."[64] One of the fastest growing movements in the United States today is the extreme right-wing cluster of

organizations known as "Christian patriots," a Christian Identity group
whose commitment is to Jesus Christ as savior, to the promise of salvation,
and to the idea that Christianity alone can offer eternal life. "The *end* of
Christian patriotism," writes sociologist James Aho, "is the preservation of
'Christian values' and 'Americanism,' as the patriots understand them."[65]
And if we understand "promise" as *code* for Christianity, and even, espe-
cially, messianic and evangelical Christianity, then the promise of the
Promise Keepers can be understood as an appropriation, and a naturaliza-
tion, of born-again Christianity as the American experience.

This is one reason why Jacques Derrida describes Francis Fukayama's
book *The End of History and the Last Man* as a "neo-evangelistic" gospel,
preaching the "good news." ("We have become so accustomed by now to
expect that the future will contain bad news with respect to the health and
security of decent, democratic political practices that we have problems
recognizing good news when it comes. And yet, the *good news* has
come.")[66] Here is Derrida's swift and devastating analysis:

> If one takes into account the fact that Fukayama associates a certain
> Jewish discourse of the Promised Land with the powerlessness of eco-
> nomic materialism or of the rationalism of natural science; and if one
> takes into account that elsewhere he treats as an almost negligible excep-
> tion the fact that what he with equanimity calls "the Islamic world" does
> not enter into the "general consensus" that, he says, seems to be taking
> shape around "liberal democracy" [p. 211], one can form at least an
> hypothesis about which angle Fukayama chooses to privilege in the
> eschatological triangle. The model of the liberal State to which he explic-
> itly lays claim is not only that of Hegel, the Hegel of the struggle for
> recognition, it is that of a Hegel who privileges the "Christian vision."[67]

In other words, "The end of History is essentially a Christian eschatology,"
the imagination of postwar America and the European Community as a
"Christian State."

It may be of more than passing interest that the place where the Southern
Baptist Convention gathered in New Orleans to adopt their "Resolution on
Jewish Evangelism" was the Louisiana Superdome, home of the New Orleans
Saints. In a cordoned-off third of the stadium, slated in a few months to play
host to Super Bowl XXXI, the assembled faithful heard their newly elected
president, Tom Eliff, urge them to "Step up to the plate and be the people of

God He expects us to be."[68] (On another occasion, one of the leaders of the Southern Baptists' mission to the Jews predicted that in the End Days of the world "It'll be the bottom of the ninth, and the Jews will be batting clean-up for Christ.")[69] The Superdome is a football, not a baseball, field, but the month was June, after all, and God (as we have already seen) is, in evangelist-speak, the Utility Infielder to end all utility infielders, a team player—and team leader—in all organized sports. ("We're scoring baskets for Jesus," declared the emcee of a Promise Keeper's event in Colorado's Folsom Stadium, another football venue.)[70] And, I want to suggest, it is neither an accident nor a mere matter of convenience that this act of spiritual cheerleading emanated from a football stadium.

What does it mean to claim that the Dallas Cowboys—or now, the Green Bay Packers—are "America's Team"? Is part of what makes "America's Team" American the fact that the players and coaches are overtly, manifestly, even ostentatiously Christian? The oppositional, ecstatic, and zealous nature of sports spectatorship and sports fandom ("Kill the ump"; "throw the bums out") raises the temperature of the crowd even as it lowers the level of nuance and subtlety. The twin phenomena—of exhibitionistic, often televised moments of prayer by players and coaches, and of the religious faithful convened for evangelical purpose in football stadiums around the country, exhorted to action by coaches who are now ministers, or ministers who are now coaches—reflect each other with uncanny and disturbing symmetry. Winning, it may turn out, converting points for "our" team, the chosen team, the team that *deserves* to win, is once again the "only thing" that counts.

The football rulebook contains a number of sounding phrases that mark infractions on the field, from "out of bounds" to "unsportsmanlike conduct" to "palpably unfair acts," like a player coming off the bench to tackle the ball carrier. "Encroachment," defensive or offensive holding, illegal motion, and falling or "piling on" are other sins of the gridiron, as is "prolonged, excessive, premeditated celebration."[71] Once upon a time, before the modern era of illuminated stadiums and luxury boxes it was also possible for a game to be "called on account of darkness." The high visibility of evangelical and salvific Christianity in sports, and its close ties with a competitive rhetoric of patriotism and Americanism, suggest that this may be the moment to call for a time out on proclamations of holiness in the huddle—time to rethink the troubling implications of public prayer on the field and organized team prayers in the locker room.

NOTES

1. Nick Cafardo, "Parcells Plays to Audience." *Boston Globe,* January 7, 1997, p. C5.
2. Gerald Eskenazi, "Jaguars and Patriots Put It On the Line: Expect a Shootout." The *New York Times,* January 12, 1997, p. H3.
3. Michael Vega, "Jaguars' Leap of Faith." *Boston Globe,* January 9, 1997, p. C7.
4. When reporter Michael Vega asked players for their favorite Bible verses, they had them ready, as if they were plays to be audibled from the huddle.

 "Philippians 4:13," said guard Rich Tylski. "That's been my favorite Scripture ever since I became a Christian in high school." "Colossians 3:23," said tight end Rich Griffith. "It has to do with 'Everything you do, do with all your heart as for the Lord and not for men.' So everything I do, I try to do it for God. I don't do it for Coach Coughlin or for anyone else. I try to do it for a superior person." As for Brunell's favorite, it was Jeremiah 29:11: "For I know the plans I have for you, declares the Lord, plans to prosper you and not to harm you, but to give you hope for the future."

 Said Jaguars' team chaplain Don Walker, "When Coach Coughlin put this team together, he didn't just stop with excellent athletes, he went looking for young men with values and character... some good guys." "What he ended up getting were good guys who are walking and looking after God." "From the very beginning," the chaplain observed, "I think there was a very strong core group, spiritually, within this team, and it has grown and progressed. There's a very, very positive atmosphere spiritually in this team and there's almost positive peer pressure to consider walking in faith. There's just a tremendous sense of prayer on this team."(Notice the interesting qualification, "almost positive peer pressure." Is that *"almost* pressure"—or "almost positive"?)
5. Adam Nossiter, "North Carolina's Faith in Football." *New York Times,* January 11, 1997, p. 6.
6. Don Beebe, quoted in Mark Blaudschun, "No Doubt White Is on a Mission." The *Boston Globe,* January 22, 1997, p. F5.
7. Timothy W. Smith, "White Wants Pulpit Between Hash Marks." *New York Times,* January 23, 1997, pp. B13, B14.
8. "Some Packers Say They Plan to Pray Publicly." *New York Times,* January 24, 1997, p. B13.
9. Rick Romell, "Packer Pride: Jubilant Hordes Jam Homecoming." *Milwaukee Journal Sentinel,* January 28, 1997, p. 5A.
10. "Having a Prayer: Christians Are Making a Statement in the NFL". *San Francisco Chronicle,* January 22, 1997, p. D1.
11. Cited by Lester Kinsolving, "Exploiting Athletes in Religion Questioned." *The Johnson City Press,* January 12, 1971, p. 10. Quoted in Robert J. Higgs, *God in the Stadium: Sports and Religion in America* (Lexington, KY: The University Press of Kentucky, 1995), p. 10.
12. Bill Heyen, "Until Next Time." Quoted in Higgs, pp. 12–13.
13. Higgs, p. 12, citing Gary Swan, "Religion's a Hit in Baseball Clubhouses." *The Greenville Sun,* August 25, 1990, p. B1 (AP story).
14. Described by W. Brown Patterson, Dean of the College at the University of the South. Quoted in Higgs, p. 238.
15. Joe D. Willis and Richard G.Wettan, "Religion and Sport in America: The Case for the Sports Bay in the Cathedral Church of Saint John the Divine." *Journal of Sport History,* vol. 4, no. 2 (Summer 1977), pp. 189–207. Cited in Higgs, p. 236. The chapel's racing runners would seem to illustrate St. Paul's instruction to the Corinthians, "Know yet not that they which run in a race run all, but one receiveth the prize? So run, that ye

may obtain" (1 Cor.9:24)—rather than Ecclesiastes, "the race is not to the swift" (Ecc.9:11) or even Paul's more temperate—or marathon-like—"let us run with patience the race which is set before us" (Heb.12:1).

16. Cited in Higgs, p. 325. See John T. McNeille, "The Christian Athelete in Philippians 3:7–14." *Christianity in Crisis: A Christian Journal of Opinion* (August 2, 1948), pp. 106–7.

17. Quoted in William Martin, *A Prophet With Honor: The Billy Graham Story* (New York: William Morrow, 1992), p. 347. Cited in Higgs, p. 289.

18. Frank Deford, "Endorsing Jesus." *Sports Illustrated* (April 26, 1976), pp. 54–69.

19. James A.Mathisen, "From Muscular Christians to Jocks for Jesus." *Christian Century* (January 1–8, 1992), pp. 11–15. Quoted in Higgs, p. 15.

20. Matt Harvey, "Super Bowl Sunday Stokes Creative Fires of Clergy Nationwide." *Johnson City Press,* January 28, 1995, p. 7. Cited in Higgs, p. 15.

21. Rajiv Chandrasekaran, "A Reverse in the End Zone: After Liberty's Challenge, NCAA Clarifies Rule, Allows Praying After Touchdowns." *The Washington Post,* September 2, 1995, C1. "N.C.A.A. Clairifies Rule to Permit Prayers." *New York Times,* September 2, 1995, p. A26. Arthur Hoppe, "Football Prayers." *San Francisco Chronicle,* September 6, 1995, p. A15.

22. Wendy Kaminer, "The Last Taboo." *The New Republic* (October 14, 1996), pp. 28, 32.

23. Herrmann, "A Legal leg to Stand On." *Chicago Sun-Times,* March 14, 1996, p. 8. Roscoe Nance, "Abdul Rauf to Stand, Pray During Anthem." *USA Today,* March 15, 1996, p. 1C.

24. Peter Steinfels, "Beliefs." *New York Times,* June 22, 1991, p. A10.

25. Rick Reilly, "Save Your Prayers, Please." *Sports Illustrated* (February 4, 1991), p. 86.

26. Grantland Rice, "Alumnus Football." *Only the Braves: and Other Poems* (New York: A. S. Barnes, 1941), pp. 142–44.

27. Steinfels, "Beliefs."

28. Skip Bayless, "God's Playbook." *New York Times,* December 1, 1996, p. E7.

29. Peter Monaghan, "Religion in a State-College Locker Room: Coach's Fervor Raises Church-State Issue." *The Chronicle of Higher Education* vol. 32, no. 3 (1985), pp. 37–38, and Peter Monaghan, "U. of Colorado Football Coach Accused of Using His Position to Promote His Religious Views." *The Chronicle of Higher Education* vol. 32, no. 12 (1992), pp. A35, A37. For this and subsequent references, see also Gil Fried and Lisa Bradley, "Applying the First Amendment to Prayer in a Public University Locker Room: An Athlete's and Coach's Perspective." *Marquette Sports Law Journal* 301 (Spring 1994).

30. Charles R. Farrell, "Memphis State Coach is Accused of Imposing Religious Beliefs on Players." *The Chronicle of Higher Education* vol. 29, no. 6 (1984), p. 26.

31. Harry M. Cross, "The College Athlete and the Institution." *Law and Contemporary Problems,* vol. 38 (1973), pp. 150, 168-69. Cited in Fried and Bradley, note 57.

32. "Not a Prayer." *Boston Globe,* October 16, 1992. From wire services.

33. *Menora, et al., v. Illinois High School Association, et al.* 527 F. Supp. 637.

34. *Ibid.,* 642.

35. *Ibid.*

36. *Ibid.,* 646.

37. Sigmund Freud, "Group Psychology and the Analysis of the Ego" (1921), in James Strachey, ed. and trans., *The Standard Edition of the Complete Psychological Works of Sigmund Freud* (London: The Hogarth Press and the Institute of Psycho-Analysis, 1955), vol. 18, p. 95.

38. Higgs, *God in the Stadium,* pp. 225, 227.

39. Freud, "Group Psychology," p. 103.

40. Diana Fuss, *Identification Papers* (New York: Routledge, 1996), p. 45.

41. Freud, "Group Psychology," p. 141.

42. Brian Pronger, *The Arena of Masculinity: Sports, Homosexuality and the Meaning of Sex* (New York: St. Martin's Press, 1980), p.197.

43. Lionel Tiger, *Men in Groups* (New York: Random House, 1969), p. 91.

44. Mariah Burton Nelson, *The Stronger Women Get, the More Men Love Football* (New York: Harcourt Brace,1994), p.116.

45. Freud, "Group Psychology," p. 91.

46. Alan Dundes, "Into the Endzone for a Touchdown: A Psychoanalytic Consideration of American Football." In Dundes, *Interpreting Folklore* (Bloomington: Indiana University Press, 1980), p. 209.

47. Barbara Moon, "For the Sake of Argument." *Maclean's Magazine* (October 5, 1963). Cited in Tiger, p. 122.

48. Tiger, p. 122.

49. Frank Rich, "'Thank God I'm a Man.'" *New York Times,* September 25, 1996, p. A21.

50. Gustav Niebuhr, "Men Crowd Stadiums to Fulfill Their Souls." *New York Times,* August 6, 1995, p. A1.

51. Ibid., p. A30.

52. "New Men for Jesus." *The Economist* (June 3, 1995), p. 21.

53. Freud, "Group Psychology," p. 120.

54. Michael Janofsky, "At Mass Events, Americans Looking to One Another." *New York Times,* October 27, 1997, p. A21.

55. Sigmund Freud, "The Psychogenesis of a Case of Homosexuality in a Woman," in *Standard Edition,* vol. 18, p. 151.

56. Lewis Way, *Jewish Repository I* (London, 1813), pp. 279-80. Quoted in Michael Ragussis, *Figures of Conversion: "The Jewish Question" and English National Identity* (Durham and London: Duke University Press, 1995), p.6.

57. Gustav Niebuhr, "Baptists Censure Disney for Gay-Spouse Benefits." *New York Times,* June 27, 1996, p. A14.

58. Leonard Garment, "Christian Soldiers." The *New York Times,* June 27, 1996, p. A23.

59. M. Jastrowitz, "Muskeljuden und Nervenjuden," *Jüdishe Turnzeitung* 9 (1908), pp. 33–36. Cited in Sander Gilman, *The Jew's Body* (New York and London: Routledge, 1991), pp. 53–54.

60. Benjamin Ward Richardson, *Diseases of Modern Life* (New York: Bermingham and Co., 1882), p. 98. Cited in Gilman, p. 52.

61. Larry Lewis, former president of the Home Mission Board that supervises the Southern Baptist Convention's United States-based missionaries. Quoted in Jeffrey Goldberg, "Some of Their Best Friends are Jews." *New York Times Magazine,* March 16, 1997, p. 43.

62. James Carroll, "Critics of Albright's Conversion Ignore the Essence of Judaism." The *Boston Globe,* February 18, 1997, p. A11.

63. Freud, *Civilization and Its Discontents,* in *The Standard Edition,* vol. 21, p. 114.

64. Ronald Smothers, "For Mississippi's Governor, Another Fight Over Power." *New York Times,* July 10, 1996, p. A10.

65. James A. Aho, *The Politics of Righteousness: Idaho Christian Patriotism* (Seattle and London: University of Washington Press, 1990), p. 15. Since, according to the logic of these groups, only the Anglo-Saxon peoples have fulfilled all of God's promises in the Bible, they alone are His chosen people. Thus Gordon "Jack" Mohr, the co-founder of a group called the Christian Patriot Defense League and a member of the Christian

Identity movement, can claim that Talmudism is Satan worship, that Jews are born evil, and that the real Israelites, the ones to whom God promised a chosen future, are white Aryans. Mohr's book on this topic is called *Exploding the 'Chosen People' Myth.* In it he suggests, among other things, that Jews *cannot* be converted, because the "Jewish character" is inherited from "2,500 years of legacy." "Judah," in fact, say some Christian Identity believers, was the homeland of the Aryan people known as the Jutes, who lived in northern Germany. Under the headline "Adolf Hitler was Elijah," a brochure distributed by the Socialist Nationalist Aryan Peoples Party declared that the "message of Identity" was that Aryans are, "to the exclusion of all others, representative of the only Covenant agreeable to our God." Jews are "vipers," "murderous," "mongrelizing" international bankers, rightly opposed by the prophet Hitler. A color brochure from Mythos Makers, Aryan Nations (reproduced in Aho's Appendix), advertises—among other items—a Mythos baseball jersey (50 percent cotton, 50 percent polyester) bearing the logo, "White Pride World Wide." Such extremist groups, often overtly and proudly anti-Semitic, "Aryan," and racialist, are far from the mainstream of American Christian opinion. But whether Jews and homosexuals are cast out forever, or capable of being "saved" and "converted" to the majority's faith makes less difference than the fact that self-appointed experts have determined their right to coax and coach them into conformity.

66. Francis Fukuyama, *The End of History and the Last Man* (New York: Maxwell Macmillan International, 1992).

67. Jacques Derrida, *Specters of Marx* (New York and London: Routledge, 1994), p. 60.

68. Tom Elliff, President of the Southern Baptist Convention. In Art Toalston, "SBC Challenges Disney, Church Arsons, Moves Ahead with 21st Century Thrust." *Baptist Press News Service,* June 13, 1996.

69. The Rev. Phil Roberts, quoted in Goldberg, "Some of Their Best Friends are Jews," p. 43.

70. Kenneth L. Woodward and Sheery Keene-Osborn, "The Gospel of Guyhood," *Newsweek* (August 29, 1994), p. 60.

71. Ralph Hickok, *The Pro Football Fan's Companion* (New York: Macmillan, 1995), pp. 42–44.

CONTRIBUTORS' NOTES

Dorothy A. Austin is Associate Professor of Psychology and Religion at Drew University where she holds a joint appointment in the Graduate School and the Theological School. She has held positions on the Harvard faculties of Divinity and Medicine, and was the Director of the Erik H. and Joan M. Erikson Center, dedicated to interdisciplinary and intergenerational work in psychology, arts, and humanities. She is an ordained priest in the Episcopal Church.

Michael Eric Dyson is Ida B. Wells University Professor and Professor of Religious Studies at DePaul University. He is the author of several books on race and culture, including *Race Rules: Navigating the Color Line* (1996) and most recently *I May Not Get There With You: The True Martin Luther King, Jr.*

Diana L. Eck is Professor of Comparative Religion and Indian Studies at Harvard University and teaches in both the Religion and Sanskrit Departments as well as in the Divinity School. Her books include *Banaras: City of Light, Darśon: Seeing the Divine Image in India,* and *Encountering God: A Spiritual Journey from Bozeman to Banaras.* As Director of the Pluralism Project she has published a multimedia CD-ROM, *On Common Ground: World Religions in America.*

Barbara Claire Freeman is an associate professor of English at Harvard University. Her publications include *The Feminine Sublime: Gender and Excess in Women's Fiction* (Univ. of California Press) and numerous essays on literary and cultural theory.

Marjorie Garber is William R. Kenan, Jr., Professor of English at Harvard University and Director of the Center for Literary and Cultural Studies. Her books of cultural criticism and theory include *Vested Interests: Cross-Dressing and Cultural Anxiety* (1992), *Vice Versa: Bisexuality and the Eroticism of Everyday Life* (1995), *Dog Love* (1996), and *Symptoms of Culture* (1998). She is also the author of three books on Shakespeare.

Cheryl Townsend Gilkes is MacArthur Associate Professor of African American Studies and Sociology and Director of the African American Studies Program at Colby College. She is also an assistant pastor at the Union Baptists Church in Cambridge, Massachusetts. Her articles on sociology of religion, African American women, W. E. B. Du Bois, and African American religious traditions have appeared in several journals and anthologies.

Irving (Yitz) Greenberg is President of *CHAverIm kol yisrael/* Jewish Life Network, a Judy and Michael Steinhardt Foundation. Rabbi Greenberg has published articles on Jewish thought and religion and American Jewish history. His books include *Theodore Roosevelt and Labor, 1900–1918* (New York: Garland Publications, 1988), *The Jewish Way* (Summit Books, 1988), and *Living in the Image of God: Jewish Teachings to Perfect the World* (Jason Aronson, 1998.)

William R. Handley has taught at Harvard and is currently an Assistant Professor of English at the University of Southern California. He has written articles on Virginia Woolf and Toni Morrison and is completing his first book, *Imagining America in the Literary West,* an examination of the cultural meanings and uses of the American West in historiography and fiction from the 1890s to the 1960s.

Peter S. Hawkins is a professor of religion and literature at Yale Divinity School. He has a Ph.D. in English from Yale and a MDiv from Union Theological Seminary in New York. His most recent book, *Dante's Testaments: Studies in Scriptural Imagination,* is forthcoming from Stanford University Press. Hawkins has also published on American fiction, the literature of utopia, and the *Names* Project AIDS Quilt.

Azizah Y. al-Hibri is Professor of Law at the University of Richmond, and founder and current president of "Karamah: Muslim Women Lawyers for Human Rights." She is author of various articles on women's rights and democracy in Islamic jurisprudence. Al-Hibri has lectured on these issues in numerous Muslim countries, as well as in the United States and Europe.

Janet R. Jakobsen is Associate Professor of Women's Studies and Religious Studies at the University of Arizona. She is the author of *Working Alliances and the Politics of Difference: Diversity and Feminist Ethics.*

David Lyle Jeffrey teaches English Literature at the University of Ottawa in Canada and at the Peking University in Beijing. He is general editor and principal author of *A Dictionary of Biblical Tradition in English Literature* (1992), and his most recent monograph is *People of the Book: Christian Identity and Literary Culture* (1996).

David Kennedy is the Henry Shattuck Professor of Law at Harvard Law School, and Director of the European Law Research Center. He teaches international law, international economic policy, European law, legal theory, contracts and evidence. He has practiced law with various international institutions, including the United Nations High Commissioner for Refugees and the Commission of the European Union, and with the private firm of Cleary, Gottlieb, Steen and Hamilton in Brussels. He is the author of various articles on international law and legal theory, and founder of the New Approaches to International Law project.

Robert Kiely is Loker Professor of English at Harvard. He teaches courses in the modern and postmodern novel, the English Bible, and Christian literature. Recent publications include *Reverse Tradition: Postmodern Fictions and the Nineteenth-Century Novel* and his edited version of the Dalai Lama's commentaries on the Christian Gospels: *The Good Heart.* Professor Kiely is currently at work on a book dealing with the relationship between the textual and painted versions of religious narratives.

Deborah E. Lipstadt is Dorot Professor of Modern Jewish and Holocaust Studies at Emory University in Atlanta. Her book *Denying the Holocaust: The Growing Assault on Truth and Memory* is the first full length study of those who would deny the Holocaust. She is currently working on a book about the history of Holocaust commemoration in the United States between the years 1945 and 1995. Dr. Lipstadt was a historical consultant to the United States Holocaust Memorial Museum where she helped design the section of the Museum dedicated to the American Response to the Holocaust. Dr. Lipstadt has also written *Beyond Belief: The American Press and the Coming of the Holocaust,* which examines how the American press covered the news of the persecution of European Jewry between the years 1933 and 1945.

Ann Pellegrini is Associate Professor of Women's Studies at Barnard College, Columbia University. She is the author of *Performance Anxieties: Staging Psychoanalysis, Staging Race* (Routledge, 1997) and co-editor of the forthcoming anthology *Queer Theory and the Jewish Question.*

Stephen Prothero is an assistant professor in the religion department at Boston University. His *The White Buddhist: The Asian Odyssey of Henry Steel Olcott* (1996) was named the Best First Book in the History of Religions for 1996 by the American Academy of Religion. He is also co-author of *The Encyclopedia of American Religious History* (1996), coeditor of *Asian Religions in America: A Documentary History* (1998), and a regular contributor to the Internet magazine *Salon.* He is currently working on a history of cremation in the United States.

Rebecca L. Walkowitz, a graduate student in English and American literature at Harvard University, writes on cosmopolitanism and twentieth-century narrative. She is an editor of *Media Spectacles, Secret Agents,* and *Field Work,* all published by Routledge.

INDEX